KILL FOR PEACE

KILL FOR PEACE

American Artists Against the Vietnam War

MATTHEW ISRAEL

UNIVERSITY OF TEXAS PRESS ⦦ AUSTIN

The publication of this book was supported in part by the UT Press Fine Arts Endowment, funded by the Mattsson McHale Foundation, the Stillwater Foundation, Frances Dittmer, Jeanne and Michael Klein, and Jean and Dan Rather.

Requests for permission to reproduce material
from this work should be sent to:
Permissions
University of Texas Press
P.O. Box 7819
Austin, TX 78713-7819
http://utpress.utexas.edu/about/book-permissions

The paper used in this book meets the minimum requirements of
ANSI/NISO Z39.48-1992 (R1997) (Permanence of Paper). ∞

Library of Congress Cataloging-in-Publication Data

Israel, Matthew (Matthew Winer)
Kill for peace : American artists against the Vietnam War / by Matthew Israel.
 p. cm.
Includes bibliographical references and index.
ISBN 978-0-292-74542-1 (cloth : alk. paper)
ISBN 978-0-292-74830-9 (pbk. : alk. paper)
1. Art, American—20th century—Themes, motives. 2. Art—Political aspects—United States—History—20th century. 3. Art and society—United States—History—20th century. 4. Vietnam War, 1961–1975—Protest movements—United States. I. Title.
N6512.I87 2013
701'.03097309046—dc23
2012042868

doi:10.7560/745421

To Samara, Ben, Amina, Mom, and Dad;
and in memory of Pop.

It is essential that the community of artists and civilized men register dissent, outrage, and infinite grief as spokesmen for the conscience of society.

DORE ASHTON

In short, America was . . . engaged in a battle at home, a combat whose subject—the bloody military incursions being fought thousands of miles away—existed only in absence. In this country, the antiwar movement and the defenders of the Pentagon were ultimately waging a war of representation, a battle of words and images.

MAURICE BERGER

One continuing sociological characteristic of these rebellions of the oppressed has been their "spontaneous," short-term character. They have come and they have gone, having such effect as they did. When the next such rebellion came, it normally had little explicit relationship with the previous one. Indeed this has been one of the great strengths of the world's ruling strata throughout history—the non-continuity of rebellion.

GIOVANNI ARRIGHI

Contents

Acknowledgments

THROUGHOUT THIS PROJECT many people and institutions provided me with support. I would like to thank the following: Vito Acconci, Carl Andre, Artsy Daniel Belasco, Catherine Belloy, Maurice Berger, Judith Bernstein, Mel Bochner, Kay Brown, Charles Cajori, G. B. Carson, Vija Celmins, the Center for the Study of Political Graphics, Seymour Chwast, Carter Cleveland, Lincoln Cushing, Sebastian Cwilich, the Department of Art History at New York University, Frederick Doner, David Douglas Duncan, Erin Edmison, the Felix Gonzalez-Torres Foundation, James Foster, Gagosian Gallery, Rupert Garcia, the Getty Research Institute, Evelyn Glaubman, Robert Goodnough, Red Grooms, Priscilla Harmel, Dakin Hart, Jon Hendricks, Steven Heller, Alessandra Henderson, Chrissie Iles, Ann Imbrie, Robert Indiana, the Institute of Fine Arts at New York University, (my brother) Jesse Israel, Pepe Karmel, Stephen Koch, Jesse Krotick, Lucy Lippard, Robert Lubar, Matthew Marks Gallery, Marc Morrel, Robert Morris, The Museum of Modern Art, New York Molly Nesbit, Linda Nochlin, Michele Oka Doner, the Paula Cooper Gallery, David Platzker, Violet Ray, Martha Rosler, Peter Saul, Carolee Schneemann, Simon Shagrin, Alan Shapiro, Ava Shapiro, Michal Shapiro, Joel Smith, May Stevens, Robert Storr, Priscilla Soucek, Jeffrey Weiss, (my grandmother) Evelyn Winer, and the Whitney Museum of American Art.

KILL FOR PEACE

Introduction

DURING THE AMERICAN PHASE of the Vietnam War (1964–1975), a substantial number of American visual artists created works that were either conceived of or interpreted as being "antiwar." Significant examples of this politically engaged production, which encompassed painting, sculpture, performance, installation, posters, short films, and comics—and which ranged from the most "representational" to the most "abstract" forms of expression—have been seen often since the war in exhibitions devoted to individual artists, or occasionally in exhibitions concerning the broader relationship between art and war.[1]

Two exhibitions have attempted a survey of this material: Maurice Berger's 1988 *Representing Vietnam* at Hunter College and half of Lucy Lippard's traveling 1990 exhibition *A Different War: Vietnam in Art* (the other half of the exhibition concerned art created after the end of the war). Additionally, art-historical scholarship outside of exhibitions has dealt with this material through monographic studies, within broad surveys of art and war, or in projects concerning the relationship between avant-garde practice and leftist politics, such as Francis Frascina's *Art, Politics, and Dissent: Aspects of the Art Left in Sixties America* (1999) and Julia Bryan-Wilson's *Art Workers: Radical Practice in the Vietnam War Era* (2009).[2]

To date, however, art history has not produced a suitable survey of this work. Consequently, we know little about the overall character of antiwar art production and its producers during the Vietnam War; and the greater definition of what "antiwar" art was during the period remains quite vague.

While this lack of scholarship can be explained by the aesthetic disengagement with social issues of many New York avant-garde artists during the Vietnam War; the resistances to such work in the American fine art system of the 1960s; or the prevalent notion that art conceived or interpreted as antiwar is one-dimensional (and not complex enough for substantial scholarship), this has resulted in a significant art-historical gap. Far from one-dimensional, the best examples of Vietnam-era engagement are some of the most formally challenging, emotionally devastating, and memorable American paintings, sculptures, graphics, and photographs of the last fifty years. These works have also been influential on subsequent generations of American (as well as international) artists, primarily in that they created a renewed sense, "at the so-called triumphant moment of American high modernism," that art could play a significant role in social change. These Vietnam-era works also provided some of the formal and conceptual starting points for 1970s and 1980s politically and socially engaged art-making.[3]

Accordingly, a greater understanding—using a range of art-historical methods—of the collective nature of antiwar art, both its producers and its public—and therefore a refined but also expanded definition of what antiwar art was in the United States during the Vietnam War—is the purpose of this book.

Chapter 1 concerns the origins of the Vietnam War and aims to provide historical context for all later discussion of the war—and specifically antiwar engagement by artists. It begins with the U.S. support of France in its "dirty war" against Vietnamese Nationalist communist forces that lasted from 1946 to 1954. It then discusses the conclusion of this war—the 1954 Geneva Accords, which split Vietnam into democratic and communist states—and U.S. postwar clandestine actions to support democratic South Vietnam against encroaching communist forces from within and from the North over the next decade (e.g., a U.S.-engineered coup that overthrew the besieged South Vietnamese Diem government in 1963). Subsequently, chapter 1 considers the 1964 Gulf of Tonkin Resolution, after which the U.S. role in Vietnam changed drastically. The resolution, created in reaction to two incidents between U.S. naval forces and the North Vietnamese, for the first time formally established a conflict in Vietnam for the United States and authorized President Lyndon Johnson to use military force in the region without officially declaring war. Chapter 1 then continues to discuss Johnson's 1964 reelection and heavy debate in November and December 1964 among his cabinet as to what strategies they would pursue next in Vietnam. Then the chapter discusses the Johnson administration's approval of air strikes in North Vietnam and the

sustained bombing of the country (code-named Operation Rolling Thunder) in response to communist attacks of South Vietnamese army installations in Pleiku in early 1965. Against this background, the chapter turns to American domestic dissent regarding the war. The first major antiwar protests in the United States were organized. College students mobilized for huge marches in Washington, DC, New York City, and Berkeley. In addition, the first "teach-ins" took place. These were lectures given to students outside of class hours by experts or academics engaged with U.S. foreign affairs. American intellectuals began to write against the conflict in significant numbers in major periodicals, such as *The Nation*, the *New Yorker*, *Harper's*, and the *New York Review of Books*.

Chapter 2 begins with the first protests by American artists in 1965. Artists' initial antiwar actions were what I define (within what will in this book emerge as a general typology for antiwar protest) as extra-aesthetic actions. This category of protest (nothing new to protest in the least) encompassed an array of strategies of engagement: marches, advertisements, strikes, walkouts, and petitions. These strategies in themselves also suggested an assortment of aspirations. Chief among them were raising awareness of the irrationality of specific actions of the U.S. government, and shutting down art institutions and art-making in order to propose that art could not support war-making. Extra-aesthetic actions occurred throughout the war, but inasmuch as they lacked a visual aspect or did not relate to what could be considered an art context, I label them extra-aesthetic. (In this way these actions often resembled those undertaken by nonartist protest groups.)

Extra-aesthetic actions were one of the most common means by which American artists protested over the entire course of the war, and by the end of the war these actions had involved more artists than any other type of artistic engagement. This fact stands in contrast to a prevalent conception, based on a scholarly reliance on the activities of a few avant-garde artists, that the majority of politically active artists began their protest making works of art, and, in a manner of radical progression, gravitated toward these types of more immediate actions after finding engaged artworks to be ineffective.

In the spring of 1965, the New York–based group Artists and Writers Protest (AWP) organized the first extra-aesthetic actions: two full-page advertisements in the *New York Times*, which asked those in the cultural community to "End Your Silence" on the war (figs. 1 and 2). Around the same time, the Los Angeles–based Artists' Protest Committee (APC) ran its own comparable ad in the *Los Angeles Free Press*, in which the group pleaded with the government to stop its escalation of the war (fig. 3). APC followed the ad with a series of "Stop Escalation" protest activities in Los Angeles. In one of them, they asked local

galleries not to exhibit art but instead to cover their works of art and windows with white paper bearing their "Stop Escalation" logo, an inverted ladder. As much as this activity could be understood as an extra-aesthetic action, because it whited-out all works, it can be seen as another type of engagement, which I have defined as collective aesthetic endeavors. (It should be said here that this ability of works to demonstrate more than one strategy simultaneously was common over the course of the war.)

Collective aesthetic endeavors were group artworks, usually murals or large quilt-like works, which relied on their size and collective facture—rather than the particular character of the individual contributions involved—to make their statement against the war. While this is the nature of the type, it was made obligatory by the characteristically low quality of individual contributions. Most dispensed with substantive creative expression in word-based rants (lashing out against political figures or stating harsh realities of the war), opting instead to go without pictures. Almost as often contributions consisted of one-dimensional symbols like skeletons or images of bombs. APC's Stop Escalation protest also involved the picketing of the new Los Angeles County Museum of Art and the obstruction of car and pedestrian traffic in the central Los Angeles gallery district on La Cienega during LA's monthly Monday night "Art Walk," when most of the galleries arranged to hold their exhibition openings. In June, APC continued its engagement with the war by protesting outside the RAND Corporation. RAND (whose name stemmed from Research ANd Development) was a nonprofit formed by the Douglas Aircraft Company in 1948 that offered research and analysis to the United States Armed Forces. During the Vietnam War, RAND was one of the major forces behind formulating American military policy.[4] APC's protest of RAND led to two debates between RAND and APC. One was private, held at RAND headquarters, and the second was public, held in August 1965 at the Warner Playhouse in downtown Los Angeles. Both debates were seen as triumphs for the Los Angeles artistic community, since artists had debated "ably" at both venues and helped show that at many points "the war was indefensible even in front of non-experts."[5]

Chapter 3 describes America's further expansion of the war during 1966 and artists' attempts during that year to incorporate antiwar sentiment into works of art for the first time. In Los Angeles, which continued to be a center of engagement, APC created one of the major collective aesthetic endeavors of the war, its *Artists' Tower of Protest*, more commonly called the *Peace Tower* (figs. 4 and 5). In New York, former marine Marc Morrel's controversial exhibition of antiwar flag sculptures was installed at the Stephen Radich Gallery (fig. 14). Morrel's was the first of a host of antiwar works that would deface

patriotic symbols. In addition to the American flag, the Statue of Liberty and Uncle Sam were also defaced (figs. 49 and 50). Such defacement characteristically took patriotic symbols and visually reversed what they stood for; rather than acting as symbols of freedom, idealism, and democracy, they were revised into images representative of a police state, terrorism, or fascism. Also in New York, but in the confines of her studio, Nancy Spero began her *War Series* (fig. 17). The *War Series*, which Spero would work on until 1970, and which would become one of the best-known pieces to concern the Vietnam War, was one of the first artworks to disfigure American weaponry. Spero's work turned helicopters into serpents and snakes, converting what in the wake of World War II had been symbols of pride into images of sin and deceit. Spero's series was also the first to graphically associate American weaponry with the male sex drive—faulting men for the death and destruction of war. This practice could be seen later in works by Judith Bernstein (fig. 18) and in antiwar posters (fig. 19). Further, 1966 saw the first instances of minimalist works engaging with the war: Dan Flavin's crossbow of fluorescent red lights titled *monument 4 those who have been killed in ambush (to P.K. who reminded me about death)* (fig. 6) as well as Wally Hedrick's series of black paintings (fig. 7). Despite these works, and in the face of recent scholarship arguing for political engagement particularly in the works of Carl Andre and Donald Judd, minimalism's engagement with the war was limited. To understand why this was the case—as well as how unwelcome initial artistic contributions were in the larger art world and how disconnected American artists were from previous political art—this chapter discusses the dominance and politically disengaged character of formalism, pop, and minimalism in the American fine art system of the 1960s.

Chapter 4 follows the continued escalation of the war during 1967 and considerable events of the antiwar movement from that year, such as the Spring Mobilization to End the War in Vietnam, which took place in New York, and the publication of Noam Chomsky's "The Responsibility of Intellectuals"—arguably the single most important piece of antiwar literature written during the war.[6] Subsequently, it discusses activities by artists. Collective aesthetic endeavors against the war flourished in 1967. The most important was Angry Arts Week, the largest collective aesthetic protest effort of the antiwar arts community that would ever be held. Angry Arts Week featured five hundred artists and included virtually anything that could fit into the allotted areas of artistic "dissent." The central work of the week was the *Collage of Indignation* (fig. 23), a large mural of protest paintings, drawings, and prints contributed by any artists who wanted to be involved. Carolee Schneemann's film *Viet-Flakes* (figs. 20 and 21) was another highlight of the week. Its incorporation

of atrocity images made it one of the first examples of a work to include direct evidence. "Direct evidence" as a legal term refers to evidence directly related to the facts in dispute. I use this term here—as Maurice Berger did in his previous study—to identify photography from the war front that characteristically featured Vietnamese women and children civilians injured by American attacks. Since the dawn of photography, images of direct evidence from the war front have been central to dissent—these historical examples will be explained in this chapter—and it would be no different during Vietnam.

Apart from Angry Arts Week, 1967 saw Abbie Hoffman's attempt to collectively exorcise the Pentagon during the March on the Pentagon in October, one of the central antiwar protests of the era. One hundred thousand people confronted the Department of Defense at its Arlington, Virginia, headquarters. Hoffman and his later work with the Yippies is integrated into art history here because of its correspondence with other performative works of the sixties, such as Happenings, as well as Hoffman's links to the downtown New York artistic community. Another, much more traditional form of group aesthetic endeavor during 1967 was the creation of a print portfolio by *Artists and Writers Against the War in Vietnam* (details are figs. 41 and 42). This portfolio included works by artists, in the words of Max Kozloff, whose "consciences have been provoked" and who have "chosen to express their conscience through the medium of their own work." While most of the works in the portfolio employed direct evidence, disfigured American weaponry, or defaced patriotic symbols to make their respective statements, abstract works were included that had nothing to do with the war. These were examples of what I will call benefit works. Benefit works were created by artists who wanted to donate their work to benefit the antiwar effort financially (in portfolios, auctions, and gallery exhibitions) but did not want to modify their work—which did not engage with the conflict—in any way to do so.

Though collective aesthetic endeavors were the primary foci of the antiwar movement throughout 1967, extra-aesthetic protests continued, as did the creation of individual works employing new strategies. An unsuccessful petition was circulated that asked Pablo Picasso to remove *Guernica* from the Museum of Modern Art as a symbolic protest against the war. *Guernica* was chosen in order to draw comparisons between the actions of the United States in Vietnam and those of the Nazis and Franco in Guernica during the Spanish Civil War, but also because it was the most significant piece of political art in New York (and arguably in the world). In 1967, Martha Rosler also began her series of collages, *Bringing the War Home: House Beautiful* (figs. 24, 25, and 26). These works exhibited an innovative approach to making antiwar work: the

juxtaposition of direct evidence from the war with contemporary domestic interiors. In so doing, they suggested the stark division between home and the war, and the apathy of the American public regarding the war. Rosler would continue to work on the series until 1972.

Paintings whose central images were rape and napalm victims first surfaced in 1967 as well. Images of napalm victims—which were either photographs or photographic imagery adapted into paint—served as further immediate and shocking examples of direct evidence from the war. Images of rape rendered in paint testified to the ubiquity of the practice by American soldiers of Vietnamese women and the symbolic rape of the country of Vietnam itself by the United States. Examples of how napalm and rape images were incorporated into works by Peter Saul (figs. 29 and 30), Rudolf Baranik (fig. 37), Jeff Schlanger (fig. 31), and Leon Golub (figs. 32–34) are the focus of the end of the chapter.

Chapter 5 opens with an extended discussion of the critical and divisive political events of 1968: the Vietcong's Tet Offensive, Johnson's announcement that he would not run for reelection, the shootings of Martin Luther King and Robert F. Kennedy, and the riots during the Democratic National Convention (DNC) in Chicago. Though Tet had great potential to encourage antiwar protests, Johnson's shocking decision, the shootings of King and Kennedy, and the events surrounding the DNC led to confusion among those involved in the antiwar movement and the concentration of their energies elsewhere. Candidates, feminists, and those combating racial inequalities integrated antiwar messages into their protest or left them aside for others to tackle. This predicament of the antiwar movement was also generally reflected in artists' behavior in relation to the war. A few important exhibitions featuring antiwar works were organized nevertheless. In September, following the violence in Chicago—which was provoked by Mayor Richard J. Daley and the Chicago Police Department's harsh security measures—Chicago gallerist Richard Feigen organized the *Richard J. Daley Exhibition* of protest works. Most of the works, such as Barnett Newman's *Lace Curtain for Mayor Daley* (fig. 40), focused on insulting or injuring the mayor—akin to other antiwar works seeking to do the same to other political figures (like Lyndon Johnson or Richard Nixon, such as in Philip Guston's *Poor Richard* series of drawings). Yet the combination of directness, subtlety, and violence in Newman's work was unique. It comprised only a vertical open square steel structure with barbed wire crisscrossing its interior. For the Daley exhibition James Rosenquist contributed an image (fig. 39) of the mayor painted on thin strips that hung down vertically. Visitors could interact with these strips—which were

akin to those at a car wash—and thus break the mayor's face apart (if they wanted to). Back in New York, during the fall, Lucy Lippard, the artist Robert Huot, and Ron Wolin (a political organizer with the Socialist Workers Party) organized the first minimalist protest exhibition at the Paula Cooper Gallery (fig. 43). Despite Lippard's effort to frame the show as a groundbreaking effort by nonobjective artists to engage with politics, none of the artists altered his or her work at all for the exhibition, and as a result the event was a (by then) familiar example of an exhibition of benefit work.

Outside of exhibitions, in 1968 artists continued to expand the possibilities for protest works. May Stevens insulted another kind of American symbol, the "ordinary working-class man" who supported the war, by making him a grotesque, bald, fat, pasty white figure in her *Big Daddy* series (fig. 51). Edward Kienholz created the first of what I will call advance memorials with his *Portable War Memorial* (fig. 44). Advance memorials critiqued historical war memorials—the principle example in the United States being the national Marine Corps Memorial—through the following techniques: featuring dead soldiers or empty, grave-like spaces instead of valiant heroes; siting works on the floor without historical contextualization (as opposed to elevated, monumental podiums that clearly explained the historical event); and constructing monuments out of ephemeral materials. Kienholz was also one of the first artists, in *The Eleventh Hour Final* (fig. 45), to juxtapose body counts with an individual victim. Such a strategy could be seen in later protest works and aimed to humanize the death toll. At the University of Michigan, the antiwar movement appropriated Michele Oka Doner's *Tattooed Dolls* (fig. 36) as symbolic of victims of napalm attacks (discussed in the previous chapter). Oka Doner's was not the only work somewhat inaccurately identified as antiwar. A similar situation occurred with James Rosenquist's *F-111* in 1968—the painting was finished in 1965—and Claes Oldenburg's *Lipstick (Ascending) on Caterpillar Tracks* (fig. 9) in 1969 (discussed in chapter 3).

Chapter 6 begins with the calm that settled over the antiwar movement in the fall of 1969 after the election of Richard Nixon and his promise to scale back American involvement with his strategy of "Vietnamization." In general, Vietnamization sought to progressively replace (and bring home) American troops through increased air power and larger numbers of South Vietnamese troops. Yet this calm was short-lived. In November 1969, the reporter Seymour Hersh broke the story of what would become known as the My Lai Massacre, American soldiers' March 16, 1968, assault and murder of more than five hundred unarmed South Vietnamese men, women, and children without any proof that they were Vietcong. The disclosure of the events at

My Lai spurred another increase in antiwar engagement in general as well as significant activity by artists. Participants in the activist group Art Workers' Coalition (originally formed around the cause of artists' rights vis-à-vis museums) created *And Babies* (fig. 52).[7] *And Babies* was a protest poster featuring an image of direct evidence from the war: dead men, women, and children from My Lai with two lines of text superimposed at the top and bottom of the image. The text "Q: And babies?" was at the top and "A: And babies" was at the bottom. *And Babies* has ended up being—with the *Peace Tower*—the most recognizable example of protest work from the war. The Guerrilla Art Action Group (GAAG), a small offshoot of AWC, created graphic performance "actions," such as *A Call for the Immediate Resignation of All the Rockefellers from the Board of Trustees of the Museum of Modern Art* (better known as *Blood Bath*) (figs. 54–57), which took place at the Museum of Modern Art, and which, in its final presentation—of a pileup of bloodied bodies—directly recalled photographs of My Lai. GAAG's contribution to protest was groundbreaking. It fused street actions, performance art, damning research, and powerful images of direct evidence into an entirely new form of artistic activism, which engaged with the art institution directly and immediately.

The conclusion of this chapter discusses the first appearance in 1969 of works presenting dead American soldiers, such as Duane Hanson's *War* (also called *Vietnam Scene*) (fig. 58) and Edward Kienholz's *The Non-War Memorial* (fig. 59), both further examples of advance memorials. Though images of dead Vietnamese were available and used from the beginning of the antiwar movement, images of dead American soldiers appeared relatively late in the movement. This was due to America's historical (and still present) practice of keeping images of war casualties from the public, for fear of the intense discomfort they would create in the American populace. As such, for much of the war, images of dead Americans were not available (and were possibly viewed as too extreme) for use in artworks.

Chapter 7 discusses Nixon's invasion of Cambodia in the winter and spring of 1970—a shocking event for the American public. While the president rationalized the invasion by explaining that he was attacking significant enemy forces hiding out in Cambodia, in the eyes of the American antiwar movement, he was controversially and illegally expanding the war across borders when the expectation since his election had been that he was scaling the war back. Labor unions and students demonstrated across the country in reaction to Nixon's actions. This led to rioting and in some cases to tragic deaths, such as at Kent State in Ohio and Jackson State in Mississippi. New York artists responded with a return to extra-aesthetic actions on an unprecedented scale.

They organized the largest artists' action against the war (which also sought to fight the American racial divide), *The New York Art Strike Against Racism, War, and Repression* (fig. 60), a one-day attempted shutdown of major New York museums and galleries. Out of the *Art Strike*, a group formed calling itself the Emergency Cultural Government. This group continued the energy and strategy of the *Art Strike* with an attempted strike of the 1970 Venice Biennale. As a result, many of the artists chosen by the American government pulled out of the exhibition. During 1970, the *Guernica* petition (of 1967, discussed in the previous chapter) was also reprised, though again the organizers met with little success.

The prevalence of extra-aesthetic actions in 1970 did not mean artists stopped attempting to protest the war through works of art. A few antiwar exhibitions were organized, such as *My God, We're Losing a Great Country* at the New School for Social Research, and the Academic and Professional Action Committee for a Responsible Congress published an antiwar print collection, the *Peace Portfolio*. Artists also continued to create works apart from collective projects. Robert Morris completed a series of prints, his *Five War Memorials* (fig. 61), which again, like the works of Kienholz and Hanson, employed the strategy of the anti-memorial. Hans Haacke exhibited his *MoMA-Poll* (fig. 62)—one of the lone examples of conceptual art to engage the war—in Kynaston McShine's seminal MoMA exhibition of conceptual art, *Information*. To contextualize Haacke's contribution, the relationship between conceptual art and politics is evaluated.

Chapter 8 discusses the dissolution of the antiwar movement after the spring of 1970. Nixon's successful institution of Vietnamization and the beginning of peace talks with the North Vietnamese in 1972 pacified many protestors, while others continued the drift, which had begun in 1968, toward other political causes. A small minority pursued further antiwar radicalism, as seen in the antigovernment terror of groups like the Weathermen. Women gravitated toward the feminist movement. While artists' activity was again a reflection of the behavior of the greater antiwar movement, there were still important isolated instances of engagement in 1971 and 1972. In New York in 1971, a new *Collage of Indignation*—comprising posters, not a continuous mural of written statements and drawings—was installed at the New York Cultural Center, and the exhibitions *The Artist as Adversary* at the Museum of Modern Art and *American Posters of Protest* at the New School were organized. Both of these exhibitions sought to generally foreground the idea of the artwork as politically antagonistic in reference to a range of issues, including the war. And in 1972 the Brooklyn Museum exhibited *Vietnam: A Photographic*

Essay of the Undeclared War in Southeast Asia, which featured photojournal-istic coverage of the war in order to expose what war truly was. These years also marked the beginning of Leon Golub's series of *Vietnam* paintings (fig. 63), and the creation of Öyvind Fahlström's exceptional political map works (figs. 64a and 64b), which used the approach of a cartoon map to inundate the viewer with copious information and small illustrations indicting American imperialism.

The conclusion discusses the influence of American artistic protest dur-ing Vietnam to further establish this engagement's relevance and importance. First, it discusses the impact of AWC, Vietnam-era "artist calls," and GAAG on art and activism in the 1970s and 1980s. Subsequently it looks at the substantial effect of Vietnam-era engagement on artistic engagement during American conflicts in Iraq and Afghanistan after September 11, 2001. For example, dur-ing this period, contemporary practitioners re-exhibited or revised Vietnam-era (and previous) examples of dissent, and strategies of the Vietnam era continued to be found. Government rhetoric was again juxtaposed with di-rect evidence, direct evidence again infiltrated contemporary advertising, and the strategy of the advance memorial was often utilized, such as in the 2007 exhibition *Memorial to the Iraq War* at the Institute of Contemporary Arts, London, which invited twenty-six contemporary artists to create a memorial to the war before the war had ended. As a final note, I discuss the major dif-ference between Vietnam-era and contemporary protest work: contemporary production's emphasis on more complete media coverage of the war. This was not an issue during the Vietnam War because media coverage was ground-breaking and extensive. However, since Vietnam (and as a result of it), the United States and its allies have markedly restricted media access to the front of any military conflicts in which they have been involved.

While the constraints of this study don't allow everything to be covered—particularly protests against the Vietnam War outside of the United States, as well as further analysis of the relationship between Vietnam-era antiwar and political work since—hopefully these chapters collectively provide one of the most detailed understandings of American antiwar engagement dur-ing the Vietnam War yet. I also hope this project directly informs the work of others undertaking monographic studies of artists included in this book, as well as the work of scholars trying to understand artists' relation to war more broadly.

Now, moving on from this preamble, we will begin this narrative in Viet-nam in the aftermath of World War II.

1

The Beginnings of the Vietnam War and the Antiwar Movement

THE U.S. ACTIONS THAT EVENTUALLY LED to the Vietnam War began in 1946, when, in the aftermath of the Second World War, the United States began to advise and financially support France's *la sale guerre* or "dirty war" against Vietnamese Nationalist communist forces. The militant Ho Chi Minh, who during the 1930s worked internationally as a secret Comintern agent for the Soviet Union and helped form the Indochina Communist Party, led the communist forces (also called the Vietminh) against France. The Vietminh fought for Vietnamese independence in a country that had been a French colony for roughly a century.[1] The United States initially justified its support of France in the conflict by explaining that France was an ally and needed assistance retaining its colonial holdings in the wake of the Second World War.[2] As the dirty war continued into the 1950s, however, the United States focused less on securing a French colony and more on defending Vietnam against communism.

The U.S. agenda changed because these were the watershed years of the Cold War, when the Soviets and Americans—former anti-Nazi allies of World War II—and their respective communist and democratic political systems transformed into enemies. A series of aggressive actions by the USSR—the subversion of postwar regimes in Greece and Turkey, a communist coup in Czechoslovakia, and the Berlin blockade—threatened the potential influence of the United States in the postwar environment and provoked a strong U.S. response focused on forming a large democratic alliance. In 1947, the United States established the Truman Doctrine, which pledged military and economic assistance for any countries fighting against communism, because,

as Truman maintained, totalitarian regimes coerced "free peoples" and thus "undermine[d] the foundations of international peace and . . . the security of the United States."[3] In 1948, the United States implemented the Marshall Plan, a massive program of economic aid to western Europe, created to curb communist influence in Italy and France. In 1949, a coalition of European nations and the United States created the North Atlantic Treaty Organization (NATO), an allied defense against Soviet incursion. Mao Zedong's establishment of the People's Republic of China in October 1949 and China's entry into the Korean War, backing North Korea, in October 1950 also pushed the United States to fear that a loss of Vietnam to the communists would be the end of democracy in Southeast Asia.[4] This worldview marked the beginning of the "domino theory," which ruled American foreign policy regarding communism in Southeast Asia into the mid-1960s.[5]

The dirty war lasted until 1954, when Ho Chi Minh's forces defeated a French army 80 percent funded by the United States.[6] The final battle of the war was at Dienbienphu, where a French garrison fell on May 7, 1954.[7] France's defeat did not immediately lead to the creation of a communist country. China and the USSR feared that such a move would be a pretext for U.S. intervention in Indochina, and thus a new war. As a result, the conclusion of the fighting led to seventy-four days of negotiations in Geneva between the Vietminh and the French, as well as countries with a significant stake in the outcome: Cambodia, Laos, the United Kingdom, the United States, the Soviet Union, and China (which was making its first appearance on the international diplomatic stage). The negotiations resulted in the Geneva Accords of July 21, 1954, which split Vietnam into two countries at the 17th parallel, along which would run a thin, ten-kilometer-wide demilitarized zone, known as the DMZ.[8] Two states came to be created on each side of the DMZ. The Communist Democratic Republic of Vietnam (DRV) would control the North, with its capital in Hanoi. The democratic State of Vietnam—alternatively known as the Government of the Republic of Vietnam or South Vietnam—would be established in the South, with its capital in Saigon. France would transfer its power to the South (under the democratic Vietnamese rule of Bao Dai and Ngo Dinh Diem). The Accords stated that the creation of two states was a temporary solution, meant to allocate space for each side to retreat its forces until 1956, when elections would be held to reunify the country.[9]

From the beginning, while both North and South Vietnam outwardly supported the Accords, neither side truly complied. Numerous Vietnamese communists failed to retreat from the South to the North, and joined by those sympathetic in the South to their cause, they formed a growing oppositional

movement to renew their struggle.[10] For its part, the United States saw the accords as giving the Communist Party of Vietnam too much power and consequently began providing substantial military and economic aid to the South. This aid came directly under the cover of a newly created coalition of anticommunist countries inspired by NATO: the Southeast Asia Trade Organization (SEATO), comprising the United States, Britain, France, Australia, New Zealand, Thailand, and Pakistan. In August 1954, the United States, via the CIA, began conducting secret sabotage missions against the communist forces in the South, in direct violation of the U.S. promise at Geneva to "refrain from the threat or the use of force" in the country.[11]

Until 1956 the South Vietnamese government and its leader, Ngo Dinh Diem, were able to keep the communists at bay through a series of repressive laws.[12] Yet these laws provoked the communists. In 1957, they commenced attacks as well as assassinations of politicians and others associated with the South Vietnamese government. By 1959, communist armed forces (which became commonly referred to as the Vietcong or VC) were regularly involved in firefights with the South Vietnamese army. At the same time, more and more South Vietnamese—both communists and those sympathetic to the communist cause—joined the National Liberation Front (NLF). The NLF was the political arm of the Vietcong and was employed as an umbrella organization to embrace anyone in the South who opposed Diem and wanted to reunify Vietnam.[13] Also, the Central Committee of the Vietnamese Communist Party—located in North Vietnam—privately resolved to help the Vietcong use force to overthrow Diem.

Between 1961 and 1962, because of the increasing power of communist forces both inside and outside South Vietnam, it became progressively clear that the Army of the Republic of Vietnam (ARVN), or the military of South Vietnam, could not adequately defend the country. In 1961, there were more than one hundred ambushes and attacks on ARVN posts per month. Between 1959 and 1961, the number of South Vietnamese government officials assassinated by the Vietcong increased from twelve hundred to four thousand a year. By 1962, almost thirteen thousand communist cadres had infiltrated the South from the North. These forces were supplied from the North via the Ho Chi Minh trail, a network of roads that ran north and south through Laos, and with American weapons captured from the South Vietnamese or sold by Diem's corrupt military officers.

In response to this situation, during 1962 and 1963—the last two years of President John F. Kennedy's administration—the United States dramatically increased its aid to South Vietnam and Diem. The form of Kennedy's

aid differed in character from what it had been historically. It significantly enlarged the presence of American (CIA and military) "advisers" at all levels of the Vietnamese military and government, from eight hundred, which it had been throughout the 1950s, to more than nine thousand.[14] Following the lead of a report by his advisers Walt Rostow and General Maxwell Taylor, Kennedy also supplied South Vietnam with military hardware, such as helicopters and armored personnel carriers. This increased U.S. military investment in South Vietnam was kept secret from the American public.

Over the next few years, Kennedy's aid did little. One of its more dramatic failures was the addition of helicopters, which the VC quickly learned to shoot down with antiaircraft guns. This period also saw the striking collapse of major U.S.-devised initiatives like the Strategic Hamlet Program, launched in 1962. Reminiscent of earlier approaches pursued by the United States in South Vietnam (such as the "Agroville" scheme, which had failed three years previous), the program sought to concentrate peasants into more defensible positions and segregate them from VC influence.[15] Yet it backfired and proved one of the most destructive ARVN strategic maneuvers. South Vietnamese peasants, moved to unfamiliar hamlets outside their villages, refused to defend them against other Vietnamese who had grown up in or near the area. In displacing villagers far from their homes and farms, the program also created masses of poor and distraught men and women. In all, the Strategic Hamlet Program resulted most often in the conversion of peasants into communists or communist sympathizers.[16]

The continuing decay of the Diem government further impeded Kennedy's aid. Diem's brother Ngo Dinh Nhu was mentally unstable, and it was believed he was negotiating secretly with the North.[17] Nhu's wife occupied the place of first lady of South Vietnam (as Diem was celibate), and infuriated many in the population by her arrogance and by instituting puritanically repressive social laws. She abolished divorce, made adultery a crime, closed Saigon nightclubs and ballrooms, and allowed cafés to remain open with the stipulation that the women who worked there (many of whom were prostitutes) wear white tunics that made them look like dental assistants. Conjointly, in 1962–1963, Diem began to severely antagonize the Buddhist population, which had been protesting the regime at the same time as the NLF. One of the most harrowing examples of this occurred on the birthday of the Buddha, on May 8, 1963. Buddhist crowds were angered because the government censored a popular monk's radio address, and the regime used the army to disperse the crowd. A stampede resulted in which eight children died. In the summer, Buddhist unrest became international news. On June 11, a sixty-year-old Buddhist monk

named Thich Quang Duc climbed out of a motorcade, sat down on the ground, and as other monks and nuns encircled him allowed himself to be doused with gasoline and lit on fire, thus committing ritual suicide. Buddhists and others watched him in reverence, prostrating themselves as he burned in the streets. A photograph of the scene, taken by Malcolm Browne, an Associated Press photographer who had been tipped off by the monks, was on the front page of almost every significant international newspaper the next morning. Further Buddhist protests provided a variety of dissidents (who hadn't joined the NLF) an outlet for nationalist tendencies.[18] Members of Diem's government even came to the Buddhists' defense. Madam Nhu's father, Tran Van Chuong, quit his post to denounce the government alongside the Buddhists.[19] Foreign Minister Vu Van Mau resigned and shaved his head like a Buddhist monk as a gesture of protest.[20]

Though Washington told Diem to conciliate with the Buddhists, Diem decided to raid Buddhist pagodas in South Vietnam in his belief that they were harboring communists. In conjunction with the near-collapsed state of the Saigon government, this action led the United States to quietly encourage a coup (originally proposed by South Vietnamese generals) to remove Diem. Engineered by Henry Cabot Lodge (the U.S. ambassador in Saigon), the coup eventually took place on November 1. ARVN units seized Saigon, disarmed Nhu's security forces, and occupied the presidential palace. Though the coup intended to spare the lives of Diem and Nhu, insurgents captured and murdered them both. Diem's murder allegedly shocked Kennedy, who himself would be killed three weeks later.[21]

After the coup, the situation in South Vietnam became even more politically unstable.[22] During the seven months between December 1963 and June 1964, the South Vietnamese leadership changed hands four times.[23] In January, the commander of the First Corps, General Nguyen Khanh (with the help of the Catholic General Tran Thien Khiem), toppled the junta that had displaced Diem only three months before.[24] Following Khanh's move was a demi-coup by the "Young Turks": Generals Nguyen Cao Ky, Nguyen Van Thieu, Nguyen Chanh Theiu, Nguyen Chanh Thi, and Le Nguyen Khang.[25] Then Khanh retook power, after which Van Theiu, Ky, and Nguyen Huu Co proclaimed themselves the National Leadership Council and Ky was selected to be chief of the Executive Council charged with the day-to-day administration of the country.

During this period, U.S. Secretary of Defense Robert McNamara—in many respects the chief architect of American involvement in Vietnam—began making it clear to Johnson and his administration (newly installed following

Kennedy's assassination) that he believed U.S. strategies were grossly in error. This was a startling turnaround, since throughout his management of the armed forces in Vietnam until that point, McNamara had consistently assured Kennedy of the military's stable progress. According to McNamara, the Southern regime and its hold on the countryside were now deteriorating much faster than he had anticipated.[26] To make matters worse, in late 1963 the North Vietnamese, fearful that the United States would further escalate the conflict, persuaded the Soviet Union to support them. This move heavily bolstered defenses around North Vietnam's major cities and coastline and solidified the conflict as another principal site of U.S.–Soviet Cold War engagement.[27]

In the summer of 1964, the nature of the U.S. role in Vietnam changed drastically. On August 2, it was reported that North Vietnam had conducted an unprovoked attack on the USS *C. Turner Joy* and the USS *Maddox*, two American ships stationed in the Gulf of Tonkin. Two days later a second attack was reported. Though the details of the second attack were unclear—and years later it was concluded that the attack never happened, and that the initial North Vietnamese attacks were actually provoked by U.S. espionage—President Johnson and his staff seized on the sequence of events to justify the implementation of a new military plan, which had been prepared two months before.[28] The plan formally established a conflict in Vietnam, and as a result, Johnson proposed a congressional resolution to authorize military force in the region—without, however, making a formal declaration of war. Known as the Gulf of Tonkin Resolution, the measure passed both the House and the Senate, with only two dissenting votes, on August 7, 1964.[29]

Following the passage of the resolution, the government undertook reprisal attacks against the DRV, yet on the whole it exercised caution.[30] According to polls, the country approved of Johnson's actions, and he and the Democratic Party rode this approval into the election of 1964.[31] Against the hawkish Republican candidate Barry Goldwater—who wanted to expand the conflict in Vietnam—Johnson called himself the "peace candidate," and during the campaign he pledged to "never send American boys to Vietnam to do the job that Asian boys should do."[32] Johnson's strategy worked. In November 1964, he won by the largest margin in U.S. history up to that point.

After the election, U.S. strategy was heavily debated. Johnson's Joint Chiefs of Staff wanted to wage a massive bombing campaign in North Vietnam. They believed it was the way to make the communists submit and to stabilize the regime in Saigon. The Joint Chiefs' faith in such an action stemmed from an almost mystical American confidence in the supremacy of U.S. airpower as a result of its successes in World War II.[33] Civilians in the Pentagon

were more hesitant. They argued for more selective bombings, which they believed would sufficiently pressure the communists. Outside these two groups, George Ball, one of the president's advisers, proposed "an immediate political solution that would avoid deeper U.S. involvement."[34] Johnson stalled making any decisions. He did not want to intensify the conflict, and he was worried that any U.S. move would prompt a communist response that the current U.S. force in Vietnam (of twenty-three thousand) could not withstand. By the end of the year, the only decision Johnson made was to preapprove retaliatory bombings of North Vietnam immediately following the occurrence of what was defined as "a spectacular enemy action."[35]

Such an action took place on the night of February 6–7, 1965: the Vietcong attacked army installations in Pleiku, South Vietnam. These attacks led first to the Johnson administration's approval of a series of retaliatory air strikes, code-named Operation Flaming Dart. Flaming Dart lasted through the month of February and focused on air bases and logistics and communications centers in North Vietnam and the DMZ. On March 2, 1965, Flaming Dart gave way to an order of sustained bombing missions, called Operation Rolling Thunder, in which pilots dropped over eight hundred tons of bombs on North Vietnam every day.[36] Rolling Thunder initially continued for eight weeks. The United States believed that after a strong show of force, the war would come to a quick end. In the words of the David Halberstam, the United States conceived its strategy as "the use of power to prevent using power."[37]

Rolling Thunder did not end the war. In actuality, its only immediate effect was to cause the first official deployment of U.S. ground troops in Vietnam. For as Johnson had been advised since he began the bombing missions, air campaigns necessitated the defense of air bases with ground troops. Troops began arriving in South Vietnam on March 8, 1965, when thirty-five hundred American marines deployed in response to a formal request from the commander of U.S. forces in Vietnam, General William Westmoreland, to protect an airbase in Danang.[38]

As was the case with the bombing missions, Johnson initially deflected criticism from the American public by representing the deployment of troops as a short-term expedient. Also, he requested few troops. The president quickly had to find other means to defend his policies, however, because he had to commit additional men. Soon after Westmoreland's original request, Johnson sent two more marine battalions to South Vietnam and then roughly nineteen thousand logistical troops. Then the State Department disclosed, "almost casually," that American forces were no longer in South Vietnam for defensive purposes but would engage in attack missions. Or as one marine commander

of the time put it, the military would now be able to "start killing the Viet-cong instead of sitting on their ditty box."[39] Following this disclosure, Rolling Thunder continued unabated and even more troops streamed into the country. During the summer and fall of 1965 there began a rapid and sustained increase in military inductions. Between January 1962 and June 1965 there were eighty-seven hundred draft calls a month; in July the number rose to twenty-nine thousand a month.[40] By the end of 1965 there were two hundred thousand soldiers in Vietnam.

From the beginning of Flaming Dart, the 1965 actions of the U.S. government in Vietnam gave rise to constant U.S. newspaper, magazine, and television coverage, which would continue virtually unabated until the war's conclusion. David Halberstam, Neil Sheehan, Malcolm Browne, and Harrison Salisbury were among the major journalists covering the conflict in the United States. Browne, who wrote and photographed for the Associated Press, and Halberstam, of the *New York Times*, had shared the 1964 Pulitzer Prize for their reporting on South Vietnam and each released a book on the war in 1965 (Browne authored *The New Face of War* and Halberstam, *The Making of a Quagmire*).[41] Tim Page, Sean Flynn, Don McCullin, and Phillip Jones Griffiths were the most significant photographers of the war. Walter Cronkite of CBS News was the primary television news anchor reporting critically on the unfolding conflict.

Television was crucial to the domestic understanding of the Vietnam War. Vietnam was the first war to ever be regularly seen on television, the primacy of which led the war to be dubbed, by *New Yorker* columnist Michael Arlen, the "living room war."[42]

Flaming Dart and Johnson's subsequent military moves of the spring of 1965, accompanied by consistent American media coverage of them, provoked the first significant antiwar protests in the United States.[43] On April 17, 1965, Students for a Democratic Society (SDS), one of the biggest and most important activist organizations of the New Left during the 1960s, held the first major march against the war in Washington, DC. Twenty-five thousand people showed up in what was the largest march ever recorded to date in the nation's capital.[44] SDS's march led to other antiwar marches that year at the University of California, Berkeley, in New York City, and again in Washington. The first "teach-in" took place in the spring of 1965 at the University of Michigan. This new form of protest quickly spread to many other college campuses.[45] Characteristically, teach-ins were lectures given to students outside of class hours by experts or academics (from inside and outside the university) engaged with U.S. foreign affairs. These lectures sought to inform students

about U.S. policies in Vietnam. Due to its calm and scholarly nature, the teach-in immediately appealed to a broad segment of the student population, many of whom might have been against more involved or aggressive demonstrations.[46] Though these initial marches and teach-ins generally focused on stopping the war, they often—as societal protest would do until 1970—concentrated on the issue of the draft, a fact that is well-known about Vietnam-era protest. Students were characteristically the target age for the draft and antiwar students fought (in some cases for many painful years) to avoid fighting in a war they did not support.[47]

In addition to marches and teach-ins, in 1965 significant numbers of American intellectuals began to write against the conflict. Periodicals were the main vehicle for the expression of this mode of dissent, and the most popular were *The Nation, Commonweal,* the *New Yorker, Dissent, Harper's, Atlantic Monthly, Partisan Review, New Republic, Evergreen Review, Ramparts, I. F. Stone's Weekly,* and the *New York Review of Books.* The *New York Review of Books* arguably offered the most sustained concentration of antiwar writings for the largest readership.[48] There were also small, although influential, mainstream publishing projects that sought to feature and promote intellectual opposition. One was *Authors Take Sides on Vietnam: Two Questions on the War in Vietnam Answered by the Authors of Several Nations,* published by Simon and Schuster in 1967. Its construction was relatively simple, though it contained a wealth of intellectual perspectives. Its editors, John Bagguley and Cecil Woolf, invited more than three hundred well-known authors from several countries to answer the following questions: "Are you for, or against, the intervention of the United States in Vietnam? How, in your opinion, should the Vietnam conflict be resolved?"

Before discussing the antiwar movement any further, it must be said that it did not function independently from the rest of 1960s sociopolitical engagement, but was consistently involved in and intertwined with other political and social movements such as the civil rights movement, the free speech movement, black power, Chicano rights, the women's liberation movement, and gay rights. (Good illustrations of this are the graphics of Emory Douglas, the minister of culture for the Black Panther Party from the late 1960s until the party disbanded in 1979–1980.) This was plainly because those involved in antiwar protest activities were routinely involved in protesting other issues during the politically vibrant 1960s, though for many the antiwar movement led to a general political awakening and an involvement in these other issues.

Other contemporary movements also provided examples of engagement for the antiwar movement. The civil rights movement in particular presented

the predominantly white antiwar movement with some of its central approaches to protest, such as its methods of civil disobedience and moral witness.[49] Established links between the civil rights movement, black nationalism, and the antiwar movement made this broader connection possible. The Student Nonviolent Coordinating Committee (SNCC), one of the leading groups involved in the civil rights movement, was the first to forge such a link. This took place in early 1964 at a memorial service outside Philadelphia, Mississippi, for three SNCC workers (James Chaney, Andrew Goodman, and Michael Schwerner). All three had been killed near there that summer by the Ku Klux Klan after the first day they had volunteered as part of Freedom Summer, a huge push to register southern blacks to vote in the forthcoming presidential election. As Howard Zinn explained:

> It was a very tense and very moving memorial. Mrs. Chaney [James Chaney's mother] was there. Bob Moses [one of the central figures in SNCC] held up a copy of the Jackson [Mississippi] newspaper and it said something like LBJ SAYS "SHOOT TO KILL" IN THE GULF OF TONKIN. The Tonkin Gulf incident had just taken place and here were these three fellows who had been murdered and Bob Moses was making the point of the connection with the violence that the government was tolerating [in Mississippi]—they refused to send federal marshals to Mississippi to protect the civil rights workers, [and] they were ready to do violence in Asia.[50]

Malcolm X, a national spokesman for the Nation of Islam, who appealed to many blacks in the early 1960s because of his charismatic rhetoric and his use of bold black nationalist tactics, also linked the war to the African American struggle in 1964. He called the U.S. government hypocritical for drafting African Americans to Vietnam when they "could not even register to vote without fear of being murdered."[51] In January 1965, in a speech at Oxford University, he argued that Africans and African Americans should be on the same side as the Vietnamese, "those little rice farmers" who defeated French colonialism, and he predicted that the United States would lose the Vietnam War.[52]

Martin Luther King most famously connected the African American struggle and the Vietnam War on April 4, 1967, in a speech he gave at New York City's Riverside Church. Although he had held antiwar views before this time, King refrained from making it a focus previously because his critics saw the war and civil rights as separate issues and his speaking on the war as possibly jeopardizing the cause of civil rights. As testament to the power of images to change one's point of view, photographs published in *Ramparts* of women

and children victims of American attacks were the major catalysts for King's speech.[53] King said that the photographs, which he had seen in January, left him "nauseated and energized," and he told an associate (who asked why he was not eating anything that night) that "nothing will ever taste good to me until I do everything I can to end the war."[54] At Riverside Church, King explained to the crowd that the American government's repression of the Vietnamese liberation struggle was parallel to its domestic repression of blacks. Correspondingly, to young men, both black and white, who considered American policy "dishonorable and unjust," King recommended boycotting the war through conscientious objection.[55] This (albeit brief) introduction to the developing relationship between the antiwar movement, the civil rights movement, the free speech movement, black power, Chicano rights, the women's liberation movement, and gay rights concludes the process of providing the very necessary historical context for explaining the focus of this study, how American artists engaged with the war. The following chapter now explores the origins of artistic antiwar engagement.

2

The Beginnings of Artistic
Antiwar Engagement

Artists and Writers Protest and the
Artists' Protest Committee

THE BEGINNING OF SUBSTANTIAL ACTIONS by the American antiwar movement in the spring of 1965 coincided with the first examples of antiwar engagement by American artists. These efforts took the form of what I have defined as "extra-aesthetic actions." The New York–based group Artists and Writers Protest (AWP) organized the first extra-aesthetic actions. They consisted of two full-page advertisements run in the *New York Times* on April 18 (Easter Sunday) and June 27, 1965 (figs. 1 and 2). Both implored the cultural community to "END YOUR SILENCE" regarding the war.[1] The two ads listed a large group of well-known writers and artists who were supporters, such as Hannah Arendt, Lawrence Ferlinghetti, Joseph Heller, Arthur Miller, and Philip Roth.[2] In many respects, these lists functioned as the focus of the advertisements.[3] Though these ads broke the ice for the American art community, they were not innovative in the context of the rest of the antiwar movement. Other professional groups—such as doctors, teachers, and physicists—had previously run similar advertisements in the *Times*, among other publications.[4]

In conjunction with the block of supporters in the April ad, AWP made two statements. First it outlined the principles of the group. The AWP described itself as follows: "We are grieved by American policies in Vietnam. We are opposed to American policies in Vietnam. We will not remain silent before the world. We call on all those who wish to speak in a crucial and tragic moment in our history, to demand an immediate turning of the American policy in Vietnam to the methods of peace." Second, in response to an announcement

END YOUR SILENCE

We are grieved by American policies in Vietnam. We are opposed to American policies in Vietnam. We will not remain silent before the world.

We call on all those who wish to speak in a crucial and tragic moment in our history, to demand an immediate turning of the American policy in Vietnam to the methods of peace.

A PROTEST OF WRITERS AND ARTISTS

LIONEL ABEL : SAMUEL M ADLER : GEORGE ABBE : WILLIAM ALFRED : THEODORE AMUSSEN
JACK ANDERSON : HOWARD ANT : EMIL ANTONUCCI : ELISE ASHER
GEORGE ANTHONY : RUDOLF ARNHEIM : DAVID ANTIN : HANNAH ARENDT
DORE ASHTON : ELIOT ASINOF : EDWARD AUERT
RUDOLF BARANIK : LEONARD BASKIN : ED BAYNARD : JEROME BEATTY JR : HAROLD BECKER
SYLVIA BERKMAN : WILLIAM BERKSON : CAROL BERGE : WENDELL BERRY
ELIZABETH C BESTON : MORRIS BISHOP : PAUL BLACKBURN
SAM BLUM : LOUISE BOGAN : PHILIP BONOSKY : PHILIP BOOTH : DAVID BOROFF : KAY BOYLE
SAM BRADLEY : GEORGE BRECHT : HARVEY BREIT : GERMAINE BREE : BESSIE BREUER
JAMES BROOKS : MICHAEL E BROWN : ROBERT BRUSTEIN : STANLEY BUETENS
J R DE LA TORRE BUENO : KENNETH BURKE : MARGARET F CABELL : JOHN CAGE : HORTENSE CALISHER
VICTOR CANDELL : HAYDEN CARRUTH : EMILE CAPOUYA : GIORGIO CAVALLON
REMY CHARLIP : ALAN CHURCHILL : ROBERT M CHUTE : MARVIN CHERNEY : ROBERT CLAIBORNE
ELIZABETH COATSWORTH : ROBERT M COATES : ARTHUR A COHEN : WILLIAM COLE
J L COLLIER : GRANDIN CONOVER : JANE COOPER : EVAN CONNELL : PHILIP CORNER
M JEAN CRAIG : ROBERT CREELEY : ROBERT M CRONBACH : ROBERT DASH
WESLEY DAY : JUNE OPPEN DEGNAN : DOROTHY DENNER : ELAINE DE KOONING
GUY DANIELS : BABETTE DEUTSCH : ALEXANDER DOBKIN : NOLA L DOLBERG : DOUGLAS F DOWD
DAVID DEMPSEY : ROBERT DUNCAN : BARROWS DUNHAM : JOE EARLY : GALEN EBERL
GEORGE EGONOMOU : RICHARD ELLMAN : GEORGE P ELLIOTT : KENWARD ELMSLIE : ROBERT ENGLER
SYLVETTE ENGEL : BARBARA EPSTEIN : JASON EPSTEIN : SEYMOUR EPSTEIN
CLAYTON ESHLEMAN : ELEANOR ESTES : GERTRUDE EZORSKY : HOWARD FAST : MORTON FELDMAN
LAWRENCE FERLINGHETTI : LESLIE FIEDLER : EDWARD FIELD : DONALD FINKEL
JOSEPH FIORE : RICHARD B FISHER : DUDLEY FITTS : ADRIENNE FOULKE : KATHLEEN FRASER
RONALD FREELANDER : ANN FREILICH : LLOYD FRANKENBERG : ANNE FREMANTLE
JEAN FOREST : SIDEO FROMBOLUTI : HOWARD FUSSINER : JEAN GARRIGUE : MAXWELL GEISMAR
JACK GELBER : HUGO GELLERT : HANS H GERTH : WILLIAM GIBSON : ROCHELLE GIERSON
JEAN GLEASON : RALPH J GLEASON : HERBERT GOLD : MIMI GOLDBERG
MITCHELL GOODMAN : JONATHAN GREENE : JEAN GOULD : HAROLD GREENFELD
SEYMOUR GRESSER : ANTONI GRONOWICZ : CHAIM GROSS : RENEE GROSS : BARBARA GUEST
ALBERT J GUERARD : ROBERT GWATHMEY : YVONNE HAGEN : DONALD HALL
JAMES BAKER HALL : MARGARET HALSEY : SID HAMMER : DAVID HARE : JAMES HARRISON
BURT HASEN : CURTIS HARNACK : ROBERT HATCH : H R HAYS : ROBERT C HAWLEY
ROBERT HAZEL : SHIRLEY HAZZARD : MACDONALD HARRIS : AL HELD : LILLIAN HELLMAN
JOSEPH HELLER : NAT HENTOFF : JOHN HERSEY : THOMAS B HESS : JOHN H HICKS
DICK HIGGINS : JOSEPH HIRSCH : GEORGE HITCHCOCK : DANIEL HOFFMAN : SANDRA HOCHMAN
PAULA HOCKS : MARGO HOFF : HENRY BEETLE HOUGH : FLORENCE HOWE : IRVING HOWE
HELEN HOWE : LEO HURWITZ : DAVID IGNATOW : ROBERT INDIANA
EMMETT JARRETT : PAUL JACOBS JESS : EDORE JOHNSON : CROCKETT JOHNSON
MATTHEW JOSEPHSON : DON JUDD : MERVIN JULES : H PETER KAHN : JOSEPH KAPLAN
ALLEN KATZMAN : LEANDRO KATZ : STANLEY KAUFFMAN : ALFRED KAZIN : WILLIAM MELVIN KELLEY
CALVIN KENTFIELD : BASIL KING : WILLIAM D KING : KATHERINE T KINKEAD : GALWAY KINNELL
FREDA KIRCHWAY : GEORGE KIRSTEIN : ERIK KIVIAT : NEIL KLEINMAN : HANS KONINGSBERGER
KARL KNATHS : JOSEPH KONZAL : ALBERT KRESCH : SEYMOUR KRIM : RUTH KRAUSS
LOUISE KRUGER : KATHARINE KUH : LEE KRASNER : STANLEY KUNITZ : TULI KUPFERBERG
VERA B LACHMAN : KENNETH LAMOTT : JOHN LANGE : JEREMY LARNER
ALEXANDER LATTIMORE : RICHMOND LATTIMORE : JOE LASKER : SIDNEY LAUFMAN
JAMES LAUGHLIN : DON LA VIERE TURNER : JACOB LEED : DENISE LEVERTOV : SI LEWEN
HARRY LEVIN : LEONARD C LEWIN : OSCAR LEWIS : JACK LEVINE : ROY LICHTENSTEIN
BETTY JEAN LIFTON : LINDA LINDEBERG : RON LOEWINSOHN : EPHRAIM LONDON
ROBERT LOWELL : WALTER LOWENFELS : LOIS LOWENSTEIN : ROBERT M MACGREGOR : JACKSON MACLOW
IRIS LEZAK MAC LOW : BERNARD MALAMUD : LEO MANSO : JACK MARSHALL : DAVID MANDELL
LENORE G MARSHALL : AGNES MARTIN : DAVID MCREYNOLDS : CAREY MCWILLIAMS
AMY MENDELSON : EVE MERRIAM : W S MERWIN : SIDNEY MEYERS : ROBERT MEZEY : ARTHUR MILLER
EDWIN H MILLER : WARREN MILLER : JESSICA MITFORD : HARRY T MOORE : FREDERICK MORGAN
IRA MORRIS : FREDERIC MORTON : MARTIN S MOSKOF : STANLEY MOSS
ROBERT MOTHERWELL : HOWARD H MYER : DANIEL NAGRIN : HOWARD NEMEROV : ALICE NEEL
MARY PEROT NICHOLS : ROBERT NICHOLS : IRIS NOBLE : ISAMU NOGUCHI
JAMES L NUSSER : NED O'GORMAN : GEORGIA O'KEEFE : TILLY OLSEN : GEORGE OPPEN
MARY OPPEN : JOEL OPPENHEIMER : PETER ORLOVSKY : ROBERT OSBORN
BARBARA OVERMYER : ROCHELLE OWENS : ALFREDO DE PALGHI : RAYMOND PARKER : BETTY PARSONS
FELIX PASILIS : DAVID PASCAL : MERLE PEEK : GERI PINE : PAUL PRENSKY
JAMES PURDY : SIMON PERCHIK : HENRI PERCIKOW : PRUDENCIO DE PEREDA
VIRGILIA PETERSON : GEORGE PLIMPTON : JAMES TENNEY : ANTHONY TONEY : EDNA AMADON TONEY
TONY TOWLE : PAUL ELLSWORTH TRIEM : EVE TRIEM : NICCOLO TUCCI
MARTIN TUCKER : JOHN R TUNIS : JULES RABIN : PHILIP RAHV : HENRY RAGO
ROBERT E RAMBUSCH : MARGARET RANDALL : F D REEVE : ANTON REFREGIER : AD REINHARDT
PHILIP REISMAN : KENNETH REXROTH : DAN RICE : ADRIENNE RICH : CAROL RITTER
HENRY ROBBINS : RALPH ROBIN : M G ROGERS : MEYERS ROHOWSKY
NED ROREM : W K ROSE : BARNEY ROSSET : HENRY ROTH : PHILIP ROTH : JEROME ROTHENBERG
MARK ROTHKO : ROSE ROSBERG : MURIEL RUKEYSER : ARTHUR SAINER
JOOP SANDERS : DONALD SCHENKER : HERMAN SCHNEIDER : STEVEN J SCHNEIDER
NINA SCHNEIDER : CAROLEE SCHNEEMAN : ARMAND SCHWERNER : RICHARD SEAVER : THALIA SELZ
PETER SELZ : ANNE SEXTON : BERNARD SEEMAN : BEN SHAHN : WILFRED SHEED
HERMAN SHUMLIN : MAURICE SIEVAN : ERNEST J SIMMONS : JOEL SLOMAN : MICHAEL SMITH
JOSEPH SOLMAN : JAY SOCIN : THEODORE SOLOTAROFF : SUSAN SONTAG
VIRGINIA SORENSON : GILBERT SORRENTINO : TERRY SOUTHERN : MOSES SOYER
RAPHAEL SOYER : A B SPELLMAN : NORA SPEYER : JEAN STAFFORD : GEORGE STARBUCK
FRANCIS STEEGMULLER : FRANCES STELOFF : STAN STEINER : EMMA G STERNE
BRITA STENDAHL : RUTH STEPHAN : DANIEL STERN : MAY STEVENS : DONALD STEWART
HAROLD STRAUSS : GEORGE SUGARMAN : WILLIAM STYRON : ELIZABETH SUTHERLAND : HARVEY SWADOS
WYLIE SYPHER : GRETA SULTAN : MARK DI SUVERO : LOUIS UNTERMEYER
CONSTANCE URDANG : STAN VANDERBEEK : ROBERT VAS DIAS : TONY VEVERS : MARIUSA VER BRUGGHE
ESTEBAN VICENTE : ELIZABETH GRAY VINING : AMOS VOGEL : IVAN VON AUW
IRA WALLACH : THEODORE WEISS : NAT WERNER : MILDRED WESTON : ALLEN B WHEELIS
MORTON WHITE : DAN WICKENDEN : THEODORE WIENTZ
MRS WM CARLOS WILLIAMS : EDMUND WILSON : MITCHELL WILSON : SOL WILSON
CLARA WINSTON : RICHARD WINSTON : ISRAEL G YOUNG : MARGUERITE YOUNG
JACK YOUNGERMAN : ADJA YUNKERS : LOUIS ZUKOFSKY
MANY OTHER SIGNATURES WERE RECEIVED TOO LATE TO BE INCLUDED

This statement was formulated three weeks before the President announced that he was willing to begin "unconditional discussions" with "the foe." Will his speech be followed by action?—peaceful, responsible action, NOT the further use of force? . The American people have begun, in letters to Washington and in the statements published by other concerned groups, to voice their horror at a policy of violence. The President has replied to this expression of public opinion. Let us not now relax our insistence on the necessity for an immediate cessation of the bombings in North Vietnam. Let us support that part of Mr Johnson's speech which seems to offer hope of negotiations, and at the same time let us persist energetically in expressing our opposition to any but peaceful policies. WRITE TO THE PRESIDENT

Co-secretaries; Denise Levertov : Mitchell Goodman : WRITERS AND ARTISTS PROTEST Post Office Box 1356 Church St. Station New York NY 10008

1. Artists and Writers Protest, "End Your Silence" advertisement. Printed in the *New York Times* on April 18, 1965.

END YOUR SILENCE

We, the undersigned, painters and sculptors, writers and editors, musicians and theater artists of the United States, feel we must protest the power being exercised in our names and those of all the American people. We can not remain silent about a foreign policy grown more nakedly inhuman with each passing day.

A decade ago, when the people of Vietnam were fighting French colonialism, the artists and intellectuals of France—from Sartre to Mauriac, from Picasso to Camus—called on the French people's conscience to protest their leaders' policy as immoral and to demand an end to that dirty war—"la sale guerre." Today, we in our own country can do no less.

Our President must be made aware that his words of "peace" will not be heard above the din of the bombs falling on Vietnam; that his concern for "freedom" in South Vietnam is mocked by eleven years' maintenance there of brutal police regimes assisted by American money, American guns, and finally . . . American blood.

Our President must be told that our actions in the Dominican Republic are nothing less than armed intervention in a civil war of another nation. Our leaders must be reminded that in VIETNAM and the DOMINICAN REPUBLIC they are violating international law, the charter of the UN, and, indeed, the spirit of our own constitution.

They must learn that their plans for United States hegemony . . . for a "Pax Americana" . . . must lead not to peace but to death and destruction. They must accept the fact that they have no more right in Vietnam than did the French colonialists before them; further, that their intrusion in Latin America is justifiably interpreted, both abroad and here at home, as aggression.

American artists wish once more to have faith in the United States of America. We will not remain silent in the face of our country's shame. We call on all citizens of our nation to join with us:

End Your Silence!

The Artists Protest Committee of Los Angeles, representing two hundred working artists, expresses its full support for the above statement.

Further contributions to continue our work are needed. Make checks payable to:

ARTISTS PROTEST,

Lydia Edwards, Secretary-Treasurer
P.O. Box No. 239, Old Chelsea Station
217 West 18 St., New York, N.Y. 10011

2. Artists and Writers Protest, "End Your Silence" advertisement. Printed in the *New York Times* on June 27, 1965.

by Johnson that he would begin "unconditional discussions" with North Vietnam, AWP urged people not to relax their insistence on an immediate end to the bombing and to "write to the president" about it.

AWP's June ad presented its opinions more confidently. It depended slightly less on its signatories and instead marshaled specific historical evidence for its argument against the war. To begin with, it paralleled U.S. actions in the Vietnam War with France's during the Algerian War for Independence (1954–1962), and compared the budding American antiwar movement with the anticolonialist movement against the Algerian War, in which French artists and intellectuals—from Jean-Paul Sartre and François Mauriac to Pablo Picasso and Albert Camus—called on the French people's conscience to protest their leaders' policy as immoral and to demand an end to the war.[5]

Comparing Vietnam and the situation in Algeria was not an abstract endeavor for some of the artists involved in AWP as well as other American artists who would become involved in antiwar engagement in later years. In particular, Leon Golub and Nancy Spero (who were married) and Irving Petlin—all of whom would either go on to organize a significant proportion of New York and Los Angeles antiwar activities or create seminal antiwar artworks—had lived in Paris between 1959 and 1964 and had firsthand exposure to violence and antiwar protests in Paris related to the Algerian War.[6] They witnessed bombings in Parisian cafés and newspaper offices by groups opposed to Algerian independence—such as the Organisation de l'Armée Secrete (OAS)—as well as public assassinations and militant (but for the most part peaceful) demonstrations against the war by the French Left. Petlin was almost killed due to his involvement in a February 1962 protest. A march he was taking part in against OAS was corralled by French police into the Charonne Métro station and the officers beat many of those involved. Nine died in the confrontation, and Petlin narrowly escaped. Petlin's and Golub's experiences undoubtedly prepared the ground for their later protests against Vietnam.[7] Petlin, for one, saw the Algerian War as "a kind of pre-pattern of what would happen in the [United States] when a supposed liberal democracy tries to carry out a colonial war, and when it can't win with its power, starts using methods which [are] horrendous."[8] In this way, he saw France "transformed by [the Algerian] war," and he believed the United States "was headed in exactly the same direction."[9] Golub commented that because of his experiences in Paris, he was convinced the American government was lying to him during the Vietnam War. He explained, "Having witnessed the French involvement in Algeria, and having read about [France's] earlier involvement in Vietnam, I understood that it wasn't going to stop . . . that [it] would get bigger and

bloodier, and that we had the technology to cause tremendous destruction and suffering and death."[10]

In addition to paralleling Algeria and Vietnam, AWP's second advertisement exposed the "invasion" of Vietnam by the United States as the continuation of over a decade of covert CIA actions. Further, it condemned the recent U.S. invasion of the Dominican Republic as "nothing less than armed intervention in the civil war of another nation." (This invasion took place after the first AWP ad had been run, and it was a major motivation behind AWP's decision to publish a second so quickly.)[11] The ad concluded that these colonial aspirations of the United States would come to a horrible end. Nonetheless, while the first ad had recommended writing to the president, AWP's second statement, like many protest actions that would appear during the era, offered no road map for how to solve these current problems. In other words, though the statement bore witness to current injustices and condemned U.S. involvement, it offered no policy.

Though the American art press barely acknowledged AWP's ads, the second provoked a surprising reaction in the *New York Times*, and one that came indirectly from the Johnson administration. The staunchly conservative group Freedom House ran a full-page ad on July 25, 1965, titled "The Silent Center Must Speak Up." The ad accused some of the artists who placed the AWP ad of being avowed communists and offered a list of reasons to support U.S. involvement in Vietnam. This list was presented in the form of a six-point "credo." And above it the group inserted into the ad a letter of support for their effort from none other than President Lyndon Johnson.

The other group involved in extra-aesthetic actions during this early period of artistic engagement was the Los Angeles–based Artists' Protest Committee (APC). Petlin was a major factor in the group's formation and the group's chief instigator. Between 1964 and 1966, while he was involved with AWP (which, again, was based in New York), he was artist-in-residence at the University of California, Los Angeles (UCLA), and used his appointment to create a protest group similar to AWP in LA. Although APC existed only for one year between 1965 and 1966, it marked the beginning of artistic engagement on the West Coast, and it made a substantial impact on subsequent national antiwar engagement.

APC began with a meeting on the subject of artists and the war, which Petlin called at LA's Dwan Gallery in the spring of 1965. Dwan was then best known as the West Coast gallery of Jasper Johns and Robert Rauschenberg. Petlin said in retrospect that he called the meeting almost on a "dare." He explained, "I had been talking with people at dinners, casually, about how we

should do something . . . and the reaction was: 'this is Los Angeles—are you kidding?' So I decided to [see if I could] get people out for a meeting. . . . The first meeting had twelve attendees. As meetings followed, they included more and more 'artists and art world people.'"[12]

One of APC's first actions was, again, an advertisement, run in the *Los Angeles Free Press* in May 1965 (fig. 3).[13] The ad urged an end to the escalation of the war through three elements: the presentation of a symbol of a ladder leading upward accompanied by the word "stop"; the names of 174 supporters; and a statement. Like the second AWP ad, APC's statement expressed its commitment to an American foreign policy that prioritized the immediate removal of U.S. forces from Vietnam and the Dominican Republic. Following this explanation was a description of what APC called "The Realities." The group used this device to bring its constituency up to speed on foreign affairs. In sum, these realities were: force cannot stop transition in world nations; people all over the world should have the freedom to revolt; the United States, through its military intervention, is "destroying" the United Nations and compromising its own ideals; and finally, U.S. actions abroad weaken its pleas for domestic freedom. In this respect, APC wrote that "Selma and Santo Domingo are inseparable," aligning American activity in the Dominican Republic with Alabama state troopers' recent attack of six hundred civil rights marchers on March 7, 1965, which sparked widespread response in the United States.

What differentiated APC's ad from those created by AWP is that it informed the public of a subsequent plan of action in which they could take part. It explained that a "Stop Escalation" protest would occur that weekend in Los Angeles, during which the following would take place: (1) on Saturday, APC would cover exhibited paintings in a large number of galleries on La Cienega Boulevard (then the center of Los Angeles galleries) with a large band of paper bearing the image of the "Stop Escalation" ladder; (2) on Sunday, APC would picket the brand-new Los Angeles County Museum of Art (LACMA) building—which at that time was the second-largest museum in the United States, after the National Gallery of Art—with placards bearing the "Stop Escalation" ladder; and (3) on Monday, APC would stage a "walk across" in which artists would use four crosswalks at a major intersection in the gallery district to block traffic on La Cienega during the Monday night Art Walk. The Art Walk was one of the major social and cultural events in Los Angeles at the time, during which all the major galleries—such as Ferus, Feingarten, David Stewart, and Felix Landau—held coordinated openings. The review column in the *Los Angeles Times* was even called "Art Walk."

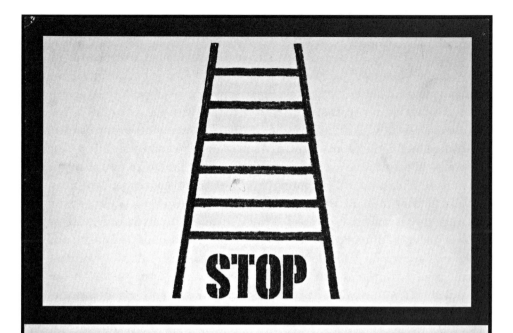

3. Hardy Hanson and Artists' Protest Committee, "Stop Escalation" flyer, which was run as an advertisement in the *Los Angeles Free Press* on May 14, 1965, volume 2, issue 20, pp. 6–7. Offset lithograph. Sheet: 18 × 14 $\frac{1}{16}$ in. Charles Brittin Archive, Getty Research Institute. Used with permission.

More than one thousand people participated in the Saturday APC event. La Cienega between Melrose and Santa Monica was covered with Stop Escalation signs. They could be seen on parking meters, lampposts, telephone poles, and in the windows of many of the galleries. Some (though not many) of the galleries even took the step of covering their works of art with the placards. On Sunday, visitors to LACMA came face-to-face with the activists—a five-hundred-person vigil at the entrance of the museum—with many of them deciding to join the protestors. On Monday, one thousand people "carrying posters calling for an end to the bombing[,] . . . for the UN to take charge in Vietnam," and occasionally shouting "stop the war," walked the series of cross-walks in front the galleries on La Cienega in a line two blocks in length and several people wide that obstructed traffic at several intersections.[14] Yet the three-day event drummed up little attention outside those in attendance. And the media virtually ignored it. In other words, as the *Los Angeles Free Press* explained, (with the exception of their own coverage) "the White Out was blacked out." As a result it has been absent from almost all extant histories of the era.[15] One can surmise that Los Angeles–based media outlets chose not to cover the event because of a fidelity to the cause of the war in these early years. Yet there was also the fact that the press may have believed the actions of artists were simply inconsequential.

Possibly in response to the Stop Escalation protest's lack of impact, in the summer of 1965 APC moved the site of its public, extra-aesthetic protest against the war away from Los Angeles art galleries, museums, and the art-going public, and closer to the institutions of the U.S. government itself. This move ran counter to what American antiwar arts groups did in later years concerning extra-aesthetic actions. With the rise of the Art Workers' Coalition and the Art Strike in New York in the late 1960s, these actions focused more on museums, which were seen as the most appropriate site for protests by artists. (This move paralleled a greater tendency of protest to focus on smaller institutions relevant to one's profession, the idea being that through one's own institutions, which one knew more about, more could be achieved.) APC's new locus of protest was the RAND Corporation, the think tank for postwar U.S. foreign policy, which had a major hand in the U.S. approach to Vietnam. Petlin in particular argued for a focus on RAND because of his interaction with RAND employees in Los Angeles. One of them was a man named Roman Kolkowicz. Kolkowicz was greatly concerned about the escalation of the war, engineered in part by RAND, as well as the parallels between the war and the Holocaust, in which his family had died. Petlin had similar concerns. In later years he

commented that the Holocaust—like his experiences in France—made him aware of "what governments and powers can do . . . the cruel and horrible things that can happen to men and women."[16] Petlin met other RAND employees at various art parties, dinners, and openings on Monday nights on La Cienega, "the way artists tend to get to know such people." These men were quite different from Kolkowicz. According to Petlin, the way they approached the war indicated an ignorance of Vietnam's particular identity. He explained, "Listening to [these men] talk about the war, it was as if things like culture and history did not matter. They didn't seem to know or care that the French had been unable to defeat the Vietnamese, or what the Vietnamese might be fighting for. The RAND people I met had a detached, businesslike approach to the war. They were the intellectuals, the 'liberals,' in a way—that's how they saw themselves."[17] RAND's "intellectual" theories regarding the war, which were made known at the time, were quite drastic, and they horrified Petlin. In general, RAND wanted to relocate the civilian population to small areas. Then, on what they could expect to be either empty land or Vietcong territory, they would "unleash the full effects of American technological warfare."[18]

The *Los Angeles Free Press* announced that APC would be protesting at RAND headquarters in a front-page article on June 26, 1965, the day before the protest would take place. The article included a statement from APC—echoing the thoughts of Petlin—that explained its view of RAND. It read:

> The Rand Corporation is the site and target of this demonstration because it is for us here in Los Angeles a physical and visible symbol of the "new" strategic thinking that dominates the Johnson administration. This area of function by the Rand Corporation supports administrative unilateral recourse in foreign lands and thereby violates our commitment to the United Nations as the proper peacekeeping agency for the world. Today, the United Nations celebrates its twentieth anniversary of founding on American soil. We respectively celebrate this U.N. anniversary. We dishonor any national establishment which knowingly and indifferently eliminates the function of the United Nations.[19]

Regardless of whether it was because they were forewarned, RAND employees immediately intercepted APC's protest. At first APC was bluntly dismissed. When the RAND employees learned that APC planned to be there on a weekly basis, however, they proposed alternatives to public action. They first asked if APC would agree to debate its issues with the organization privately at a future

date, but APC members rejected this notion out of hand, because they wanted the protest to remain public in some way. Both parties eventually agreed to have two debates—one public and one private. While the attention and consideration RAND paid to APC may seem surprising, it is essential to remember that at this juncture in the war Vietnam protests were quite rare, and therefore were taken very seriously by the Johnson administration. Robert McNamara himself advised RAND about the APC protest. It was supposedly his idea to propose a debate. At the time, McNamara allegedly explained that he wanted to see what this group of forward-looking intellectuals was thinking, and in so doing, use his findings to understand what the rest of the country would be thinking six months in the future.[20]

The private debate between APC and RAND took place on July 7, 1965, at RAND headquarters. Though accounts differ, among those involved were Petlin, Golub, Larry Bell, Lloyd Hamrol, Craig Kauffman, Michael McClure, Robert Duncan, Max Kozloff, and Annette Michaelson and nine RAND representatives.[21] The physical details of the debate are clear. It lasted nearly six hours; it took place at a large conference table; papers were distributed to the attendees; there was careful questioning and answering, and much tension between the two groups; and it was highly secure (to the extent that APC members had to be accompanied to the bathroom). Additionally, it was observed by at least twelve members of the RAND Corporation, possibly including Daniel Ellsberg (who famously leaked the *Pentagon Papers* in 1971), and it was purportedly recorded—though when APC members asked for a tape after the debate, RAND said the recording device they used had malfunctioned and no tape existed.

Francis Frascina describes the first debate's content as follows:

> The artists attributed the United States methods and their origins to historical Fascist methods of state terror, with technology being used as a new potential method of genocide either through indifference and inattention or through intent and focus: technology made either possible. The RAND representatives argued that different technologies and methods were essentially [attributable] to the nature of the difference between the two societies in the conflict; each one fought with what was "best" for itself. For the artist the enormous difference between the relative effects of B-52 bombers and Third World guerrilla warfare was ignored by RAND's ideological defense of the United States in Vietnam. A basic moral gulf that separated the two sides was the artists' disbelief that these intelligent RAND people could feel so positive about continuing such an unequal policy against a peasant society. A basic historical

and political gulf centered on the role of the United States as an imperialist power since the late 1940s particularly in Southeast Asia.[22]

While no reaction from RAND employees was recorded, APC attendees felt after the debate that they were on equal footing with RAND regarding their understanding of the current state of the war and what future action the United States should take. This was an important realization for those involved. In particular, it was a major turning point for Golub, one that would have a profound effect on his future artistic production. In retrospect he explained:

I . . . learned something in that meeting . . . It was kind of profound, really. Here were these experts, big guys, okay? They had all these studies, some of them had been to Vietnam, they knew the numbers, and so on. But really, when you got right down to it—and this was a startling thing for me—they basically had no better idea than we did as to what was actually going on. Where was the war headed? What would the situation be like a year or two down the road? They had no idea, really . . . It was in this meeting . . . [that] I saw that those in power cannot be simply trusted to do the right thing, to even know the right thing—[and] that they play hunches, take gambles, even, as in this case, with peoples' lives. And you could say that ever since that meeting I have . . . been trying to call people's attention in one way or another to the way power is used and abused.[23]

The planned public debate between APC and RAND took place on the evening of August 3, 1965, at the Warner Playhouse in Los Angeles. Each side had three representatives. For APC, they were Golub, Petlin, and Kozloff. Representing RAND were two employees who had participated in the previous debate: Guy Pauker, an expert on Southeast Asia, and Bernard Brodie, a well-known author and nuclear strategist. A China expert also joined them, though this individual's name is not in the historical record. The moderator was Judd Marmor of UCLA, a well-known psychiatrist. The debate sold out and attendance was far over capacity. Four hundred people fit into the playhouse but eight hundred showed up. Spectators stood in the aisles and sat outside the theater. Those outside listened to the proceedings on a loudspeaker.

In general, what APC and RAND said over the course of the public debate was similar to that of the private debate, although during the public debate RAND's comments were less candid and APC's more rhetorical. Like the private debate, APC also remembered the public debate as a "win" for their side. As

Lucy Lippard explained, "To many it appeared that the small but intense and extremely well-informed artists' group came out on top."[24] She commented that the debate also gave the "sense not only that [one] should do something about the war—but could." The reticence of RAND representatives to speak freely during the debate, which Petlin believes was because they were under instruction not to reveal classified information, helped APC's side. The artists were also quite confident, knowledgeable, well-spoken, and skilled in debate—especially Golub—and their arguments showed that the way the United States was pursuing the war was indefensible, even in front of "non-experts."[25] Further, the audience, made up primarily of hundreds of antiwar students, nearly all backing the artists' position (over the course of the evening), became so vocal in their support of APC and their dislike of RAND that the moderator could hardly keep them quiet. After the public debate, RAND executives were reportedly instructed never "to get into such a spot again."[26]

At the end of 1965, even with the successes of the RAND debate, APC reviewed its previous actions and decided that they were not having the desired effect. The war had escalated virtually unabated, and the group's messages had been effectively kept away from a national audience. Consequently, APC decided it needed to pursue higher-profile tactics that would have more lasting impact and be more in keeping with the profession. Thus was born the idea for a large, collective artwork that would make a visible statement against the war. This idea eventually became 1966's *Artists' Tower of Protest* (also commonly known as the *Peace Tower*).

As a final note, apart from the actions of AWP and APC in 1965, it is worth mentioning artists' involvement in extra-aesthetic actions related to the poet laureate Robert Lowell's public refusal to participate in June 1965's White House Festival of the Arts—the first festival of its kind to ever be sponsored by a president. In the *New York Times* (and excerpted in the *New York Review of Books*), Lowell had expressed his "dismay and distrust" of U.S. foreign policy and commented, "Every serious artist knows that he cannot enjoy public celebration without making subtle public commitments."[27] Lowell further explained that he would not want his attendance to be "mistaken for personal approval of . . . Johnson's Vietnam policies."[28]

While all the artists who had been invited did attend—and among them were Jasper Johns, Mark Rothko, Larry Rivers, Alexander Calder, Paul Strand, and Jack Levine—they did so only after signing a telegram in support of Lowell (and they explained their attendance by claiming they did so "in order to give the arts in general a much-needed boost").[29] During the festival, the critic Dwight MacDonald also collected signatures for a petition supporting Lowell.

Those who signed included Isamu Noguchi, Herbert Ferber, Peter Voulkos, Willem de Kooning, *Art News* executive editor Thomas Hess, Brandeis University museum director Sam Hunter, and Library of Congress consultant Reed Whittemore. The outcome of the petition is unknown. However, the affair attests to the involvement of high-profile artists and art professionals in antiwar activities from the early stages of the war as well as their interest in making an antiwar statement in a decidedly public forum.

3

Creating Antiwar Art

OVER THE COURSE OF 1966, U.S. involvement in Vietnam deepened. Four hundred thousand U.S. troops were deployed in the country; monthly spending on the war ballooned to $2 billion—it had been $105 million in 1965—and American military engineers and private U.S construction firms created an extensive infrastructure in the country: roads, bridges, barracks, ports, and airfields. Despite these actions, the Vietcong increased its strength.[1] A major reason for this was Operation Rolling Thunder's ineffectiveness. Rolling Thunder was intended to crack the morale of Hanoi's leaders, compel them to call off the Southern insurgency, and weaken the communist fighting capacity by impeding the flow of men and supplies to the South along the Ho Chi Minh trail. However, Rolling Thunder achieved none of these goals. There were few substantial targets in North Vietnam that could be attacked. The North Vietnamese government was decentralized. The population was expertly dug in, especially in the cities.[2] Moreover, North Vietnam was an agrarian nation with much of its military matériel dispersed in the countryside or moving down the Ho Chi Minh trail. Additionally, although American aircraft bombed the trail daily, it was extremely well hidden and protected. The Vietcong buried their installations deep underground so that they could not be seen from the air. Further, one of the strongest air defense concentrations in the world protected the trail: eight thousand antiaircraft guns, more than two hundred surface-to-air missiles, a complex radar system, and computerized control centers, all of which were supplied by the USSR.[3] What was coming down the

trail was also minimal. In contrast to the needs of the South Vietnamese and American forces, the Vietcong had no airplanes or tanks, and they did without most of the daily "necessities" American soldiers enjoyed in the field, such as plentiful fuel, spare parts and shells, not to mention beer, shaving cream, and talcum powder. In fact, the North Vietnamese and Vietcong needed no more than a total of fifteen tons of supplies a day from the North in order to sustain their effort in the South. Rolling Thunder also complicated negotiations. Pham Van Dong, the North Vietnamese prime minister, insisted that discussions could not be held until the bombing ended.[4] Finally, the communists' success against Rolling Thunder encouraged them to pursue a protracted conflict with the United States. They saw that they could bog the U.S. forces down in an unwinnable situation that would make them question their objectives.

During 1966, antiwar protests similar to those undertaken in 1965 continued. At the same time, dissidents in the American government began to become aware of the problems of the deepening conflict and used a congressional investigation to publicly highlight their concerns. Arkansas senator William Fulbright carried out this investigation in February 1966. What became known as the Fulbright Hearings were particularly significant in the course of the war. They illustrated for the first time to the American public—in nationally televised proceedings—that respectable, high-profile people were unsympathetic to the Johnson administration's waging of the war. Among these respectable men were Fulbright, Wayne Morse (one of two senators who opposed the Gulf of Tonkin Resolution), and the foreign policy expert and Cold War theorist George F. Kennan. Although Kennan's ideas regarding international diplomacy inspired the Truman Doctrine, he believed they were not applicable to the situation in Vietnam. The hearings also confirmed for many in the older generation that their sons and daughters' protests were genuine.[5]

In contrast to 1965, during which almost all artistic engagement took the form of extra-artistic actions, in 1966 antiwar engagement stemmed predominantly from artists' efforts to incorporate antiwar sentiment into works of art. The major arena for these efforts was again Los Angeles, and in particular APC's organization and creation of the *Artists' Tower of Protest*, known most often as the *Peace Tower* (figs. 4 and 5). In order to fully contextualize the *Peace Tower* as well as other efforts artists would make to combine art and politics in their work from 1966 onward, one must understand how such efforts would have been undesirable and unwelcome in the American fine art system of the 1960s, which was dominated by the formalist ideas of Clement Greenberg and the pop and minimalist movements (which were both in part informed by Greenberg's ideas).

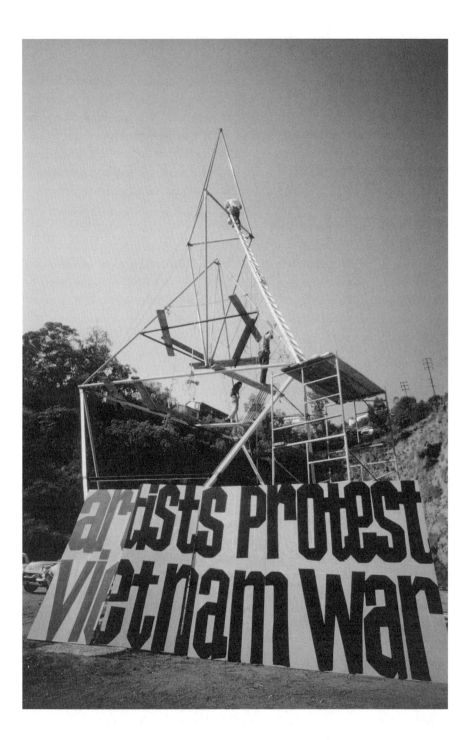

4. Charles Brittin, *Photograph of the Artists' Protest Committee Artists' Tower of Protest*, Los Angeles, 1966. Silver dye bleach print, chromogenic process. Charles Brittin Archive, Getty Research Institute. Used with permission.

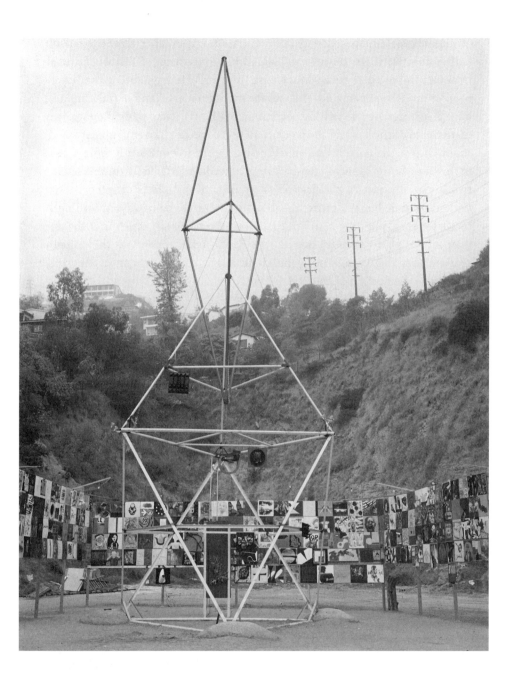

5. Charles Brittin, *Photograph of the Artists' Protest Committee Artists' Tower of Protest*, Los Angeles, 1966. Charles Brittin Archive, Getty Research Institute. Used with permission.

Greenberg, arguably the most influential American art critic of the second half of the twentieth century, explained his conception of formalism most famously in his 1960 essay "Modernist Painting." He argued that the "rationale" of modernist painting—like all the modernist arts (and in this thinking he was inspired by the writings of Immanuel Kant)—was to employ its own methods to criticize itself. Such criticism was done not, Greenberg explained, "in order [for the medium to] subvert [itself], but to entrench it more firmly in its area of competence."[6] For painting, according to Greenberg, this meant two things. First was a purification of painting of the effects of any other artistic mediums, but sculpture, theater, and literature primarily. Accordingly, for Greenberg, painting could not be three-dimensional, which was the domain of sculpture; it could not be representational, which was the domain of literature; and it could not generate dramatic effects outside its material, which was the domain of theater.

The second aspect of painting's critique of itself was a stress on the limitations that constitute the medium of painting. These limitations consisted of three things: the rectangular shape of the supports, the properties of pigment, and the flat surface of the support. The flatness of the support was the most important limitation modernism could critique, according to Greenberg, for flatness was unique to the medium of painting. (The "enclosing" shape of the supports, in contrast, was shared with theater, and color was shared with sculpture and theater, Greenberg explained.) In this way, according to Greenberg, historically "realistic, illusionist art had dissembled the medium, using art to conceal art. Modernism [starting with Manet] used art to call attention to art."[7]

Consequently Greenberg considered political art irrelevant to and irreconcilable with avant-garde practice, and thus a kind of retrograde art that was aesthetically inferior.[8] In a 1969 interview, during an intense period of debate about the war and artists' rights, he declared that the role of the artist was to make good art, and social awareness had not "worked" to make good art in the last hundred years or so. For him, art "solve[d] nothing, either for the artist himself or for those who receive his art."[9] If given the chance, Greenberg probably would have also echoed Arshile Gorky's sentiments about political work, that it was "poor art for poor people."[10]

Though Greenberg was the most influential advocate of formalism, as the 1960s progressed he was not its only champion. There was a climate of taste and opinion that aligned itself with Greenberg's approach to art criticism and art history, not least because formalism offered an attractive, sophisticated, aesthetic, intellectual approach that had not previously existed in American

art-writing.[11] Within this milieu were two influential younger critics, Michael Fried and Rosalind Krauss, who were particularly important to the extension of Greenberg's influence. (For this reason, Hilton Kramer, among others, has called Krauss and Fried—and Barbara Rose, although "less so"—the "School of Greenberg.")[12] During the late 1960s Krauss and Fried were primarily writing for *Artforum*, which had become a major arbiter of taste in the American art world, and whose editor in chief, Philip Leider, gave both of them—but especially Fried—principal placement in the magazine. (As testament to Leider's confidence in Fried, Leider devoted an entire 1969 issue to Fried's doctoral dissertation on Manet's sources.)[13]

Greenberg's influence did not truly start to fade until the early 1970s, when his acolytes began to rebel against formalism and his longtime opponents were increasingly able to have their opinions heard. Greenberg's theories were principally criticized for being too dogmatic (especially in an environment where post-structuralist theory was making major inroads); unrelated to artists' work; and generally inconsistent. A common grievance was his vague definition of "quality," which was a concept central to his evaluation of artworks. Others felt that political and social issues of the time unavoidably affected art, and consequently, that formalism was no longer tenable.[14] Still others broke with him in the late 1960s after his controversial decision to let paint weather off some of the sculptures of David Smith (of whose estate Greenberg was made a trustee in 1965). Since Greenberg had unsuccessfully tried to persuade Smith to leave his work unpainted during his lifetime, this move was condemned as crowning evidence of Greenberg's often-noted arrogance and his feeling of superiority over the artists and art about which he wrote.[15]

Alongside formalist theory, the dominance of the (rarely conflated) pop and minimalist movements in the United States throughout much of the 1960s also discouraged the creation of politically engaged work. With few exceptions, artists associated with both movements created works that rejected metaphorical connections with anything outside their material attributes, such as the artist's psyche, feelings, or emotions as well as current events. In this way, pop artists and minimalists—though their artworks were markedly different—emphasized the coolness, cleanliness, and factory-made, serial, anonymous qualities of their works, and their works' complete lack of material attributes like gestures and particular relational arrangements, which had been central to abstract expressionism, the dominant postwar American avant-garde movement. Though pop artists obviously included readily recognizable subject matter in their work, such as images from comic books and

consumer products, they both proposed that these images were chosen for their meaninglessness and banality, and underscored their interchangeability. It is important to note that even though their thinking was influenced by Greenberg (who refused to embrace either movement), pop and minimalist artists were also encouraged in their approach by a variety of artists, writers, and philosophers who either proposed an object-focused approach to art-making or promoted ideas that inspired such an approach, such as John Cage, Marcel Duchamp, Ad Reinhardt, Samuel Beckett, Ludwig Wittgenstein, George Kubler, Susan Sontag, and Alain Robbe-Grillet.[16]

Though Robert Morris and Donald Judd contributed significant writings on the subject of minimalist practice, Frank Stella and Andy Warhol were the two most influential exemplars of 1960s pop and minimalist sensibility. Carl Andre's comments about Stella's work in the catalog for Dorothy Miller's *Sixteen Americans* exhibition in 1959 in many respects constituted the minimalist sensibility's "opening statement."[17] Andre wrote, "Art is the exclusion of the unnecessary. Frank Stella has found it necessary to paint stripes. There is nothing else in his paintings. He is not interested in sensitivity or personality, either his own or those of his audience. He is interested in the necessities of painting. Symbols are counters passed among people. Frank Stella's painting is not symbolic. His stripes are the paths of brush on canvas. These paths lead only into painting."[18] Later in the sixties, Stella expanded on Andre's description. He explained, "I always get into arguments with people who want to retain the old values in painting—the humanistic values that they always find on the canvas. If you pin them down, they always end up asserting that there is something there besides the paint on the canvas. My painting is based on the fact that only what can be seen there *is* there. It really is an object."[19] Warhol, for his part, famously explained that he wanted to be a machine and that "if you want to know all about Andy Warhol . . . just look at the surface of my paintings and films and me, and there I am. There's nothing behind it."[20]

Despite pop and minimalism's apolitical approach, it must be mentioned that over the course of the war a few such artists did attempt to reconcile their work with their sentiments about the war. Further, most (if not all) of the artists involved with both movements were antiwar and attended antiwar activities, or just considered their work subversive or their practices socially engaged enough to have some relevance to the antiwar effort.

One of the first examples of a minimalist politically engaged work was Dan Flavin's *monument 4 those who have been killed in ambush (to P.K. who reminded me about death)* (fig. 6). Installed as part of the Jewish Museum's landmark 1966 exhibition *Primary Structures*—the first major museum exhibition of

what would become known as minimalism—Flavin's sculpture consisted of his signature fluorescent lights—with red-colored gels covering the bulbs—set into a corner at about waist height. The bulbs were arranged in the shape of what could best be described as a crossbow. One of the lights, which could be seen as the arrow of the crossbow, was set parallel to the floor, jutting out into the gallery space directly toward the viewer. It rested on other perpendicular lights that appeared to be the bow.[21] Taking Flavin at his word (i.e., the title), the work served as a memorial for soldiers who were victims of ambushes. According to Alex Potts, this reading coincides with Flavin's personal attention to the "concrete politics" of the mid-1960s, when ambushes were becoming a "big concern" for soldiers.[22] Flavin's hinting of the work to be a memorial also places it in the company of various future antiwar works (by artists such as Ed Kienholz and Robert Morris, after his surprising political awakening in 1970), which used the motif of memorials-before-the-fact (i.e., advance memorials) as a way to protest the war before its end. These memorials both established the undeclared war in Vietnam as an actual war—one that necessitated a memorial—as well as foregrounded the increasing numbers of American dead.

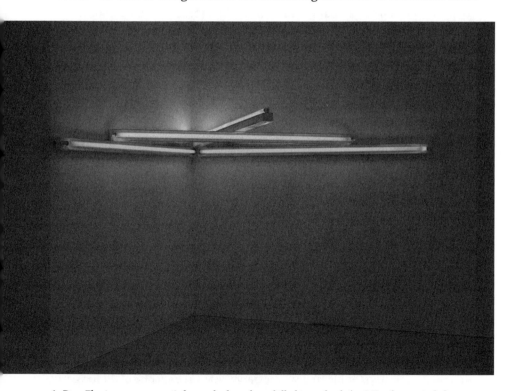

6. Dan Flavin, *monument 4 those who have been killed in ambush (to P.K. who reminded me about death)*, 1966. Red fluorescent light. 8 ft. (244 cm) wide, 6 ft. (183 cm) deep. CL no. 108. Photograph by Cathy Carver. © 2012 Stephen Flavin/Artists Rights Society (ARS), New York. Courtesy of David Zwirner, New York.

One should be hesitant though to allow the title (and Flavin's words) to entirely govern the understanding of this work, primarily because it obfuscates the work's aggression. Again, Flavin's bulbs are configured into the shape of a crossbow that seems to aim a blood-red arrow at the viewer's chest. One wonders if the work was meant to echo the feeling of an ambush for the viewers, possibly encouraging them to identify with the victims.

Art historians, mostly in recent years, have also proposed subtle antiwar arguments for other minimalist objects and in turn the artists who created them. Minimalist works' non-elitist materials, integrity, efficiency, and simplicity, for example, have been seen as an argument for a non-stratified society, objecting to a hierarchical world order in which war and conflict are common occurrences. Carl Andre's late 1960s floor pieces are a case in point. Julia Bryan-Wilson, for example, has most recently read them as a subversive gesture, a "mute anti-utilitarianism" that "acts powerfully to redress the balance" in society.[23] As well, she argues that the movement of such unaltered materials into an art context unchanged was Andre's attempt to foreground a "zero-zero economic vector" and disrupt these materials' movement in society from use-value to exchange-value.[24] Further, for her, Andre's floor works' horizontal equivalences suggest a "utopian space" for human interaction.

Andre's eventual involvement in the Art Workers' Coalition, as well as the ideas of Herbert Marcuse's "dimension of possible liberation," buttress this opinion of Andre's production. Aligning Marcuse and Andre is understandable, for during the 1960s, Marcuse's ideas were brought to bear on Andre, Morris, and others through a set of art critics (foremost among them Gregory Battcock). In such texts as *Counterrevolution and Revolt* and *Essay on Liberation*, Marcuse called artists the primary agents of change in his idea of the "new economy." He saw artists as able to create new forms that "could sustain a dialectical unity between what is and what can (and ought to) be"—though significantly, he gave no indication of what these art forms might look like.

Donald Judd's political engagement has also been considered in recent scholarship. As opposed to the obdurate blankness of his minimalist production, David Raskin has argued that Judd's anti-traditional, anti-subjective, symmetrical, serial art was generally "in keeping with the oppositional movements of the 1960s and its rhetoric" and was "designed to counter the concentration of power in the elite," due to its aesthetic, which "rejected the pernicious social values institutionalized in Modernism."[25] Raskin also believes Judd's "art contained a subtle call to action," for, like Andre's work, it foregrounded a rejection of hierarchy in society.[26] Raskin uses one of Judd's early, red, untitled works from 1962 to demonstrate this. He explains, "No aesthetic hierarchy is generated in the geometric opposition of near-right angles, the

physical opposition of materials, or the visual opposition of colors. As the work defines both internal and external volumes and stresses its status as an object in the real world through its lack of a base, it allows no part to be more important than any other, nor than the structure as a whole."[27] At the same time, Raskin explains that Judd believed art was a weak instigator of social change, and that any art that advocated an agenda was at risk of becoming propaganda and thus failing as art. Like Andre, Judd was involved in pacifist political action outside his work during his life in New York.[28] Most significantly, Judd opposed the construction of the Lower Manhattan Expressway and was involved with Citizens for Local Democracy (run by H. R. Shapiro) and their organ, a newspaper called *Public Life*. Citizens for Local Democracy was particularly interested in promoting a Jeffersonian township model of government, and Raskin has sourced a good deal of Judd's political commentary in his writings of the period to *Public Life*. A reliance on Jeffersonian ideals was not unusual for the time. As the historian Barbara Tischler explains, political activists during the 1960s took the ideas of Locke and Jefferson quite seriously.[29]

Judd also actively opposed the war in Vietnam. Early on, he donated and contributed work to the *Peace Tower* and marched against the war. In the summer of 1969, during a residency at the Aspen Center for Contemporary Art, he and his wife, Julie Finch, published an antiwar announcement in the *Aspen Times* on behalf of the War Resisters League.[30] Judd created one antiwar work of sorts as well, his "Yellow Poster," for the 1970 Westbeth Peace Festival (which benefited the New York Peace Action Coalition and Student Mobilization Committee to End the War in Vietnam). The poster was made from four mimeographed 8.5 × 11 inch yellow pieces of paper printed together as one. The four pages together contained thirty-two quotations Judd culled from historical and contemporary sources that advocated pacifism by illustrating the horrors of excessive government power.[31]

Political interpretations of the major minimalists such as Flavin, Andre, and Judd did not go over well with more "outright" political artists during the Vietnam War. Leon Golub, for example, took such points of view to task. In a letter to *Artforum* in 1969, he explained that he saw no political engagement in minimalist production and considered minimalism as just another expansion of formalism, which, he said, maintained "the dream of the perfectibility of art" while supporting the technological masters of American empire that "export destruction [and] . . . burn and drive peasants from their homes." Moreover, Golub argued against ideas that minimal shapes refer to the world. "Sure," he said, "the 'real' world has bricks, gas stations, earth, and cubes . . . the 'real' world is also Americans in Asia or Guatemala."[32]

Others also have argued that minimalism actually colluded with the aims of the U.S. government.[33] For example, some Art Workers' Coalition participants argued that Flavin collaborated with the enemy because in his works he used General Electric fluorescent bulbs and GE made munitions for the war.[34] And James Meyer has proposed that minimalism's 1968–1969 circulation through Europe in exhibitions such as *The Art of the Real: USA, 1948–1968* and *Minimal Art* became a pretext for European contestation of U.S. military policy at the height of the war.[35] It seems doubtful, however, that the specific aesthetics of minimalism should be credited with awakening Europe to U.S. foreign policy, as another art form may have been just as representative of American hegemony at this historical juncture.

Apart from the more canonical minimalists, during the late 1960s there was one prominent antiwar exhibition of minimalist work, the Paula Cooper Gallery's 1968 *Benefit for the Student Mobilization Committee to End the War in Vietnam*, which will be discussed at length later on, as well as the production of works by Phoebe Helman, Ellsworth Kelly, and Brice Marden that took the form of gray or black monochromatic paintings. These works have been viewed as signifying the melancholic mood induced by the war.[36] The black paintings of Wally Hedrick (who was one of the first artists to engage with the American presence in Vietnam with his 1959–1963 *Anger*) were another example of this type of work (figs. 7 and 8).

Hedrick's black paintings were entirely, deeply black, with surfaces ranging from scumbled to flat. They were unique among the painters of black canvases of the time, such as Ad Reinhardt, Frank Stella, and Robert Rauschenberg, in that the paintings were originally nonblack, figurative works, and Hedrick had tarred them over with heavy layers of black paint. Yet during the 1960s, Hedrick moved toward the production of "virgin" black works—which had no image to begin with underneath and were simply black paintings. To Hedrick, these more basic monochromes signified the withdrawal of his talent from Western culture, as well as the black of death and mourning, symbolizing the loss of lives and the loss of light (enlightened thinking) in the United States. In an exhibition of some of the paintings, Hedrick even comically and eerily compared damage to some of the early paintings in the series—the reason for which was probably just their means of storage and transportation—to the physical injuries of Vietnamese war victims. For example, he wrote in notes that were on display, "P.S. Those in the Aid Station, to the rear of the Gallery, are wounded, M.I.A.s and war orphans that received little or no medical help. Please open your heart and home to them."[37]

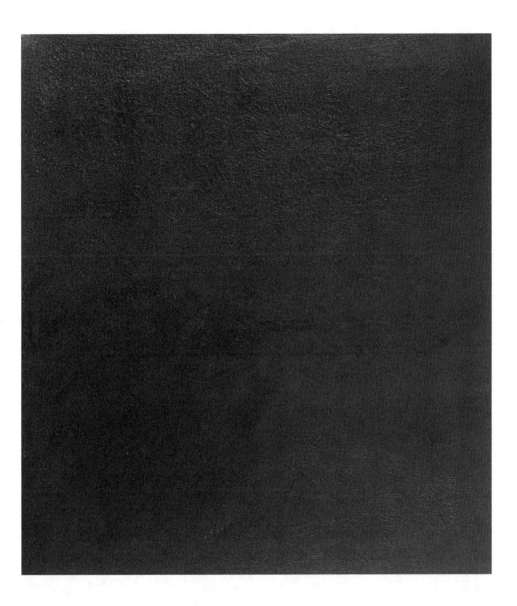

7. Wally Hedrick, *Vietnam*, 1968. Oil on canvas. 73 × 66 in. Photo: M. Lee Fatheree. Estate of Wally Hedrick.

8. Wally Hedrick, *War Room*, 1967–1968/2002. Oil on canvas, 8 panels; 132 × 66 in. each. Courtesy the Estate of Wally Hedrick and The Box, Los Angeles. Photo by Fredrik Nilsen. Collection of Paul and Karen McCarthy.

In 1970 Hedrick began work on an installation of black paintings, called the *Black Room*, which is alternatively called the *War Room*. *Black Room* was planned as an entire room (with ceiling, floor, walls, and door) made out of bolted-together black canvases. The whole work, for Hedrick, was at once his largest rejection of "irrelevant aestheticism" and an expression of how the United States had "boxed itself in" with the war in Vietnam. Hedrick said that he also wanted to create a place for people to confront their feelings about the war. Depending on your politics, the door would either shut you in or serve as an escape hatch. While the *Room* was never completed—it has no floor or ceiling because the war ended, and the war was, for Hedrick, the reason for its existence—the installation (comprising only walls that create a five-foot square space) was resurrected and exhibited with the onset of the Gulf and Iraq Wars.

As far as the antiwar character of pop art, while for the most part it was apolitical, at points during the war James Rosenquist and Roy Lichtenstein created works that engaged with the war or other related 1960s political issues, and the antiwar work of artists like Peter Saul, Martha Rosler, and Öyvind Fahlström had immediate relations to pop.[38] Also, especially at moments and in situations where a connection with the war was desired by artists, art critics, or the viewing public, arguments were proposed that major pop works were in point of fact antiwar. For example, in 1968, upon its first major exhibition in New York at the Metropolitan Museum of Art, James Rosenquist's *F-111* was labeled antiwar, and this interpretation has adhered to the painting to the present day.[39] The major reason behind this line of thinking was that in 1968 its primary subject—the F-111 airplane—had become a catastrophic failure for the U.S. military in Vietnam.[40] The F-111 was incredibly costly to produce, structurally problematic, and impotent in the face of advanced Soviet missile defense and guerrilla war in Indochina. Rosenquist's foregrounding of the plane was thus interpreted as criticism. Importantly, however, Rosenquist did not intend *F-111* as a specific commentary on Vietnam. The painting was completed before the war became well-known, and when the F-111 was still in development. In this respect, as Michael Lobel has recently argued, if Rosenquist had wanted to comment on Vietnam in 1965, he could have easily picked a plane that was being used in the conflict, or better yet, a helicopter, which (as seen in Nancy Spero's works and the writings of Michael Herr) was "already indelibly linked with the American military's [Vietnam] operations."[41] The fact remains, however, that after *F-111* was embraced as a Vietnam painting, Rosenquist did not come out and publicly reject the label.[42]

A similar situation occurred with Claes Oldenburg's *Lipstick (Ascending) on Caterpillar Tracks* (fig. 9) in 1969, which was considered antiwar during the war, primarily by Barbara Rose, because of its juxtaposition of "a classic consumer product with militarism," as well as its insinuation, akin to the work of Spero and Judith Bernstein, that "American military policy was an outgrowth of repressed sexual drives."[43] Rose went further to say when *Lipstick* failed to inflate—the lipstick portion was initially inflatable, and faulty—the implicit question becomes, "of course, how virile is America?"[44] In recent scholarship, however, Tom Williams has questioned Rose's point of view. Specifically, Williams believes the sculpture, even though it did suggest antiwar themes, was much more engaged with current Yale internal politics and university building plans, particularly for what would become the Yale Center for British Art. According to Williams, students sought, by planting the work in the center of—and thus "defiling"—the university's "technocratic" but crucial Beinecke Plaza, to protest Yale's indifference to the needs of students and the broader New Haven community, which were consistently an issue in the late 1960s.[45]

Lipstick was not Oldenburg's only association with the antiwar movement. Though its reference to Vietnam was not specific upon its creation in 1965, Oldenburg's imaginary advance memorial, the *Proposed Monument for the Intersection of Canal Street and Broadway, New York: Bloc of Concrete Inscribed with the Names of War Heroes* (fig. 10), was eventually sold at auction in September 1970 to benefit antiwar congressional candidates.[46] Oldenburg's block was a huge cube that would be the same height as the surrounding buildings and would occupy and render useless the entire square area of the intersection. On the one hand, Oldenburg's work is aggressive—blocking an intersection even temporarily in New York is a cardinal sin. On the other hand, the work is extremely playful—a quality lacking in most memorial projects. Other Oldenburg memorial proposals, such as his proposal to replace the Statue of Liberty with a table fan and the Washington Monument with a moving pair of scissors, are similarly humorous. [47]

The American art world's faith in formalism, pop, and minimalism meant that artistic antiwar engagement was virtually ignored in museums and galleries. On the rare occasions in which museums and galleries did exhibit such work, political hypotheses were assimilated into what Max Kozloff labeled "an apparatus of mild titillation."[48] Most media outlets and nearly all of the art press ignored such work, too. Regarding *Artforum*, Kozloff recently explained, "None of the critics had the habit of looking at visual art from the vantage, of all things, of public events. You will search the pages of [the magazine], and other American art journals of the 60s in vain to find any such notice."[49]

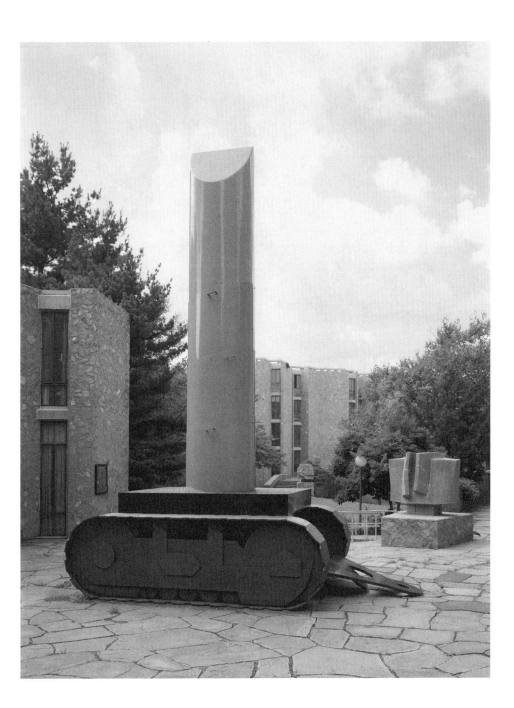

9. Claes Oldenburg, *Lipstick (Ascending) on Caterpillar Tracks*, 1969. COR-TEN steel, aluminum, coated with resin and painted with polyurethane enamel. 23 ft. 6 in. × 24 ft. 10 ½ in. × 10 ft. 11 in. (7.16 × 7.58 × 3.33 m). Collection Yale University Art Gallery, Gift of Colossal Keepsake Corporation. Photo credit: Attilio Maranzano. Photo courtesy Oldenburg van Bruggen Studio. © 1969 Claes Oldenburg.

10. Claes Oldenburg, *Proposed Monument for the Intersection of Canal Street and Broadway, N.Y.C.—Block of Concrete, Inscribed with the Names of War Heroes*, 1965. Crayon and watercolor. 11 ¾ × 17 ½ in. (29.9 × 44.5 cm). Collection Estate of Dan Flavin. Courtesy Oldenburg van Bruggen Studio. © 1965 Claes Oldenburg.

As a final note, the pervasiveness of formalist approaches also led to the dismissal of political artworks in most college and university art and art history courses. For example, during her graduate study at the Institute of Fine Arts (IFA) from 1960 to 1962, Lucy Lippard has said that though she knew of artists who had been politically engaged, such as Philip Evergood, Philip Guston, David Smith, and Ad Reinhardt (who took eleven courses at the IFA between 1943 and 1952), they were constantly examined outside their historical references or through examples of their work that were not politically engaged. Max Kozloff, who was also at the Institute from 1960 to 1962, has likewise explained that the "tradition of Marxism and its historiography in criticism had been, by and large lost" during his graduate study. At the IFA, he said, "they emphasized patronage values, the state's, the church's—and iconographical studies—of the kind developed by Panofsky."[50] He also has commented that he wasn't aware there were any other options until, in the early 1970s, a student handed him a copy of "The Nature of Abstract Art" by Meyer Schapiro, published in the *Marxist Quarterly* in 1937, and when he came across Leo Steinberg's seminal critique of formalism, "Other Criteria," which was published in *Artforum* in March 1972.[51]

This state of affairs created an environment where artistic precedents of politically engaged work (individual works or movements) were not readily available and even difficult to find for those interested. Those which were accessible and which came to have added political significance attributed to them (because of challenging exhibitions or scholarship) during the 1960s included Dada, which influenced the activities of politically attuned performance artists, and Russian constructivism.[52] There were also the works of Francisco Goya, whose *Saturn Devouring His Children* and *Disasters of War* appeared in antiwar posters, such as Jay Belloli's *Amerika Is Devouring Its Children* (fig. 11). And then there was the example of Picasso's *Guernica*. Although Picasso created other explicitly political paintings in the postwar period, such as 1951's *Massacre in Korea*, *Guernica* was the lone political work that was able to truly slip through formalism's barriers and both subtly and explicitly affect Vietnam-era antiwar production.

Guernica—in its entirety, or portions of it—throughout the years of the war would either be directly appropriated or serve as a kind of template for the creation of a range of Vietnam-era artists' protest works (from posters to political actions), which attempted to have a dialogue with the past (fig. 12).[53] The work was quite familiar to American artists in the 1960s because of its loan to MoMA since 1939 and its international renown. The connection Vietnam-era artists made between *Guernica* and the Vietnam War suggested that what Picasso represented in his painting paralleled the inhumane actions

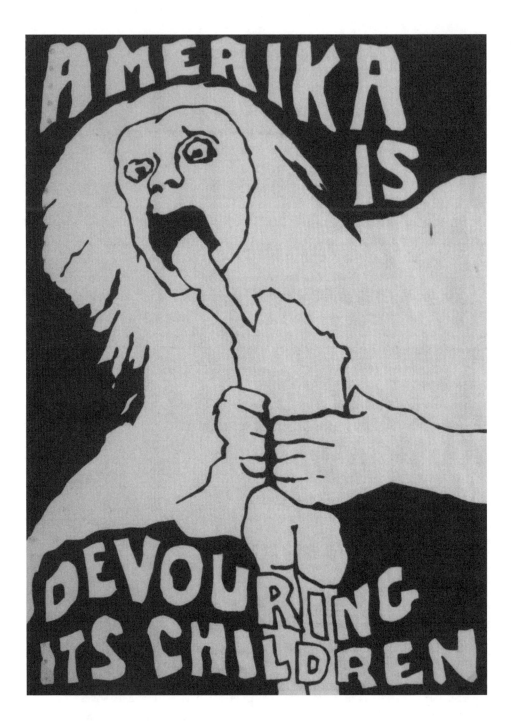

11. Jay Belloli, *Amerika Is Devouring Its Children*, 1970. Silkscreen. 55.9 × 38.1 cm (22 × 15 in.). Courtesy of the Center for the Study of Political Graphics.

of the United States in Vietnam. *Guernica* depicted the 1937 total destruction of the ancient Basque town of Guernica by the German Condor Legion, operating with Francisco Franco's consent during the Spanish Civil War. Guernica was the cultural capital of the Basque people and the bombing did not have any strategic military targets but was used to break the Basque resistance to Franco's forces. Guernica served as a testing ground for a horrific Nazi military tactic that would be used during the subsequent world war: the carpet bombing of a civilian population to demoralize the enemy. Picasso had given the painting to MoMA on extended loan in 1939 to enable it to travel internationally—which it did until the late 1950s—and also to keep the painting from Spain until the resumption of democracy in the country. (The painting was finally returned, as a symbolic gesture, to Spain's new democratic government in 1981.) *Guernica*'s relationship to American artists during the Vietnam War may have been accentuated by the fact that in the summer of 1967, MoMA organized a special thirtieth-anniversary exhibition of the work, which included fifty of Picasso's studies for the painting.[54]

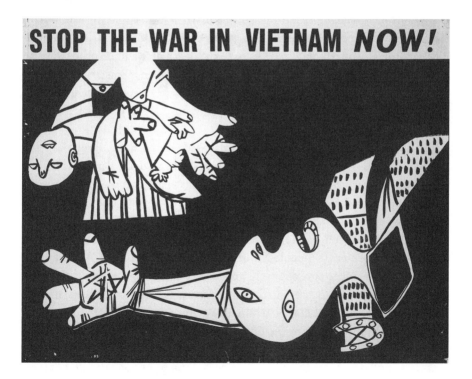

12. Artist unknown, *Stop the War in Vietnam Now!* circa 1970. Offset. 44 × 56 cm (17 ⁵⁄₁₆ × 22 ¹⁄₁₆ in.). Courtesy of the Center for the Study of Political Graphics.

It also must be said that various doves created by Picasso were also re-produced or referenced during the late 1960s in American protest posters as symbols of peace (fig. 13). On the one hand, the use of the dove as a symbol of peace during the 1960s may seem straightforward. The dove historically sym-bolized peace (as well as spirituality and resurrection) in both the Christian and non-Christian world, and had been used previously during the twentieth century as an antiwar symbol, such as in John Heartfield's *The Meaning of Ge-neva* (1932).[55] On the other hand, for an older segment of the antiwar move-ment, the dove was firmly communist. Between 1947 and the early 1960s, Picasso's doves were internationally recognized, central symbols of the Com-munist Party's "Peace Movement."[56] The Peace Movement was a nonmilitary defense strategy of the Cold War, positioned against American imperialism and orchestrated by the Communist Party—though publicly it was presented as an intellectual and politically nonaligned movement.[57] Communist intellec-tuals would write in publications and speak at conferences and congresses in support of peace and communist ideals, and against what they saw as Ameri-can warmongering during the Cold War. The movement, according to Gertje Utley, author of *Pablo Picasso: The Communist Years*, was "the most powerful non-military weapon that the Soviet Union set up to confront NATO." Accord-ing to historian Tony Judt, "From 1946 to the death of Stalin no other topic so dominated public discussion [in Europe]."[58] Importantly, Picasso was not just contributing his doves to the movement but was a prominent, active member both of the Peace Movement and of the Communist Party itself from 1944 until his death in 1973.

Because of the Peace Movement, Picasso's doves became familiar around the world. One of the first uses of his doves was actually a pigeon Picasso made (which the symbolist poet and Communist Party official Louis Aragon decided to call a dove) in a poster for the first Congrès mondial des parti-sans de la paix in 1949. Soon after, the original (and more often, new, highly simplified line-drawing versions) showed up on backdrops for political rallies, as well as on posters, schedules, and pins all across Europe.[59] According to Utley, Picasso's doves subsequently appeared on the front page of the New York *Daily Worker*, on posters in Japan, on postage stamps in China and the Soviet Union, and on the stage curtain for Bertolt Brecht's *Mother Courage and Her Children* in the theater of the Berliner Ensemble. In France, Picasso's dove became so well-known that it rivaled the post office's calendar and Millet's *An-gelus* in popularity, according to Utley. The last major use of a dove by Picasso was for the July 1962 World Congress for Disarmament and Peace in Moscow.

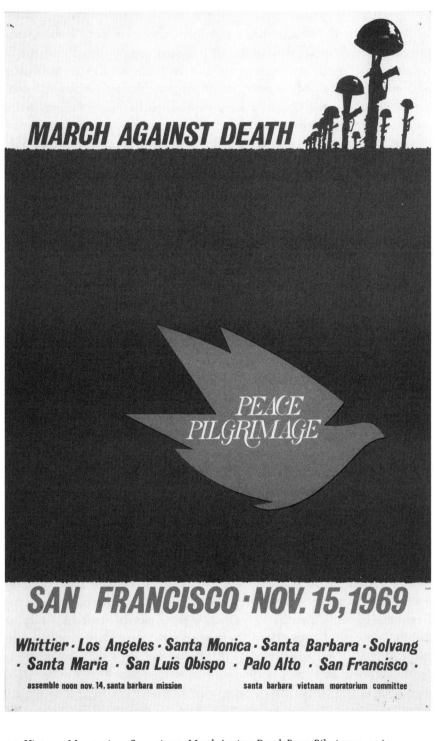

13. Vietnam Moratorium Committee, *March Against Death Peace Pilgrimage*, 1969. Offset. 54 × 34 cm (21 ¼ × 13 ⅜ in.). Courtesy of the Center for the Study of Political Graphics.

APC conceived its idea for the *Peace Tower* in 1965. The idea stemmed from the group's desire, in the wake of its previous activities, to make a substantial, collaborative, "visual statement about the war" that would simulate public opinion and debate, and the group raised roughly $10,000 to create it.[60] Robert Rauschenberg and William Copley were two of the major donors. Petlin spearheaded the tower's organization.[61] Other significant people from APC involved in the project were Judy Gerowitz—who later became known as Judy Chicago—and her husband, the sculptor Lloyd Hamrol.[62]

Eventually completed on February 26, 1966, the tower stood on a highly visible rented lot at the corner of Sunset and La Cienega Boulevards in Los Angeles and consisted of two parts. The major part was a hollow, fifty-eight-foot-tall tower constructed of steel poles painted yellow and purple. The tower's shape was quite complex. It was an octahedron, tetrahedron, and double tetrahedron tensional configuration, which was a variation of Buckminster Fuller's tensegrity constructions.[63] The sculptor Mark di Suvero designed the tower. Though he lived in New York at the time, di Suvero was in Los Angeles in late 1965 and became involved with APC as a result of his show at the Dwan (which was highly acclaimed in *Artforum*, among other places).[64]

The other part of the tower was a ten-foot-tall, one-hundred-foot-long billboard that was affixed to the base, eight feet off the ground. At the foot of the billboard was a large sign—of black lettering on a yellow ground—which read "Artists Protest Vietnam War," and covering the billboard were hundreds of two-foot-square weatherproof painted panels. The panels had been sent in by individual artists to be installed on the billboard in response to a bulletin APC distributed internationally in 1965.[65] The bulletin had asked artists for panels that would express their dissent. So many contributions were received—allegedly 418—that all the panels could not fit on the billboard and many had to hang on the lot's surrounding fence.[66]

Those who donated panels to the project were by no means only "political" or "figurative" artists (as might be gathered from the number of artists involved) but were working in a range of styles. At the same time, the panels did not diverge markedly and can be understood as existing in three different categories.[67] The most prominent type of panels—by artists such as James Rosenquist (again, one of the few pop artists to engage at points with war and politics during the 1960s), Elaine de Kooning, Alice Neel and Rafael Soyer—featured quick, furious, rant-like slogans or symbols that often strayed from an artist's characteristic style. Rosenquist's contribution simply said "Body Count" in large letters. Neel created a skeleton that was burning up in flames behind the words "Stop the War."[68] A second group of panels

were those created in an artist's recognizable style but altered in some way to reflect a desire for peace or a halt to the war. Panels by Rudolf Baranik, Golub, and Lichtenstein—the other significant pop artist to engage (in a few situations) with the war—fell into this category. A third group of artists, including Donald Judd and Tom Wesselman, made what I have called benefit works. As mentioned previously, these were works done completely in an artist's recognizable style, with no adjustment for the needs of a specific event or effort (i.e., there was no discernible antiwar content), but which were contributed to benefit the event or effort, whether financially or because the artist's reputation would add import to the cause.

The tower opened to the public in a dedication ceremony on February 26, 1966. Susan Sontag and Donald Duncan spoke at the ceremony. Duncan was a former member of the U.S. Army Special Forces and the author of a searing and influential critique of American involvement in Vietnam published in *Ramparts* that same month.[69] Sontag's speech announced that with the creation of the tower, those against the war were expanding their activities. No longer were those involved in the antiwar movement solely writing members of Congress and signing petitions, Sontag explained, but through the means of the tower they were "establishing a *big thing* to stand here, to remind other people and ourselves that we feel the way we do."[70] As Julia Bryan-Wilson has written, Sontag's use of the less-than-eloquent term "big thing" as a way to describe the effort can be read as a reflection of the basic "uncertainty" of Sontag—who was one of most eloquent critics of the twentieth century—about the tower, and in a larger sense, the American avant-garde's lack of faith in "objects" or "big things" as a form protest. This lack of faith would continue to be present in the (again) predominantly formalist American avant-garde throughout the years of the war.[71]

While those involved with the tower hoped it would exist until the end of the war, from the moment of its inception its future was uncertain. Though guarded twenty-four hours a day, it was threatened and attacked during and after its construction, and according to Petlin, some of the attacks were aided by the Los Angeles Police Department's lack of sympathy for the project.[72] One of the worst attacks found Petlin defending the tower with a sparking light stanchion against a crew of marines bent on tearing it down. Coverage of this incident appeared in the *New York Times* and inspired Frank Stella—despite his own formalist stance—to donate $1,000 to the cause. Stella explained that he gave the money because "any artist who would risk his life defending a work of art deserves my support." The owner of the lot in which the tower stood also tried to evict APC. He was furious because APC did not

disclose their intention to build a huge antiwar statement when they rented the lot, and he would have never approved the lease if he had known.[73]

These problems led APC to shop the tower around to see if it could be moved somewhere else. APC approached the Pasadena Art Museum, the Center for the Study of Democratic Institutions in Santa Barbara, and the Institute for Policy Studies in Washington. Despite APC's efforts, there were no takers, primarily because, according to Therese Schwartz, the work was too politically unrestrained to be exhibited.[74] As a result, APC decided to disassemble the work and not reinstall it when their lease expired. Upon its disassembly, sections of the tower's steel poles were compressed into square "pillows" and distributed to the individual participants as mementos. The panels were wrapped in brown paper and auctioned off anonymously at a local peace center.[75] According to Petlin, this auction raised roughly $12,000 and benefitted the California Civil Liberties Union, which was "trying to get . . . out of jail" people who were being denied bail.[76]

In New York during 1966, a few artists began to incorporate antiwar sentiment into their works of art. The most visible instance was Marc Morrel's December 1966 exhibition at the Stephen Radich Gallery, in which Morrel—a marine, freshly back from Vietnam—installed thirteen constructions all featuring the American flag (fig. 14). Among the constructions was a flag draped in chains, a flag shaped as a phallus on a cross, and a flag suggesting a symbolic figure hanging from a yellow noose. Antiwar songs played in the background. Morrel's sculptures became well-known not on their own merits, but because Radich was arrested and charged with violation of the state penal law stating that "no person shall publicly mutilate, deface, defile or defy, trample upon or cast contempt upon the American flag."[77] (While this law has since been repealed, there continue to be events that revive interest in it and Congress has consistently attempted to pass a constitutional amendment to allow the government to ban flag desecration.) Radich's arrest garnered a great deal of publicity because it seemed so ridiculous. Yet surprisingly, Radich was eventually found guilty, even though the American Civil Liberties Union stepped in to defend him.[78]

When asked about his work in a 1967 panel discussion, Morrel explained that he saw the flag as "the one symbol that could reach people other than a burnt or bloody doll or a draft card."[79] Other artists agreed with Morrel, and in the years after his exhibition, numerous antiwar works employed the American flag. Most, like Morrel's works, defaced the flag and relied on this strategy to express an anti-American sentiment. Obviously, this was nothing new, as desecrated flags had historically been used in the United States and

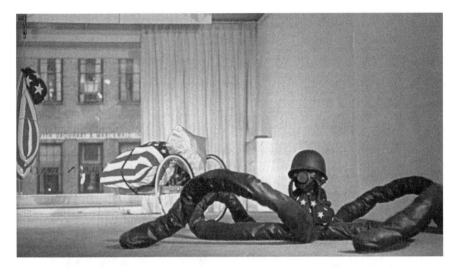

14. Installation view of Marc Morrel flag works at the Stephen Radich Gallery, December 1966. Courtesy Marc Morrel and *Art in America*.

many other countries to express dissatisfaction with one's government. In 1969, for example, Jasper Johns—who was already famous for his painted American flags of the 1950s—created *Flag (Moratorium)* (fig. 15) for the first Moratorium to End the War in Vietnam in October 1969. The Moratorium— literally a suspension of activity—was the largest national antiwar protest to occur during the war. Millions of Americans in thousands of cities, towns, and villages across the United States participated, and in the months and years following, several other similar moratoria occurred. Johns's print was a toxic green, black, and orange version of the stars and stripes—the retinal reverse of red, white, and blue, signifying the upended state of the union. Directly in the middle of the work, Johns punched a small, perfectly round circle that for most viewers signified a bullet hole. At best, the bullet hole was a stray shot from the antiwar movement. At worst, it was a bull's-eye through the heart of the United States, the kill shot in a diseased body.[80] Johns's inverted flag became a familiar icon of the period. Initially sold by Leo Castelli Gallery in an edition of three hundred signed prints as part of a benefit exhibition for the Moratorium, it subsequently was made into a mass-produced poster, bringing awareness of the event to a much larger audience.[81]

Another iconic work based on the American flag was Fluxus cofounder George Maciunas's 1966 *U.S.A. Surpasses All the Genocide Records* (fig. 16). Like Johns's work, Maciunas's flag included subversive imagery within its design. Yet Maciunas's meaning was much less subtle than Johns's. Fifty skulls replaced the fifty stars in its canton, undeniably converting the flag from a

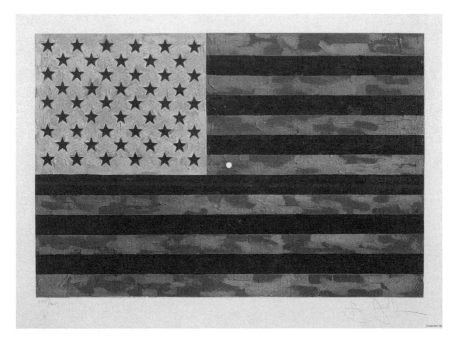

15. Jasper Johns, *Flag (Moratorium)*, 1969. Offset lithograph in colors. On wove paper, signed in pencil. Lithograph: 17 ¼ × 26 in. Sheet: 20 ½ × 28 ⅝ in. Published by the Committee Against the War in Vietnam. Edition of 300. Art © Jasper Johns and ULAE, licensed by VAGA, New York.

U.S.A. SURPASSES ALL THE GENOCIDE RECORDS!

KUBLAI KHAN MASSACRES 10% IN NEAR EAST

SPAIN MASSACRES 10% OF AMERICAN INDIANS

JOSEPH STALIN MASSACRES 5% OF RUSSIANS

NAZIS MASSACRE 5% OF OCCUPIED EUROPEANS AND 75% OF EUROPEAN JEWS

U.S.A. MASSACRES 6.5% OF SOUTH VIETNAMESE & 75% OF AMERICAN INDIANS

FOR CALCULATIONS & REFERENCES WRITE TO: P.O. BOX 180, NEW YORK, N.Y. 10013

16. George Maciunas, *U.S.A. Surpasses All the Genocide Records!* 1967. Offset. 54 × 88 cm (21 ¼ × 34 ⅝ in.). Courtesy of the Center for the Study of Political Graphics.

patriotic symbol to one of danger, poison, and death. Additionally, where there would be stripes, bluntly written in capital letters was a catalog of historical genocides, all to conclude that the United States is the historical leader in the deliberate or systematic destruction of people. The poster read, "U.S.A. SURPASSES ALL THE GENOCIDE RECORDS! KUBLAI KHAN MASSACRES 10% IN NEAR EAST; SPAIN MASSACRES 10% OF AMERICAN INDIANS; JOSEPH STALIN MASSCARES 5% OF RUSSIANS; NAZIS MASSACRE 5% OF OCCUPIED EUROPEANS AND 75% OF EUROPEAN JEWS; U.S.A. MASSACRES 6.5% OF SOUTH VIETNAMESE & 75% OF AMERICAN INDIANS; FOR CALCULATIONS AND REFERENCES WRITE TO: P.O. BOX 180, NEW YORK, N.Y. 10013." Importantly, though Maciunas utilized language like that of other artists of the period, his use was not an escape from his typical mode of expression since text had always been one of his primary mediums.

By far the most important use of the American flag as an antiwar statement, next to Morrel's exhibition, was the *People's Flag Show*, which would be held at the Judson Memorial Church in November 1970. As Bradford Martin has explained, in 1970 "the issue of artists' appropriations of the flag [again] loomed in the public eye" in part because the Radich case was pending before the U.S. Supreme Court.[82] Organized by Jon Hendricks, Jean Toche, and Faith Ringgold, the *Flag Show* sought to challenge flag desecration laws and welcomed submissions (via an ad in the *New York Times*) from sympathetic artists and citizens. A poster advertising the show declared, "A flag that does not belong to the people to do with as they see fit should be burned and forgotten." The organizers also asserted that the flag "should be available to the people to stop killing."[83]

Critics reviewing the show in the *Times* and the *Village Voice* found most of the works to be of low artistic quality.[84] Examples of inclusions were a "baked flag cake, a flag constructed of soft drink cans[,] . . . a flag in the shape of a penis," and a "flag draped over a toilet bowl."[85] There were a few, more nuanced pieces, however, such as Yvonne Rainer and her dance troupe Grand Union's nude dance with flags. Abbie Hoffman also contributed a speech that he delivered in a flag shirt, which he had been arrested for wearing in 1968. During his talk Hoffman ostentatiously made a gesture of wiping his nose on the shirt's cuff.[86] Like Morrel's show, the *Flag Show* became historically significant because it prompted the arrest of its organizers. This occurred on November 13, 1970, when the police took away Hendricks, Toche, and Ringgold (who became known as the "Judson Three") and closed down the show a day before it was supposed to end.[87] Eventually (even though like Radich, they received help from the ACLU) a federal court found the three guilty of flag desecration.[88]

17. Nancy Spero, *Gunship*, 1966. Gouache on paper. Framed: 27 ½ × 39 ½ in. (69.9 x 100.3 cm). Art © Estate of Nancy Spero/Licensed by VAGA, New York. Courtesy Galerie Lelong, New York.

Concurrent with Morrel's exhibition, in 1966 Nancy Spero began her *War Series* (fig. 17), which she would continue to work on until 1970. Spero's essential strategy in the series was disfiguration, and her works, like others created over the course of the war by Roy Lichtenstein, Nancy Graves, Bernard Aptekar, and Arnold Belkin, sought to disfigure American war machines, particularly the weapons of the U.S. Armed Forces.[89] Originally conceived in the middle of the night as throwaway works (akin to graffiti or posters) that no one would see, Spero's series turned American weaponry into predatory serpents or insects, or male genitalia, which often rooted war-making in the male sex drive. A stiff erection becomes a blood-spewing atomic bomb, or an airplane raining down a liquid hell reminiscent of clotted blood. A helicopter turns into a sickly fish (with long, birdlike legs), which vomits a torrent of dead bodies in a shower of blood and excretes a small pile of bones. A fleet of planes appears as large gray dragons labeled "F.U.C.K." that swoop down with naked people in their jaws, spraying blood. Missiles and bombs become flies; a bug coexists with a helicopter and victim; planes look like beetles; and another helicopter becomes a defecating slug. Spero's painting technique reinforced the crudeness of her works. Gouaches were severely washed out, smeared across the newsprint, often in muddied browns, as if the medium were feces spread on the wall by someone psychologically unstable.

Judith Bernstein's *Supercock* series of drawings—done while Bernstein was a student at Yale—directly relate to Spero's works. Yet because they associate only weapons and penises, and do not complicate the depiction through, for example, the inclusion of serpent imagery, the resulting effect is more one-dimensional than that achieved in the *War Series*. Their presentation was also less remarkable compared to Spero's nuanced, smeared approach. Then again, Bernstein's 1967 *Fun Gun* (fig. 18), a diagram of the male reproductive system, which included real bullets and transformed the penis into a lethal automatic weapon, is a wonderful and powerful counterpart to historical male mechanizations of the female by Picabia and Duchamp, and can be likened to contemporary sexualized diagrams by Warhol as well as Lee Lozano's gray tool renderings.[90]

In later years posters took up the themes of Spero's and Bernstein's works. One example was a 1970 poster created by the Committee for the Promotion of the Selective Youth in Asia (a fake organizational name that punned on selective euthanasia), titled *My Lai* (fig. 19). The poster featured a pinup shot of a naked white soldier (identified through a gas mask pulled back on top of his

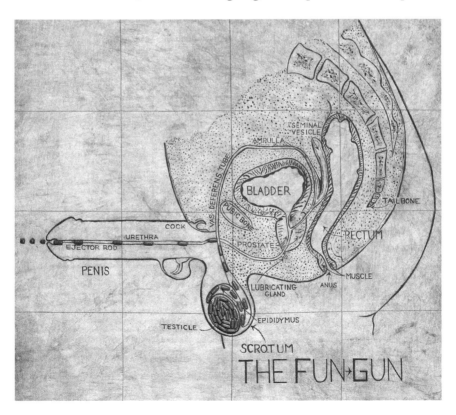

18. Judith Bernstein, *Fun Gun*, 1967. Acrylic on canvas with collaged .45 caliber bullets. 57 × 60 in. Collection of Paul and Karen McCarthy. © Judith Bernstein.

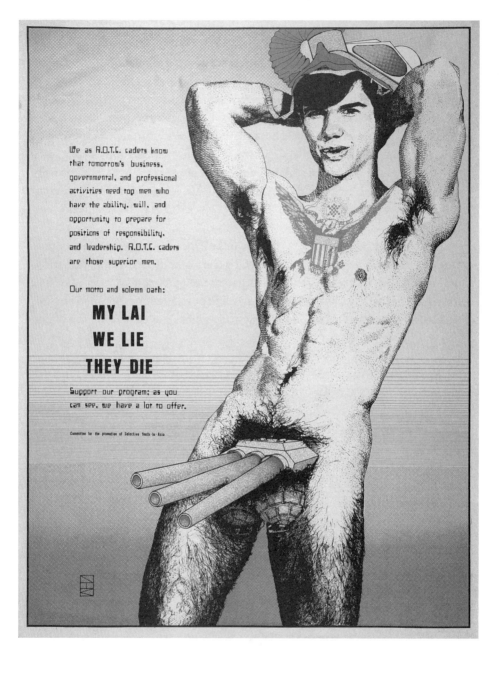

19. Jeff Kramm, *My Lai*, 1970. Offset lithograph. 24 × 18 in. © Jeff Kramm. Courtesy Lincoln Cushing.

head and a tattoo of a large heraldic eagle on his chest). His hands are pulled back behind his head and he flaunts his wares: in place of his penis, three large antiaircraft guns jut out and below them, where his testicles would be, hang two grenades.

It is important to note that these grotesque and provocative sexualizations stood at odds with the sexiness often attributed to American weaponry at the time (and since), especially among the armed forces. A telling comparison is between these works and Michael Herr's description of American helicopters in *Dispatches*, his memoir of his time embedded with the army during the Vietnam War.[91] Herr saw the helicopter as "pure sex."[92] He wrote, "In my mind it was the sexiest thing going; saver-destroyer, provider-waster, right hand–left hand, nimble, fluent, canny and human; hot steel, grease, jungle-saturated canvas webbing, sweat cooling and warming up again, cassette rock and roll in one ear and door-gun fire in the other, fuel, heat, vitality and death, death itself, hardly an intruder."[93] In this way, Herr sees the helicopter as a kind of entertaining and endlessly responsive female sex toy, available to move with him wherever he desired, and receive whatever his aggression and desire to destroy had to give. Additionally, what cannot be omitted from any discussion of Spero's *War Series* or Bernstein's works is the fact that these women made these figurative, topical, ephemeral works in a spirit of anger, not just against the war, but also against the New York art world. Even though the *War Series* would eventually be hailed as predicting feminist production (particularly through its sexualization of weaponry), its almost deliberate rejection of the current New York avant-garde aesthetic meant it was relegated to the periphery.[94] Spero and Bernstein's physical and ideological location at the margins of the New York art world bore little relation to that of the U.S. government, where the following year the war was seen as moving in the right direction.

4

Angry Arts

THE JOHNSON ADMINISTRATION publicly called 1967 a successful year in Vietnam, primarily because it said the enemy was in retreat from populated areas. Yet privately the administration knew things weren't progressing well, and as a result those involved were engaged in a divisive debate over strategy during much of the year. The Joint Chiefs of Staff still advocated intense bombing as they had in the fall of 1964. McNamara offered a drastically different approach aimed at negotiations with the North. He called for restraint, a stabilization of bombing, limited troop increases, and a pacification drive. The Joint Chiefs called McNamara's plan "defeatism,"[1] and Johnson rejected his proposal outright. In response, in November, McNamara resigned, to the shock of the nation. Accordingly, at the end of 1967, no future war strategy had been decided and the administration raised troop strength to five hundred thousand men.

Antiwar protests increased steadily over the course of the year. The Spring Mobilization to End the War in Vietnam in New York City on April 15 was one of the largest efforts to take place. It drew anywhere from one hundred thousand (police estimate) to four hundred thousand (organizers' estimate) people.[2] On February 23, 1967, the *New York Review of Books* (NYRB) published Noam Chomsky's "The Responsibility of Intellectuals," which has since been called the single most influential piece of antiwar literature written during the Vietnam War.[3] The piece offered one of the most penetrating critiques of the prominent intellectuals working on the war in the upper echelons of the Johnson administration. It was Chomsky's claim that these men were failing

in their greater responsibility and privilege as intellectuals. In one of his most recognized statements, he explained that the responsibility of intellectuals was "to speak truth . . . expose the lies of governments, [and] analyze actions according to their causes and motives and often hidden intentions. In the Western world, at least, they have the power that comes from political liberty, from access to information and freedom of expression. For a privileged minority, Western democracy provides the leisure, the facilities, and the training to seek the truth lying hidden behind the veil of distortion and misrepresentation, ideology and class interests, through which the events of current history are presented to us."[4] But for Chomsky, the Johnson intellectuals (the "New Frontiersmen" like Walt Rostow, Henry Kissinger, McGeorge Bundy, Arthur Schlesinger, and Dean Rusk) had rejected such responsibilities. Chomsky took these scholar-experts to task by demonstrating their lies; their dismissal of truth and history; their contempt for their audience; their shocking naïveté and fatuousness; and finally, their steady exertion of a will to power, joined with an assumption of the purity and infallibility of American motives. In the face of this, Chomsky urged the reader—who was assumed to be part of the liberal American public—to question the administration's pseudo-objectivity, and to ask him- or herself, "What have I done?" in creating, mouthing, or tolerating deceptions that were used to justify defenses of American freedom and fresh atrocities in Vietnam on a daily basis.

Chomsky's article elicited strong response, most notably from the novelist and literary critic George Steiner. In fact, Steiner's dialogue with Chomsky resulted in the NYRB publishing an exchange of letters between the two in March. Overall, within the exchange, Steiner praised Chomsky for exposing the true nature of Johnson's brain trust. Like many involved in the protest of the war, however, he asked Chomsky for policy. He wrote, "You rightly say that we are all responsible, you rightly hint that our future status may be no better than that of acquiescing intellectuals under Nazism, but what action do you urge or suggest?"[5] Steiner asked whether Chomsky would now help his students escape to Mexico (in the same way that Frances Jeanson had helped his students escape from the country during the French war with Algeria, leading what was called the "suitcase brigades").[6] In the year following his exchange with Steiner, Chomsky advocated nonviolent resistance, such as draft counseling and assistance for those who were trying to leave the country. Yet Chomsky maintained that "intellectuals must not recklessly use their eloquence and rhetorical skills to force others—especially the young who are bound to suffer for it much more severely—to commit civil disobedience." "Resistance must be freely undertaken," he explained.[7]

The most significant antiwar effort from the arts community during 1967 was Angry Arts Week, which took place in New York City between January 26 and February 5. Angry Arts Week was the largest collective aesthetic endeavor to occur during the war, and was, in many respects, the East Coast's version of the *Peace Tower*.[8] Like the tower, Angry Arts Week had its origins in an artists' call. Dore Ashton and Max Kozloff sent out this call on behalf of AWP (though the Week was eventually sponsored by NYU's chapters of SDS and the Committee of the Professions as well as the Greenwich Village Peace Center). The call explained:

> We, the ARTISTS AND WRITERS PROTEST, call upon you to participate in a Collage of Indignation, to be mounted in the cause of peace, from January 29 to February 4, 1967, at Loeb Student Center, New York University. Titled *The Angry Arts*, it will feature, in a context of happenings, poetry readings, films, music and theater, panoramic size canvases, upon which you the artists of New York, are asked to paint, draw, or attach whatever images or objects that will express or stand for your anger against the war . . . We are also interested in whatever manner of visual invective, political caricature, or related savage materials you would care to contribute. Join in the spirit of cooperation with other artistic communities of the city in a desperate plea for sanity.[9]

Eventually, roughly five hundred artists were involved in the Week. Their works were made in a wide variety of media. Performance art, music, poetry, as well as visual art (painting, sculpture, and photography) could be viewed.[10]

There were some memorable works exhibited during the Week. One was Carolee Schneemann's *Viet-Flakes*, a film montage (dating from 1965) based on atrocity images, which Schneemann showed in conjunction with the performance piece *Snows* at the Kinetic Theatre (figs. 20 and 21). Since she had first heard of U.S. involvement in Vietnam as a graduate student at the University of Illinois, Schneemann, like many other artists of the period—such as Leon Golub—had been assiduously compiling atrocity images.[11] She culled these images from newspapers and magazines, or from the Liberation News Service. Schneemann was motivated to construct something out of these images around 1966, when she became particularly upset about America's growing presence in Vietnam. She also has commented that it was in 1966 that images of the war began to appear within her daily life as hallucinations. These hallucinations occurred near, and inside, her home in upstate New York. She has said she would see Vietnamese bodies hanging from trees and her kitchen stove become smoldering villages (so much so that she was afraid to use it).[12]

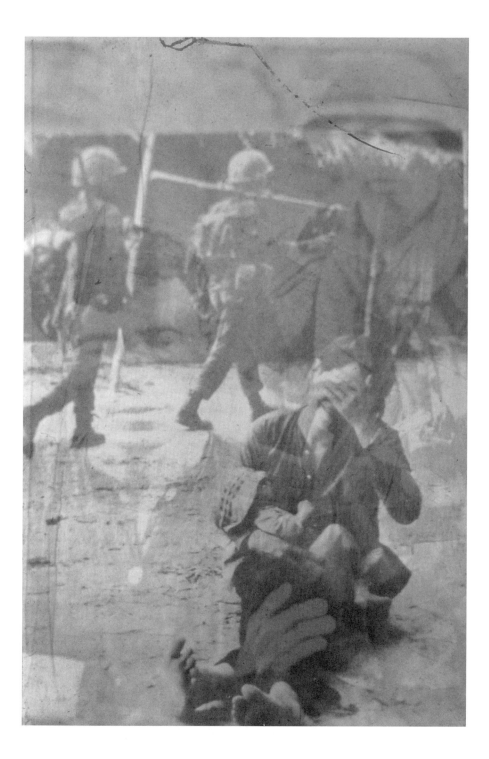

20. Carolee Schneemann, *Viet-Flakes*, 1965. Film still from DVD of original toned B&W 16mm film. © Carolee Schneemann.

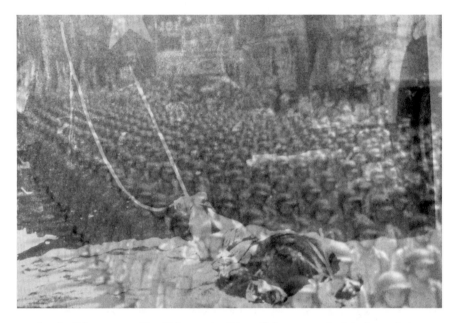

21. Carolee Schneemann, *Viet-Flakes*, 1965. Film still from DVD of original toned B&W 16mm film. © Carolee Schneemann.

In *Viet-Flakes*, Schneemann used an 8mm movie camera to intensify the effect of her atrocity images and to "force" what she called the "putrid," "militaristic jerk-off" of the war on her audience, many of whom she saw as being "ferociously" in denial of current events in Vietnam.[13] To create the work, Schneemann laid out the collection of photographs she had compiled over five years in arcs on the floor and obsessively and quickly zoomed in and out on individual examples (often over and over) with her camera, so that the eye never rested on any one image or even brought a singular image into focus. Coupled with popular songs like Jackie DeShannon's "What the World Needs Now Is Love," Question Mark and the Mysterians' "96 Tears," and the Beatles' "We Can Work It Out"—all of which were abruptly cut off and restarted in a kind of "bricolage of structural effects in sound"—the experience of viewing Schneemann's flashing onslaught of collected photographs is disorienting and nauseating.[14]

Viet-Flakes was the first of many works made during the war to use direct evidence of casualties—or in the words of Maurice Berger, "the awful human waste of [the] war"—as a means of protest. The use of direct evidence became one of the dominant strategies through which American artists exhibited their dissent.[15] The general idea behind the use of such images of violence

was that exposure to the viewer and the shock they would produce would help eliminate violence.[16] Such presentations were nothing new for art, for they had been the stock-in-trade of antiwar works historically, dating back in Western art history to Jacques Callot's 1633 *Miseries of War*. Alexander Gardner, for example, remarked of his images of the American Civil War that their presentation of "dreadful details" exposed "the blank horror and reality of war, in opposition to its pageantry."[17] Regardless of the aforementioned fact that 1960s American artists either did not know of them or neglected them due to prejudice against such work, various American social realists of the 1930s were another precedent for creating antiwar work featuring such alarming visual horrors. Paintings and prints by Philip Evergood, George Biddle, Ben Shahn, Rockwell Kent, William Gropper, Philip Guston, Edward Hagedorn, and Thomas Hart Benton, for example, protested the injustices of the Spanish Civil War and the Second World War through the depiction of suffering or dead civilians in countries sympathetic to the U.S. agenda.

During the Vietnam War, the subjects of images of direct evidence were most often Vietnamese noncombatant women and children who had been the victims of American attacks. Usually these images were directly appropriated with little alteration from the mass media's photographic or televised coverage of the war. While the reason for their depiction may seem obvious, it is important to state that during the Vietnam War, women and children, especially South Vietnamese children, were recognized by the liberal American public to be innocents caught up in the conflict and thus victims of war.

During Angry Arts Week, Peter Schumann's Bread and Puppet Theater also performed; the theater's puppets and masks were often present during political protests between 1964 and 1967. Their performance featured a physician lecturing to medical students about napalm burns and the treatment of them, while in back of him a puppet representing a Vietnamese citizen extended a giant hand to the audience, asking for treatment for the napalm victims in a "fumbling gesture of the helplessness of the victims of war." Napalm was an incendiary jelly invented during World War II and used in the Vietnam War from 1966 onward, dropped from planes in bombs to defoliate wide swaths of North Vietnamese jungles that the Vietcong used to conceal themselves. Almost immediately after its initial use, napalm was a lightning rod for the antiwar movement, and soon after, a subject of antiwar artworks when it became known that napalm was horrifically burning Vietnamese soldiers and civilians as often as the foliage for which it was intended.[18] After the initial discussion of napalm burn treatments, Schumann's performance launched into a torrent of information about the war: facts about rape, images of napalm

victims, scenes from a Vietnamese wedding, and tapes of bombings. At the end of the evening, because the performance went quite late, the crowd and the cast traveled up to Lincoln Center dressed in a kind of theatrical Vietnamese garb—which included hats with words written on them like "Peace" and "Vietnam"—and descended on affluent theatergoers on their way home from performances.[19]

A mobile part of the Week was the "Caravan of the Angry Arts," a flatbed truck performance space that carried an ongoing rotation of poets and actors, singers, artists, and films to fifteen locations in Manhattan, from Greenwich Village to Harlem. The truck was originally decorated with a sign designed by Alan D'Arcangelo depicting Lyndon Johnson as a dragon and Lady Bird Johnson riding him. D'Arcangelo's work was accidentally destroyed, however, and replaced by enlargements of the same photographs of napalm victims published in *Ramparts* that had profoundly affected Martin Luther King. The Caravan also distributed twelve thousand leaflets to the public, which were designed by Rudolf Baranik (fig. 22). On the outside was an image of a napalmed child and the caption "For this you've been born?"—which was the title of an image in Goya's *Disasters of War*—and inside were poems.[20] The Caravan drew large crowds and made it all the way to 124th Street and Lenox Avenue, at which point the police stopped the participants, telling them they could not continue unless they had an American flag as part of their Caravan.

Other notable contributions to Angry Arts Week were Werner Bischoff's installation of photographs titled *Life in Vietnam*; a "war toy" exhibit; a conductor-less concert at Town Hall—"to symbolize the individual's responsibility for the brutality in Vietnam"—and a "Contemplation Room," which featured more than two hundred color slides of everyday life in Vietnam combined with WBAI radio reports on the war by Dale Minor. (WBAI was a significant force in 1960s and 1970s New York counterculture.)[21] Yet as one can glean from the original call for participation, the *Collage of Indignation* was Angry Arts Week's central focus (fig. 23). Completed in just a few days before the Week's opening, in its finished form the *Collage* was a massive 10 × 120 ft. installation of wall-like panels (each 10 × 6 ft.) that featured paintings, drawings, and prints, all of which functioned like a scrapbook of protest. Though its various contributors represented a number of artistic schools of the period, the *Collage*'s components were most often angry tirades of words stylistically derived from graffiti, political posters, and cartoons, akin to those works made by the *Peace Tower*'s "artist–citizens." Examples of note were Jack Sonnenberg writing into one of his abstractions; Mark di Suvero burning words into a rusty piece of metal; Petlin's "unflattering image of LBJ" captioned with

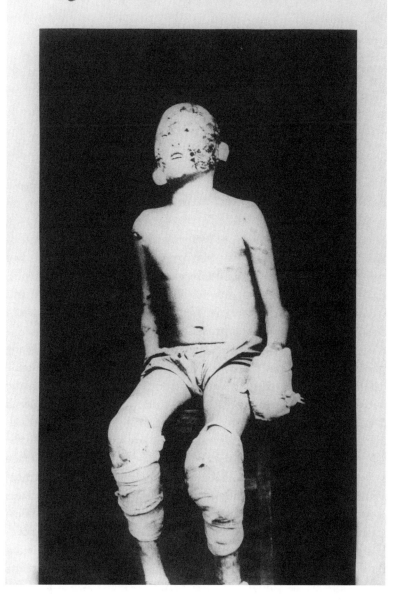

22. Rudolf Baranik, *Angry Arts*, 1967. International Center of Photography, gift of the Artists' Poster Committee with funds provided by the ICP Acquisitions Committee, 2002 (881.2002). Courtesy ICP and the Estate of Rudolf Baranik.

23.
Photograph of a
portion of Angry Arts
Week in New York's
Collage of Indignation,
1967. © E. Tulchin.

"Johnson is a murderer—In Memory of Women and Children Killed by Bombs in Vietnam"; May Stevens's scrawled "Morrison Shall Never Die" (referring to Norman Morrison, who immolated himself in 1965 to protest the war); and Nancy Graves and the activist group Black Mask writing "HUMP WAR" and "REVOLUTION," respectively.[22] Other artists, like Jacob Lawrence, just wrote their names. Fraser Dougherty submitted his draft card.[23]

While at NYU, the *Collage* attracted roughly ten thousand people.[24] Many of the organizers, like Baranik, saw the *Collage* as a landmark effort, the noble public rebirth of political activism in New York, dormant since the 1930s, and a visual success. Regardless, the *Collage* did not impress the media. As with the *People's Flag Show* three years later, it was criticized principally for its prioritization of instinctive, angry scrawl and for its low level of creativity. In the *New Yorker*, Harold Rosenberg said the *Collage* looked as if it had been made according to "craft standards."[25] In *The Nation*, Kozloff penned one of the most peculiar critical reviews—peculiar since he was one of the *Collage* organizers and also contributed to the show (with a splatter of red paint). Kozloff called the *Collage* a "wailing wall, alienated and homeless in style, embattled in content," and argued that instead of arousing protest, in its identity as individualistic, emotional relief, the work was most effective only in creating distaste for the work of the artists who participated.[26] After being shown at NYU, the collage was installed at Columbia University. After that it was burned instead

of stored. This decision was made by central organizers to ensure that the work was never sold or institutionalized. In their mind, it was designed to be a specific intervention that was not intended to last or be co-opted by the forces it was protesting, such as museums and the government.

Though not considered art at the time, at least by New York art world standards, Abbie Hoffman's October 21, 1967, *Exorcism of the Pentagon* should be considered one of the significant collective aesthetic antiwar protests of the period, especially if one understands its origin in the form of Happenings and also compares it to similar Dada performances or the contemporary works of Joseph Beuys (such as his famously ironic suggestion to the West German authorities that they raise the Berlin Wall five centimeters to give it better proportions).[27] Hoffman's *Exorcism* was truly an attempted exorcism of the Pentagon. Twelve hundred people (in Hoffman's words, "sorcerers, swamis, priests, warlocks, rabbis, gurus, witches, alchemists, speed freaks and other holy men") invoked gods, sang, and chanted, most often "Out Demons Out," in the massive parking lot of the home of the U.S. Department of Defense.[28] According to Hoffman, the power of such an action would raise the Pentagon three hundred feet, turn it orange, and make it vibrate until (as Norman Mailer explained in his *Armies of the Night*) "all evil emissions had fled. . . . At that point the war in Vietnam would end."[29]

Unfortunately, the Pentagon did not rise. Nonetheless, Hoffman's attempt added—at least for some—a welcome carnival atmosphere to a quite sober, much larger protest of seventy thousand people of which his exorcism was considered a part. This protest, the Spring Mobilization to End the War in Vietnam, had been organized by the Mobilization Committee to End the War in Vietnam, a loose coalition of 150 different groups. After a series of speeches on the National Mall, the protest aimed to shut down regular Pentagon operations by blocking access to the building and surrounding it with antiwar demonstrators. Protests that day (along with events in Chicago the next year) signaled for many in the antiwar movement a significant change, from mostly passive protests against the war to a focus on civil disobedience and active resistance.[30]

While Angry Arts Week was the major accomplishment of antiwar protest during 1967, nonaesthetic endeavors continued, as did the creation of individual works. Angry Arts, for example, authored a petition asking Picasso to remove *Guernica* from MoMA as a means of protesting the continued U.S. pursuance of the war. Organized by Golub, Petlin, Kozloff, Michaelson, William Copley, and Walter de Maria, the petition read as follows: "We the undersigned American Artists urge you to withdraw your painting *Guernica*

from the Museum of Modern Art in New York, as an act of protest against the United States bombing in Viet Nam. Thousands of Vietnamese villagers are undergoing the same kind of bombing that the citizens of Guernica suffered. Please let the spirit of your painting be reasserted and its message once again felt, by withdrawing your painting from the United States for the duration of the war."[31] The petition was circulated "quietly, out of respect for Picasso," according to Petlin; signed, Petlin said, by basically "every single artist in New York"; and then brought to Europe by him, where it was given to the surrealist writer Michel Leiris, a friend of Picasso's, to pass along to him.[32] Yet various people attempted to stop the petition from reaching Picasso. In New York, for example, Alfred H. Barr Jr., the recently retired founding director of the Museum of Modern Art, was alerted to the petition's existence and wrote to Picasso expressing his opposition. According to Petlin, when the petition reached Europe it was also "sabotaged [there] by all of Picasso's closest associates. They didn't want him to do [it] because [they believed] it would ruin the American market for his paintings." As a result, it is conceivable that Picasso never saw the petition, and in fact he never responded.[33]

Critiquing the attitude of Americans on the home front, and especially their complacency and apathy regarding the Vietnam War, was another discernible strategy of antiwar art. The greatest demonstration of this was Martha Rosler's series of collages *Bringing the War Home: House Beautiful*, which she began in 1967 and continued to work on until approximately 1972 (figs. 24–26). Rosler's works reacted to what she has called the dangerous, dualistic separation between "the here and the elsewhere," by trying (in some, but importantly, not all, collages of the series) to bring the war home to the American public.[34] Before progressing further, it should be noted that Rosler made these works as agitprop, and as a result she did not think of them as having formal titles or constituting a proper series. She has said that she only would loosely refer to them as having certain titles and that the art world's interest in them has progressively insisted on them having titles and dates—though she says the dates are somewhat imaginary since she refused to sign or date the works.

"Bring the war home" was a popular slogan in the antiwar movement, though it had acquired a double entendre by the late 1960s. While on one hand it suggested that the United States downscale the war, more than this it insinuated that because of the mismanagement of a war that lacked a clear reason for being, a war of protest must be waged at home to stop it. Specific events of 1965–1966 catalyzed Rosler's antiwar engagement and production of her series. She remembers lying in bed and registering shock when

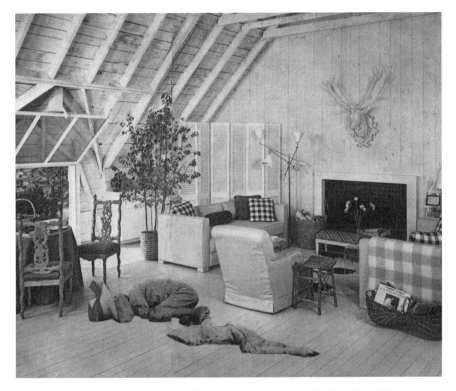

24. Martha Rosler, *Roadside Ambush*, from the series *Bringing the War Home: House Beautiful*, 1967–1972. Photomontage. © Martha Rosler.

Westmoreland asked for an escalation of half a million men.[35] She also has a vivid memory of sitting in her mother's house one day reading the newspaper and seeing a (now iconic) picture of an agonized-looking Vietnamese woman swimming in a river with her baby. She remembers thinking to herself, "We're doing this to people. To peasants. We're bombing them! This is insane. I can't stand it!" She commented later that "that image made me want to make images . . . [and it has] stuck in my brain . . . even forty-odd years later."[36]

Primarily inspired by Jess and Max Ernst, and looking back to the more political work of Hannah Hoch and John Heartfield (though Hoch and Heartfield were virtually unknown to Rosler when she began working on the series), Rosler's collages brought the war home pictorially through the insertion of often-familiar, dark, and dirty war photographs of combat zones in the Mekong Delta and Khe Sanh, into plush and pristine American domestic scenes. Many of the domestic scenes were clipped from 1950s and 1960s magazines like *Life* and *Architectural Digest* and from architectural prints that Rosler picked

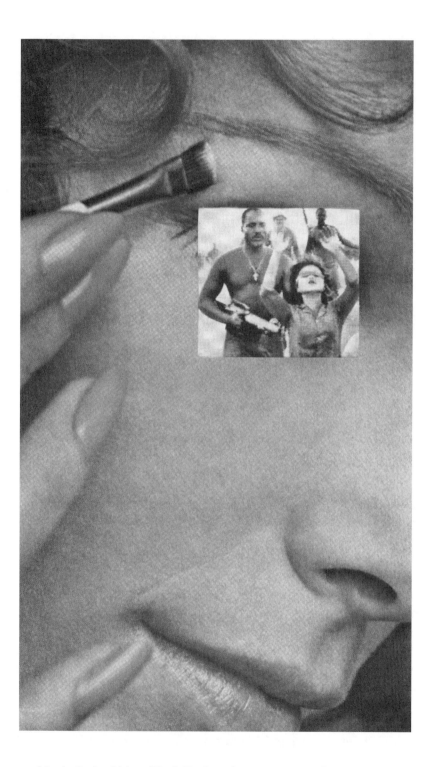

25. Martha Rosler, *Makeup/Hands Up*, from the series *Bringing the War Home: House Beautiful*, 1967–1972. Photomontage. © Martha Rosler.

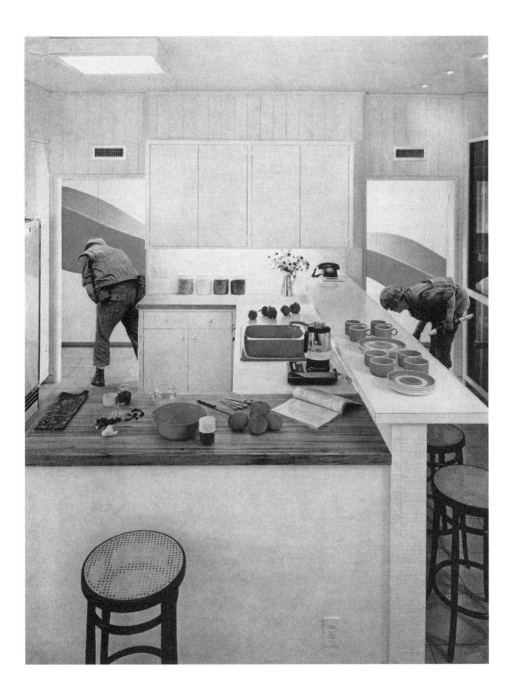

26. Martha Rosler, *Red Stripe Kitchen*, from the series *Bringing the War Home: House Beautiful*, 1967–1972. Photomontage. © Martha Rosler.

up at used bookstores on Fourth Avenue in New York. Rosler chose 1950s images of homes, and more often, of women, shown in advertising because, she recently stated, she saw them as "deeply formative for the postwar US mythos of home, family, and domesticity as a 'haven in a heartless world.'"[37]

Contrary to Homi K. Bhabha's belief that Rosler's collages clearly define an "inside and an outside," or the domestic environment versus the war front (separated by curtains and plate glass windows), Rosler's collages do not always maintain a dualistic division.[38] In actuality, the war images are inserted within and without the domestic environment. As such, Rosler does not only bring the war home so that it can be seen as only outside the home's boundaries but brings it into the home as well.[39] This can best be observed in *Red Stripe Kitchen*, the most well-known work in the series (arguably because a C-print of it is owned by both the Metropolitan Museum of Art and the Solomon R. Guggenheim Museum). The work features two soldiers who seem like they are looking for something (but who are probably planting mortars) in a streamlined, white kitchen, dotted with red bowls and a red sink, and framed in the rear by an Ellsworth Kelly–esque, "red stripe" of a painting (or a wall design). Rosler's *Roadside Ambush* also incorporates Vietnam into its domestic environment. In this work, a Vietnamese mother and child curl up on the ground in the serene whitewashed living room of an American "country house." Notably, Rosler's series includes images that do not feature any kind of domestic interior at all, such as *Makeup/Hands Up*, a close-up of a woman applying eye shadow whose eye has been covered up (blinded) by a square black-and-white photograph. The photograph features a blindfolded woman prisoner held at gunpoint by a shirtless black American soldier.

While C-prints of Rosler's collages are now framed behind glass at the Met and the Guggenheim among other institutions—suggesting they are limited in number—and the collages themselves were unique, Rosler created the collages to be reproduced and disseminated as widely as possible. At the time she made them, she regularly photocopied the collages in black and white and distributed them at antiwar protests in New York and San Diego. The collages also found their way into underground newspapers, reprinted as illustrations for antiwar articles, or published independently as works of art. One newspaper that reproduced Rosler's work was the feminist journal published in San Diego, *Goodbye to All That!*[40] Underground press outlets were rising sharply in prominence at this time, in response to Americans' mounting frustration with mainstream news outlets and the increasing possibility of alternative media. Readership of these outlets, according to contemporary reports by the *Wall Street Journal* and *Newsweek*, increased the most between 1968 and 1969.[41]

At the time, in the United States, the label "underground press" referred to at least five hundred underground newspapers, and another five hundred to one thousand dissident high school papers. Three of the earliest and eventually most prominent underground newspapers were New York City's *East Village Other*, the *Berkeley Barb* out of California and the *Los Angeles Free Press*, which included early coverage of APC's actions. There were also close to three hundred GI newspapers available to soldiers, many of them put out by active-duty troops on military bases and warships around the globe. The popularity of the medium led to American military veterans' creation of the GI Press Service, serving as the AP of the GI movement.[42] The underground press's coverage of the Tet Offensive in 1968 was its defining moment. The coverage entirely contradicted the narrative proposed by the mass media and was mostly ignored at first. Yet when it was discovered that the "underground" version of the conflict was correct, the mainstream media adopted this perspective and even attempted in its future reporting to use the methods and character of the underground press, namely, the challenging, investigative reporting.[43]

Another artist who made collages during the war, many strikingly similar to those of Rosler's, was Violet Ray, the pseudonym of a virtually unknown male artist who lived in New York (figs. 27 and 28).[44] Ray's collages differed from Rosler's, however, in that they focused more on juxtaposing images from the war front with those from American advertising. One example was his *Spell of Chanel*, which features the actress Ali McGraw posing nude in a bath with her back turned (in an ad for Chanel). Inserted into the image—so that the water from one subtly mixes with that of the other—is a picture of a Vietnamese woman with a baby and two older children struggling to wade through the river (they were doing so to avoid American bombs).[45]

More so than in Rosler's works, Ray's jarringly combine the sheer luxury of Western life (or the luxuries many Westerners at that time aspired to have) and the sheer horror and anxiety of the Vietnamese people. Another work from Ray's series is *Revlon Oh-Baby Face*, which conflates a Revlon ad featuring a young baby-faced model (and copy that reads "Revlon adopts the *oh-baby face*") with a Vietnamese girl whose face has been injured in the war. Her left eye is covered with a large gauze pad and there is a dark scar under her right eye. She also holds her hand behind her back and stares blankly to the edge of the image, enforcing her difference from the Revlon lady.

While their works have quite a lot in common, there are some incisive distinctions one can make between Ray and Rosler. Ray's works are much closer to the advertisements themselves, and much more confrontational. Ray's collages are also unmistakably more graphic than Rosler's. While these

Revlon adopts
the oh-<u>baby</u> face.

Moon Drops 'Blushing Silk'

Without another blessed thing on your skin but this <u>not-quite-makeup</u> makeup (a miracle merger of moisture-and-color), you'll look so rosied and rested and fresh-faced and young—it's like stealing beauty secrets from a baby!

27. Violet Ray, *Revlon Oh-Baby Face*, 1967. Ad collage. 13 ½ × 10 ¼ in. Courtesy Violet Ray.

28. Violet Ray, *The Spell of Chanel*, 1967. Ad collage. 13 ⅛ × 10 ¼ in. Courtesy Violet Ray.

qualities might make Ray's collages less nuanced and less applicable for an art audience, Ray's slickness, proximity to the strategies of advertisements, and graphic punch allow the work to affect a viewer who might be impatient with Rosler's more Brechtian approach.

Ray's collages, like Rosler's, were distributed at antiwar marches and rallies. According to Ray, he handed out thousands of three of his collages (*Chanel*, *Revlon*, and *Fresh Spray Deodorant*) during the Spring Mobilization march in New York City. Ray's collages also appeared in the French antiwar film *Far from Vietnam* (an indictment of the American war effort by six film directors, including Jean-Luc Godard and Alain Resnais), as well as in slideshows and newspapers, such as the *Aspen Times*. The *Times* ran Ray's collages for twenty straight weeks between July 9 and November 16, 1967, on its editorial page under the heading "Great Advertising Art." Three Ray collages (*Chanel*, *Fresh Spray Deodorant*, and *Chiquita Banana*) also figured prominently in the *Rat* underground newspaper.

Like many others in the 1960s, Ray eventually became disillusioned with the state of movement politics. An undated pamphlet he anonymously copublished from the era titled *The Anti-Mass* was critical of mass organizing and outlined ideas for the formation of collectives dedicated to local issues. But a section of the pamphlet (inspired by Situationist and feminist theory), titled "The Need for New Formats," promoted the use of advertising techniques, which Ray had used in his work. It called advertising a "revolutionary mode of production," whose rejection stagnated many radical political messages and kept ignorant those who romanticize political culture and the print medium.[46]

The depiction or suggestion of rape in American artists' paintings and performance works was one of their most provocative antiwar strategies. Even though the Geneva Convention prohibited rape and the mutilation of women's bodies in wartime, as disillusionment set in among soldiers during the Vietnam War and as in almost all historical wars, rape was often considered standard operating procedure.[47] Reports began surfacing about American soldiers raping civilians in Vietnam around August 1966, when the *New York Times* reported the conviction of five GIs for the rape of a pregnant mother of six. The following month the paper carried the story of a soldier who raped a thirteen-year-old prisoner of war. By the end of 1967, a soldier explained that rape was "an everyday affair. . . . You can nail just about everybody on that—at least once." Another soldier reported that during 1967, he was not by any means an anomaly for witnessing at least ten to fifteen rapes.[48] American soldiers were rarely punished for rape. Of the eighty-six who were actually tried between 1965 and 1973, only fifty of them (58 percent) were convicted,

and sentences were relatively light.[49] The prevalence of rape in Vietnam was blamed on the U.S. military's acceptance of it as an inevitable consequence of wartime activity.[50] Soldiers needed sex, the rationale went; they needed to kill or harm the enemy, and they were bored. Not to be dismissed was an American home front that—especially after 1966—discussed and produced images of violent rape and sexual deviancy on a massive scale.[51]

In addition to bearing witness to American soldiers' raping of Vietnamese women, the image of rape could symbolize the ruin of the country of Vietnam by the often-inhuman (or all-too-human) American military. Both meanings can be seen in Peter Saul's "errant breed of Pop" paintings concerning the war, such as his 1967 *Saigon* (fig. 29).[52] *Saigon* employed satire and hyperbole in depicting—as the painting explains on its surface—"WHITE BOYS TORTURING AND RAPING THE PEOPLES OF SAIGON."[53] As part of this text, however, we are forewarned that we are viewing the "HIGH CLASS VERSION." This suggests that the real situation in Vietnam was—or that Saul himself may be capable of—much worse.[54]

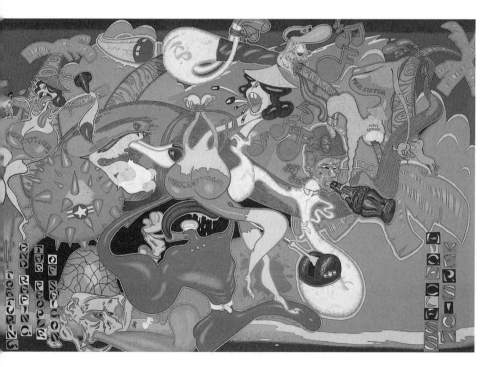

29. Peter Saul, *Saigon*, 1967. Enamel, oil, and synthetic polymer on canvas. 92 ¾ × 142 in. (235.6 × 360.7 cm). Whitney Museum of American Art; purchased with funds from the Friends of the Whitney Museum of American Art 69.103. Photograph by Sheldon C. Collins.

In *Saigon*, Saul's distorted, cartoony "white boys"—identified through their helmets, green berets, titles, stars and stripes, or what they imbibe (soft drinks in bottles)—perform their sexual misdeeds with satirically gymnastic diversity.[55] In a Day-Glo or Technicolor Pacific Eden, which the art historian and critic Alfred Frankenstein wrote was as "uncomfortable in its contrasts as the point of a bayonet," the central rape is of the *Playboy*-fantasy "Innocent Virgin" (this name is written across her voluminous chest) by what appears to be an elongated, Q-tip-like gun.[56] Another large blue admiral or policeman—headless except for a large tongue—also rapes her and binds her hands. (He uses his hand both for the sexual act and to bind her.) The Innocent Virgin's bound pose is reminiscent of a crucifixion scene. A further soldier at the top of the image acts out some horrific entertainment for his fellow soldiers. He has been impaled on a tree and he bears the label "K.P.," which stood for kitchen patrol, a duty usually assigned as punishment to soldiers. Moreover, the tree to which the soldier is bound is used to sodomize the Innocent Virgin's father (his name is written on his chest, too). While being sodomized, he still manages to serve another soldier a bottle of Coca-Cola.

Saul's troops sexually assault with their eyes and mouths as well. One of them, toward the bottom of the painting, extends a tongue—which could be a penis or the heavy flow of ejaculate—to lick the behind of the blue admiral, and a baby's eyes at the center of the picture bulge heavily out from their sockets and seemingly stick to the Innocent Virgin's chest.[57] Further, Saul's soldiers not only abuse others but also are physically abused themselves. They look diseased: their faces are pasty and covered with multicolored lesions. Whether they acquired such diseases from sex, their own psychological dysfunction, or from the greater sickness of the war, however, is left ambiguous.

Though the graphic rape representations in *Saigon* distract from the formal composition of the work, it was a significant aspect of the painting for Saul and it was rooted in art history. Saul has cited the work of Thomas Hart Benton, Salvador Dali, José Clemente Orozco, and Jacques-Louis David as influences. Yet the principal art-historical reference point for *Saigon* was *Guernica*, which Saul had known since he was a child (and which he used as a departure point for two other paintings, *Saul's "Guernica"* and *Liddul "Guernica,"* both from 1973).[58] As David McCarthy has observed, *Saigon* echoes, alludes to, and transforms certain aspects of *Guernica*. There is a tripartite organization in both paintings. Picasso's use of grisaille to "evoke newspaper reports and political cartoons" is similar to Saul's use of the "lurid coloring of cartoons and comics and the Technicolor of Hollywood" because it evoked the 1960s mass cultural equivalents of the newspaper: television and movies.[59] *Guernica*,

according to McCarthy, also gave Saul license for the illustration of "gruesome antiwar sentiment." The Innocent Virgin with her mouth open at the center of the image recalls the screaming horse in *Guernica* (which signified the people of Guernica and of Spain, according to Picasso).[60] Further, Saul's blue figure is akin to Picasso's bull, symbolizing the "forces of brutality and darkness" or "unrestrained, instinctual desire."

Despite all these references, however, McCarthy insists that the paintings' larger strategies are different. *Guernica*, he maintains, was meant to "elicit mourning and anger," while *Saigon* "use[d] shock to counter complacency."[61] Like Spero and Bernstein, Saul also used his paintings to shed light on a very dark side of the American (and human) psyche, "the frenzy of sadistic pleasure linking sexual aggression and murder." The contrast, in 1967, between the various schema within *Saigon* and Saul's surroundings in San Francisco— he lived in Mill Valley, north of the city—was severe. While Saul had counterparts in the Bay Area work of underground comix, such as R. Crumb (whose work Saul greatly admired), he was definitely in the minority as a painter. McCarthy explains, "To [create *Saigon*] . . . during the so-called Summer of Love, playing out just a few miles south of his studio, was to dismiss an entire ethos, perhaps best captured in the slogan 'Make Love, Not War,' as a woefully inadequate means of protest."[62]

In the years of the war following his completion of *Saigon*, Saul created works that similarly foregrounded rape and murder. Take, for example, his *Typical Saigon* of 1968 (fig. 30). At the center of the painting, a jelly-bean-eyed blue monster–soldier (who has only half a body) orally fondles a Vietnamese woman as she is raped. He bites her breast and licks her leg as what looks like a laser-beam bazooka penetrates and bloodies her. The same scene is visually echoed at the left-hand side of the image, where what can best be described as a baby–soldier, whose body is a swollen bubblegum pink, penetrates—with a kind of laser beam—a purposefully stereotypical "Asian" woman.

Discussions of Saul's Vietnam engagement frequently overlook works included in his 1966 exhibition of *Vietnam Drawings* at the Allan Frumkin Gallery. These drawings are significant because they foreshadowed themes Saul would later take up more substantially in *Saigon* and *Typical Saigon*. *Rich Guy* of 1966, for example, refers to the issue of rape in a speech bubble, explaining, "BUTTON YOUR PANTS WHITE GUYS YELLOW GAL IS SMART."[63] In contrast to Saul's later works, however, *Rich Guy* presents a less-victimized image of Vietnam. While Vietnam is personified the same way she would in later years, as a buck-toothed, large-breasted "yellow" woman wearing a patched-up cocktail dress, she determinedly fights U.S. planes in the name of "poor people" (which

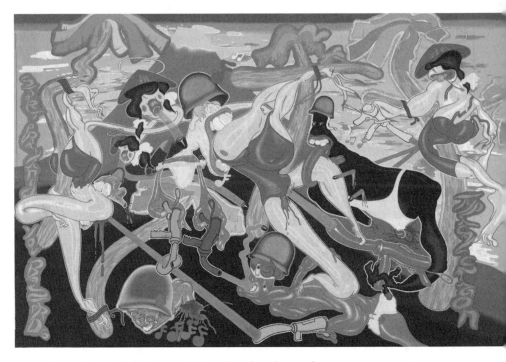

30. Peter Saul, *Typical Saigon*, 1968. Acrylic, oil, and enamel on canvas. 93 × 144 in. Krannert Art Museum and Kinkead Pavilion, University of Illinois at Urbana–Champaign. © Peter Saul.

is literally written into the painting).[64] Lest we are unsure, this lady Vietnam is a communist: a hammer adorns one breast and a sickle the other. Saul presents a less-victimized image of Vietnam because less was known about the conflict, especially all the horrific particulars that would populate Saul's later Vietnam paintings.

Compared with the majority of artists creating antiwar work, Saul's paintings had great potential to affect people's perspectives on the war because they were nationally exhibited. Between 1967 and 1970, *Saigon* was shown at the San Francisco Art Institute, Reed College, and in the exhibitions *Violence in American Art* at the Museum of Contemporary Art in Chicago and *Human Concern/Personal Torment: The Grotesque in American Art*, which was organized by Robert Doty at the Whitney Museum of American Art (and which traveled to the University Art Museum at the University of California, Berkeley). Also, during and after the May 1970 "New York Art Strike Against Racism, War, and Repression," *Saigon* was hung in the Whitney's ground-floor lobby alongside an antiwar petition signed by the staff.

On the whole, art professionals and institutions sympathetic to the anti-war movement accepted Saul's works as antiwar.[65] In interviews, Saul also said that he was not "putting people on," that he categorized his works as "social protest," and that he viewed *Saigon* as a "serious charge against the American soldiers actually present in Vietnam." In a Whitney questionnaire about his work (which was sent to him after the museum bought his painting), Saul even wrote that if the museum had not bought the painting from him, he would have "sent it as a gift to the North Vietnamese Govt."[66]

Nevertheless, Saul was—and should be considered—a more complicated artist in relation to the antiwar movement. He has always left open the issue of whether he condoned his depictions of sexual perversity and whether his racist depictions of Asians were supposed to represent the point of view of himself or American soldiers (and a portion of the American populace). This silence and its resultant provocation was motivated in part by Saul's affinity for against-the-grain ideas, which focused on and pronounced art-making that both the "liberal" and the "avant-garde" art audience didn't want to see. In a recent interview, Saul said that his attitude was (and has been) rooted in his reaction to his consistent dismissal and lack of acceptance by the American avant-garde art world. Accordingly, Saul has said, "Then [and now] there was a tremendous need to not be seen as a racist, not seen as a sexist. So I wanted to make sure I [was] seen as those things."[67] He also intentionally made the text included in the painting sound "completely arrogant and completely the opposite of [the language of] *Artforum*," a magazine he despised for its formalist agenda and the power it held over his critical reception.[68]

In 1967, besides Peter Schumann's Bread and Puppet Theater, other artists began creating works that focused on the subject of napalm to foreground the inhumanity of the American war effort. These works most often featured napalm victims, characteristically women and children, depicted through either photographic or photographically rooted direct evidence. Of the various posters featuring photographs of napalm victims, one of the most influential was Jeff Schlanger's *Would You Burn A Child?* (fig. 31). Schlanger's poster includes the title text accompanied by two images, one on top of the other. The top image, above the question "Would you burn a child?" features a man's extended (dress-suit-adorned) arm holding a lit Zippo lighter under a child's hand. (Zippo lighters had been standard military issue since World War II.) The bottom image—below the words "When necessary"—shows a Vietnamese woman sitting on the ground holding a baby who has been badly burned. Schlanger's poster gained wide recognition. Grace Paley's short story "Faith in a Tree," published in the *New American Review* in 1967 (and later in Paley's

important 1974 collection of short stories, *Enormous Changes at the Last Minute*) includes a discussion of a poster almost identical to it. The story recounts how Faith (Paley's alter ego) turned to political activism after seeing what was probably a version of Schlanger's work in an antiwar protest in New York's Washington Square Park. Paley writes:

> A short parade appeared—four or five grownups . . . pushing little go-carts with babies in them, a couple of three-year-olds hanging on. . . . The grownups carried three posters. The first showed a prime-living, prime-earning, well-dressed man about thirty-five years old next to a small girl. A question was asked: would you burn a child? In the next poster he placed a burning cigarette on the child's arm. The cool answer was given: WHEN NECESSARY. The third poster carried no words, only a napalmed Vietnamese baby, seared, scarred, with twisted hands.
>
> We were very quiet. Kitty put her head down into the dark skirt of her lap. I trembled. I said, Oh!

As Joyce Carol Oates has explained, in Paley's story the poster injects the "ugly, stirring, in personal terms cataclysmic," realities of the war into "Faith's droll, child-centered world of small neighborhood adventures. . . . [This was the] 'before' and 'after' in Faith's life, as in Paley's short fiction."[69]

Napalm was the title of a series of paintings Leon Golub created in 1969 (figs. 32–34). In addition to Golub's central involvement in nonaesthetic antiwar activities, his paintings became some of the most important statements of postwar American politically engaged art. Golub began painting in the late 1940s and early 1950s in a style that stood in contrast to abstract expressionism, the dominant movement in American art at the time, for he believed it was bad for art and artists. For him, the movement's abstract, formalist conception of meaning dismissed the world, history, and humanity itself. Instead, Golub aligned himself with figurative painters of the European avant-garde, especially Jean Dubuffet and his *art brut*–inspired canvases. Like Dubuffet, Golub sought to paint figurative pictures about the world's horrors directly and bluntly. He also started laboriously scraping down the surfaces of his paintings using a meat cleaver, a technique that eroded and scarred the figures and scenes he presented and helped intensify his scenes of violence.[70] This recalled the precedent provided by Christian imagery of saints and martyrs whose breasts were cut off and skin was peeled in paintings of great formal and expressive beauty. Golub's allegiance to the world and its darker forces (like his European counterparts) also stemmed from an engagement with existentialist thought.[71]

WOULD YOU BURN A CHILD?

WHEN NECESSARY.

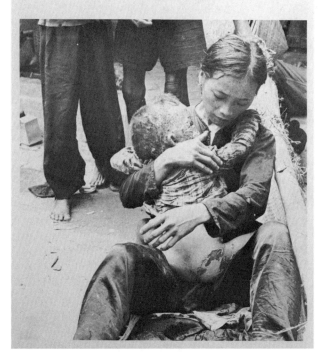

31.
Jeff Schlanger and Artists'
Poster Committee, *Would
You Burn A Child?* circa
1968. Offset lithography
poster. 54 × 21.6 cm (21¼
× 8 ½ in.). Courtesy of the
Center for the Study
of Political Graphics.

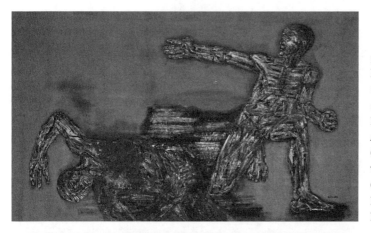

32.

Leon Golub, *Napalm I*, 1969. Acrylic on linen. 116 × 198 in. Photo: Hermann Feldhaus. Art © Estate of Leon Golub/Licensed by VAGA, New York. Courtesy Ronald Feldman Fine Arts, New York.

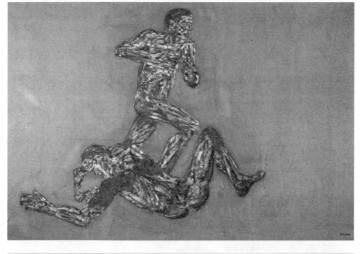

33.

Leon Golub, *Napalm II*, 1969. Acrylic on linen. 114 × 168 in. Art © Estate of Leon Golub/Licensed by VAGA, New York. Courtesy Ronald Feldman Fine Arts, New York.

34.

Leon Golub, *Napalm III*, 1969. Acrylic on linen. 111 × 156 in. Art © Estate of Leon Golub/Licensed by VAGA, New York. Courtesy Ronald Feldman Fine Arts, New York.

Golub's place in the 1950s American art world was initially promising. By 1954, he had gained significant attention for his work. He represented an influential style. He was part of Alan Frumkin's "Monster Roster" in Chicago. (Other artists in the "roster" were George Cohen and Cosmo Campoli.)[72] At one point Golub was even discussed as an American Dubuffet. Yet by the late 1950s, as formalism's dominance solidified in the United States, Golub began to fall out of favor. MoMA's 1959 *New Images of Man*, curated by Peter Selz, initiated Golub's descent. The exhibition, which included five works by Golub and works by other figurative artists, such as Francis Bacon, Richard Diebenkorn, Dubuffet, Alberto Giacometti, and Willem de Kooning, tried to define the next big movement in the United States following abstract expressionism. However, the exhibition was widely derided by an American art public wedded to abstraction's centrality. Future MoMA curator William Rubin wrote the most scathing review of the show in *Art International*, one of the leading art magazines of the period. Rubin's review condemned Golub's work in particular: "The works on view constitute as disparate and uninteresting a group as has ever been assembled for a major museum show. . . . [Golub] seems to interest a few people whose opinion I greatly respect, and it may be that I'm blind to Mr. Golub's virtues, [yet] I must say that I've seen very little outside the school studios that is so inflated, archaizing, phonily 'expressive,' badly painted, and generally 'pompier.' The only thing big about the result is its windiness."[73] As a result of Rubin's review and the greater unfriendliness in New York to figurative painting, Golub's career hopes plunged. During the 1960s he had no sales and felt marginalized, isolated, and irrelevant. He explained, "[The situation became] worse than being attacked [by Bill Rubin]. [I was known but] there was little interest among critics and viewing the work. The work I was doing had no connection to the current crucial issues in art. In this kind of situation, a painter like myself did not count."[74]

In the early 1960s Golub left the United States with Spero to live in Paris. When he returned he immediately became actively involved with AWP and the antiwar movement, and began to create large-scale scenes of violence based on ancient imagery (Assyrian, Hittite, Aztec, Etruscan, and Roman), including a major series of works called the *Gigantomachies*, which were symbolic battle scenes based on the Hellenistic Altar of Zeus from Pergamon, specifically a frieze depicting battling gods and giants.

In 1969, Golub shifted gears again and began his *Napalm* series, which for the first time tied his interest in scenes of violence with the war he was actively protesting. This decision was a deliberate one for Golub. He felt he could no longer be politically active against the war and paint scenes that condemned

violence but which focused only on historical subjects. He commented in an interview with David Levi-Strauss that, at the time, while he could not fault a "totally abstract artist who was against the war for separating his practice from his activism" (since he believed there wasn't room in entirely abstract art for political engagement), he could fault himself because he was "making figurative images dealing with violence and tension and stress, and there was violence and tension and stress right in front of [my] eyes and the two didn't connect."[75]

Like Schneemann's *Viet-Flakes*, Golub built his *Napalm* paintings on photographs he collected from books, papers, and magazines.[76] He would continue this practice until the end of his life, amassing a vast archive of photographic sources for his works. Golub did not have any qualms about this practice, for he believed photography was an unavoidable aspect of modern seeing. He explained, "Photographic imagery is everywhere. [The images I use] we don't have to take . . . in: They permeate. They enter our perceptual systems in such a way that they form—the way I think of it—a kind of residue. We store these images in that computer in our head. Even when we are looking at somebody or something we know, an actual person or an object of some kind, we see them through a filter of photographic information. What we feel, okay? Desire? This photographic stuff to a large measure determines it."[77] As opposed to Schneemann's works, though, the resulting images in Golub's paintings were never rooted in just one image. What's more, while the source photographs were primarily images of napalm victims, Golub used photographs unrelated to the war, such as those from sports magazines, to produce the figures he desired.

During the creation of the *Napalm* series, Golub also moved for the first time toward exhibiting his paintings as unstretched canvases attached to the wall with grommets, which made the work reminiscent of war or trophy banners. Further, he began to cut away sections of his canvases, which had grown to monumental proportions during the mid-1960s, leaving wide-open spaces that enforced the viciousness of his imagery and suggested "blown-apart documents," censorship by the powers that be, or the fact that the artist removed parts of the image he believed were unfit for public consumption.[78] Doing this in a monumental canvas, which placed the work in the realm of history (and thus a quite public form of painting), increased the significance of the deletions.

Though this has never been discussed—probably because the three works have rarely been grouped together—Golub's three numbered *Napalm* paintings appear to depict a narrative of a napalm attack on two men. *Napalm I* is

the moment of attack. A lone standing figure protests a shower of the flammable jelly, while another figure lies on the ground—already hit—with a large red hole burning in the center of his chest. *Napalm II* is the men's attempt to recover. The upright man now runs, and the man on the ground—although covered with red burns on his shoulder, back, and knee—tries to raise himself up. *Napalm III* testifies to napalm's final triumph over the men. Red pigment has now expanded over the surface of the image to cover both of their bodies, concentrating mostly on the torso and legs of the figure lying down. While all of Golub's *Napalm* series were paintings, he also created napalm images that were used in mass-produced posters and flyers. His contribution to the *Collage of Indignation* used photostat versions of figures similar to those in his *Napalm* paintings, in conjunction with the text "burnt man" printed across the bottom, to suggest a napalm victim.[79]

Because of their scarred surfaces and missing eyes and limbs, the sculptor Michele Oka Doner's *Death Masks* and *Tattooed Dolls* (produced between 1967 and 1968) were also seen during the war as napalm images (figs. 35 and 36). Specifically they were understood as direct depictions—or at least as inspired by depictions—of napalmed children. Because of this, the antiwar movement at the University of Michigan (where Oka Doner was an undergraduate student) appropriated *Death Masks* for its purposes. The work was reproduced in the student literary magazine *Generations* and served as a rallying point for student dissent. In this way, Oka Doner recently commented that they became poster children for the deformities caused by napalm.[80] Rarely mentioned is the fact that Oka Doner did not originally intend for this work to be associated with the war. While she accepted the napalm interpretation, in making the work she said she was not thinking of the war but was instead engaging with African ceremonial tattooing and decorative scarring. Oka Doner was exposed to this tradition by an exhibition of Igbo sculpture held in 1965–1966 at Michigan and curated by Frank Starkweather, a close friend of hers.[81]

Rudolf Baranik, like Golub, was involved in both nonaesthetic antiwar protest and making paintings that engaged with the war. Baranik's most significant paintings of the Vietnam War period were his *Napalm Elegies*, which he worked on between 1967 and 1974 (fig. 37). Baranik saw napalm as the primary "outcry-symbol, a signifier of the anguish [Americans] felt about the war."[82] The centerpiece of almost all the paintings in the series was an image of a badly burned child victim of napalm.[83] Isolated in various arrangements of gray and white on a black field, duplicated at times, and depicted in a range of intensities from the impressionistic to the nearly photographic (which testified to the source of the image from an actual news photograph, which Baranik

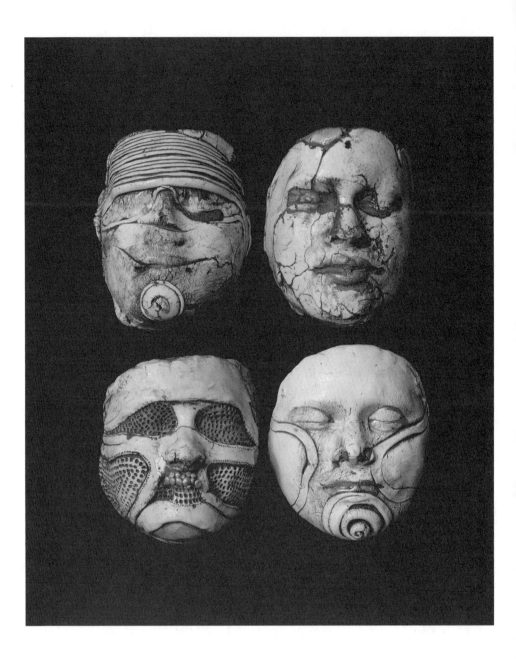

35. Michele Oka Doner, *Death Masks*, 1967. Ceramic, four pieces. 6 × 6 × 3 in. each.
Collection: Stephanie Freed, Miami Beach. Photo: D. James Dee.

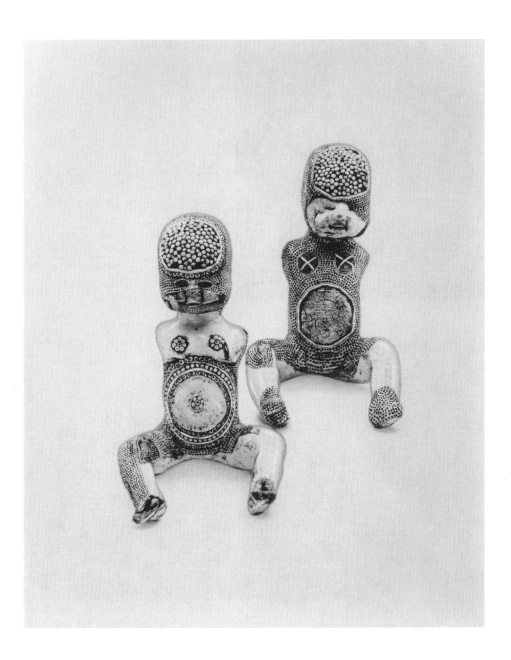

36. Michele Oka Doner, *Pair of Tattooed Dolls*, 1968. Glazed porcelain with iron oxide. 13 × 9 × 9 in. each. Collection Museum of Arts and Design, New York. Photo: Hugh Laing.

37.
Rudolf Baranik, *Napalm Elegy*, 1972.
Oil on canvas. 72 × 72 in. Courtesy
the Estate of Rudolf Baranik.

38. Antonio Frasconi, *Viet Nam!* 1967. Illustrated book with thirteen woodcuts and seven
relief halftones. Page: 21¹⁄₁₆ × 13¹⁵⁄₁₆ in. (53 × 35.4 cm); prints: various dimensions.
Publisher and printer: Antonio Frasconi, South Norwalk, CT. Edition: 5. Walter Bareiss
Fund and Gift of Leo Auerbach (by exchange). The Museum of Modern Art, New York.
Art © Antonio Frasconi/Licensed by VAGA New York. Digital Image © The Museum of
Modern Art, New York/Licensed by SCALA/Art Resource, New York.

used for posters), the burned boy functions like a recurring nightmare. The constant image of the burned boy recalls Schneemann's pulsing *Viet-Flakes*. In the same vein, Antonio Frasconi's 1967 *Viet Nam!* book of woodcuts (fig. 38) used red, black, and white repetitions of a U.S. bombing mission and close-up views of the wailing faces of women and children to generate a sort of flip-book of Vietnam-era horror and misery.

Baranik defined his painting practice as "social formalism." Inspired by *Elegies to the Spanish Republic* by Robert Motherwell (who was known for his active liberalism, but also for separating his politics from his art) as well as Picasso's *Guernica*, Baranik explained that social formalism was using political content in ways that kept the work grounded in explorations of painting as a medium. In pursuing this method, Baranik was one of the few artists of the period who actively sought to unite formalism with politics, an approach entirely antithetical to contemporary formalist dogma. Baranik commented in 1977, "I don't consider formalism my enemy, contrary to the way some expressionist or political artists view it. Formalism is much more than the Greenbergian version. . . . I see form as the very sensitive nerve-ends of content, as important at least as the general impulse which sent it on its way, and there is no art of validity which is not formalist."[84]

5

1968

JANUARY 31, 1968, marked the onset of the North Vietnamese Tet Offensive. So called because it began on Tet, the first day of the Vietnamese calendar and the most important Vietnamese holiday (usually a truce period), "Tet" was a huge series of coordinated attacks by the DRV and the NLF on U.S. and South Vietnamese forces, designed to bring the Americans to the bargaining table.[1] During the month of February, eighty-four thousand Vietcong soldiers stormed into more than one hundred cities and towns in the South, from the DMZ to the base of the Ca Mau peninsula. Saigon was a major target. VC took over its radio station, and nineteen commandos occupied the city's U.S. embassy—long a symbol of America's unshakeable place in Vietnam—for six and a half hours. The communists also beset the city of Hue in a meticulously planned attack targeting more than two hundred of the city's "cruel tyrants and reactionary elements," who they believed were sympathetic to the South Vietnamese regime.[2]

Another significant focus of the Vietcong during Tet was the U.S combat base at Khe Sanh, a plateau in northwestern Quang Tri Province. Used since 1964 as a springboard for air attacks against communist sanctuaries in Laos and to gather intelligence on the Ho Chi Minh trail, Khe Sanh was besieged by the VC between January 21 and April 8 with what the U.S. estimated was a force of forty thousand. Since the United States believed Khe Sanh to be one of its key strongholds in South Vietnam, it did everything in its power to hold the base. General Westmoreland positioned six thousand extra men on the base and put into effect the bombing mission Operation Niagara, which

involved dropping seventy-five thousand tons of explosives on the VC over six weeks—the largest amount of explosives that had ever dropped on a single target in the history of warfare.[3]

At the conclusion of the offensive, the communists lost roughly twenty times the number of men as their American counterparts and were forced out of nearly all the towns and cities they invaded. Nevertheless, their campaign was a significant (if not *the*) turning point in the Vietnam War for the United States. Tet emphasized to the Johnson administration that victory in Vietnam would require a much greater commitment of men and resources than the American public, which had been shocked by Tet, was willing to invest. Polls showed that Johnson's approval ratings were at a new low of 35 percent and that the majority of Americans believed the country had made a mistake committing combat troops to Vietnam.[4] Americans could not understand how their country had been so unprepared.[5] They were also taken aback by the VC's power, size, and resilience, as well as its presence in Vietnamese cities at a point when Americans had been repeatedly given optimistic forecasts by the U.S. government.

How news of Tet was transmitted to the American public was crucial to the domestic reaction. Before Tet, Americans were used to seeing the war in a particular way. In the words of Stanley Karnow:

> Americans at home had been accustomed to a familiar pattern of images. Columns of troops, disgorged from hovering helicopters, cut through dense jungles or plodded across muddy rice fields toward faraway villages, occasionally stumbling upon mines or booby traps, or drawing fire from hidden guerrillas. Artillery shelled distant targets from lonely bases, and aircraft bombed the vast countryside, billows of flame and smoke rising in their wake. The screen often portrayed human agony in scenes of the wounded and dying on both sides, and the ordeal of civilians trapped by the combat. But mostly it transmitted the grueling reality of the strug-gle—remote, repetitious, monotonous—punctuated periodically by moments of horror.[6]

By contrast, Tet occurred openly in the cities and American television crews were able to film the VC up close as they struggled and fought to the death with American soldiers.[7] Some of the most shocking photographs from the war were also taken during Tet. Eddie Adams's horrific photograph of the Saigon chief of police General Nguyen Ngoc Loan executing a VC captive is arguably the most well-known.[8]

During and after Tet, the major newsmagazines and television stations not only covered the war in unprecedented detail but began for the first time to criticize war policy overtly. Walter Cronkite's criticisms were the most significant and far-reaching. Amid Tet, Cronkite traveled to Vietnam himself. When he returned to New York, CBS broadcast a half-hour special, Cronkite's *Report from Vietnam*, which ended with Cronkite voicing his conclusion about the state of the war directly to the camera:

> Who won and who lost in the great Tet Offensive against the cities? I'm not sure. The Vietcong did not win by a knockout, but neither did we. . . . It seems now more certain than ever that the bloody experience in Vietnam is to end in a stalemate. This summer's almost certain standoff will either end in real give-and-take negotiations or terrible escalation; and for every means we have to escalate, the enemy can match us, and that applies to invasion of the North, the use of nuclear weapons, or the mere commitment of 100 or 200 or 300,000 more American troops to the battle. And with each escalation, the world comes close to the brink of cosmic disaster. . . . On the off chance that military and political analysts are right, in the next months we must test the enemy's intention in case this is indeed his last big gasp before negotiations. But it is increasingly clear to this reporter that the only rational way out of there will be to negotiate, not as victors but as an honorable people who lived up to their pledge to defend democracy, and did the best they could.[9]

On the basis of his visit, Cronkite saw no positive outcome—and definitely no victory—for the United States in Vietnam other than compromise and concessions, which needed to be arrived at through negotiations. Up close to the enemy, he found them the equal of American forces. If the United States chose not to negotiate, he warned that disaster was a distinct possibility.

During and after Tet, politicians looking toward the fall presidential election began to speak out and campaign strongly against the war. In Chicago, on February 8, Robert F. Kennedy delivered what the *New York Times* called "the most sweeping and detailed indictment of the war and of the Administration's policy yet heard from any leading figure in either party."[10] Kennedy called Johnson's claims of progress "illusory," the Saigon regime "enormously corrupt," and explained, "The history of conflict among nations does not record another such lengthy and consistent chronicle of error. . . . It is time for the truth. It is time to face the reality that a military victory is not in sight and that it probably will never come."[11] In early March, the student-run, decidedly antiwar presidential campaign of Senator Eugene McCarthy gained

unexpected support and surprised the nation by winning 42 percent of the popular vote in the New Hampshire primary (to Johnson's 49 percent). This strong support for McCarthy sped up the sequence of events that would lead to a nationally televised address by Johnson on March 31, 1968. Johnson began the address by making it clear that the United States was looking for a way to end the war. He explained that the nation would not pursue targets above the 20th parallel (thus restricting the United States from 90 percent of North Vietnam), and that he would authorize negotiations when the North Vietnamese were ready.[12] Then, suddenly, he announced that he would not seek and would not accept the nomination for the presidency by the Democratic Party.

After Johnson's startling announcement, Americans were optimistic about the upcoming election, McCarthy and Kennedy as potential Democratic nominees, and the Democratic National Convention (which would take place in Chicago in late August). Then the McCarthy campaign sputtered, Robert Kennedy was assassinated on June 6, and it seemed clear that Vice President Hubert H. Humphrey, whose views more or less reflected Johnson's, would be the probable Democratic candidate—despite the fact that 80 percent of the primary voters had voted for antiwar candidates. Fueled by this situation and the anger and unrest following the assassination of Martin Luther King Jr. on April 4, the country's mood regarding the war changed drastically.[13] Various groups focused on Chicago as the site of forceful protests. Students for a Democratic Society and the National Mobilization Committee to End the War in Vietnam, for example, saw the DNC as a major forum in which they could voice their anger at, and sense of disenfranchisement from, the powers that be.[14] The Youth International Party (i.e., the Yippies), formed by Abbie Hoffman and others, likewise planned a protest against the Democratic Party and the war, their comical "Festival of Life." In the face of all these mounting plans, Chicago's Democratic mayor, Richard J. Daley—who had gained a reputation of zero tolerance for demonstrations after enacting a "shoot to kill" order during riots following the April King assassination—made his own preparations. He pledged to keep order. He talked tough. He refused to grant permits. He sealed off the convention site with barbed wire. And he arranged for twelve thousand Chicago police officers, five to six thousand national guardsmen, and a thousand FBI agents to be in Chicago during the convention.[15] Moreover, Daley placed six thousand U.S. Army troops on active duty in the suburbs surrounding the city.

Though the protests in Chicago were not as large as Daley anticipated (one hundred thousand protestors were estimated but only about ten thousand showed up), they were violent, due primarily to the provocations of Daley's

police.[16] In the words of Todd Gitlin (SDS president in 1963 and 1964, who went on to become one of the most important historians of the 1960s), in crucial instances, Chicago police came down on protestors without much reason, like "avenging thugs. They charged, clubbed, gassed, and mauled—demonstrators, bystanders, and reporters." When Daley's cops' cleared protestors out from Lincoln Park with tear gas and clubs, battles ensued for two days. A short clash between police and protestors outside the Conrad Hilton Hotel was broadcast by TV cameras to eighty-nine million Americans. It was at this moment that protestors famously announced to the cameras that "the whole world is watching," voicing their belief that their unrest was being witnessed by the entire world and their protest was significant enough to warrant their viewership. Images of the Chicago street clashes also made it inside the halls of the convention center, where they prompted Senator Abraham Ribicoff to condemn what he called the police's "Gestapo tactics." This comment in turn provoked Daley to yell (although the TV couldn't pick up the sound), "Fuck you you Jew son of a bitch you lousy motherfucker go home."[17]

In conjunction with the March on the Pentagon, the 1968 DNC protests ended up being one of the primary sites for the radicalization of American protest of the 1960s, marking a significant alteration of strategy from protest to resistance. Moreover, the August engagement at the DNC caused the art world to collectively mobilize for the first time since the beginning of 1968. The chaos of the preceding months combined with the hope injected into the antiwar movement by Johnson's departure from the presidential race dissuaded earlier engagement. Members of the Chicago art community organized activities. Because of Daley's actions, they initially proposed an artistic withdrawal from the city. The idea was floated that no art be exhibited in Chicago for two years; some even said ten years would be the more effective form of protest.[18] While this boycott never occurred on a group level or for any comparable amount of time (because arguments won out that removing art would actually rob artists of any voice), Claes Oldenburg, who had been injured by the police during the convention, did take the step of canceling his fall one-person exhibition at the Richard Feigen Gallery. He explained in a letter to Feigen, "In Chicago, I, like so many others ran head-on into the model American police state. I was tossed to the ground by six swearing state troopers who kicked me and choked me and called me a Communist."[19]

While Feigen was sympathetic, rather than close the gallery (and thus support the idea that no art was the best form of protest) he decided to replace Oldenburg's show with a one-month statement against Daley, his *Richard J. Daley Exhibition*, which would demonstrate "the outrage of many left-leaning

artists" in response to Daley's actions in Chicago.[20] The artists participating in the Feigen show included Lee Bontecou, Christo, CPLY, Sam Francis, Golub, Red Grooms, William Gropper, Ray Johnson, Judd, Jack Levine, Motherwell, Barnett Newman, Kenneth Noland, Oldenburg, Petlin, Larry Rivers, Rosenquist, Seymour Rosofsky, Schneemann, and Spero.[21]

The majority of works employed strategies comparable to those used for the *Peace Tower*. To express antiwar sentiment, artists contributed written rants, and small alterations to works done in their characteristic styles. Other artists, such as Francis, Judd, Noland, and Motherwell, chose to contribute benefit work—which was basically unchanged for the event and was there to exhibit the artist's support for the cause.[22] A few artists created memorable political parodies of the mayor.[23] Rosenquist created a screen print of Daley's head on long polyester strips (that looked like the hanging bands of cloth one would see in a car wash), which visitors could engage with—for example, they could break up Daley's face (fig. 39) with their fist if they so desired.[24]

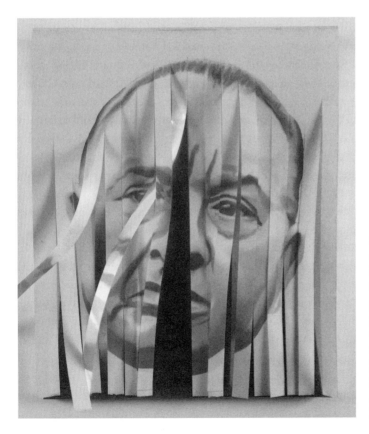

39.
James Rosenquist, *Daley Portrait*, 1968. Oil on slit Mylar, with posterior aluminum panel. 24 ½ × 20 in. (62.2 × 50.8 cm). Art © James Rosenquist/ Licensed by VAGA, New York. Courtesy Acquavella Galleries, New York.

Newman's *Lace Curtain for Mayor Daley* was the exhibition's centerpiece (fig. 40). Divorced from the artist's usual formalist and quasi-religious production, *Lace Curtain* was a barbed-wire grid set in a six-by-four-foot heavy steel frame, installed upright and splattered with blood-red paint. The work's form called to mind barriers used for crowd control on the front of government trucks during the convention. The title was similarly provocative. By substituting a harsh material for a genteel one, Newman signifies brutality. Almost certainly in response to Daley's anti-Semitic heckling of Ribicoff, Newman likewise associated Daley with the "lace-curtain Irish," a well-recognized term meaning one who tried to mask their working-class roots or unrefined nature with material goods.[25]

Due to the provocative works included in the exhibition and the extensive press coverage the exhibition was receiving, supporters of the mayor threatened to close the show down. At one point the gallery was even trashed by vandals. Yet Feigen hired a bodyguard to protect his staff, and halfway through the run of the exhibition, on November 2, 1968—which was on the weekend before the presidential election—other Chicago galleries joined them in solidarity by organizing a one-day series of protest exhibitions, *Response to Violence in Our Society*. While little documentation of the shows exists, it is known that the Richard Gray Gallery exhibited the collages of William Weege, some of which included images of napalm victims, and the Phillip Freed Gallery of Fine Art showed the *Artists and Writers Protest Against the War in Vietnam* portfolio (figs. 41 and 42). Organized by Jack Sonenberg and sold originally from April 24 to April 29, 1967, at the Associated American Artists Gallery, the portfolio included prints and poems by artists and writers whose "consciences have been provoked" and have "chosen to express their conscience[s] through the medium of their own work," wrote Max Kozloff, in the portfolio's introduction. Kozloff explained, "This is, then, a collective project which is partially an imaginative response to a tragic event of our times, and partially a more indirect acknowledgment of the war's anguish by the placing of works in this special context. No matter how varied their theme or form, these visual and verbal images are meant to testify to their authors' deep alarm over a violence which, as they have shown here, has been impossible for them to ignore. It is to such indignation, social as well as aesthetic, that this art has been dedicated."[26] The artists included in the portfolio were Paul Burlin, Charles Cajori, CPLY, Allan d'Arcangelo, di Suvero, Golub, Charles Hinman, Louise Nevelson, Petlin, Reinhardt, Sonenberg, George Sugarman, Carol Summers, David Weinrib, and Adja Yunkers. Akin to those in the Feigen exhibition, their works were mostly done using familiar methods of engagement. Dead and injured bodies along with written rants dominated the contributions. There

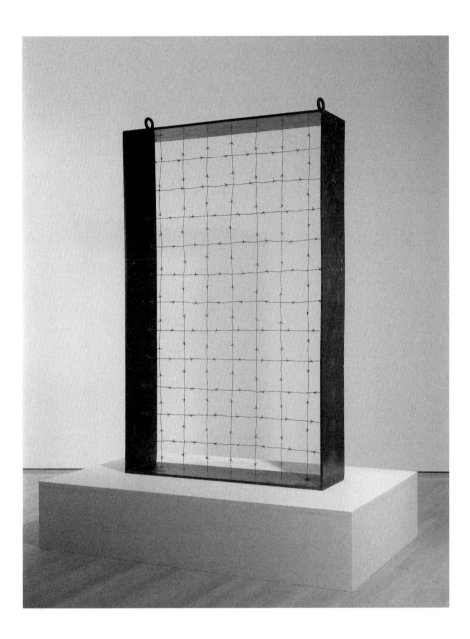

40. Barnett Newman, *Lace Curtain for Mayor Daley*, 1968. COR-TEN steel, galvanized barbed wire, and enamel paint. 177.8 × 121.9 × 25.4 cm (70 × 48 × 10 in.). The Art Institute of Chicago. Gift of Annalee Newman, 1989. © 2012 The Barnett Newman Foundation/Artists Rights Society (ARS), New York.

41.
Ad Reinhardt, *Untitled (Postcard to War Chief)*, from *Artists and Writers Against the War in Vietnam*, 1967. Screenprint with collage. Composition: 11¼ × 3¼ in. (28.6 × 8.3 cm); sheet: 25¾ × 20¹⁵⁄₁₆ in. (65.4 × 53.3 cm). Publisher: Artists and Writers Protest, New York. Printer: Chiron Press, New York. Edition: 100. © 2009 Estate of Ad Reinhardt/Artists Rights Society (ARS), New York. Digital Image © Museum of Modern Art, licensed by SCALA/Art Resource, New York.

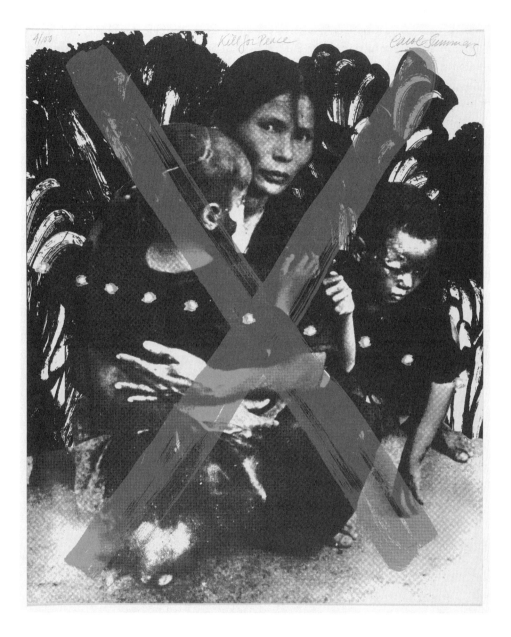

42. Carol Summers, *Kill for Peace*, from *Artists and Writers Against the War in Vietnam*, 1967. Screenprint with punched holes. Composition: 23⁵⁄₁₆ × 19³⁄₁₆ in. (59.2 × 48.7 cm); sheet: 23⁵⁄₁₆ × 19³⁄₁₆ in. (59.2 × 48.7 cm). Publisher: Artists and Writers Protest, New York. Printer: unknown. Edition: 100. Digital Image © Museum of Modern Art/ Licensed by SCALA/Art Resource, New York.

were also abstract benefit works. Yet despite their strategic familiarity, a few things stood out in this show. Summers's *Kill for Peace* (fig. 42) was a searing image, a black-and-white photograph of a Vietnamese woman and her two injured children, crossed out in a large red *X*. Characteristically a symbol of editorial rejection, the *X* simultaneously referred to the elimination of people.

The most provocative item in the portfolio was Ad Reinhardt's silk screen telegram, which protested both the war and art's relationship with war with two long lists. The first list, on the back of the card, was a catalog of things Reinhardt did not want in the world. It read:

NO WAR

NO IMPERIALISM

NO MURDER

NO BOMBING

NO NAPALM

NO ESCALATION

NO CREDIBILITY GAP

NO PROPOGANDA

NO BULLSHIT

NO LYING

NO IGNORANCE

NO GRAFT

NO DRAFT

NO FEAR

NO SLAVERY

NO POVERTY

NO HUNGER

NO HATE

NO INJUSTICE

NO EVIL

NO INHUMANITY

NO CALLOUSNESS

NO CONSCIOUSLESSNESS

NO CONSCIENCELESSNESS

On the front of the card, next to the address—"War Chief, Washington, D.C., U.S.A."—where a note would usually be written, Reinhardt included his second list. Shorter than the first, this list explained that art could not be involved in any way, shape, or form with the issue of the war.

NO ART OF WAR

NO ART IN WAR

NO ART TO WAR

NO ART ON WAR

NO ART BY WAR

NO ART FROM WAR

NO ART ABOUT WAR

NO ART FOR WAR

NO ART WITH WAR

NO ART AS WAR.

On the one hand, Reinhardt's statements reflected his long-standing commitment to an art entirely without reference. His untitled black paintings were obdurately art-as-art and nothing else. Yet simultaneously, Reinhardt created this work, as well as his comics for *PM*, in the belief that painting should not be the only activity of the modern artist. He asked in 1946, "Do you think that when a painter expresses an opinion of political beliefs he makes even more of a fool of himself than when a politician expresses an opinion on art?" He answered himself with a categorical "NO!"[27] Reinhardt's consistent involvement in antiwar activities (in addition to his various other political activities) from 1965 onward testified to this vehement refusal.

Back in New York in the fall of 1968, distanced from the events of Chicago, artists mobilized for peace. While Johnson had taken the major steps of beginning negotiations in Paris and stopping the bombing of the North, and Humphrey and Richard Nixon (the Republican presidential candidate) had made peace plans a primary part of their respective platforms, artists believed the war could not be concluded fast enough and organized efforts to say so.[28] The most intriguing expression of this was the inaugural show of Paula Cooper's pioneering SoHo gallery, its *Benefit for the Student Mobilization Committee to End the War in Vietnam* (fig. 43), which ran for just nine days, between October 22 and 31, 1968.[29] Cooper's show, curated by Lucy Lippard, the artist Robert Huot, and the activist Ron Wolin (of Veterans for Peace in Vietnam, and a political organizer with the Socialist Workers Party), was timed to open during the anniversary week of the 1967 March on the Pentagon, which the Student Mobilization Committee had helped organize, and in conjunction with a week of antiwar events in Japan, Great Britain, Canada, and many other countries.

The exhibition touted itself as the first antiwar benefit exhibition of "non-objective art"—and this was true—though almost all the works included in

43. Installation view of *Benefit for the Student Mobilization Committee to End the War in Vietnam*, 1968. Paula Cooper Gallery, 96 Prince Street, New York, October 22–31, 1968. Courtesy Paula Cooper Gallery, New York.

the exhibition were what would now be labeled more specifically "minimalist" works. Among the artists included in the exhibition were Carl Andre, Jo Baer, Dan Flavin, Donald Judd, Robert Ryman, Robert Mangold, and Sol LeWitt. LeWitt's contribution to the show was a breakthrough work—his first wall drawing, a major moment in the development from minimalism to conceptualism.[30] The press release for the exhibition—which was headed "FOR PEACE"—stated:

> As a rule, non-objective artists in America have been politically inactive since the 1930s. In 1948, Robert Motherwell and Harold Rosenberg went so far as to say that "Political commitment in our time means logically—no art, no literature." During the 1960s, this attitude has been drastically revised. An increasing number of abstract artists have found it morally necessary to protest the political climate, their art-for-art's sake position

notwithstanding. A specialized exhibition like this one further allows them to put their particular esthetic achievement on the line. By contributing to the peace cause their most important possessions—major examples of their work—these artists have demonstrated their involvement in the strongest possible manner.[31]

The curators saw the exhibition as a solution for nonobjective artists who were politically active in the antiwar effort but did not engage politics in their work.[32] The curators believed the exhibition of these artists' best works was the strongest way they could protest the war. While the curators left it somewhat ambiguous in the press release whether they believed this was the best way for art to protest, they were more explicit in other forms of media, such as the *New York Times*. Echoing Stephen Radich's 1966 remarks, Lippard commented to Grace Glueck that she saw the show as "a kind of protest against the potpourri peace shows with all those burned dolls' heads. . . . It really looks like an exhibition first and a benefit second."[33] Accordingly, Lippard prioritized minimal expressions of protest over figurative ones, which made sense given her allegiance at the time to minimalism.

Although the run of the Cooper exhibition was extremely short and the ideas proposed in the press release were soon abandoned, the exhibition provoked reaction from the antiwar community. In the *New York Free Press*, Gregory Battcock questioned—as many did of minimalist artists during the war—how, if an artist was truly against the war, he could fail to engage the war in his work. Battcock also disputed the artists' dedication to the cause, since they all received the cut they would get for any other gallery exhibition for their participation—and thus had not entirely "contributed" the works. Additionally, Battcock lampooned the central idea of the exhibition: that a cohesive group of important works made the most forceful statement for peace. He explained:

If indeed an exhibition of a cohesive group of important works makes a forceful statement for peace, would not an exhibition of wearing apparel by, let's say, Cardin, Gernreich, and St. Laurent, presented under similar imprimatur, make an equally forceful statement for peace? Or how about an exhibition of pastels and watercolors offered under the same circumstances by the National Society of Bird Artists? What would be the story if the best wine merchants and importers got together and offered a tasting of their finest vintages to oenophiles and claimed the whole affair is really a protest against the war in Vietnam?[34]

Surprisingly, at the end of his article, after the criticism and humor, Battcock opened his mind up to the show. He acknowledged that this idea that the highest style is the best form of benefit protest might actually be useful and legitimate.[35] Unfortunately, after Cooper's show, nothing comparable occurred again.

Outside of collective exhibitions and benefits, 1968 saw artists continuing to make individual works that employed strategies used in previous years—though through new material means that allowed for further complexity. Edward Kienholz, for example, created his iconic *Portable War Memorial* (fig. 44), which, like Dan Flavin's light work of three years previous, used the strategy of creating an advance memorial or memorial-before-the-fact. However, Kienholz's sculpture was a life-size mixed media diorama comprising several large-scale elements. These elements collectively countered a memorial's traditional approbation of a war as well as popular propaganda devices' historical promotion of "patriotic solidarity."[36] Both are exemplified for American audiences in the Marine Corps War Memorial (opened in 1954), commonly called the Iwo Jima Memorial. The Iwo Jima Memorial features a collective unit of soldiers (their bodies aligned in a valiant crescendo) planting an American flag. The

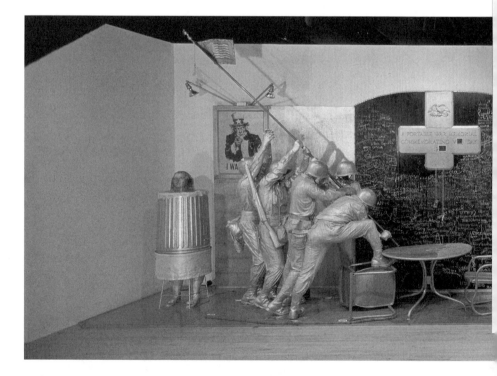

composition was based on the iconic photograph taken by Joe Rosenthal during the World War II siege of Iwo Jima, Japan, which was possibly staged.[37] The men stand on a substantial base that reads "Uncommon Valor Was a Common Virtue."

The left side of Kienholz's sculpture features revisions of what he described as "the traditional propaganda devices." There is a reconsideration of the Iwo Jima memorial, in which faceless American soldiers plant a tiny reproduction of the American flag—a far cry from the size of the original—into the umbrella hole of a patio table (which is situated in front of an Uncle Sam *I Want You* poster). Next to the soldiers sits a giant black chalkboard tombstone that includes an inverted cross with the title of the work written on it; a blank space for indicating which war this memorial is supposed to commemorate; and the names of almost five hundred countries that no longer exist because of war and boundary changes throughout history. Chalk and an eraser hang to aid the addition of future entries. To the right of the chalkboard Kienholz included a section called "Business as Usual." Two more patio tables (with chairs set around them) have been set up, and behind them is a couple eating ground-up meat products at a diner. Chili and hot dogs are available for customers at

44. Edward Kienholz, *The Portable War Memorial*, 1968. Mixed media tableau. 114 × 384 × 96 in. (289.6 × 975.4 × 243.8 cm). Museum Ludwig, Cologne. © Kienholz. Courtesy L.A. Louver, Venice, CA.

this diner, it is explained in huge letters above the couple, and one can also purchase a Coca-Cola in a real machine. On the one hand, the scene represents status quo in the United States: Americans enjoying their hamburgers, hot dogs, and soda. On the other hand, the way the diner is juxtaposed with the chalkboard suggests that ground-up men from the list of extinct countries are the dinner fare. In the background of the work, the sound of Kate Smith singing Irving Berlin's patriotic anthem "God Bless America" does not grandly boom from speakers but crackles from a strange figure in an upside-down garbage can. At the other side of the tableau, next to the barbecue stand, is a tombstone, blank (like the chalkboard) to prepare for the dead of future wars. Hard to see on it is a two-inch-tall man crucified with burned hands, symbolizing for Kienholz humankind's "nuclear predictability and responsibility."[38] Kienholz's work is arguably one of the most important pieces of protest art created during the Vietnam War, yet its presence in a German collection (the Museum Ludwig, Cologne) has limited its exposure.

Kienholz's 1968 work *The Eleventh Hour Final* (fig. 45) is also in a German collection, the Hamburger Kunsthalle. The work is a full-scale recreation of a "typical" American living room of the 1960s, complete with wall-to-wall carpeting, wood-paneled walls, a worn-in couch, a wooden coffee table (with a *TV Guide* on it), and an end table. The focus of the room is a tombstone-shaped TV set (made out of concrete) and its remote control, whose wire winds back across the room from the TV set to the coffee table. Broadcast on the TV are body counts of "THIS WEEKS TOLL" from the war. There is the amount of "AMERICAN DEAD: 217, AMERICAN WOUNDED: 563, ENEMY DEAD: 435, ENEMY WOUNDED: 1291." Behind these numbers lies a sculptural representation of a Vietnamese child's head. The head hovers sideways and stares at the viewer from the TV. Shockingly breaking up the quiet of this typical suburban tableau, and supplanting the American concern for American dead and the abstraction of numbers with the image of a Vietnamese child, Kienholz's work is similar to Rosler's. He juxtaposes an image from the war with an American domestic environment far removed from the death and destruction taking place in Vietnam, in order to bring the war home. At the same time, he also utilized another strategy: the juxtaposition of an individual victim with a depersonalized body count.

Focusing on individual death within mass death to humanize a war's victims is familiar to antiwar art. Ernst Friedrich's book *War Against War*, published in Berlin after World War I, is one of the most horrifying examples. Friedrich's book humanized the carnage of the First World War by featuring shocking images of soldiers whose faces and bodies had been virtually

45. Edward Kienholz, *The Eleventh Hour Final*, 1968. Mixed media assemblage. 120 × 144 × 168 in. (304.8 × 365.8 × 426.7 cm). Private collection. © Kienholz. Courtesy L.A. Louver, Venice, CA.

destroyed and then grotesquely repaired. The images were juxtaposed with ironic text and images that glorified battle and war and the role of the soldier.

In relation to Vietnam, there was the very early 1965 example of the comic *Blazing Combat* (fig. 46).[39] Distributed by Warren Publishing, written by Archie Goodwin, and drawn by Frank Frazetta, Wally Wood, John Severin, Alex Toth, Al Williamson, Russ Heath, Reed Crandall, and Gene Colan, *Blazing Combat*'s stories (many of them set in other American wars, from the Revolutionary War to Korea, in addition to Vietnam), like "Long View" (not pictured), focused on the deaths of Americans and their units in battles featuring senseless mass murder and destruction. (All the while their superiors tell these men they are making heroic sacrifices for their country.) A recurring final scene in each of the stories is a juxtaposition of the armed forces' textual description of their victory with an up-close image of the protagonist's dead body, eyes open and mouth agape. Other *Combat* stories presented the deaths of individual Vietnamese, giving a face and identity to what so often

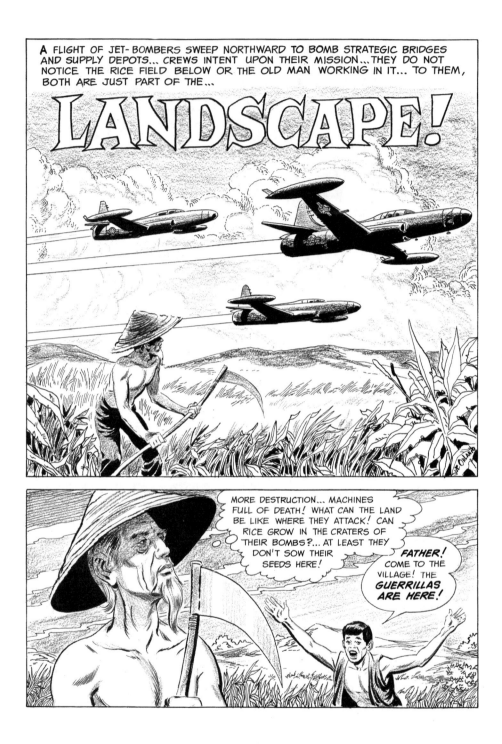

46. First pages from "Landscape!" a story in the comic *Blazing Combat*, 1965. Reprinted in Archie Goodwin et al., *Blazing Combat* (Seattle: Fantagraphics Books, 2009), 46–47. Courtesy Fantagraphics Books. © Michael Catron.

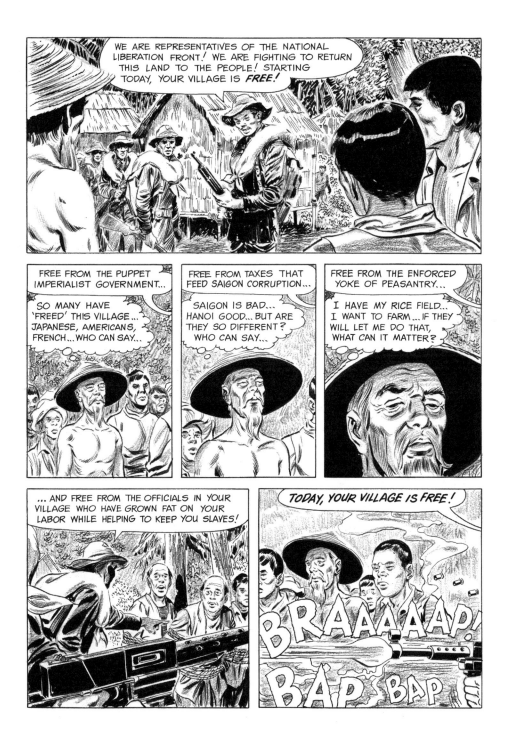

was an unknown enemy. An example from *Blazing Combat* no. 2 is its concluding story, "Landscape!," in which an old Vietnamese man, who simply wants to farm his rice and avoid the war, is killed in the chaos of an American ambush.[40] Unfortunately, *Blazing Combat* was little known during the Vietnam War. Its second issue, and particularly "Landscape!" whose general theme was the "futility of war," was protested by the military, and as a result the comic was banned from sale on military bases. The American Legion also objected to the comic, leading some magazine wholesalers to halt any further sales of it. In the 1960s market for comic books, losing a few wholesalers spelled the end of a comic, since wholesalers held a virtual monopoly on the business.[41]

As opposed to the previous examples of Friedrich and *Blazing Combat*, Kienholz's work opposed the individual to a body count, which during the Vietnam War charted progress on a nightly basis. In later years, other artists followed him in using this approach. To humanize slain American soldiers, Carlos Irizarry collaged photographs of those who had been killed in one week (from *Life* magazine) into his *My Son, the Soldier, Parts I–II* (1970). In James Dong's 1969 *Vietnam Scoreboard*, an American pilot keeps track of the number of times he hits his target by adding marks to the side of his plane. Yet when one looks closely at the work, the marks do not appear alone, but rather are joined by the silhouette of an Asian family (whose full image can be seen at the left-hand side of the work). While Dong identified this family as Vietnamese war victims, he actually sourced the image from his own Chinese family.

Because of missteps by the Johnson administration during the Tet Offensive, protests during the DNC and the presidential election, and the eventual election of Richard Nixon, the defacement of political figures became a prevalent strategy for antiwar works over the course of 1968. Johnson was a primary target. He was crucified, TNT was shoved up his rear end, his penis was tied up and burned off at the bottom with a match, his body was turned into a bloated yellow worm, and his ignorance was exaggerated by making him speak an insulting parody of an "Asian" language ("Ching Chong")—and all this appeared in just one work by Peter Saul, *Ching Chong (LBJ)*. Peter Dean depicted Johnson as a cannibal with a ferociously bloody mouth, grinning, seemingly post-meal in *#1 Cannibal*. Dean's image recalled Red Grooms's *Patriots' Parade* of the previous year, which also focused on Johnson. In *Parade*, Johnson leads two veterans and their large American flags—which they wield like baseball bats—along a parade route. Grooms pictures the president as a caricature of himself, with enlarged ears, stepping on children, and taking his hat off to the crowd. Tipped so that the viewer can see into it, the hat is a central aspect of the work. Off of Johnson's head, upside down, it reveals a black-and-white

skull, which recalls the skull contained in the light bulb looming in the back of Otto Dix's 1920 *Skat Players*. "Miss Napalm" also leads Johnson's parade. She is Grooms's inversion of (and replacement for) the Statue of Liberty. In addition to Johnson, artists abused other political figures. As noted, Mayor Daley earned himself an entire exhibition in Chicago. The smug faces of Richard Nixon and Dean Rusk were juxtaposed with the tortured countenance of a Vietnamese victim of war in Joe Raffaele's *Vietnam Collage*.[42]

As seen with Grooms's Miss Napalm, artists skewered American political symbols alongside their upending of politicians. Uncle Sam was a popular target. Perhaps the most iconic presentation of him was in *End Bad Breath* (fig. 48), created by the graphic designer Seymour Chwast. *End Bad Breath* features a green Uncle Sam opening his mouth to reveal bombers in Vietnam, equating war-making with a disease in the body politic of the country. In other works, Uncle Sam appears badly beaten up, as in Steve Horn and Larry Dunst's *I Want Out* (fig. 49), a parody of James Montgomery Flagg's iconic *I Want You* poster used to recruit soldiers during both world wars.

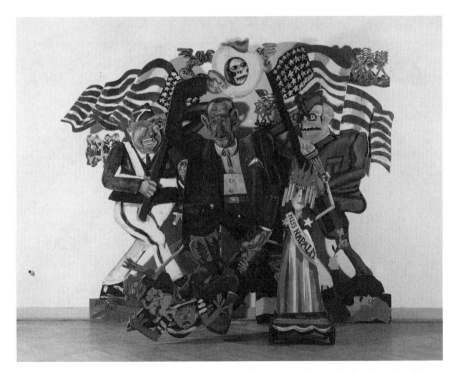

47. Red Grooms, *Patriots' Parade*, 1967. Construction, painted wood. 8' × 4" × 11' 40". Collection Moderna Museet, Stockholm, Sweden. © 2012 Red Grooms/Artists Rights Society (ARS), New York.

48. Seymour Chwast, *End Bad Breath*, 1967. Offset lithograph. 24 × 36 in.
Courtesy Seymour Chwast.

49. Larry Dunst, *I Want Out*, 1971. Committee to Help Unsell the War. Photographer: Steve Horn. Offset. 101 × 76 cm (39¾ × 29¹⁵⁄₁₆ in.). Courtesy of the Center for the Study of Political Graphics.

50. Student Mobilization Committee to End the War in Vietnam, *Pull Him Out Now*, circa 1969. Offset. 68.6 × 45.7 cm (27 × 18 in.). Courtesy of the Center for the Study of Political Graphics.

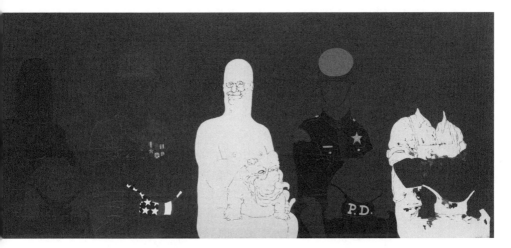

51. May Stevens, *Big Daddy Paper Doll*, 1970. Acrylic on canvas. 72 × 168 in. (182.9 × 426.7 cm). Brooklyn Museum, Gift of Mr. and Mrs. S. Zachary Swidler, 75.73. © May Stevens.

The quagmire that was the war by 1971 also threatened to devour Uncle Sam. In a poster for student demonstrations that year (fig. 50), Uncle Sam literally is being swallowed up by the ground, sinking into the quicksand of Cambodia and Vietnam. The poster demands, "Pull him out now!"

In her series *Big Daddy*, which featured the consistent representation of an imposing, bald, overweight, pasty white man—whose overall form suggested a penis—May Stevens insulted another kind of American political figure: the ordinary working-class man who supported the war fully, didn't criticize the government, and didn't get into politics. Big Daddy was based on Stevens's father, who lived in Quincy, Massachusetts—where Stevens grew up—and the series was triggered in part by the threat that her son would be drafted.[43] In Stevens words, Big Daddy watched you with "total incomprehension . . . his eyes [were] blank," just as many of the "hawks" of the United States looked at the "doves" protesting the war.[44] An example from Stevens's series is her *Big Daddy Paper Doll* (fig. 51). In it, Big Daddy is depicted naked (with a bulldog humorously hiding his penis) in the format of what could be a children's book.[45] Various outfits he can don—including a soldier's and a butcher's uniform—surround him. For Stevens, the assumption was that all these positions in society represent forms of the Big Daddy personality.

The distrust of authority present in Stevens's works reflected the greater political and social upheaval of 1968, and specifically the belief that Vietnam had truly become a quagmire. In response, the U.S. government began 1969 by introducing a way to downscale American involvement.

6

1969

AWC, Dead Babies,
Dead American Soldiers

SOON AFTER HIS INAUGURATION in January 1969, Richard Nixon announced a plan to end American troop involvement in the war: "Vietnamization."[1] Vietnamization, according to Nixon, would allow American ground troops to be sent home in stages by progressively transferring their duties to ARVN forces, hence the name: the war would go from being *Americanized* to *Vietnamized*. The United States would compensate for the departure of U.S. troops with an expansion of the (less troop-heavy) air war over the DRV. In the future, Vietnamization would lead to the departure of all American troops from Vietnam, according to Nixon, leaving the war—or hopefully peace by that point—in the hands of the DRV.

Yet by the fall of 1969, almost eight months after his initial announcement, Nixon had done very little to put Vietnamization into effect. Members of the antiwar movement once again rose up and organized in response. This time their protest was an unprecedented statement, Vietnam Moratorium Day, which took place on October 14, 1969. Millions of Americans in thousands of cities, towns, and villages across the United States demonstrated as part of the Moratorium. It remains the largest public protest in U.S. history. In their seminal, comprehensive history of the antiwar movement, *Who Spoke Up? American Protest Against the War in Vietnam, 1963–1975*, Nancy Zaroulis and Gerald Sullivan described the scene:

A Whitmanesque alchemy was at work; a gentle spirit of comradely acceptance pervaded gatherings large and small where every shade of dissent was represented. For some, long kept in silent restraint by radical usurpation of the ground they might have taken, it was, at last, a chance to be safely heard. Only a few minor incidents of violence were reported, there were no ugly mob scenes; instead, in town after town, there were silent, reproachful vigils, endless reading of the names of the Americans killed in the war, candlelight processions, church services, and, in some cities, larger meetings where politicians spoke in muted terms. The extremes of citizen opposition to the war came together and whatever radical impulse strayed about the fringes of these gatherings was submerged in a spirit of civic solidarity in common enterprise.[2]

After 1968, in which protests time and again expressed dissension and new expressions of violence, here was an unprecedented and peaceful consensus calling for an end to the war. The hope was that these resounding numbers and an almost religious piety would convince Nixon and the administration to change its course.

In the wake of this extraordinary expression of dissent, Nixon went on the offensive. On November 3 he delivered a major speech to the American people. He began by explaining that the purpose of the speech was to inform Americans of "the truth" about current American policy in Vietnam, including Vietnamization, in his belief that "the [country's] deep division about Vietnam" was due to a lack of information. He then explained that Vietnamization, what he called a "long overdue change in American policy," was working. Air operations, for example, had been reduced by 20 percent. Further, he said that he had "worked out" a plan "in cooperation with the South Vietnamese for the complete withdrawal of all U.S. combat ground forces, and their replacement by South Vietnamese forces on an orderly scheduled timetable." Then Nixon abruptly switched gears and changed the focus of his speech to the American civilian population. Regarding his plan of action, he asked not for the whole country's support, but only for support from "the great silent majority" of Americans—by which he meant those not currently speaking out against the war and who inaudibly supported Nixon. With this comment, Nixon converted the address into one of the most divisive ever given by a sitting president. Suddenly, public opinion changed from something to be won over by persuasion to something that could be won through the method of divide and conquer. Nixon made the division between his silent majority and

the antiwar movement starker still by inferring that the antiwar movement was not just outside his concerns, but that those involved in it were the real enemy. He said, "North Vietnam cannot defeat or humiliate the United States. Only Americans can do that."[3]

While Nixon's speech was immediately trumpeted as a great success by his administration, which paraded heaps of telegrams from the newly audible "silent majority," it did not calm the American political waters. Events of the ensuing months made calm seem impossible, especially the revelation a little more than a week after Nixon's speech of what had taken place more than a year before at the My Lai hamlet in the Song My district of South Vietnam. A report by Seymour Hersh in the *Cleveland Plain Dealer* (accompanied by Ron Haeberle's photographs) disclosed that at My Lai, on the morning of March 16, 1968, in the span of a few hours, American soldiers from Charlie Company murdered more than five hundred Vietnamese villagers.[4] The deaths stemmed from a search and destroy mission the company had been ordered to undertake. When the soldiers had arrived at My Lai they expected an intense battle, and a good deal of the men in the company wanted one. Many were especially agitated after the Vietcong had killed some members of their unit during the previous weeks. Yet what the company came upon was a quiet village where none of the men and women posed a direct threat, and where it was highly questionable that anyone had links to the Vietcong. Regardless, this did not stop the Americans from carrying out their orders, which were reinforced by those in charge, notably Lieutenant William Calley. According to eyewitnesses that morning, American soldiers committed mass murder. They bayoneted old men, shot women and children in the back, and mowed down with machine guns groups of people they had lined up in front of trenches. After the revelation of the incident, there was enough evidence to convict only Calley, and he received a life sentence. Despite this fact, because of political pressure Nixon commuted Calley's sentence. Nixon made him serve only three days in jail and then allowed him to be released into house arrest. Three years later Calley was free.

For most antiwar Americans (though in later years similar comparable incidents were revealed) My Lai became the representative incident of war crimes in Vietnam.[5] It sparked a great deal of antiwar protest, including efforts by artists, the best-known of which was the *And Babies* poster, created by the poster committee of the Art Workers' Coalition.

The Art Workers' Coalition had its origins in a series of events involving the artist Takis (Vassilakis). One of Takis's works—*Telesculpture* of 1960, which was in the collection of the Museum of Modern Art—had been included

in MoMA's winter 1969 exhibition, *The Machine as Seen at the End of the Mechanical Age*.[6] But *Telesculpture* was not the work Takis had thought would be included in the exhibition. He had been told MoMA would feature a more recent work that he considered more representative of what he was currently making.[7] In response to this replacement, Takis decided to protest MoMA. In doing so, he wanted to bring attention not only to his own particular situation but also to how the museum dealt with artists and their works in general. Takis was particularly concerned with how museums exhibited artists' works without their consent, the idea of "exclusive" museum ownership of a work, and the common practice of taking unauthorized photographs of artists' works.[8]

Takis's protest occurred on January 3, 1969. He entered *The Machine as Seen at the End of the Mechanical Age*, removed his work, and retreated to the museum's sculpture garden with the work in his hands. When MoMA staff (including the curator of the exhibition) got wind of his action and approached him to inquire about it, Takis asked the curator if his work could be removed from the exhibition. The curator and the museum said it couldn't be, after which Takis and a few others began a sit-in at the museum and distributed a handbill to the public. The handbill explained Takis's aforementioned agenda and the fact that this would "be the first in a series of acts against the stagnant policies of art museums all over the world."[9] Takis's act led to meetings being scheduled with Bates Lowry, MoMA's director. In the time between these meetings and Takis's initial protest, friends and supporters sympathetic to Takis joined his cause. This group included artists who showed with Takis at the Howard Wise Gallery—such as Wen-Ying Tsai, Tom Lloyd, Len Lye, Farman, and Hans Haacke—and artists and critics from other areas of the art world, like Carl Andre, Lippard, John Perreault, Petlin, Rosemarie Castoro, Kozloff, and Willoughby Sharp.

As it became larger and involved more and more people of like mind, the group catalyzed by Takis's actions eventually decided to refer to itself as the Art Workers' Coalition (AWC). Julia Bryan-Wilson has recently noted how this name called to mind some significant precedents: namely, the New York Artists Union chapter of the 1930s, and the Art Workers Guild, established in England in 1884 as an outgrowth of William Morris's Arts and Crafts Movement. The most immediate link, though, was with the Black Emergency Cultural Coalition, formed to protest the 1969 *Harlem on My Mind* exhibition at the Metropolitan Museum of Art.[10] Fluxus and the network of performance artists associated with Judson Memorial Church in Greenwich Village provided other important local precedents for anti-institutional collective artistic

activity in New York.[11] (Actually, members of both groups, such as Jon Hendricks and Yvonne Rainer, became AWC participants.) AWC kept its organization deliberately loose. Decisions were made based on direct participatory democracy; membership could be determined only by the number of people who appeared at an activity or meeting; and anyone could be a member: critics, museum and gallery personnel, even art audiences.[12]

With the formal creation of AWC, the group expanded Takis's protest to include other new demands of the museum. They wanted MoMA to (1) set up a section of the museum that would be dedicated to the exhibition of black artists (and be directed by black artists); (2) extend itself into "Black, Spanish and other communities"; (3) establish a committee of artists who would organize exhibitions; (4) make itself free for everyone; (5) have it pay a rental fee to show artists' works; (6) hire staff that was specifically trained to handle the installation and maintenance of technological works; and (7) create a section of the museum to show works by artists who did not have gallery representation.[13]

Over the next few months as they negotiated their demands with Lowry, AWC became the largest political artists' organization in the United States and buttressed their statements and negotiations with highly visible actions.[14] Three hundred AWC participants gathered outside MoMA to protest the museum's lack of representation of black artists. They held an "Open Hearing" at the School of Visual Arts in which fifty members of the coalition clarified or critiqued AWC's demands and proposed new issues to an audience of approximately 250 people.[15] Beginning in April 1969, AWC participants began protesting against the Vietnam War. The most significant of these antiwar protests took the form of a poster now widely known as *And Babies* (fig. 52), which was created in November 1969.

And Babies featured two main elements: a photograph reproduced in color and blood-red typewriter-like text printed at the top and bottom of the photograph. The photograph was one of Ron Haeberle's appalling images of direct evidence of the My Lai Massacre. Because of its publication in *Life* magazine in December 1969, the picture had already become the primary image of the incident and one of the most iconic of the war. On a dirt road lined with tall grass and a bent-over wire fence, more than twenty women and children lie dead. Some of their bodies are in the middle of the road, some lie off to the sides. Some are clothed; some are not. Within the group of bodies are three dead babies.[16]

The text used in *And Babies*, which is the source of the title history has given the work, reads: "Q: And babies?" and at the bottom "A: And babies." Both

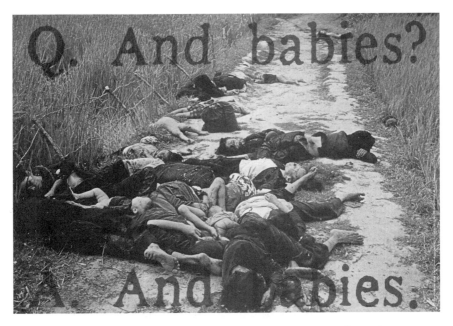

52. Artists' Poster Committee of Art Workers' Coalition: Frazier Dougherty, Jon Hendricks, and Irving Petlin, *Q. And babies? A. And babies*, 1970. Photographer: R. L. Haeberle. Offset. 63.5 × 96.3 cm (25 × 37 ¹⁵⁄₁₆ in.). Courtesy of the Center for the Study of Political Graphics.

the question and answer stemmed from a November 24 interview broadcast on the CBS national newsmagazine program *60 Minutes* that reporter Mike Wallace conducted with Paul Meadlo, a soldier who had been involved in the My Lai incident. During the interview, Meadlo admitted to shooting unarmed men, women, children, and babies, alongside his fellow soldiers and at the orders of Lieutenant Calley. Meadlo described how soldiers shot people with their machine guns and pushed them into a ravine; he also recounted gathering others into a ditch and then dropping a grenade on them. He said American soldiers killed about 370 people that day. Nevertheless, Meadlo explained that he felt like what he did was correct in the face of the recent loss of some of his buddies. Today, the Meadlo interview is remembered by *60 Minutes* as the most "shocking" of Wallace's career. It was definitely the most horrific historical discussion of the My Lai events. Notably, while the origin of the text used in *And Babies* was the Wallace–Meadlo interview, the lettering itself was sourced from the *New York Times*, which printed the interview the following day.[17] The poster dramatically enlarged and turned red the original *Times* text.[18]

And Babies was meant to be a kind of collaboration between the AWC and MoMA, a sign of the progress AWC had made in persuading the museum to attend to its concerns and a public statement of the museum's political engagement. Between November 25 and December 3, the poster committee settled the design and it was agreed that MoMA—which was not involved in the creation of the poster—would take care of the distribution of the work if AWC would pay for it. MoMA additionally agreed to let AWC use its name to secure reproduction rights, a donation of paper, and a printer (the Amalgamated Lithographers Union) for the project. Moreover, the credit line for the poster would list both MoMA and AWC.[19] Nonetheless, according to the poster committee, at the last minute, after the color plate had been finished and the printer was waiting only for the credit line to be approved, MoMA backed out. The museum's abrupt change of heart was allegedly because of the sentiments of William Paley, the president of the museum's board of trustees, who was also a former president of CBS and the current chairman of its board. Paley had not seen the poster until the final printing days; when he was shown a mock-up of the work, he said the museum could not be associated with such a project. According to Lucy Lippard, he said "in so many words," "You must be kidding, the museum will not do this."[20]

MoMA sent out a press release summarizing the decision and the background of the situation for the public. It explained that there had never been any promise that the museum staff's executive committee (which had worked with the poster committee and was not in contact with Paley) would be empowered to make the final decision about the poster. Further, it said, "The Museum's Board and staff are comprised of individuals with diverse points of view who have come together because of their interest in art, and if they are to continue to function effectively in this role, they must confine themselves to questions related to their immediate subject. Mr. Paley said they could not commit the Museum to any position on any matter not directly related to a specific function of the Museum."[21] MoMA's statement implied a few possible conclusions. It emphasized the immediate and appropriate subject of MoMA was not projects outside its collection and that a specific function of the museum was not to be politically active. If one reads "immediate subject" as art separated from any sociopolitical relationships, MoMA's words also insinuate the museum's formalism.

AWC still printed *And Babies* without MoMA's participation, in a run of fifty thousand posters, and according to Lucy Lippard, an "an informal network of artists, students and peace workers throughout the world" distributed the posters widely, free of charge.[22] Such wide distribution led to the

poster's visibility in both "high" and "low" locations. It was put up on the street, hung up in people's homes, published in *Rolling Stone*, and, ironically, included in two major MoMA exhibitions: Kynaston McShine's 1970 seminal museum exhibition of conceptual art, *Information*, and Betsy Jones's 1971 *The Artist as Adversary*. AWC also tried to publish *And Babies* simultaneously on the cover of all four major American art magazines—*Artforum*, *Arts*, *Art in America*, and *Artnews*—yet the plan fell through because *Art in America* would run the poster only if all the other magazines did and *Artnews* did not want to be involved.[23] Importantly, the poster had another life during the 1972 Nixon reelection campaign, when all text on the poster's image was replaced with "Four More Years?"

In the months following the printing of *And Babies*, those involved with AWC continued to focus on Vietnam through a unique collective aesthetic endeavor that again centered on My Lai. During the fall Moratorium Against the War in Washington, DC, AWC participants teamed up with members of Artists and Writers Protest to fabricate and distribute masks that they had created of Lieutenant William Calley (fig. 53). The masks were black-and-white photographic reproductions of Calley's face with small holes for the wearer's eyes, so that one would in essence become Calley by putting it on. The visual effect of a sea of Calley faces approaching the Capitol was haunting. Though the majority of those who wore the masks saw them as continuing to bring awareness to Calley and the horrors of the incident, the action was not so one-sided or direct, and implied other meanings. Some felt the masks implied that everyone had a touch of Calley in them and that everyone shared responsibility for the atrocities committed. Lucy Lippard even explained that at the time, while the masks were interpreted as condemning Calley, some observing the protest thought the masks were worn in support of him.[24]

Another imaginative antiwar action organized by AWC participants was its *Mass Antiwar Mail-In*. Again executed in partnership with AWP, this action appealed to artists and writers to send to the groups "a gift, a keepsake, a trophy, a poem, an amulet, or whatever you like (the bulkier the better)," which the group would then collect and forward on to the "WAR CHIEFS OF THE PENTAGON." AWC and AWP participants ended up with a good deal of material, and on April 2 they gathered what had been sent (to 530 LaGuardia Place, the home of Leon Golub and Nancy Spero), and walked it, in a procession, to the Canal Street Post Office. At the post office, those involved in the action "stood in line . . . and flaunted their packages, which included a papier-mâché bomb," a "disheveled papier-mâché Statue of Liberty," and an amusing napalm toilet seat by Golub. The post office staff—to the group's amazement—accepted

53. Art Workers' Coalition, *Mask of Lieutenant William Calley*, 1969.
Lithograph. 14 × 10 ¼ in.

everything, as if they were conscious of the symbolism of the action and their role as participants, but no one can confirm what was done with the materials afterward.[25]

On October 15, 1969, two AWC members, Jean Toche and Jon Hendricks—who was involved with Fluxus as well as with Happenings, through his directorship of the Judson Gallery during the mid-1960s—formed the Guerrilla Art Action Group (GAAG), in response to their belief that AWC was not committed or extreme enough to effect political change.[26] They saw those involved with AWC as too liberal, too willing to accept the art world status quo and its ability to mediate their dissent, and as too reluctant to sacrifice their identities as artists.[27] (A picket at the Guggenheim Museum, in which AWC's protest collapsed because participants suddenly left for lunch, was the breaking point for Hendricks and Toche.) On the contrary, GAAG explained that there was nothing it "wanted to get into museums," and it didn't want to submit to negotiations like other groups of the period.[28] For the most part, members said, GAAG would create public performances—which the group saw as politicized "Art Actions"—in appropriated, unrestricted spaces that would bring direct attention to human crises.[29] They saw these actions as the most effective means of protest, as Schneemann, Hoffman, and artists involved in Angry Arts Week had in years previous, and as increasing numbers of artists involved in antiwar engagement would in an art environment more and more influenced by performance or object-less works. Dore Ashton commented at the time that the greater employment of performative work was motivated by a sense of exasperation and futility that befell artists in the face of current events.[30] The appropriated, unrestricted spaces mentioned by GAAG were often museums, and as a result, GAAG is credited with being one of the first groups to bring 1960s artistic movements such as destruction art, conceptual art, and performance art into public spaces and encouraging others to do the same.[31]

GAAG's best-known action was *A Call for the Immediate Resignation of All the Rockefellers from the Board of Trustees of the Museum of Modern Art*, which occurred on November 18, 1969 (figs. 54–57), and which is better known as *Blood Bath*. The action used the issue of rape along with the pseudo-direct evidence of blood to draw attention to the war in Vietnam. It began when Hendricks and Toche and two women—Poppy Johnson and Sylvianna (the name filmmaker Sylvia Goldsmith chose to go by), who often participated in GAAG actions—entered MoMA with bags of beef blood taped to their bodies but hidden in their clothes. After one of them threw down one hundred copies of their statement, all the GAAG members started ripping at one another's

54. Guerrilla Art Action Group, *A Call for the Immediate Resignation of All the Rockefellers from the Board of Trustees of the Museum of Modern Art*, November 10, 1969. Photograph by Hui Ka Kwong. Courtesy Jon Hendricks.

clothes, puncturing the bags of blood and crying out gibberish and occasionally "Rape!" (Images of the event can be seen in figs. 54 and 55, the statement is presented in fig. 56, and a communiqué about the event is shown in fig. 57.) The blood exploded from the bags, staining the participants' clothes, the floor, and the statements. After a few minutes of further clothes-ripping, the artists then dropped to the floor, moaning and groaning, and the action shifted from what they described as "outward aggressive hostility into individual anguish."[32] Eventually the noises and movement stopped and all became silent. A crowd, which had gathered around the group at the museum, applauded, as if they watching street theater. Subsequently GAAG members got up from the floor, put their coats on, and left the building. The New York City police came eventually, but long after the artists left. While the final scene of the artists on the floor among their scattered statements suggested the iconic Haeberle image from My Lai, there is no confirmation that this was the artists' intention. What further discourages this interpretation is the fact that the performance was planned before the revelation of My Lai.

Though often ignored in historical discussions of the action, GAAG's statement was an important part of *Blood Bath* and helps clarify why the action took place at MoMA as well as how GAAG situated itself within the greater antiwar movement. The statement called for the immediate resignation of all Rockefellers from the MoMA board of trustees, because of their use of art as "a means of self-glorification" and "as a form of social acceptability," and their "use of art as a disguise, a cover for their brutal involvement in all spheres of the war machine."[33] They explained how Standard Oil, in which the Rockefeller family owned a 65 percent stake and which was a "special interest of David Rockefeller," leased one of its manufacturing plants to United Technology Center for "the specific purpose of manufacturing *napalm*." Second, they noted that Rockefeller Brothers owned 20 percent of the McDonnell Aircraft Corporation, "which has been deeply involved in *chemical and biological warfare research*." Third, GAAG explained that Chase Manhattan Bank (of which David Rockefeller was chairman of the board), McDonnell Aircraft Corporation, and North American Airlines ("another Rockefeller interest") were represented on the Defense Industry Advisory Council, which reported directly to the International Logistics Group and the International Security Affairs Division of

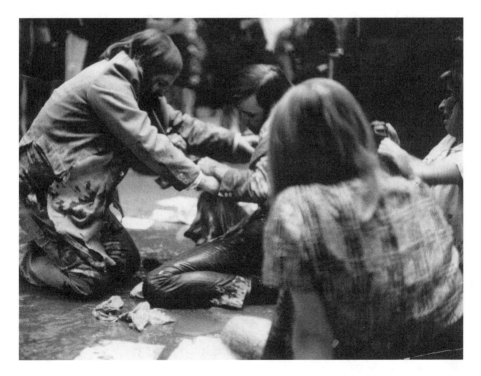

55. Guerrilla Art Action Group, *A CALL FOR THE IMMEDIATE RESIGNATION OF ALL THE ROCKEFELLERS FROM THE BOARD OF TRUSTEES OF THE MUSEUM OF MODERN ART*, November 10, 1969. Courtesy Jon Hendricks.

A CALL FOR THE IMMEDIATE RESIGNATION OF ALL THE ROCKEFELLERS FROM THE BOARD OF TRUSTEES OF THE MUSEUM OF MODERN ART

There is a group of extremely wealthy people who are using art as a means of self-glorification and as a form of social acceptability. They use art as a disguise, a cover for their brutal involvement in all spheres of the war machine.

These people seek to appease their guilt with gifts of blood money and dona- tions of works of art to the Museum of Modern Art. We as artists feel that there is no moral justification whatsoever for the Museum of Modern Art to exist at all if it must rely solely on the continued acceptance of dirty money. By accepting soiled donations from these wealthy people, the museum is destroying the integrity of art.

These people have been in actual control of the museum's policies since its founding. With this power they have been able to manipulate artists' ideas; sterilize art of any form of social protest and indictment of the oppressive forces in society; and therefore render art totally irrelevant to the exist- ing social crisis.

1. According to Ferdinand Lundberg in his book, The Rich and the Super-Rich, the Rockefellers own 65% of the Standard Oil Corporations. In 1966, according to Seymour M. Hersh in his book, Chemical and Biological Warfare, the Standard Oil Corporation of California - which is a special interest of David Rockefeller (Chairman of the Board of Trustees of the Museum of Modern Art) - leased one of its plants to United Technology Center (UTC) for the specific purpose of manufacturing napalm.

2. According to Lundberg, the Rockefeller brothers own 20% of the McDonnell Aircraft Corporation (manufacturers of the Phantom and Banshee jet fighters which were used in the Korean War). According to Hersh, the McDonnell Corporation has been deeply involved in chemical and biological warfare research.

3. According to George Thayer in his book, The War Business, the Chase Manhattan Bank (of which David Rockefeller is Chairman of the Board) - as well as the McDonnell Aircraft Corporation and North American Airlines (another Rockefeller interest) - are represented on the committee of the Defense Industry Advisory Council (DIAC) which serves as a liaison group between the domestic arms manufacturers and the International Logistics Negotiations (ILN) which reports directly to the International Security Affairs Division in the Pentagon.

Therefore we demand the immediate resignation of all the Rockefellers from the Board of Trustees of the Museum of Modern Art.

New York, November 10, 1969
GUERRILLA ART ACTION GROUP
Jon Hendricks
Jean Toche

56. Guerrilla Art Action Group, *A CALL FOR THE IMMEDIATE RESIGNATION OF ALL THE ROCKEFELLERS FROM THE BOARD OF TRUSTEES OF THE MUSEUM OF MODERN ART*, November 10, 1969. Courtesy Jon Hendricks.

COMMUNIQUE

Silvianna, Poppy Johnson, Jean Toche and Jon Hendricks entered the Museum of Modern Art of New York at 3:10 pm Tuesday, November 18, 1969. The women were dressed in street clothes and the men wore suits and ties. Concealed inside their garments were two gallons of beef blood distributed in several plastic bags taped on their bodies. The artists casually walked to the center of the lobby, gathered around and suddenly threw to the floor a hundred copies of the demands of the Guerrilla Art Action Group of November 10, 1969.

They immediately started to rip at each other's clothes, yelling and screaming gibberish with an occasional coherent cry of "Rape." At the same time the artists burst the sacks of blood concealed under their clothes, creating explosions of blood from their bodies onto each other and the floor, staining the scattered demands.

A crowd, including three or four guards, gathered in a circle around the actions, watching silently and intently.

After a few minutes, the clothes were mostly ripped and blood was splashed all over the ground.

Still ripping at each other's clothes, the artists slowly sank to the floor. The shouting turned into moaning and groaning as the action changed from outward aggressive hostility into individual anguish. The artists writhed in the pool of blood, slowly pulling at their own clothes, emitting painful moans and the sound of heavy breathing, which slowly diminished to silence.

The artists rose together to their feet, and the crowd spontaneously applauded as if for a theatre piece. The artists paused a second, without looking at anybody, and together walked to the entrance door where they started to put their overcoats on over the bloodstained remnants of their clothes.

At that point a tall well-dressed man came up and in an unemotional way asked: "Is there a spokesman for this group?" Jon Hendricks said: "Do you have a copy of our demands?" The man said: "Yes but I haven't read it yet." The artists continued to put on their clothes, ignoring the man, and left the museum.

NB:—According to one witness, about two minutes into the performance one of the guards was overheard to say: "I am calling the police!"

—According to another witness, two policemen arrived on the scene after the artists had left.

New York, November 18, 1969
GUERRILLA ART ACTION GROUP
Jon Hendricks
Poppy Johnson
Silvianna
Jean Toche

57. Guerrilla Art Action Group, *Communiqué*, November 18, 1969. Courtesy Jon Hendricks.

the Pentagon. Finally, GAAG faulted Rockefeller for the lack of political art at MoMA. The group argued that the family's "control of the museum's policies since its founding" allowed them to manipulate artists, evacuate art of social or political protest, and "render art totally irrelevant to the existing social crisis."[34]

Apart from *Blood Bath*, GAAG mobilized against the war through other actions. In an exploit concurrent with and quite similar to *Blood Bath*, members walked into the lobby of the Whitney Museum of American Art, dumped red-colored pigment on the floor, and then appeared to—with mops and sponges and a big bucket of water they brought along—in their words, "clean [the] place up," since "it is a mess from the war." People associated with GAAG who had been waiting in the museum then joined in to help the entering group. Yet GAAG only spread the "foaming red" mess further around the lobby, making it difficult for people to enter and move around the museum. (Members of the group also kept people away for safety reasons. They warned visitors that the floor was extremely slippery.)

GAAG hoped their action would help call attention to the fact that the Whitney had not closed in honor of the nationwide 1969 Moratorium. A leaflet they handed out arguably expressed this better. GAAG also made its way to a significant audience in the form of the Whitney's director of public relations, who approached the group about five minutes into the action.[35] He asked them what they were doing, and after talking about it briefly, he allowed them to leave without further trouble and without having to clean up their mess.

On January 3 and January 8, 1970, members of GAAG joined with some AWC participants and the Destruction in Art Symposium to stage a protest in front of *Guernica* at MoMA, which continued to bring attention to My Lai. On the third, the group held a memorial service "for dead babies murdered at Songmy and all Songmys." The service was led by Stephen Garmey, a chaplain from Columbia University, and it included passages from the Bible, poetry by Denise Levertov, and accounts of American soldiers killing Vietnamese children at My Lai, taken from the December 5 issue of *Life*. To further indicate the service to the museum-going public, funeral wreaths were placed under *Guernica*, the *And Babies* poster was held up, and Joyce Kozloff sat down on the ground (until she was told by the guards to get up), holding her eight-month-old baby, Nikolas, in her arms. On the eighth, the participants (most of them involved with AWC) lay down in front of *Guernica* for two hours, chanting "*Guernica, Guernica,* Song My, Murders, Murders," while others distributed, held up, and wore the *And Babies* poster on placards. In addition, a flier was distributed resurrecting the 1967 petition to remove *Guernica* that had been

sent to Picasso. The new petition, however, differed from the original. It was addressed to MoMA and stipulated that when the painting was removed, it should be replaced by "posters of the Songmy massacre until the cessation of hostilities in Viet Nam," or if this was not possible, *And Babies* posters should cover the wall facing the painting to constantly remind the world of the U.S. level of civilization.[36] MoMA ignored the petition. Nonetheless, those behind the petition continued to pursue the matter. They sent it out again to artists, critics, and art historians, asking them to write letters to Picasso; in all, 256 letters were collected.[37] Once more, the materials were hand-delivered by Irving Petlin to Michael Leiris in France. But again, no response was received from Picasso. Petlin maintains today that, as in the previous attempt, Picasso's inner circle kept the material from the artist. For instance, Petlin claims that Barr tapped his phone and sabotaged the petition from early on, contacting Picasso once he knew of the petition and telling him to ignore it.[38]

Antiwar works featuring depictions of dead American soldiers began appearing in 1969. The fact that such works surfaced so late in the course of artistic antiwar engagement resulted from the consistent appearance of dead Americans on television and in newspapers only after the Tet Offensive, and the fact that images of American war casualties had historically been kept from the American public. (This is still today the situation in the United States.) The depictions of these soldiers were mostly monochromatic and generalized because colorlessness alluded to lifelessness. In general, artists also did not want to create images that might be at all look similar to actual (serving or dead) American soldiers.

Two works in this genre, both of which also continue to engage with the idea of the war memorial, stand out: Duane Hanson's meticulously detailed *War* (also called *Vietnam Scene*) and Edward Kienholz's *The Non-War Memorial* (figs. 58 and 59). Hanson's work, which, like Kienholz's previous works, is in a German collection and is practically unknown to American audiences, consists of five soldiers, life-size and hyperrealistic like the artist's more familiar sculptures of overweight and unattractive 1970s and 1980s Americans.[39] Hanson arranged the soldiers on a large, dirt-covered tarp with nothing else added, creating a kind of non-space akin to that seen in Golub's paintings. The tarp and the men are painted entirely "army" green, except for the blood-red injuries of one of the men, who although wounded in the head and the stomach, is the only one of the four who sits up and appears to be alive. The rest of the men lie flat on the ground and have gaping holes in their torsos. Hanson's work is blunt. While not formally created as a memorial, the size and monochromatic presentation make it appear as one. In so doing, compared

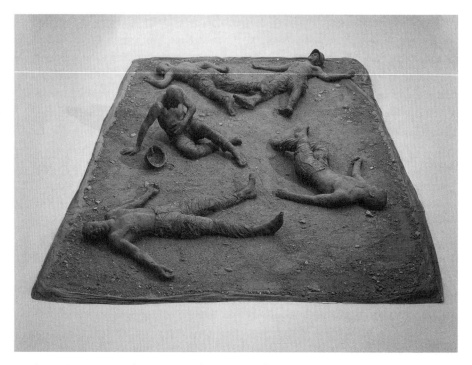

58. Duane Hanson, *War (Vietnam Scene)*, 1969. Installation with five figures, polyester resin and fiberglass, painted, different accessories. Approx. 77 × 550 × 355 cm. Art © Estate of Duane Hanson/Licensed by VAGA. Courtesy Stiftung Wilhelm Lehmbruck Museum, Duisberg. Photographer: Bernd Kirtz.

with historical memorials like the Iwo Jima memorial, the work deflates war death's heroism and the spectacular nature of more traditional monuments to remembrance. Hanson's soldiers are splayed in the dirt, divorced from any kind of illustrative, collective, or individuating context. They are merely trying to hold their bodies and lives together, and no grand rhetoric elevates their presence.

Kienholz completed his *Non-War Memorial* in 1970. Though less graphic than Hanson's work, Kienholz's piece similarly debunks the characteristic pageantry of war memorials. Planned but never fully executed—in this way it exists as one of Kienholz's many "concept tableaus"—the *Memorial* was to have consisted of fifty thousand surplus military uniforms filled with clay slurry. These uniforms would then be then spaced out randomly and laid down across a seventy-five-acre meadow near Clark Fort, Idaho.[40] According to curator and cofounder of the Ferus Gallery, Walter Hopps—a longtime friend of Kienholz's—the making of the work was to be a collective endeavor,

involving time donated by artists, students, and peace activists.[41] Neverthe-less, once finished, the work was not intended to endure like a historical me-morial, but to biodegrade and disappear. As Hopps explained, "In time, the uniforms would rot, [the] bodies [would] melt away, and wildflowers [would] grow on the site. Eventually the land would revert to alfalfa fields."[42] As a re-sult, the *non* in the title bore a twofold resonance: it stressed how atypical the work would look in contrast to traditional war memorials—since it was non-vertical and presented tens of thousands of soldiers' bodies in a field—and highlighted the fact that the memorial would eventually be *non* or *nothing*.

Part of the sculpture was *The Non-War Memorial Book*, printed in an edition of twenty-five, which recorded the elements of the sculpture for posterity. It contained photographs of each of the fifty thousand dirt-filled uniforms, laid out in twenty images per page. As an ephemeral memorial, *The Non-War Memorial* is a significant statement in the face of war and in the history of

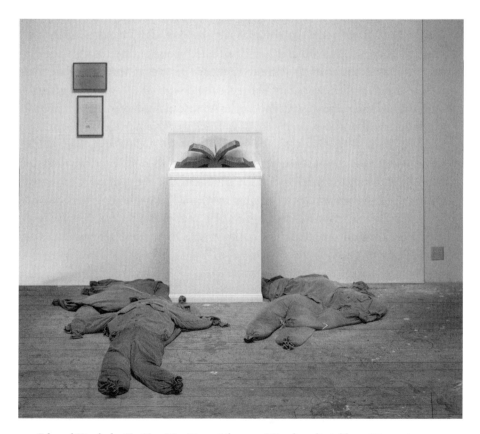

59. Edward Kienholz, *The Non-War Memorial*, 1970. Mixed media tableau. Dimensions variable. Collection of the artist. © Kienholz. Courtesy LA Louver, Venice, CA.

war memorials. War memorials are characteristically focused on concretizing memory and occupying the place of missing soldiers. *The Non-War Memorial* does concretize memory—by always having a written record of the piece— but its elimination of soldiers' bodies takes away from the traditional memorial's need to solidify life and assert the ever-present existence of the soldier's body.

Dead American soldiers did not have to be represented through bodies, but could also be referred to through other familiar containers or markers of death—such as coffins, body bags, and tombstones. The use of such objects sought—as in Hanson and Kienholz's works, and like protest works that juxtaposed body counts with images of war victims—to foreground the physicality of American soldiers' deaths in a society where death had been kept abstract, hidden in numbers or in images broadcast from a faraway land.

In May 1969, for instance, AWC participants and Artists and Writers Protest marched up Sixth Avenue to Columbus Circle carrying a group of body bags, on which they inscribed the totals of American as well as Vietnamese dead.[43] Those involved in the march also carried white cloth runners that stretched over a block in length and included names of the dead. Lucy Lippard, who was a part of the action, said that people on the streets were affected; they "threw flowers on the bags; even the police . . . were respectful."[44] Tombstones and coffins representing the American dead were present in posters and a few sculptures, such as in Kienholz's *Portable War Memorial* and Sam Weiner's *Those Who Fail to Remember the Past Are Condemned to Repeat It* of 1970. Weiner's work featured a group of coffins draped in American flags and installed in a fully mirrored room. The configuration of the mirrors connected the work to previous mirrored rooms by Yayoi Kusama and Lucas Samaras. Their infinite reflections of the coffins also proposed that the deaths would continue ad infinitum. Judging by the events of 1969 it seemed like they would.

7

The Invasion of Cambodia, the New York Art Strike, and Conceptual Art as Antiwar

AFTER THE MASSIVE OCTOBER 1969 Moratorium and the disclosure of the My Lai Massacre, it seemed that during the winter and spring of 1970 Nixon would do something to at least attempt to pacify the American antiwar movement. In fact, he did nothing. Instead, on April 30, Nixon further stoked dissent by announcing that he had expanded the Vietnam War into Cambodia. While the White House explained that the aim of Nixon's "incursion" was to eradicate communist strongholds and supply routes, the antiwar movement saw it as an illegal invasion, because regardless of North Vietnamese presence in the country, since 1954 Cambodia had maintained neutrality in the conflict.[1]

The *New York Times* called Nixon's actions a virtual renunciation of his pledge to end the war, and a number of protests broke out all across the United States, especially on college campuses.[2] Protests turned violent at Kent State in Ohio, where on May 4, national guardsmen killed four students and wounded nine others. A similar event occurred at Jackson State on May 14, when protests against the invasion—which also focused on racism, repression, and the inclusion of the experiences of women and minorities in the educational system—led to the killing of two students and the wounding of at least twelve others.[3] The shootings at Kent State and Jackson State led in turn to a sea of student protest across the country. In all, some four million students mobilized at half of the country's universities and colleges during the spring of 1970. Either because of the students' refusal to go back to classes or because of institutional fear of further violence, classes were canceled on

more than five hundred campuses across the country—that is to say, in excess of 80 percent of campuses in the United States. Approximately fifty schools closed their doors for the rest of the semester.

The New York art community reacted to Nixon's invasion through *The New York Art Strike Against Racism, War, and Repression*, the most significant extra-aesthetic action to occur in the United States during the Vietnam War, and what would be the largest collective protest action organized by American artists during the twentieth century (fig. 60). The Art Strike was a one-day strike of museums and galleries in New York City that took place on May 22, and it was specifically rooted in a protest against the invasion of Cambodia, the shootings at Kent and Jackson State, and the country's racial divide. (The name sometimes included "Sexism," too, and the strike sought to embrace this issue as well.) While the strike built on earlier Vietnam-era artist protest efforts—such as APC's *White Out* and the political engagement of those involved with AWC—its roots could be found more in an unprecedented torrent of labor revolt across the United States, and even more prominently, in shutdowns of the Jewish Museum and the Whitney by contemporary artists, motivated by the invasion of Cambodia and societal repression, during the weeks preceding the Art Strike. Artists involved in the Jewish Museum's *Using Walls* exhibition—Richard Artschwager, Mel Bochner, Daniel Buren, Craig Kauffman, Sol LeWitt, Robert Morris, and Lawrence Weiner—decided on the day of the opening by a majority vote to shut down their show (which was supposed to be installed from May 13 through June 21).[4] The resolution to close the exhibition was meant to highlight the fact that "the crash course [being] pursued by the administration would lead to a creative blackout," and to urge other cultural institutions "to take an unequivocal stance on the issue[s] of war, racism and repression"—hence the full name by which the Art Strike was eventually best known.[5] The museum negotiated with the artists and agreed to close the show on June 1.

At the Whitney, Robert Morris, who in 1968 denied any interest in politics, suddenly ended his one-person exhibition almost two weeks before it was scheduled to close, in an act inspired by the Jewish Museum artists.[6] In a statement Morris composed for the Whitney trustees and the press, he explained there was a "need . . . to shift priorities at this time from art making or viewing . . . to unified action within the art community against the intensifying conditions of repression, war, and racism in this country." Echoing the Jewish Museum artists, Morris asked that the Whitney "take an unequivocal stand on these issues" by stating its position, suspending "all normal cultural functions" for two weeks, and during the two weeks, making staff and space

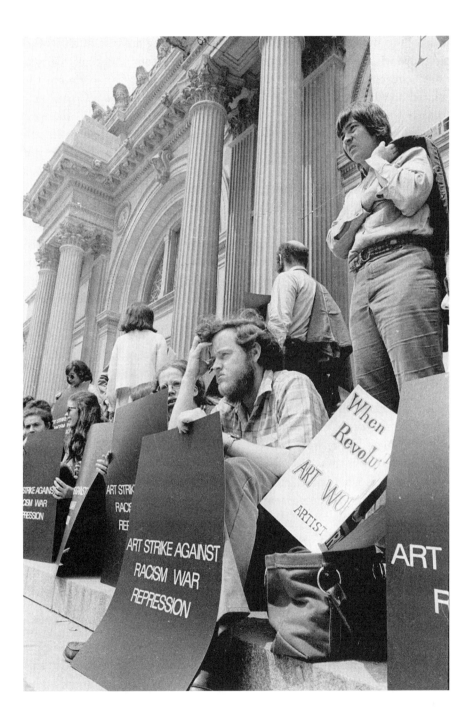

60. Jan Van Raay, photograph of *The New York Art Strike Against Racism, War, and Repression* outside the Metropolitan Museum of Art on May 22, 1970. 35mm black-and-white image, size variable.

available to have meetings open to every level of the art community. Morris ended with the following threat against the museum: "A lack of vigorous positive response to these . . . issues can only be interpreted as condoning the militarist and repressive policies which the faculty of the School of Visual Arts and participants in the current Jewish Museum show have publicly abhorred. Beyond this a reassessment of the art structure itself seems timely—its values, its policies, its modes of control, economic presumptions, its hierarchy of existing power and administration—with the view of changing that which is outmoded and corrodes our lives as people and artists."[7]

Although influenced by the actions of the *Using Walls* artists, Morris's thinking was also in line with previous actions taken by factions of AWC, and the general societal movement toward strikes by students and organized labor.[8] Morris's actions, like Andre's sculptures, have also been linked to Herbert Marcuse's theory of a "Great Refusal"—that is, "the negation of the entire establishment" outlined in his 1969 *An Essay on Liberation*.[9] Marcuse saw hopeful indications that this refusal was undermining mainstream society in the late 1960s, especially in the widespread "collapse of work discipline, slowdown, [the] spread of disobedience to rules and regulations, wildcat strikes, boycotts, sabotage, [and] gratuitous acts of noncompliance."[10] Julia Bryan-Wilson has recently commented that another possible motivation for Morris's decision to shut down his own show was that his exhibition's foregrounding of artistic labor—in a collaborative production with a team of dozens of workers—no longer had resonance in the United States. Labor riots in New York City, in which hardhat construction workers attacked antiwar protestors, had severed the connection the leftist world had been trying to forge with organized labor. (This was an outcome of Nixon's strategy of giving voice to the silent majority.) Beforehand, Morris and other artists like Richard Serra had been pronouncing such a connection.[11] As a final note, what was included inside the walls of Morris's exhibition has been conceived as rejecting the state of the country and relating to Morris's cancellation. Because Morris's process or "anti-form" installation valorized labor and democratic creation through its participatory nature and the use of construction equipment in the creation of the exhibition, it has been read as being predicated on the New Left's broader sociopolitical foundation, which was also committed to overturning the commodity-based dynamic of modernist culture and capitalism. In this way, Maurice Berger comments that "the nature of the New Left, summarized in a single word . . . [was] process. It signals an almost religious return to *experience* . . . [and a] retreat from the abstractions of the red politics of yesterday . . . rhetorical repetition, procedural debate, moral invitations to kindness

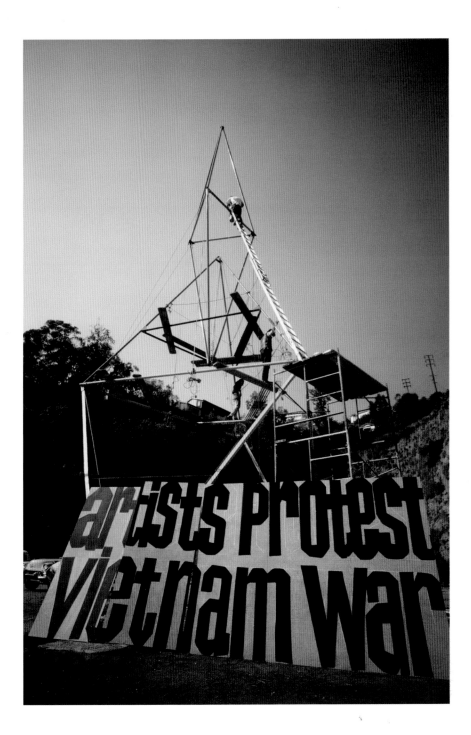

Charles Brittin, *PHOTOGRAPH OF THE ARTISTS' PROTEST COMMITTEE ARTISTS' TOWER OF PROTEST*, Los Angeles, 1966. Silver dye bleach print, chromogenic process. Charles Brittin Archive, Getty Research Institute. Used with permission.

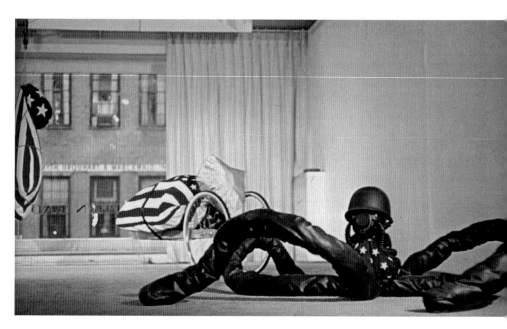

Installation view of Marc Morrel flag works at the Stephen Radich Gallery, December 1966. Courtesy Marc Morrel and *Art in America*.

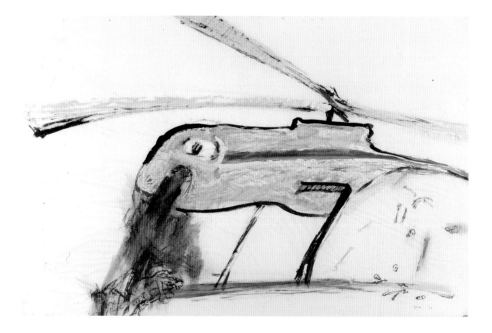

Nancy Spero, *Gunship*, 1966. Gouache on paper. Framed: 27 ½ × 39 ½ in. (69.9 x 100.3 cm). Art © Estate of Nancy Spero/Licensed by VAGA, New York. Courtesy Galerie Lelong, New York.

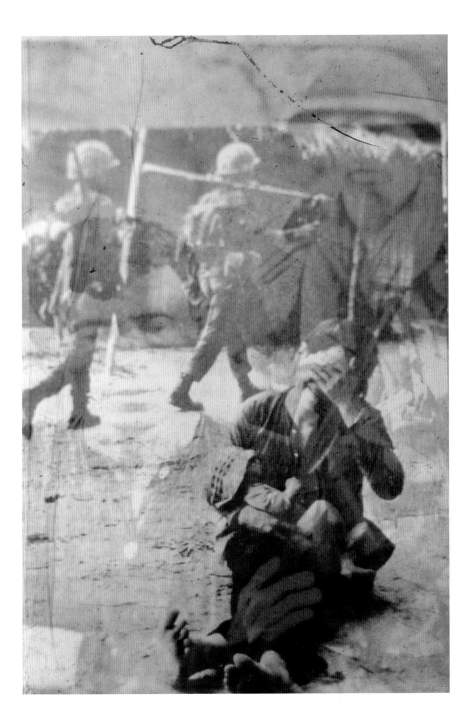

Carolee Schneemann, *Viet-Flakes*, 1965. Film still from DVD of original toned B&W 16mm film. © Carolee Schneemann.

Martha Rosler, *Red Stripe Kitchen*, from the series *Bringing the War Home: House Beautiful*, 1967–1972. Photomontage. © Martha Rosler.

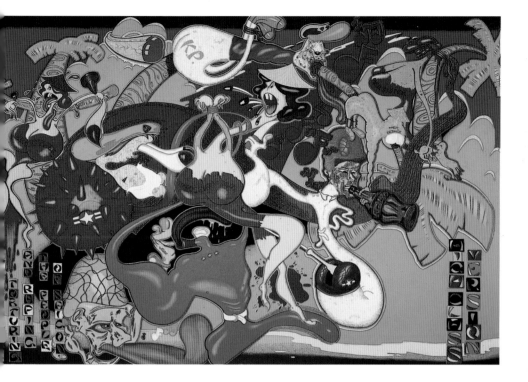

Peter Saul, *Saigon*, 1967. Enamel, oil, and synthetic polymer on canvas. 92 ¾ × 142 in. (235.6 × 360.7 cm). Whitney Museum of American Art; purchased with funds from the Friends of the Whitney Museum of American Art 69.103. Photograph by Sheldon C. Collins.

Michele Oka Doner, *Death Masks*, 1967. Ceramic, four pieces. 6 × 6 × 3 in. each. Collection: Stephanie Freed, Miami Beach. Photo: D. James Dee.

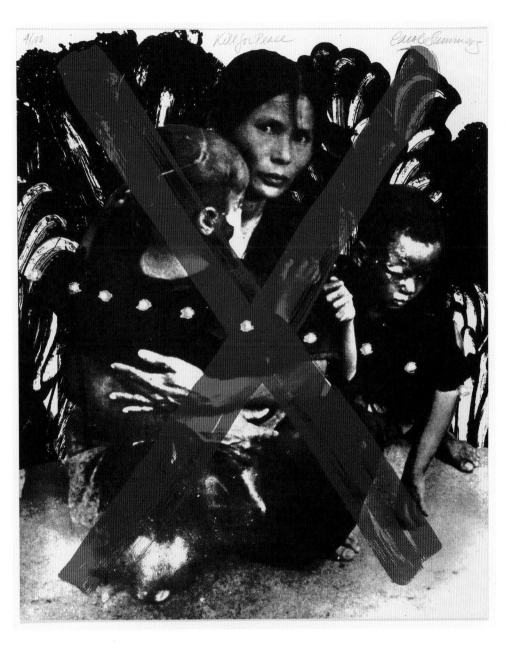

Carol Summers, *Kill for Peace*, from *Artists and Writers Against the War in Vietnam*, 1967. Screenprint with punched holes. Composition: 23⁵⁄₁₆ × 19³⁄₁₆ in. (59.2 × 48.7 cm); sheet: 23⁵⁄₁₆ × 19³⁄₁₆ in. (59.2 × 48.7 cm). Publisher: Artists and Writers Protest, New York. Printer: unknown. Edition: 100. Digital Image © Museum of Modern Art/Licensed by SCALA/Art Resource, New York.

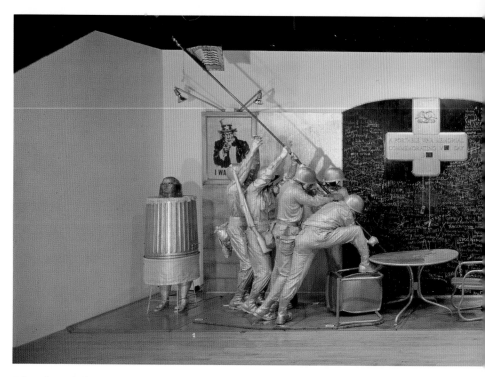

Edward Kienholz, *The Portable War Memorial*, 1968. Mixed media tableau. 114 × 384 × 96 in. (289.6 × 975.4 × 243.8 cm). Museum Ludwig, Cologne. © Kienholz. Courtesy L.A. Louver, Venice, CA.

May Stevens, *Big Daddy Paper Doll*, 1970. Acrylic on canvas. 72 × 168 in. (182.9 × 426.7 cm). Brooklyn Museum, Gift of Mr. and Mrs. S. Zachary Swidler, 75.73. © May Stevens.

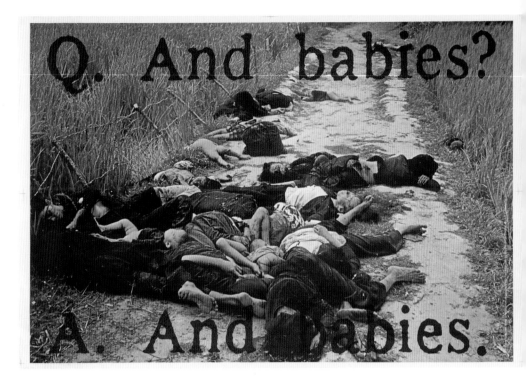

Artists' Poster Committee of Art Workers' Coalition: Frazier Dougherty, Jon Hendricks, and Irving Petlin, *Q. And babies? A. And babies*, 1970. Photographer: R. L. Haeberle. Offset. 63.5 × 96.3 cm (25 × 37 ¹⁵⁄₁₆ in.). Courtesy of the Center for the Study of Political Graphics.

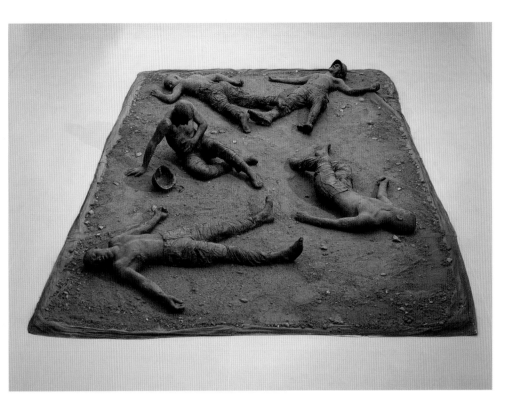

Duane Hanson, *War (Vietnam Scene)*, 1969. Installation with five figures, polyester resin and fiberglass, painted, different accessories. Approx. 77 × 550 × 355 cm. Art © Estate of Duane Hanson/Licensed by VAGA. Courtesy Stiftung Wilhelm Lehmbruck Museum, Duisberg. Photographer: Bernd Kirtz.

Leon Golub, *Vietnam II*, 1973. Acrylic on linen. 120 × 480 in. Art © Estate of Leon Golub/ Licensed by VAGA, New York. Courtesy Ronald Feldman Fine Arts, New York.

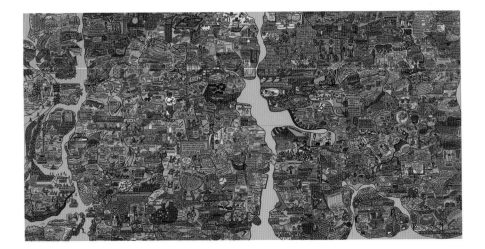

Öyvind Fahlström, *World Map*, 1972. Acrylic and India ink on vinyl mounted on wood. 91.5 x 183 cm. Private collection. © 2011 Sharon Avery-Fahlström.

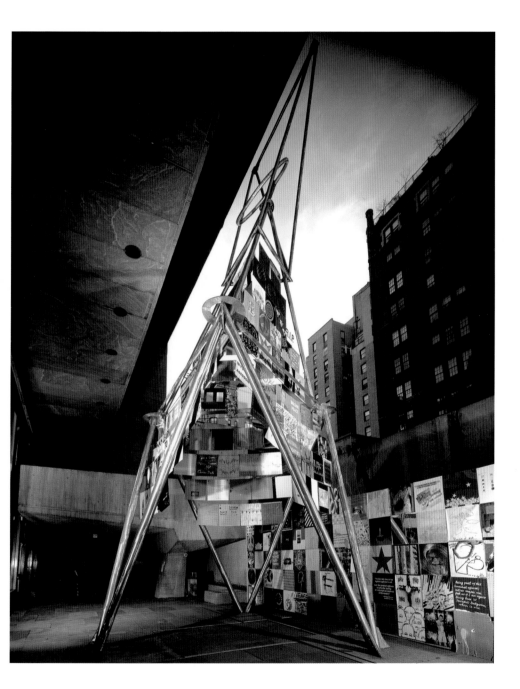

Mark di Suvero and Rirkrit Tiravanija, *Peace Tower*, 2006. Mixed media. © Mark di Suvero.
Courtesy Paula Cooper Gallery, New York. Installation view at Whitney Biennial 2006: Day
for Night, Whitney Museum of American Art.

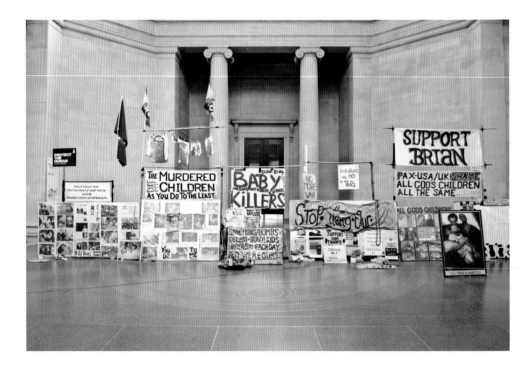

Mark Wallinger, *State Britain* (detail), 2007. Mixed media installation. Approx. 570 cm × 190 cm × 43 m. Installation at Tate Britain, 2007. © Mark Wallinger. Courtesy Anthony Reynolds Gallery, London. Photograph by Dave Morgan.

and equality were all part of the process of community building, a psycho-political experience in which duration played a purgative part in transform-ing traditional political interactions into what was described as 'movement behavior.'"[12]

In this way, Morris reflected other lessons of Marcuse, especially in his call for "liberated work" whose instinct is "cooperation, which grounded in soli-darity, directs the organization of the realm of necessity and the development of the realm of freedom."[13] Morris's stipulation that all the materials would be acquired "on loan"—that is, cycled back into the economy of construction after the exhibit was taken down as untransformed materials, and that the economic value of the show cost no more than the value of the materials—is understood much like Andre's work, as a "liquidation" of the commodity na-ture of the art object.[14]

Interpretive efforts to connect Morris's strike to his work have repeated-ly ignored a series of five 1970 prints he made that directly referenced the war. These five representational prints were a definite departure from the concep-tual work of the Whitney show and reflected a return to an outright reference to war in Morris's work, which had been unseen since the early 1960s (when he made a series of drawings titled *Crisis* that responded to the harrowing events of the Cuban Missile Crisis).[15] The representational nature of this work is arguably the main reason it is often glossed over. Titled *Five War Memorials*, these prints present, like the work of Kienholz, Hanson, and Flavin, examples of advance memorials (fig. 61). Phrased between the language of minimalism and earthworks—and in certain respects very much like Maya Lin's eventual national memorial to the war—Morris's concepts for monumental memori-als visually testify to the emptiness that remains after a war, and at the same time serve as sites for personal or societal reflection. Three out of the five prints are at the same time contemplations of twentieth-century weapons of mass destruction: a triangular lead brick wall housing scattered atomic waste; an enormous smoking crater, which suggests an eternal testimony to a mis-sile or bomb attack; and a cross dug out into trenches filled with chlorine gas. Morris's remaining two memorials were a half-mile-wide concrete star sur-rounded by a stainless steel bar that listed the names of the war dead (which, again, uncannily resembled Lin's eventual memorial); and an infantry archive to be walked on barefoot that is oddly similar to Carl Andre's floor pieces.

Initially the Whitney refused Morris's demands. Yet after Morris threat-ened a sit-in, the museum capitulated and closed his exhibition on May 17.[16] This triumph—the heroic cancellation of a crowning one-person exhibition at one of the most prominent museums in the world—propelled Morris to the

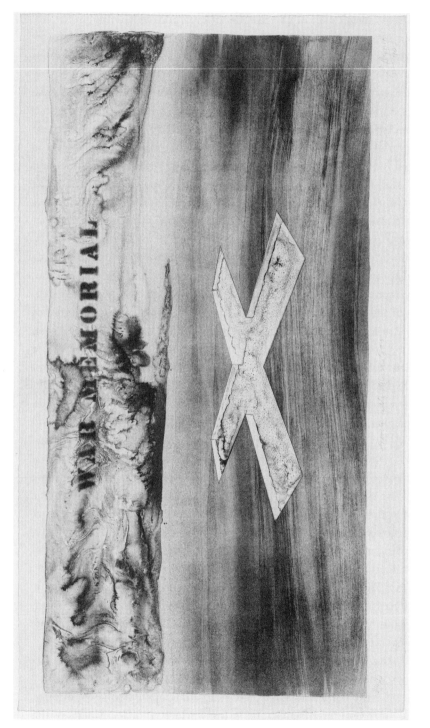

61. Robert Morris, *Trench with Chlorine Gas*, from *Five War Memorials*, 1970. Lithograph, 24³⁄₁₆ × 42½ in. Whitney Museum of American Art, New York. Purchased with funds from Print Committee 2003. 108.1. © Whitney Museum of American Art 2012. Robert Morris/Artists Rights Society (ARS), New York.

front of New York activist artist circles, even though he had not been involved in them at all before that point. Not everyone was happy about it. While his name was allegedly "on everyone's lips," stickers appeared all over downtown New York that read "Robert Morris: Prince of Peace," mocking his sudden political awakening.[17] (Exactly who these dissenters were is unknown.)

A massive New York art world strike to protest Cambodia and the shootings at Kent and Jackson State, on the heels of the Whitney and Jewish Museum walkouts, was first formally proposed by the School of Visual Arts faculty immediately after the Kent State shootings. (Morris alludes to this fact in his demands of the Whitney.) The idea spread quickly and led to the SVA faculty's organization of a mass meeting that ballooned to one to two thousand attendees and took place the day after Morris's show was closed, at New York University's Loeb Student Center on May 18, 1970. At the Loeb Center, speeches by Morris, Poppy Johnson, Andre, Petlin, and other representatives from AWC, AWP, and the Student Committee of Artists United discussed a range of strike options.[18] Eventually the crowd elected Morris and Johnson (who were linked romantically at the time) as its cochairs and agreed on four resolutions.[19]

The four resolutions were as follows. First, the Art Strike would seek a "cultural blackout" in New York: the closure of all the major New York museums and many of the influential galleries, as well as the suspension of artists' production of objects for one day (and possibly extending the closing for two weeks). Second, the strike would establish an "emergency cultural government . . . to sever all collaboration with the Federal Government on artistic activities." Third, artists would use the ground floors of galleries and museums "to help politicize visitors." And fourth, 10 percent of the sale of every artwork made would go toward a fund for "peace activities."[20] Morris and Johnson concluded that they saw art as the fig leaf of American life—a cover for the U.S. war machine. Removing the leaf would starkly expose the government's wrongs as well as express the art world's refusal to be associated with government-linked art institutions.[21]

The night after the meeting at the Loeb Center, a small steering committee met at Yvonne Rainer's loft and hammered out a more definite course of action.[22] The strike would focus on closing down the five major New York museums: the Met, the MoMA, the Whitney, the Guggenheim, and the New York Cultural Center. Letters would be hand-delivered to each institution, stating the Art Strike's intentions. Two days later, on May 21, the committee decided that if any of these museums did not close, the organization would protest one museum at a time. The committee decided not to protest all the museums at once in order to not dissipate the strength of their activity.

The museums demonstrated mixed reactions to the Art Strike demands. On the day of the strike, the Jewish Museum and the Whitney sympathized the most. On the twenty-second, they both closed for the day. The Whitney even designated a wall on its ground floor for peace information, during and beyond the day of the strike, and they hung Peter Saul's *Saigon* (fig. 29, ch. 4) next to an antiwar petition signed by the staff. The Guggenheim stayed open, but as a concession offered free admission. Additionally, in a slightly paranoid move, the museum removed all art from its galleries, fearing damage. Director Thomas Messer explained that the museum's decision should not be misinterpreted: "The museum has always stayed clear of political issues. . . . Empty walls are in themselves a sobering comment on violence and coercion of every kind."[23]

Like the Guggenheim, MoMA stayed open for free, and took several actions it believed would satisfy the strike. At the request of Frank Stella (mobilized to political action again as he had been in relation to the *Peace Tower*), they closed his exhibition, and they allowed Jo Baer and Robert Mangold to remove works they had on view for the month of May. MoMA also set up information centers on the war in the lobby and the garden, screened a film on the bombing of Hiroshima and Nagasaki, and organized an exhibition of photographs of recent antiwar events such as the Kent State protest. Despite these concessions, Director John Hightower took the opportunity to harshly criticize the Art Strike. He called its demand that museums close repressive and even compared their actions to those of Hitler and Stalin and the Soviets' suppression in Czechoslovakia. He also commented that the Art Strike's demands would delight "those people in the United States . . . most responsible for repression . . . [that the strikers] . . . are striving so hard to resist."[24] The Art Strike actually responded to Hightower with a letter that spoke to each of his criticisms. GAAG sent a response, too—a cable telling Hightower to hold a press conference where he should confess his guilt while pouring a gallon of blood over his head.[25]

Like MoMA and the Guggenheim, the Met refused to close for the strike. In a provocative move, it pushed back its closing time from 5 p.m. to 10 p.m., believing access to the museum after-hours to be a more constructive move than a strike. As a result, the Art Strike decided to visibly protest the Met. Five hundred strikers showed up at the museum on the day of the strike. They carried signs, handed out pamphlets and statements against the war, and blocked the building's monumental front entrance for the entire twelve-hour day the museum was open. Their actions cut attendance from the usual four thousand to sixteen hundred people—and those sixteen hundred made

it in only because the museum eventually opened its side doors. The strikers prompted the Met to close its galleries of European paintings because, like the Guggenheim, the museum believed there could be vandalism. This occurred even amid "a vote of good faith" by the strikers—which was communicated to the museum and to the press—"that they would not allow the destruction of works of art or of anything else."[26] The majority of the art media—almost all of which were involved with the strike—wrote of the Art Strike as an "immense success."[27] It was the largest statement yet in New York of artists' ability to influence the mainstream art world and its institutions, and it included an unprecedented cross-section of the art world, unseen in previous protests.

After the Art Strike, Morris, Petlin, Stella, and Max Kozloff, working as the Emergency Cultural Government (ECG)—a group formed at the Loeb Center meeting—sought to extend the momentum of the strike by attempting to organize a boycott of the Venice Biennale, which AWP had attempted but failed to do in 1968.[28] The ECG called on all artists who had been invited to participate in the American Pavilion to withdraw their work from the exhibition to protest, as the Art Strike had done, "against the U.S. government's policies of racism, sexism, repression and war."[29] In response, twenty-six of the thirty-three artists who had originally been scheduled to exhibit withdrew their works.[30] The State Department strongly opposed the withdrawal. When informed of the impending boycott, they tried to stop the ECG by stipulating that each artist could only withdraw individually. This had little effect, and when the government realized it, it surreptitiously added new names to the list to conceal the mounting absences from the public.[31] Eventually, the State Department could not field a complete roster of artists and decided to exhibit works by artists they were able to retain and then install a poster in the exhibition space that explained that some artists had withdrawn and the State Department accepted their dissent.[32]

On July 22, back in the United States, the ECG organized an alternative Biennale of works at the SVA to showcase artists who declined to be involved in the Venice exhibition. Ironically, controversy plagued this exhibition as well. It was attacked for being racist, sexist, and ageist because it included only the white male artists who were originally slated for the Biennale.[33] The group Women Students and Artists for Black Art Liberation (WSABAL) led this attack and demanded that in order to best represent working artists, the show should include half African Americans, half women, and a quarter students.[34] WSABAL also rejected the SVA as a site for the exhibition, claiming that the institution was racist. In response, the alternative Biennale eventually became an open call, available for any artist's participation. It was also moved

to Museum: A Project for Living Artists. Museum had been founded in 1968 by eight artists, including Arthur Hughes, Gary Smith, Sharon Brant, and Robert Resnick. According to Julie Ault, a former member of the art collective Group Material and a historian of New York alternative art, Museum was "governed by artists and intended as a communication and community center with social, aesthetic, and political fluidity. The agenda was to make available services, facilities, a meeting place, a social environment, information and exhibition space. The organization's stated goal was to forge a more alive connection between art and society, without the dissipation of force and quality occurring so frequently in the current art establishment."[35] Unfortunately, in the course of the show's movement to Museum, many of the original artists dropped out. Then, for unknown reasons, works were stolen from Museum. This prompted the removal of the rest of those works originally included in the Biennale and soon thereafter the closing of the entire exhibition.[36]

Apart from the Biennale protest, the energy of the Art Strike quickly vanished from the New York art world. The strike's lack of a developed ideological program—other than a broad strike—made it collapse "under the weight of dissension and disagreement," in the words of Maurice Berger.[37] Outside the strike, a few peace activities were organized during the successive months of 1970. One was the exhibition *My God! We're Losing a Great Country*, held at the New School for Social Research during the month of June.[38] Another was the organization of the *Peace Portfolio*, an original print portfolio of twelve nonobjective abstract prints published in an edition of 175 and sold by the Academic and Professional Action Committee for a Responsible Congress in order to raise money for the politics of peace.[39] The artists involved in the project were Allan d'Arcangelo, Herbert Ferber, Adolph Gottlieb, William Stanley Hayter, Lee Krasner, Ibram Lassaw, Motherwell, George Ortman, Rauschenberg, Saul Steinberg, Esteban Vicente, and Larry Zox. Harold Rosenberg wrote the introduction. In it he explained how—in line with his beliefs regarding the division between politics and art—the abstract artists included were relieving "their frustration" over current events by making art that supported the antiwar movement as benefit works. In this way, Rosenberg argued that artists were no longer creating "mollifying" works but ones that could "act" for them "by being translated into cash." (Rosenberg's use here of "act" recalls his concept of "action painting," and the existential struggle it was conceived to emphasize.) According to Rosenberg, "The politics not in the works themselves can be introduced by the way the works are disposed of. The sale of this portfolio is an instance of genuine artist–audience collaboration. Through it art overcomes its silence by placing megaphones in the hands of peace candidates."[40]

Unfortunately, it was only toward the end of the war that the antiwar movement was given this explanation, its best definition to date of benefit work.

On the whole, when conceptual art was emerging into a recognizable movement during the late 1960s, its radical, often ephemeral, anti-institutional, systems-based works were rarely regarded as being socially aware or antiwar. In this way, like the dominant formalist, pop, and minimalist movements preceding it, and though there were exceptions like Luis Camnitzer, Liliana Porter, and the New York Graphic Workshop, politically speaking, conceptual art was highly ambiguous. Conceptual artists tended not to incorporate war themes into their work, and even with their anti-institutional stance, these artists made it clear that they could exist only because of art institutions.[41] In this respect, Lucy Lippard explained, "While trying to escape the frames imposed by convention and market, [conceptual] artists nevertheless made framing their prime device for self-containment. The only way they could maintain their 'art function' in the wide-open context they desired was to put an art framework over life. They did so in ways that blew the definition of art in many directions and in the process they also defined the limits of art."[42] Nevertheless, there are two examples of conceptual work that were understood as engaging with the war at the time they were made: Hans Haacke's *MoMA-Poll* (called also *Visitor's Poll*) of 1970 (fig. 62) and On Kawara's ONE THING-1965-VIET-NAM of 1965.

Haacke's *MoMA-Poll*, featured in Kynaston McShine's *Information* at MoMA in 1970, is the major example. It is one of the foundational moments in postwar institutional critique, because it provided a route through which conceptual work could be politically engaged. *Poll*—whose details were unknown to McShine and MoMA trustees until the exhibition was installed—consisted of color-coded ballots, which indicated the visitor's income, and two clear boxes, labeled yes and no, rigged with electronic counting devices.

MoMA asked visitors to drop a ballot in the appropriate box to answer the following question: "Would the fact that Governor [Nelson] Rockefeller has not denounced President Nixon's Indochina policy be a reason for you to not vote for him in November?" Rockefeller was not only a member of the founding family of the museum and already a subject of critique from groups like GAAG and AWC (with which Haacke was involved), he was also a high-profile member of the MoMA board of trustees and was running for reelection as governor of New York in 1970.

The *Poll* achieved three things, through what Haacke would call a "real-time system."[43] First, by asking a decidedly leading question that immediately questioned Nixon's policies, it denounced the war. Second, by outlining

62. Hans Haacke, *MoMA-Poll*, 1970. Two transparent acrylic boxes, photoelectric counting devices, paper ballot boxes. 101.5 × 51 × 25.5 cm each. © Hans Haacke/Artists Rights Society (ARS), New York. Courtesy Paula Cooper Gallery, New York.

Rockefeller's simultaneous positions as member of MoMA's board, governor, and someone associated with the various Rockefeller companies (which had in turn been connected to the production of weapons for the war), the poll made links between the museum and the war overt.[44] Third, the poll pressed MoMA visitors to voice their sentiments, transforming the passive art audience into active citizens. Final results of the poll were approximately two to one against Rockefeller (25,566 yes, 11,563 no), though Haacke afterward alluded to the fact that MoMA did not follow his instructions for the work carefully. If they had, he said, there would have been even more *yes* votes.[45]

Not often discussed in relation to the *MoMA-Poll* is the harsh press reaction to the work from both conservatives and constituencies allied with conceptual art. On the conservative side, Emily Genauer wrote in the *New York Post*, "One may wonder at the humor (propriety, obviously, is too archaic a concept even to consider) of such poll-taking in a museum founded by the governor's mother, headed now by his brother, and served by himself and other members of his family in important financial and administrative capacities since its founding 40 years ago."[46] Haacke took note of Genauer's comments and responded as follows:

> With this little paragraph [Genauer] provided some of the background for the work that was not intelligible for the politically less-informed visitors of the museum. She also articulated feelings that are shared by the top people at numerous museums. It goes like this: We are the guardians of culture. We honor artists by inviting them to show in "our" museum, we want them to behave like guests, proper, polite and grateful. After all we have put up the dough for this place. . . . Information presented at the right time and in the right place can be potentially very powerful. It can affect the general social fabric. Such things go beyond established high culture as it has been perpetrated by a taste-directed art industry. Of course I don't believe that artists really wield any significant power. At best, one can focus attention. But every little bit helps. In concert with other people's activities outside the art scene, maybe the social climate of society can be changed.[47]

Hilton Kramer, never one to applaud contemporary art, went further than Genauer. He saw the poll and the exhibition as a whole as a new low point for MoMA. He called *Information* "unmitigated nonsense . . . tripe . . . an intellectual scandal."[48] Even Gregory Battcock, usually a champion of conceptual art, wrote critically about the show in *Arts*. "Protest, not art, was a loser in this particular fight," he said. He was particularly concerned by how the

museum space neutralized protest works.[49] Julia Bryan-Wilson has recently read Battcock's comments through those of Marcuse, whose writings Battcock drew from at the time.[50]

Some AWC participants were also unhappy with *Information*. Concurrent with the Art Strike, they protested outside the museum and distributed a flyer which read as follows:

> INFORMATION! INFORMATION! . . . 1) You are involved in the murderous devastation of S.E. Asia, 2) You are involved in racism, in persecution of Young Lords and Black Panthers, 3) You are involved in discrimination and exploitation of women, 4) You are involved in political repression at home, 5) You are involved in the support of fascist dictators abroad, 6) You are involved in these crimes, committed in your name by your government. . . . YOU ARE INVOLVED UNLESS YOU STOP IT! . . . The museum is also involved, that is what we want to change, That is why we are here.[51]

In this way the pamphlet labeled conceptual practice as apolitical, and MoMA as ignorant of its own identity. The AWC participants then provided their own kind of information to the museum and artists in order for them to gain awareness.

On Kawara's three-part canvas, *one thing-1965-viet-nam* of 1965 is the other significant instance of late 1960s engaged conceptualism. Kawara's work consists of three uniformly covered, magenta canvases. The middle canvas is slightly bigger than the two flanking it, and text in capital letters is centered in the middle of each canvas. On the left canvas it reads, "ONE THING." On the middle canvas it reads, "1965." On the right canvas it reads, "VIET NAM." Kawara's consciousness of the war is reinforced in the light of Kawara's series of *Today* paintings, which the triptych initiated (though it is not considered part of them). The series chose to concentrate on daily events, and through their "subtitles" and accompanying newspaper clippings highlight hundreds of significant historical occurrences. As such, against the backdrop of the multitude of important events in later years, the one event, the "one thing" of note for Kawara in 1965, was the war. Kawara's conceptual political engagement was rooted in his initial, much more outspoken paintings. His 1954 Tokyo exhibition, for instance, included paintings of grotesque and ravaged bodies only two years after U.S.-imposed postwar censorship laws were lifted in Japan.

Kawara's postwar grotesques unfortunately had parallels with other artists' ways to capture the events of 1970 and, sadly, those of the following year.

8

Toward an End

DURING 1971, PUBLIC SUPPORT of the Vietnam War continued to deteriorate even further. The initial printing of parts of the Pentagon Papers on June 13, 1971, in both the *New York Times* and the *Washington Post* was a major factor. The Papers (leaked to the newspapers by former RAND employee and Papers contributor Daniel Ellsberg) were a top-secret chronicle of American decision making during the entire course of the conflict. They demonstrated that the Johnson administration had consistently lied about the state of the war to both the American public and to Congress. When the Papers first appeared, the government won a court order restraining any continued publication of them. Then newspapers other than the *Times* and the *Post* published excerpts. For a brief period these efforts were restrained as well. Yet on June 30, 1971, the U.S. Supreme Court ruled that newspapers could continue to print the Papers. The public quickly came to know about them. H. Bruce Franklin has called the disclosure of the Papers "an earthquake that demolished all the official narratives, revealing the shameful swamp of lies on which [the war had] been constructed."[1]

Increasing reports of disillusionment among troops further eroded support for the war. Because the U.S. Armed Forces made it virtually impossible for soldiers to demonstrate, write, or petition against the war, this disillusionment surfaced through a number of actions that could interfere with the war: drug use (primarily marijuana and heroin), desertion, the shirking of duties, sabotage, self-inflicted injury, atrocities committed against civilians, or the killing of officers who ordered hazardous missions or who were considered

inept, which was called "fragging." Fragging incidents had a particularly damaging effect on the armed forces, since officers took the threat of them seriously and as a result were less and less willing to compel their soldiers to follow them or their other superiors.

Vietnam Veterans Against the War's February 1971 organization of the *Winter Soldier Investigation* in Detroit devastated domestic opinion of the war. As a means of protest, roughly 150 veterans publicly discussed incidents of violence that they or other soldiers had committed in Vietnam. The name "Winter Soldier" was a response to Thomas Paine's pamphlet of 1776, in which he wrote, "These are times that try men's souls. The summer soldier and the sunshine patriot will, in this crisis, shrink from the service of their country." The term winter soldier, as a result, asserted the loyalty of these soldiers who were damaging the reputation of the American armed forces. During the investigation, the media paid little attention, but when Republican senator Mark Hatfield of Oregon introduced the VVAW's entire testimony into the *Congressional Record*, the story was covered nationally.

As a follow-up to the *Winter Soldier Investigation*, VVAW staged *Operation Dewey Canyon III* from April 19 to 23 at the U.S. Capitol. Dewey Canyon I and II were invasions into Laos that had taken place in 1969 and 1970. During *Dewey Canyon III*, alongside the group Gold Star Mothers, whose sons were killed in Vietnam, VVAW performed skits, spoke to passersby, illegally camped on the National Mall, tried to turn themselves in as war criminals, and, in the most dramatic part of the "operation," organized some eight hundred veterans in front of barricades to keep people off the Capitol steps and one by one tossed their Bronze Stars, Silver Stars, Purple Hearts, and campaign ribbons at the Capitol. Millions of Americans watched television coverage of the spectacle. The day before, John Kerry, a highly decorated veteran and one of VVAW's leaders, spoke in front of Congress. This event launched Kerry's subsequent political career.[2]

By the middle of 1972, Nixon pushed for negotiations with the North Vietnamese to progress further. By October it seemed that Kissinger and DRV representatives Xuan Thuy and Le Duc Tho had established a preliminary peace treaty draft.[3] Yet the leaders in Saigon, especially President Nguyen Van Thieu and Vice President Nguyen Cao Ky, rejected the Kissinger–Tho proposal, demanding that no concessions be made. In December 1972, Nixon unleashed the most concentrated air assault in the history of the war—what would later be called the "Christmas bombings"—against Hanoi and Haiphong, in order to pressure the peace proceedings to conclude.[4] Though the press reacted with outrage to Nixon's bullying tactics, Americans were generally mute about the

attack. American troops had come home in large numbers and this, to some extent, pacified their previous unrest.[5] Following the bombings, the United States convinced the Thieu–Ky regime in Saigon that America would not abandon South Vietnam if the latter signed the peace accord. This led to a final draft of a peace treaty on January 23 that ended open hostilities between the United States and the DRV. Nixon proclaimed, "We have finally reached peace with honor," and signed the agreement in Paris on January 27. Yet with the signing of the accords, the conflict did not end in Vietnam. From March 1973 until the fall of Saigon in April 1975, ARVN forces continued to fight the DRV, trying desperately to save the South from political and military takeover. The end of the war finally came on the morning of April 30, 1975, when communist forces captured the presidential palace in Saigon. In the largest helicopter evacuation on record, the U.S. mission ferried one thousand Americans and six thousand Vietnamese out of the country in the span of eighteen hours.

After the summer of 1970, even with significant numbers of Americans still against the war, the success of Vietnamization and the beginning of serious peace talks with the North Vietnamese essentially dried up the antiwar movement, or channeled its energies toward further radicalism, as practiced by urban terrorists, such as the Weathermen, or toward new causes, such as the feminist movement. For the most part, activism in the art world withered as well. Nevertheless, the post-1970 period did see substantial, although isolated, instances of engagement. In 1971, the New School for Social Research mounted the exhibition *American Posters of Protest, 1966–1970*, curated by David Kunzle. A second version of the *Collage of Indignation* was installed. In 1972, the Brooklyn Museum installed *Vietnam: A Photographic Essay of the Undeclared War in Southeast Asia*. In addition, Leon Golub's *Vietnam* series of paintings and Öyvind Fahlström's map and puzzle works focusing on Vietnam were created between 1970 and 1973.[6]

On the one hand, the second version of the *Collage* bore a direct relationship to the first because some of the same people were involved with its manifestation, and because it was another collective protest effort. On the other hand, it had little else in common with the 1967 version. Installed at the New York Cultural Center between April and August 1971, to coincide with an April mass march in Washington and San Francisco, and organized mainly by Lucy Lippard and Ron Wolin (with the assistance of Dore Ashton, Barbara Rose, and Deena Shupe), the work simply featured a collection of peace posters that had been commissioned by the committee.[7] The idea was that the posters would be sold to benefit the National Peace Action Coalition and Student Mobilization Committee, and some of the profits would be used to print

editions of the posters as further benefit works. Roughly sixty artists contributed individual works. The results were varied. Artists continued to supply verbal rants. Carl Andre contributed an often-quoted line of Lieutenant Calley ("It was no big deal, sir"); Robert Ryman created a misspelled "Pease" on a white ground. Other no longer extant works that Lippard notes were included were created by Joseph Kosuth, Douglas Huebler, Luis Camnitzer, Faith Ringgold, Rosenquist, Alex Katz, and Susan Hall. Kosuth and Huebler's presence is another sign of conceptualism's political engagement. Lippard explains that Kosuth, like several other artists, "made connections to the Nazis via Hitler or Nuremberg," and Huebler's poster was a blank page that read, "Existing Everywhere Ahead of the Above Surface Is Every Reason for Peace."[8] Only one poster, by Robert Rauschenberg, was actually published as a result of the second *Collage* installation.

While Golub's *Vietnam* series (figs. 63a, b, and c) followed immediately upon the completion of his *Napalm* series (figs. 32–34, ch. 4), his creation of the *Vietnam* paintings marked a significant transformation for his oeuvre. The new works embraced subject matters outside of napalm. Golub's figures were also rendered more realistically than they had been in the past; specific dress and clarity in faces allowed the viewer to identify immediately, for example, who is American and who is Vietnamese. And his figures were (in general)

no longer tightly grouped together but arranged to generate compositional drama. This is particularly true in the case of *Vietnam II*, which dramatically features a child's face as the fulcrum of the image. As such, these works—in their grand scale and attempt toward narrative—seem to be Golub's attempt to create history paintings for the war. Simultaneously, the *Vietnam* series refrains from supplying specific references or narrative. The series was originally called *Assassins*, but Golub changed the name years later, fearing it was too "cruel" to the Americans. He commented that the change came about because he realized he couldn't "blame the GI's for the guys who were initiating all this. The soldiers weren't assassins. . . . I became ashamed."[9]

After completing the *Vietnam* works, Golub endured a crisis in the mid-1970s in which he destroyed virtually everything he made. Then he slowly began painting again: first with a series of small, political portraits; and then in the 1980s, taking up ideas he began working with in the *Vietnam* series, he produced the most recognized paintings of his career. These works focused on mercenaries, torturers, and death squads in U.S.-supported military regimes where human rights violations were being ignored, such as in Argentina, Brazil, Chile, Uruguay, El Salvador, Guatemala, and Honduras.[10] In this respect, Vietnam was Golub's turning point. According to Gerard Marzorati, "Golub's involvement in the Vietnam protest is significant not only for what impact

63a. Leon Golub, *Vietnam II*, 1973. Acrylic on linen. 120 × 480 in. Art © Estate of Leon Golub/Licensed by VAGA, New York. Courtesy Ronald Feldman Fine Arts, New York.

63b & c. Leon Golub, *Vietnam II*, 1973. Acrylic on linen. 120 × 480 in. Art © Estate of Leon Golub/Licensed by VAGA, New York. Courtesy Ronald Feldman Fine Arts, New York.

it may have had on the art-world aspect of the antiwar movement, and, indirectly, as part of this movement, on the government, but also for where it would take his own painting. Would Golub ever have painted [his works of the 1980s] had he not been involved in the antiwar movement? I can't see how. In the 1960s, Golub for the first time stepped into the history of his own time *as an artist*."[11]

Among his many works in a wide variety of media—from paintings to written manifestoes (which were often mislabeled as pop)—Öyvind Fahlström's maps of the early 1970s condemned American imperialism and, for a time, America's war in Vietnam.[12] Fahlström's maps stemmed from the beginning of the late 1960s when, he explained, "Like many people, I began to understand . . . that words like 'imperialism,' 'capitalism,' 'exploitation,' 'alienation' were not mere ideas or political slogans, but stood for terrifying, absurd and inhumane conditions in the world. Living in LBJ's and Nixon's America during the Vietnam war—culminating in the Christmas '72 terror bombings of Hanoi and Haiphong and Watergate—it became impossible not to deal in my work—once I had the stylistic tools—with what was going on around me. *Guernica*, multiplied a million times."[13]

Among the first articulations of Fahlström's consciousness were his *Notes* of 1970–1971, sketch-like compilations of texts and figures commenting on politics. One of them detailed Nixon's dreams; another, the Pentagon. A third was subtitled "Reading Felix Greene's *The Enemy*." *The Enemy* was a book that sought to give an objective account of imperialism. Gradually Fahlström's *Notes* were consolidated in the later *Maps*. The maps featured puzzles of tightly pressed-together, colored fields that represented particular countries. These countries were sometimes generally in the right place, as in his *World Map* of 1972 (figs. 64a and b), but they could often be positioned in an entirely fanciful relationship to reality.[14] Inside the countries, whose colors consistently represented the same places—according to the artist, blue was the United States, violet was Europe, red to yellow were socialist countries, and green to brown were "Third World"—there were dense texts and little drawings.[15] The overall impression of these works is like a mix of painting, game, puppet theater, comics, medieval maps, and Aztec codices.[16] While the individual facets of these works can be identified, they feel encyclopedic. One can never seem to grasp at once all of what is presented. This impression is something of which Fahlström was well aware. He said, "If I were only, or mainly, interested in educating my viewers . . . I would create simpler structures, and use other media than handmade art. I see myself as a witness, rather than as an educator."[17]

One can identify general themes in the maps: American global conspiracy dominates the world. Capitalist greed leads to exploitation, repression,

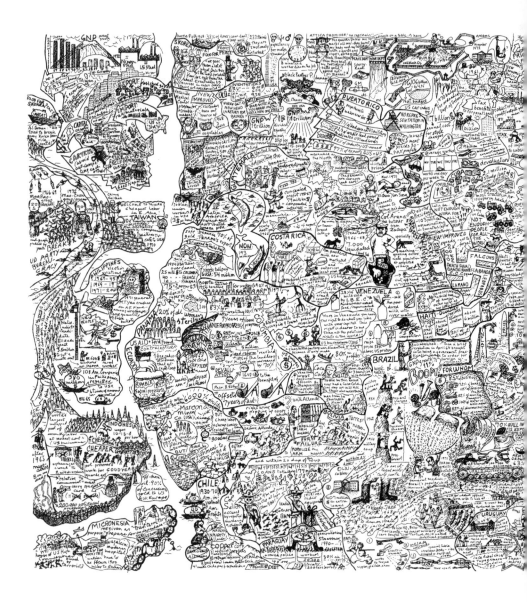

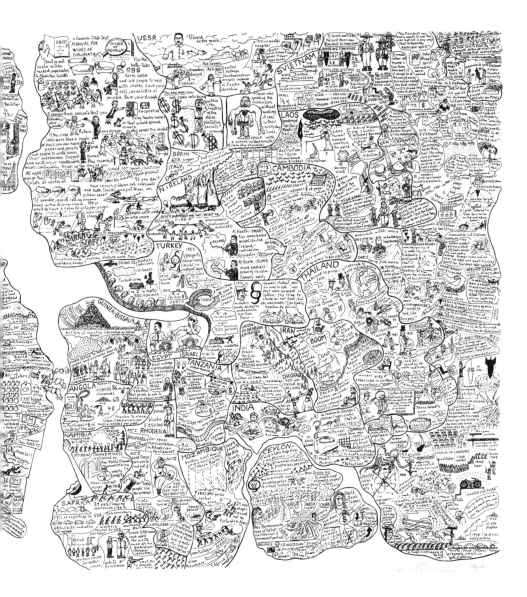

64a. Öyvind Fahlström, *Sketch for World Map*, 1973. Silkscreen (one color). 55.9 × 106 cm (22 × 41¾ in.). Edition: 150. Printer: Styria Studio, New York (Adolf Rischner, master printer). Publisher: Avery, Kenner and Weiner (AKW), New York. © 2011 Sharon Avery-Fahlström.

64b. Öyvind Fahlström, *World Map*, 1972. Acrylic and India ink on vinyl mounted on wood. 91.5 x 183 cm. Private collection. © 2011 Sharon Avery-Fahlström.

disease, and environmental depredation. Fahlström also celebrates communist peasants and Third World liberation movements. While the cartoonish quality of Fahlström's texts—reminiscent of the work of R. Crumb—suggests they were gathered casually, the artist was a scrupulous (but unassuming) researcher. He was a voracious reader in five languages of a variety of sources, including periodicals like *Ramparts* and the short-lived *Scanlan's Monthly*, though he also culled material from books on contemporary history. In sum, Fahlström's words represent a new kind of antiwar art, a fusion of conceptual information-giving and the allure of the humorous pop cartoon. The result is an endlessly appealing illustration of Fahlström's politics.

Fahlström's sentiments regarding American involvement in Indochina are best understood through his *World Map*. Almost the entire right side of the work is devoted to the subject of the Vietnam War through small texts and drawings or diagrams. These texts and images include the number of bombs dropped during the war; Johnson dressed in a colonial-era uniform explaining his refusal to be the first American president to lose a war; a description of the Con Son Tiger cages (a South Vietnamese prison whose horrific conditions were exposed by a U.S. government delegation in 1970); and the statistic that the United States built up the South Vietnamese army to be the fourth largest in the world. There is also a picture of new and improved smart bombs, napalm, and a new "electronic battlefield," as well as the effects of strategic hamlets, phosphorous bombs, and cluster bombs. Fahlström illustrates a central capability of this new electronic battlefield through five individually

numbered drawings. In the first, "planes drop millions of SYLVANIA, AT&T, HONEYWELL etc. SENSORS." In the second, the "sensors pick up signals (acoustic or seismic)." In the following drawings, the signals are relayed "back to base in Thailand," and an onboard computer directs a bomber to release bombs over an unseen target; and in the last image, the "pilot returns in time for a swim in the pool before lunch." The top right of the *Map* highlights North Vietnamese peasants who "take care to plant the rice straight so the U.S. pilots see it and know we are not afraid."

The year following his completion of *World Map*, in his *Column No. 2 (Picasso 90)* of 1973, Fahlström continued to focus on the Vietnam War. Echoing petitions by Angry Arts in 1967, and GAAG and AWC in 1970, Fahlström appealed to Picasso to remove *Guernica* to protest the Vietnam War. Fahlström's appeal was presented in the work as an excerpt from a real column and a real letter, which included his own address (121 Second Avenue, New York, NY, 10003) at the top, and read as follows: "Dear Picasso . . . you once beautifully combined protest as an artistic expression and a political gesture. Why don't you honor the pleas from American & other artists to remove Guernica from the Museum of Modern Art, until the USA completely withdraws from all of S.E. Asia incl." The manner in which the note is constructed—it includes the crossing out of words as well as punctuation and grammatical errors—points to Fahlström's dark sense of humor. A particularly entertaining part of *World Map*, for instance, is worth referring to in this regard. In it, a chapter from an illustrated "Swedish manual for diplomats' wives" represents the entirety of Europe.[18] The chapter, titled "In Case of Revolution," reads:

> Do not go out. Water will be needed especially to flush toilets. Fill the bath tubs. Serve coffee and ask people to help with chores. Save yourself. Do as little as possible. . . . Dismiss those servants you suspect of being troublemakers or that would spread rumors. . . . Retain one person who speaks the dialect. If the siege lasts more than a couple of days, you may hand out paper and pencils and ask people to write down their impressions. Suggest games and knitting or needlework. Play recorded music continually. Break up the day as you would for small children. At night, assign the toilets as evenly as possible among those present. If you don't have enough pillows, roll overcoats and bath-towels and put them in pillow-cases. If possible, avoid letting anyone sleep in the dining room. It is good to have a room to go to for people who can't sleep. Try to segregate people with colds or who snore. Coughing and sneezing disturb more than exploding bombs.[19]

Fahlström conceived his works as "orchestrat[ing] data, so people will—at best—both understand and be outraged" by the facts. But he had reservations about their art value. He wondered if their "facts about economic exploitation or torture techniques" would destroy the balance and make the works "propaganda." At the same time, however he asked whether Goya's *Disasters of War* were propaganda.[20]

Fahlström's puzzles, such as *Pentagon Puzzle* and *Pentagon Diptych*, occupy a position somewhere between his *Notes* and his *Maps*, since they are more cohesive than his *Notes* but lack text. As in *World Map*, the *Pentagon Puzzle* shows how government, military, and business collaborate to make the entire world an American sphere of influence: the CIA is represented as a greedy octopus; a scientist tests gas on mice and then drops it from a helicopter; the world itself is represented as a chained cube, symbolizing NATO and SEATO's power.[21] As Donald Kuspit has written, Fahlström's puzzles functioned "as a metaphor for consciousness—an accretion of fragments given unity by a common horizon of meaning" that could assert the user's power over the "impressions" of reality, since the user has to play with them and engage them to make them function. As such, there is hope that one can reconstruct the whole in a new manner. On the other hand, to the extent that one tries to complete the puzzle and fit the parts together in one designated form, "there is no escape from the picture of the world it presents." Kuspit has observed that in this respect such works speak also of Fahlström's "own sense of being trapped."[22] Trapped is an apt way to also describe the situation of the United States in Vietnam between 1973 and the end of the war. The country was stuck in the arduous, drawn-out process of trying to leave Vietnam.

Conclusion

THE END OF THE VIETNAM WAR necessarily ends this narrative history of American artistic engagement during it. This narrative has contextualized antiwar art-making within a detailed history of the war and tried to give attention to many of the significant artworks. It has identified specific historical occurrences and phenomena that both catalyzed and deterred such engagement. This study has also developed a general typology of American protest, which has been lacking in previous scholarship, and which aims to promote greater understanding of protest in the arts.

As a conclusion to this study, in order to expand the argument for the historical relevance of this work (and this project), I will highlight some examples where the influence of this era of engagement on some subsequent art and artists can be seen. However, because the subsequent history is not the focus of this work, this is not meant as a complete evaluation but rather an overview; a comprehensive evaluation deserves its own book. Important to note as well is the fact that arguing for the subsequent influence of any twentieth-century political work has become particularly significant in recent history in the face of a prevailing and misguided opinion that twentieth-century political art movements were "failures."

To begin with, while AWC did not form in response to the Vietnam War, nor (it must be said) did the majority of its various activities concern the war, the activities of its various factions has been by far the most influential force on subsequent American antiwar engagement as well as politically and

socially engaged production as a whole. Those involved with AWC catalyzed a lineage of various subgroups, offshoots, and initiatives. While most of these aggregations were composed of AWC's unprecedented body of participants, AWC also established its significance through publications, such as *Open Hearing* (a transcript of their April 1969 meeting at the School of Visual Arts) and *Documents 1* (a collection of letters, press, and ephemera documenting the formation of the coalition and its dialogue with MoMA). These publications were disseminated and inspired those unaffiliated with the coalition to create new political formations. Further, the activities of AWC generated a collective spirit and politicized climate that inspired those not directly connected with the group.

Among the groups formed thanks to the AWC were those that ended up cultivating the agitational, "consciousness-raising," and identity-oriented feminist art and activism of the late 1960s and early 1970s. These were such groups as Women Artists in Revolution (WAR), which split off from the coalition in 1969 to fight for women's rights in the art world; the Women's Interart Center, which evolved from WAR (and was New York's first women's alternative space); and the Ad Hoc Women's Artists' Committee. The Ad Hoc Committee emerged from AWC in 1970 and was formed specifically to address the low number of women shown in the Whitney annual—now biennial— exhibitions. The group, founded by Faith Ringgold, Poppy Johnson, and Brenda Miller—and soon joined by Lucy Lippard—staged four months of picketing outside the Whitney.[1] They urged equal representation in the exhibition, and to make it easier for the museum to find women they submitted a long list of possible candidates. This list became the foundation for the Women's Art Registry, which is still in existence.[2] The group envisioned the registry as a concrete resource to battle bias and ignorance about women's art. (The registry has since become a model for other minority groups.)[3]

AWC's activities and consciousness-raising also contributed to the founding of a plethora of alternative art museums, artist-run spaces, cooperative galleries, and art centers in New York City, such as the Studio Museum in Harlem (1968), El Museo del Barrio (1969), the Bronx Museum for the Arts (1971), the Alternative Museum (1975), 55 Mercer, Artists Space (1972), the Institute for Art and Urban Resources (1971)—which later became PS1—and 112 Workshop/112 Greene Street (1970), which in 1979 became White Columns. These institutions' focus on articulating the identity of underrepresented groups and countering the power of major museums and commercial galleries had been central to AWC.

In December 1975, veterans of Vietnam-era protest (many of whom had been involved with AWC) formed Artists Meeting for Cultural Change (AMCC). AMCC revived the organizational model of AWC to again focus attention on the continuing lack of minorities in the art world. Their most famous action—and the impetus for the group's founding—was a protest of the Whitney Museum's plan to celebrate the U.S. bicentennial with an exhibition of the collection of John D. Rockefeller III. In a letter signed by Benny Andrews (still then involved with the Black Emergency Cultural Coalition), Lucy Lippard (then of the Women's Slide Registry), and Rudolf Baranik (still of Artists and Writers Protest), AMCC argued that the Rockefeller collection ignored the art of dissent, as well as art by minorities and women. Weekly meetings at Artists Space led to the creation of an anti-catalog for the Whitney exhibition. The catalog featured critical essays and documents intended to counter the viewpoints of what they believed the Whitney was putting forth as "official culture."[4]

In 1979, Lippard began the influential archive of materials relating to political art, Political Art Documentation/Distribution (PAD/D), when she stamped an open call for such materials on the announcement card of an exhibition she was curating for Artists Space titled *Some British Art from the Left*. (Even though by then Lippard had been involved in various other organizations concerned with art and politics and particularly feminist art and politics, PAD/D could not have been formed without Lippard's previous involvement—and political awakening—in AWC.) Though PAD/D did not have an exhibition space, it was an activist art group. It practiced political art and promoted discourse by mounting socially themed streetworks and staged monthly forums and workshops called Second Sundays (at the major archive of artists' books, Franklin Furnace). PAD/D also organized exhibitions, such as *State of Mind: State of the Union* before Reagan's second presidential inauguration, and published the magazine *Upfront*. The exhibitions of Group Material, the politically and socially conscious art collective of the 1980s (which included among its members Julie Ault, Tim Rollins, Doug Ashford, and Felix Gonzalez-Torres) could be seen as a more aesthetically inclined outgrowth of PAD/D.[5]

In 1984, the poster committee that originated in AWC (and had spearheaded the organization of *And Babies*) decided to create another major poster that would respond with outrage to current political events. During a sound check prior to his weekly address on National Public Radio while running for reelection in 1984, President Ronald Reagan had played a joke on his radio technicians by announcing, "My fellow Americans, I'm pleased to tell you that I've signed legislation that will outlaw Russia forever. We begin bombing in five

minutes." While Reagan's words were not broadcast, they were leaked to the press and led to criticism, especially among those seeking to portray Reagan as a warmonger.[6] (Allegedly, the Soviet army was placed on alert for thirty minutes after the statement was leaked.) In response to this situation, APC created a poster that included a graphic depiction of a clock and the abbreviated quotation, "We begin bombing in five minutes." The poster brought to attention how Reagan's behavior was incompatible with the seriousness demanded from the presidential office and how it could lead to dire consequences for the entire world.

Apart from AWC, artists' open calls for protest work during the Vietnam War (which resulted in the *Peace Tower* and the *Collage of Indignation*) became the model for organizing later collective endeavors—which were often led by the same people who had been involved in the previous Vietnam-era calls. For example, one of the largest collective aesthetic actions of the 1980s, 1984's *Artists Call Against U.S. Intervention in Central America*, was promoted by familiar artists and critics such as Hendricks, Petlin, Lippard, and Oldenburg. The call had been inspired by demonstrations against U.S. intervention that took place in Washington, DC, and originated in January 1984 with Daniel Flores y Ascencio at the Institute for the Arts and Letters of El Salvador, Lucy Lippard, and Doug Ashford. (Julie Ault was also involved, and Coosje van Bruggen was a significant organizer for the group.) The institute asked artists working in various mediums and disciplines "to bring their originality into play to show the connection of vision that exists between our peoples and the people of Central America—to make it known that the people of Central America are not alone and that we actively share their dreams for peace and self-determination." The statement added that this was the moment for a remobilization within the artists' community, which had been dormant since its "awakening" during the Vietnam War, and one "must again stand up in protest to avoid another Vietnam."[7] The call led to thirty-one exhibitions, and various murals, film series, lectures, a calendar, and a mail-in project, though it bears mentioning that the call—like so many extra-aesthetic efforts during Vietnam—lacked any clarified "political line" except for its basic and decidedly political premise: "*No U.S. Intervention.*"[8] The proceeds from the call supported "culture and workers . . . which together comprise[d] the endangered culture of Central America."[9] And according to Lucy Lippard, "Aside from raising money and raising consciousness about the increasing militarization of Central America by the Reagan administration, the Call encouraged international solidarity among artists, set up an ongoing national network of socially

conscious artists, and provided a model for other cultural and professional groups. . . . [It also] widened the spectrum of artists who learned about the Central American situation and who realized that such issues could be part of their art."[10]

The most memorable result from the call was the Claes Oldenburg–designed poster for it that ran in the *New York Times*. Originally executed in three colors, it featured a large image, created by Oldenburg, of soldiers pulling down a monumental sculpture of a banana with a rope (thus destroying it). The banana referred to how, since the late nineteenth century, the United States has consistently made Central American countries into "banana republics," so called because Central American countries would be characteristically cultivated by foreigners to farm one agricultural product—often bananas—making them heavily dependent on foreign capital. Alongside Oldenburg's graphic were hundreds of signatures. A related artists' call from the period occurred the year previous. *Art Against Apartheid*, organized by hundreds of artists—among them Leon Golub—placed an open call for work that would raise consciousness about the battle against apartheid laws in South Africa, which had legalized racial segregation since the late 1940s. *Art Against Apartheid* exhibitions continued to be organized annually for several years into the 1990s until apartheid laws were eliminated.

Though the Guerrilla Art Action Group's activities persisted into the 1980s, their example of bringing street theater—and thus direct and bold performative actions—into the realm of visual art also proved to be a paradigm for a host of later protest groups.[11] Among them were Carnival Knowledge, an 1980s art protest group focused on reproductive rights formed by Anne Pitrone in response to the antiabortion campaign of the Moral Majority in the United States. There was also ACT UP, which raised consciousness of the AIDS epidemic; Gran Fury, a spin-off from ACT UP that was also involved with AIDS awareness; and the Guerrilla Girls. At the end of the 1980s, drawing on the example of the New York Art Strike was the organization of the first Day Without Art, which occurred on December 1, 1989. For one day, eight hundred U.S. art and AIDS action groups shut down museums, volunteered at AIDS organizations, and mounted exhibitions to raise awareness of the AIDS crisis. The day continues to be a yearly event.

While collective action was the dominant form of influence during the 1980s of Vietnam-era engagement, over the course of the last decade, throughout American wars in Iraq and Afghanistan, there has been a great lack of collective artistic activities. The historical influence of Vietnam-era

engagement has thus been limited to art objects created in the United States as well as in other countries allied with America in its wars, such as the United Kingdom and Israel. While this state of affairs has been attributed to the lack of a draft, which has lessened the urgency of the antiwar movement as a whole and in turn affected the appearance of collective aesthetic or extra-aesthetic activities in the art world, other reasons are more significant. The American and British art markets are now more sympathetic to protest objects in a way they have never been previously. This allows artists not to have to mobilize through media forms (or in this case, non-media forms) outside the gallery or museum system. There is also the often-discussed end of the public sphere and the transference of many of its previous activities into virtual outlets (like Facebook and Twitter) that are in some ways easier to manipulate and definitely less risky for the participants.

Despite the reasons for such a situation, the extent of Vietnam-era and previous antiwar production's influence on current protest artworks has been substantial. As the art historian Ara Merjian explained in 2008 in *Modern Painters*, this may have been because of the inability of Americans to truly understand the complexities of the Iraq War. He wrote, "There is something ultimately unrepresentable about the ideology with which and through which this war is being conducted. . . . It is perhaps for this reason that, while the war on terror streams in with an unprecedented instantaneity and simultaneity, so many works of art turn to previous aesthetic (and antiaesthetic) models to make sense of that information."[12]

One way that Vietnam-era production's influence has manifested itself is the fact that a common strategy of protest during the Iraq War was the re-exhibition of historical antiwar works significant to artists during Vietnam, or the subtle alteration of works made during Vietnam by their original authors so that they now refer to the situation in Iraq. For example, Picasso's and Goya's antiwar works as well as Leon Golub's Vietnam-era paintings were all exhibited as antiwar statements during the Iraq War. Picasso's paintings and prints created at the onset of the Spanish Civil War were a focus of *Barcelona and Modernity: Gaudí to Dalí* at the Metropolitan Museum of Art. The Peter Blum Gallery in SoHo exhibited eighty of Goya's *Disasters of War* etchings, explaining, "Goya's honest and sober representations of war speak not only of the past, but contain a timeless message that resonates even today."[15] And Golub's *Vietnam* and *Napalm* paintings were shown at Ronald Feldman Gallery during the winter of 2006. Martha Rosler in essence retained the same strategies from her *Bringing the War Home: House Beautiful* series, but just inserted

contemporary imagery in her new series of collages based on the Iraq War, such as *Photo Op* of 2004. Notably, Rosler's current series is exhibited in the spaces and publications she initially sought to circumvent. Rosler has commented that the rationale for this was multiple. Among her reasons were that the public for art is much larger than in the 1960s; that people are more than ready to think about alternatives to war and empire; and her belief that the shortest route to the mass media was by exhibiting in the art world.

The *Peace Tower* was essentially just updated for the Iraq War by its original driving force, Mark di Suvero. For the 2006 Whitney biennial, di Suvero created a joint venture with Rirkrit Tiravanija titled *Peace Tower* (fig. 65). Installed in the sculpture court in front of the Whitney Museum, the work recreated the original sculptural skeleton of the *Artists Tower of Protest*. The new tower was covered by hundreds of new panels that commented on the Iraq War by both contemporary artists who had nothing to do with the original tower as well as artists who had been involved with the Vietnam-era antiwar movement (but who had not necessarily contributed to the first tower). Among others, the work of Alice Zimmerman, Spero, Rosenquist, Tom Doyle, Anthe Zacharias, Ethelyn Honig, Petlin, and Haacke was included.

The artist Harrell Fletcher further created an incredibly powerful form of re-exhibition with his work *The American War* (2005). Fletcher's work was a collection of photographs the artist took in the War Remnants Museum in Ho Chi Minh City, a memorial museum for what is referred to in Vietnam as the American War. Fletcher's photographs record all the documentary photographs and texts used in the museum, all of which illustrate—at times quite graphically—the atrocities committed by U.S. forces. Some of Fletcher's photographs are at odd angles, which he used to avoid flash reflections, and all of them attempt to include some of the background walls (because, he explained, he wanted the viewer to always be aware that the images were taken in Vietnam, at the museum). Fletcher wanted to find a way to bring the museum to a wider U.S. population, and through a multitude of exhibitions around the United States he has done so.

A preponderance of artworks by contemporary artists that spoke out against the Iraq War employed the strategy of contrasting government rhetoric concerning the war with images of direct evidence, a common sight in posters during Vietnam. Peter Kuper's play off René Magritte's *The Treachery of Images*, for example, used Magritte's iconic illustration of the disjunction between utterance and appearance ("Ceci n'est pas une pipe") to spin off recent disjunctions between the rhetoric used to describe the Iraq War and the

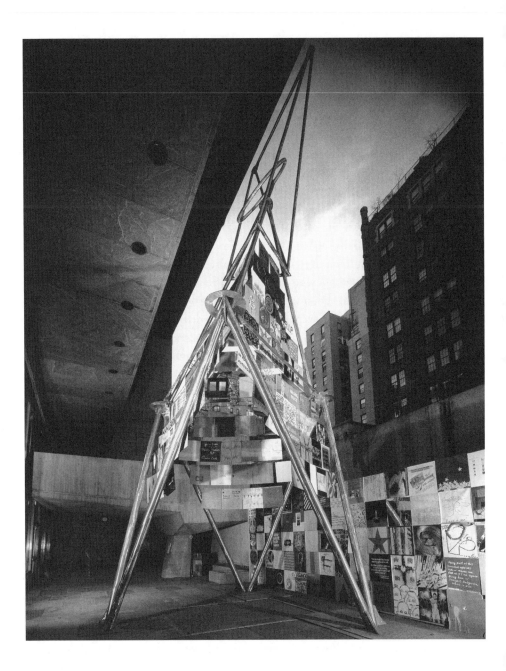

65. Mark di Suvero and Rirkrit Tiravanija, *Peace Tower*, 2006. Mixed media. © Mark di Suvero. Courtesy Paula Cooper Gallery, New York. Installation view at Whitney Biennial 2006: Day for Night, Whitney Museum of American Art.

actual human and material toll of it. The majority of the posters shown in exhibitions (or published in their self-titled book) by the Yo! What Happened to Peace? collective also employed this strategy.[14]

One of the most iconic posters included in the Yo! collective's exhibitions and book took a different approach than Kuper's work and became an icon of the recent antiwar movement. This was the *iRaq* series of posters (fig. 66), designed by Forkscrew Graphics and patterned after Apple Computer's television, print, and web advertisements for its iPod (then a personal listening device and now virtually a handheld personal computer). The iPod ads were ever present in the United States between roughly 2004 and 2008. Unlike the majority of the other works that Yo! featured, the *iRaq* posters conjure up Violet Ray's "advertising art" (as well as the work of Adbusters) and subtly alter Apple's characteristic ads into something quite subversive and multifaceted. The Apple ads featured a single color background (which were most often blue, light green, or yellow) and a black silhouette of one person dancing while wearing his or her iPod. The iPod would be represented by its trademark rectangular shape and white headphones, and would itself be undifferentiated thanks to its representation as a white silhouette, to contrast with the all-black figure. On the left hand side of the ad would be the Apple logo (the white silhouette of the fruit) and the name of the product, "iPod." The *iRaq* posters—many of which were wheatpasted in downtown Manhattan and Los Angeles—replaced the Apple logo with a grenade and the word "iPod" with "iRaq." The posters moreover swapped out the dancing silhouette for figures from the Iraq war front.

The figure most commonly used was sourced from one of the most-reproduced photographs from the war, a leaked image of a detainee from the Abu Ghraib prison. (This image was also used in Richard Serra's well-known protest posters, which above the figure declared, "STOP BUSH.") The photograph featured a man whose head is covered with a black hood and whose body is draped with a large black cloth. He stands on a box with his arms raised out parallel to the floor—looking like Jesus on the cross—and electric cables, attached to each hand, run down to the floor and up the wall. The man, whom U.S. soldiers jokingly called "Gilligan," was ordered to stand on the box. If he fell, they explained to him, he would be electrocuted. (This never happened. There was no electric current running through the wires, and the soldiers, when questioned about the event later, said they were just playing with this man.)

Other Yo! collective posters further referred to Vietnam paradigms. A map work featuring small bombs named after each of the countries the United States has bombed since World War II recalled Fahlström's maps and

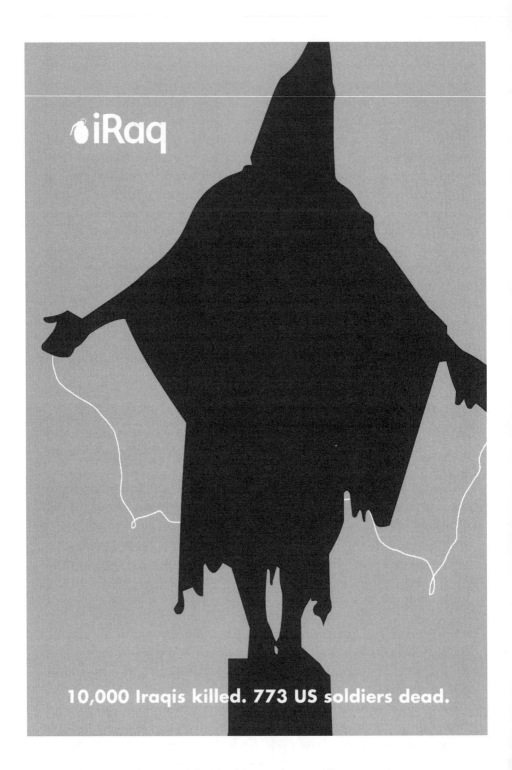

66. Forkscrew Graphics, *iRaq (Abu Ghraib Prisoner)*, 2004. Silkscreen. 86.4 × 59.1 cm (34 × 23¼ in.). Courtesy of the Center for the Study of Political Graphics.

Maciunas's flags. Another poster included Picasso's peace dove. However, this time the dove functioned both as a symbol of peace and one that pointedly rejected the American military—it defecated on American tanks.

An entire 2007 exhibition, *Memorial to the Iraq War*, at London's Institute of Contemporary Arts (ICA), was organized around the recognizable strategy from Vietnam of the advance memorial (since at that time the war was not yet over). On the one hand, the exhibition—which asked twenty-five artists from Europe, the United States, and the Middle East to propose memorials— tried to be politically neutral. In this respect, it argued that the exhibition was mounted only to encourage debate about the form of a memorial for the war. At the same time, the show was undoubtedly antiwar. Just mounting an exhibition to memorialize the war focused on the losses the war has caused and was thus extremely provocative. Also, in the museum's press materials the ICA introduced the war with a minimal focus on successes and a maximum focus on the war's death toll. Their press release began as follows:

> The American-led invasion and occupation of Iraq began in March 2003 and has resulted in the downfall of the dictator Saddam Hussein and his eventual replacement by the Iraqi National Assembly. To date the Iraq War has also resulted in the deaths of over 3300 soldiers from America, over 140 from Britain and over 120 from the other past and present Coalition countries. At the same time Iraq has slid towards the chaos of civil war and *The Lancet* estimated that by July 2006 the number of Iraqi deaths—both combatant and civilian—that could be directly or indirectly attributed to the war was over 650,000.

In the exhibition, Collier Schorr's part-photograph, part-drawing collage of a soldier's body suggested the body's disconnection. Nate Lowman's rusted gas pumps became symbolic of America's dependence on Middle East oil and stability in the region (and, as such, America's reasoning for fighting the war). The Israeli artist Yael Davids staged a performance piece titled *Choosing One's Heritage* in which participants stood behind a wall and pressed their lips through small holes specifically cut out for them. Visitors to the exhibition could only see lips pushed through the holes, and because those who stood behind the wall were behind foam and pushed their lips through it, nothing could be heard on the other side of the wall. As a result, the viewer saw only actual human lips drying out. Davids's work was a poignant statement on how little those outside the war front could understand the war's victims.

This inability to communicate was echoed in 2007's 9 *Scripts from a Nation at War* (a ten-part video installation by David Thorne, Katya Sander, Ashley Hunt, Sharon Hayes, and Andrea Geyer), which foregrounded the confining "scripts" or roles a wartime environment presents and the ability of people to embrace or reject them. This theme of constrained communication was also central to Michael Rakowitz's *Return*, an ongoing project he started in 2004 that reopened his Iraqi-born grandfather's American import–export business (Davisons & Co.) in order to send gifts to Iraqis and import goods from Iraq (dates). The project focused directly on the war due to the difficulty of transporting goods. Rakowitz's project (and specifically the storefront he opened in Brooklyn on Atlantic Avenue) also became a locus for dialogue about the war, which was rare in the art context of the time. (One other exception was Jeremy Deller's 2008 *It Is What It Is*, which attempted to engage the art-going public in New York, Chicago, and Los Angeles through dialogue with veterans, journalists, scholars, and Iraqi nationals. Objects were meant to stimulate discussion, most prominently the remains of a car that was destroyed in March 2007 by an explosion on Al-Mutanabbi, a street in Baghdad and a center of cultural life, which killed thirty people.) Rakowitz explained of his project, "The dates suddenly became a surrogate, traveling the same path as Iraqi refugees. The store became a place where that crisis and its affiliated narrative was being disseminated—hardly the exchange a customer would expect."[15]

Davids's work also directly relates to a larger tendency of this antiwar production: to argue for more complete media coverage of the war. This was not anywhere as much an issue during Vietnam, which was extensively covered by the media, especially after 1968. The U.S. government and media's heightened control of war imagery after (and as a result of) Vietnam is well-known. Claude Moller's *If Vietnam Were Now/What Would You See?* comments on the current lack of coverage. Layered on the iconic image of Nguyen Ngoc Loan executing a VC captive, Moller places a (General Electric–manufactured) television screen that frames only part of the image—that of the general's head—thus omitting the image's most important section (in which the captive is being shot and killed). The paintings of Stephen Andrews further attest to this lack of exposure. Based on photography from the war, these works are made so that the images are deliberately hard to see. Andrews transfers the photographs by rubbing crayon onto canvases that have been stretched over window screens. Andrews's titles attest to this haze of depiction and its resultant generalized information as well. One carries the title *Soldiers in the Palace* and another *jpeg* (both 2003).

Thomas Hirschhorn's 2006 installation *Superficial Engagement* (which followed his 2003 work on Iraq, *Drift Topography*) protested the media coverage in a different fashion. Rather than mourn the lack of images available, he tried to solve the problem by locating hundreds of images of dead Iraqis on the Internet and then printing them and putting them in one of his all-over installations (reminiscent of Kurt Schwitters's *Merzbau* or the First International Dada Fair) so that the viewer is bombarded by them. An understated approach to the same idea was Steve McQueen's *Queen and Country*, a series of postage stamps that featured the faces of soldiers killed in the line of duty in Iraq (figs. 67 and 68).

Apart from Nina Berman's *Marine Wedding* series (2006/2008), which cataloged the post-Iraq marriage and life of an awfully disfigured marine, and the Iraqi-born Wafaa Bilal's *Domestic Tension* (2007), in which he allowed people on the Internet to shoot him with a paint gun (reflecting on the death of his brother at a U.S. checkpoint, the increasing preponderance of drones, and the general inhumanity of the war), the best-known exposure of direct evidence from the war was Mark Wallinger's *State Britain* (fig. 69). *State Britain* was a meticulous recreation of every detail of the Iraq War protester Brian Haw's

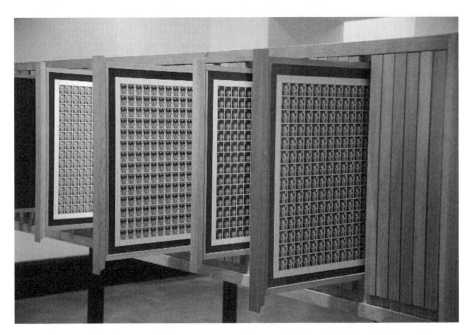

67. Steve McQueen, *Queen and Country*, 2007. Cabinet with facsimile postage sheets. Co-commission between Manchester International Festival and Imperial War Museum. Installation Manchester Central Library, February 28–July 14, 2007.

68. Steve McQueen, *Queen and Country*, 2007. Detail of cabinet with facsimile postage sheets. Image of Lance Corporal Benjamin Hyde is reproduced with the kind permission of the family. Co-commission between Manchester International Festival and Imperial War Museum. Installation Manchester Central Library, February 28–July 14, 2007. Courtesy of Marian Goodman Gallery, New York and Paris.

69. Mark Wallinger, *State Britain* (detail), 2007. Mixed media installation. Approx. 570 cm × 190 cm × 43 m. Installation at Tate Britain, 2007. © Mark Wallinger. Courtesy Anthony Reynolds Gallery, London. Photograph by Dave Morgan.

pictures, statements, flags, and donated items, which he had collected and installed on the street outside the Palace of Westminster between June 2001 (when Iraq sanctions began) and May 23, 2006, when his items were removed. The reason for the removal was a law passed in Britain defining an "exclusionary zone" of one kilometer around Parliament where protests would be deemed illegal. Wallinger's work—which when installed in Tate Britain was provocatively placed just past the one-kilometer barrier that ran through the museum—won the 2007 Turner Prize. On the one hand, Wallinger's work has been celebrated for its uniqueness. Alain Badiou, for example, has called it model for a "new realism" because it allowed Haw's action, which existed in what Badiou sees as a void in the democratic system, to exist. Yet on the other hand, the work, like GAAG's actions during the Vietnam War, continues to take strategies of protest from the street and bring them into the museum. One wonders if future protest against inevitable future wars will build off Wallinger's example or forge other paths on the basis of something else.

Notes

INTRODUCTION

1. See, for example, The 2004 *Memorials of War* at the Whitney Museum of American Art.

2. See Lucy Lippard, *A Different War: Vietnam in Art*. Ed. Independent Curators Incorporated and Whatcom Museum of History and Art (Bellingham, WA: Whatcom Museum of Art, 1990); Maurice Berger, *Representing Vietnam: The Antiwar Movement in America, 1965–1973* (New York: Bertha and Karl Leubsdorf Art Gallery, Hunter College, 1988); and Francis Frascina, *Art, Politics, and Dissent: Aspects of the Art Left in Sixties America* (New York: St. Martin's Press, 1999). After I began my research, Julia Quinn Bryan-Wilson's "Art/Work: Minimalism, Conceptualism, and Artistic Labor in the Vietnam War Era, 1965–1975" (PhD diss., University of California, Berkeley, 2004) was published as *Art Workers: Radical Practice in the Vietnam War Era* (Berkeley: University of California Press, 2009). Bryan-Wilson's study, which concentrated on the political engagement of some Art Workers' Coalition participants, has been a significant contribution to the field of Vietnam-era production. I should also mention here another point of departure, Beth Ann Handler's "The Art of Activism: Artists and Writers Protest, the Art Workers' Coalition, and the New York Art Strike Protest the Vietnam War" (PhD diss., Yale University, 2001), 86.

3. See David McCarthy, "Fantasy and Force: A Brief Consideration of Artists and War in the American Century," *Art Journal*, vol. 62, no. 4 (2003), 100.

4. For more on the RAND Corporation, see Alex Abella, *Soldiers of Reason: The RAND Corporation and the Rise of the American Empire* (New York: Houghton Mifflin, 2008).

5. Lucy Lippard, "Dreams, Demands, and Desires: The Black, Antiwar, and Women's Movements," in *Tradition and Conflict: Images of a Turbulent Decade, 1963–1973*. Ed. Mary Schmidt Campbell and Studio Museum in Harlem (New York: Studio Museum in Harlem, 1985), 77. See also Handler, "Art of Activism," 86.

6. One could clarify this statement by saying that it was the most important piece of literature with the exception of the Pentagon Papers (which I will discuss subsequently), a massive history of the war in which the war's architects revealed the faulty assumptions on which their strategies were based.

7. Please note that I specifically do not refer to actions undertaken by the Art Workers' Coalition as a whole anywhere in this text, but instead speak of them as being undertaken by *participants* of AWC or *certain factions* of AWC. This is because AWC was never a unified group. As I explain later on, it was deliberately kept loosely organized: their were no actual "members" of AWC, there was no such thing as a unified body of AWC; instead, there were endless factions, and certain AWC committees could do basically whatever they wanted without approval from anyone else. For more on this topic and the AWC, see Lucy Lippard, "The Art Workers' Coalition: Not a History," in *Get the Message? A Decade of Art for Social Change* (New York: Dutton, 1984), 10–19, originally published in *Studio International*, November 1970. This perspective was also gained from Lippard's notes on the manuscript.

CHAPTER ONE

1. The only break in French rule occurred during World War II when Japan occupied the country.

2. This was an unusual move for the United States, which historically had not involved itself in colonial wars. Franklin Delano Roosevelt had especially been against them, yet his death paved the way for an alternative approach to U.S. policy.

3. "President Harry S. Truman's Address Before a Joint Session of Congress, March 12, 1947," *The Avalon Project, Yale Law School, Lillian Goldman Law Library*, http://avalon.law.yale.edu/20th_century/trudoc.asp.

4. See Stanley Karnow, *Vietnam: A History* (New York: Penguin, 1984), 184.

5. See David Halberstam, *The Best and the Brightest* (New York: Ballantine, 1993), 338. Though the United States never gave anything more than financial support to the French, the offer of more seemed to be on the table for the duration of the war. Frances Fitzgerald comments, "It was not until June 15, 1954, that Secretary of State Dulles told the French definitively that the United States would not commit its own troops and planes to the Indochina war." See *Fire in the Lake: The Vietnamese and the Americans in Vietnam* (Boston: Back Bay Books, 2002), 76.

6. After the Vietnam War, the war became known as the First Indochina War. See Karnow, *Vietnam*, 185.

7. The major accounts of Dienbienphu are Bernard B. Fall's *Hell in a Very Small Place: The Siege of Dien Bien Phu* (Philadelphia: Lippincott, 1967); and Jules Roy's *The Battle of Dienbienphu* (New York: Harper and Row, 1965). Michael Herr, the author of *Dispatches* (New York: Vintage, 1977), which would become one of the most significant memoirs on Vietnam, commented that during the siege at Khe Sanh, these two books kept appearing among members of the press, since Khe Sanh was feared to be a repeat of Dienbienphu.

8. The DMZ specifically extended about a mile on either side of the Ben Hai River and ran west to east from the Laotian border to the South China Sea.

9. Specifically, from the date of the Accords, all armed forces and civilians were given three hundred days to retreat.

10. Karnow, *Vietnam*, 230.

11. Fitzgerald, *Fire in the Lake*, 76.

12. Diem had deposed Bao Dai, former emperor of Annam under French rule and then chief executive of the French-controlled State of Vietnam from 1949 until 1955. Ignoring the Geneva-proposed countrywide elections, he proclaimed himself head of state. Fitzgerald comments that "Diem's efforts to destroy the sects cost the American government some $12 million in bribes—or subsidies" (ibid., 79). She also explains that by 1956, the United States was paying the South Vietnamese regime an average of $270 million a year—more aid per capita than it spent on any other country in the world except for Laos and Korea (ibid., 85). See also Karnow, *Vietnam*, 246.

13. This brief explanation is not meant to deny the fact that the character of the NLF and its relationship to the communists in Hanoi has caused considerable debate among scholars, antiwar activists, and policy makers. From the inception of the NLF, government officials in Washington asserted that Hanoi directed NLF attacks against the Saigon regime. The NLF, on the other hand, argued that it was independent of the communists in Hanoi and was composed mostly of noncommunists.

14. This figure of nine thousand is specific to 1962.

15. Karnow, *Vietnam*, 272.

16. Ibid., 273.

17. Ibid., 281.

18. Halberstam, *Best and the Brightest*, 250.

19. Karnow, *Vietnam*, 301.

20. Ibid., 302.

21. Ibid., 294.

22. Halberstam, *Best and the Brightest*, 351.

23. In the words of Frances Fitzgerald, this sequence of events made "Saigon politics [take] on the pace and style of a Marx Brothers movie." *Fire in the Lake*, 257.

24. See ibid., 246; and Karnow, *Vietnam*, 350.

25. Fitzgerald, *Fire in the Lake*, 257

26. Karnow, *Vietnam*, 341.

27. Ibid., 379.

28. In mentioning espionage, I refer to covert activities that had begun in January under the code name 34A. See Halberstam, *Best and the Brightest*, 408. Robert McNamara and Vo Nguyen Giap, the brilliant leader of the Government of the Republic of Vietnam, recently concluded that the second attacks never happened. See Karnow, *Vietnam*, 152, 377, 389; and Halberstam, *Best and the Brightest*, 411.

29. The two dissenting votes were those of Wayne Morse and Ernest Gruening.

30. Though in the meantime, as Karnow explains, American aircraft flew sixty-four sorties against four North Vietnamese patrol boat bases and a major oil storage depot, "severely" hitting all the targets. See Karnow, *Vietnam*, 393.

31. Pollster Lou Harris commented at the time that before the events at Tonkin and the resulting resolution, 58 percent of Americans approved of Johnson's conduct in Vietnam, but afterward 72 percent of the country approved of his reprisals. See Halberstam, *Best and the Brightest*, 423.

32. See Johnson's address to the American Bar Association, August 12, 1964, available online at http://www.presidency.ucsb.edu/ws/index.php?pid=26434&st=&st 1=#axzz1z%20ioblljy.

33. See Halberstam, *Best and the Brightest*, 160–161. Notably, such faith had blinded these men to subsequent reports that airpower had not worked in certain instances during World War II, and allegations that it had actually intensified German resolve.

34. Karnow, *Vietnam*, 421.

35. Ibid., 426.

36. Ibid., 468.

37. Halberstam, *Best and the Brightest*, 512.

38. Ibid., 538.

39. This disclosure came months after the State Department had decided this would be its course of action. See Karnow, *Vietnam*, 433.

40. For further draft statistics, see David Card and Thomas Lemieux, "Going to College to Avoid the Draft: The Unintended Legacy of the Vietnam War," paper presented at the meeting of the American Economics Association, January 2001. Draft calls reached a high of forty-two thousand a month during the spring of 1968. In November 1969 a draft lottery was installed, dropping draft calls to nineteen thousand a month. By August 1971 the rate of induction was two thousand a month; by 1972 it was forty-one hundred a month; in February 1973 the draft was suspended.

41. Malcolm Brown, *The New Face of War* (Indianapolis: Bobbs-Merrill, 1965); David Halberstam, *The Making of a Quagmire* (New York: Alfred A. Knopf, 1965).

42. The designation of the "living room war" has stuck to this day. Omitted from our historical understanding of this term is the fact that Arlen's writings on the war and television critiqued the American media's ability to transmit the realities of the war via television. For instance, though Arlen believed that the footage of the

war was "extraordinarily good" (as was the lightning speed by which it traveled back to the United States), because of the press's disinclination to investigate all parts of the "Vietnam picture" and the necessity that news be restrictively determined by visual criteria, coverage often added up to a series of isolated details and an excessively simple view of what was, at best, a "mighty unsimple situation." Further complicating matters, according to Arlen, was "the physical size of a television screen, which, for all the industry's advances, still transmitted one picture of men three inches tall shooting at other men three inches tall, which was then trivialized, or at least tamed by, the enveloping cozy alarums of the household." In this vein, Frances Fitzgerald has noted that technology and communications made the war absurd for both sides. She explained, "To one people the war would appear each day, compressed between advertisements and confined to a small space in the living room; the explosion of bombs and the cries of the wounded would become the background accompaniment to dinner. For the other people the war would come one day out of the clear blue sky. In a few minutes it would be over: the bombs, released by an invisible pilot with incomprehensible intentions, would leave only the debris and the dead behind." See Fitzgerald, *Fire in the Lake*, 5. See also Liz McQuiston, *Graphic Agitation* (London: Phaidon, 1995), 42; and Michael J. Arlen, *Living-Room War* (New York: Penguin, 1982).

43. See George C. Herring, *America's Longest War: The United States and Vietnam, 1950–1975* (Columbus, OH: McGraw-Hill, 2001), 142.

44. When SDS first made the call for the march in December 1964, they expected only a few thousand people to attend.

45. In the weeks following the Ann Arbor event, the form was imitated at Columbia University, Case Western Reserve University, the University of Chicago, the University of Pennsylvania, and the University of Buffalo. And in May a national teach-in was held, which included members of Congress as well as State Department officials.

46. For more on the University of Michigan teach-in, see Matthew Newman, "U-M Faculty's Historic Teach-In of 30 Years Ago 'a Vital Service to Their Country,'" *Michigan Today*, October 1995, http://www.ns.umich.edu/MT/95/Oct95/mt11095.html.

47. Those who objected to the draft's greater socioeconomic inequities also protested. Later the draft came under further condemnation when it was found out (via the publication by *New Left Notes* of a Selective Service document in January 1967) to be a secret means by which the government was controlling what young men did with their lives professionally, through its process of "channeling." Channeling was a strategy of offering draft deferments to those occupations the government deemed in the national interest (teaching, engineering, etc.) and, by contrast, not offering them to professions it deemed inessential (musicians, artists, etc.). As a result, without directly ordering young men into certain professions, the government used the draft to ensure that these professions would be filled by granting deferments to students enrolled in disciplines that would lead to them. For more

on this issue, see Michael S. Foley, *Confronting the War Machine: Draft Resistance During the Vietnam War* (Chapel Hill: University of North Carolina Press, 2003), 61.

48. Notably, Peter Saul and Leon Golub, artists who were significant in antiwar protest and who will be discussed subsequently, specifically cited *Ramparts* and *I.F. Stone's Weekly* as sources of information about the war. See David McCarthy, "Dirty Freaks and High School Punks: Peter Saul's Critique of the Vietnam War," *American Art*, vol. 23 (Spring 2009), 78–103. David Schalk, a historian of intellectual political engagement in France and Vietnam during the Algerian and Vietnam Wars, has explained that the importance of the *New York Review of Books* was due to its ideological underpinnings, intended audience, the niche in the intellectual field the periodical was designed to fill, its aesthetic concerns, its editorial policy regarding biweekly coverage of general news, and, finally, the space it provided for such articles. See *War and the Ivory Tower: Algeria and Vietnam* (New York: Oxford University Press, 1991), 130. Because of its centrality, during the war members of the mainstream or conservative press regularly maligned the NYRB, as did high-ranking members of the U.S. government.

49. See Lippard, "Dreams, Demands, and Desires," 75. As well, see Nancy Zaroulis and Gerald Sullivan, *Who Spoke Up? American Protest Against the War in Vietnam, 1963–1975* (Garden City, NY: Doubleday, 1984), 41; H. Bruce Franklin, *Vietnam and Other American Fantasies* (Amherst: University of Massachusetts Press, 2000), 56; Bradford Martin, *The Theatre Is in the Street: Politics and Performance in Sixties America* (Amherst: University of Massachusetts, 2002), 134; and David R. Colburn and George E. Pozzetta, "Race, Ethnicity, and the Evolution of Political Legitimacy," in *The Sixties: From Memory to History*. Ed. David Farber (Chapel Hill: University of North Carolina Press, 1994), 121.

50. Zinn quoted in Zaroulis and Sullivan, *Who Spoke Up?* 24

51. Quoted in James E. Westheider, *The African American Experience in Vietnam: Brothers in Arms* (Lanham, MD: Rowman and Littlefield, 2007), 24.

52. See Franklin, *Vietnam and Other American Fantasies*, 59.

53. The photographs were taken by William F. Pepper, a political scientist and human rights activist, to accompany his article "The Children of Vietnam," *Ramparts*, vol. 5 (January 1967), 44–68. See also Peter Richardson's *A Bomb in Every Issue: How the Short, Unruly Life of "Ramparts" Magazine Changed America* (New York: New Press, 2009). Specifically, King saw them on January 14, 1967, while waiting in an airport. See David Maranis, *They Marched into Sunlight: War and Peace, Vietnam and America, October 1967* (New York: Simon and Schuster, 2003), 72.

54. Maranis, *They Marched into Sunlight*, 72.

55. It is important to recognize that King's speech had major critics within the upper echelon of the African American population, among them Jackie Robinson and Roy Wilkins. Such individuals believed that while the war was obviously worth protesting—since, among other reasons, it was more harmful to blacks than

whites and it drained money from poverty programs—taking a stand against it, as King was doing, was too big a risk, as there was the possibility it would alienate the support and respect the civil rights movement had worked so hard to gain over the years.

CHAPTER TWO

1. These advertisements were reminiscent of a 1962 advertisement the group had placed to advocate for nuclear disarmament, which stated, "We artists of the United States are divided in many ways, artistically and ideologically, but we are as one in our concern for Humanity." See Lippard, "Dreams, Demands, and Desires," 77. This is not to say that this early engagement was substantial at all compared to AWP's subsequent engagement with the Vietnam War.

2. AWP noted, however, that the list could have been even bigger. At the end of the ad the group explained, "Many other signatures were received too late to be included."

3. The prime movers behind the statements were Denise Levertov and Mitchell Goodman (both of whom had links to *The Nation*). See Frascina, *Art, Politics, and Dissent*, 21.

4. As Therese Schwartz explained, "The artists' action, in its substance and method, was indistinguishable from theirs [the ads of other professional groups]." See "The Politicization of the Avant-Garde: Part I," *Art in America*, vol. 59, no. 6 (1971), 98.

5. The Algerian War began in 1954, when an Algerian guerrilla force, the National Liberation Front (Front de Libération Nationale, FLN), started a campaign in Algeria against France, which had occupied the country since 1830, and appealed to the UN for sovereignty. The central fighting of the war took place in Algiers during the "Battle of Algiers," between 1956 and 1957. It was the intensity of this urban fighting—which began with brutal attacks by the FLN and ended with the brutal suppression of the FLN (by more than five hundred thousand French troops)—that eventually led the French government to concede the right of the Algerians to rule themselves in 1959. Three years later, Algerians were officially given their independence. This eventual independence came, however, after more violence in Algiers, but also in France, where French groups opposed to Algerian independence staged terrorist attacks. The principal group undertaking these actions was the Organisation de l'Armée Secrete, which was implicated in more than six hundred bombings in 1961.

6. It should be noted also that May Stevens and Rudolf Baranik lived in France, yet during an earlier period, between 1948 and 1951.

7. Intellectuals linked the two conflicts early on. One of the first to do so was D. A. N. Jones, in his article "The Monstrous Thing," which was published in the *New York Review of Books* on December 17, 1964. For a discussion of further similarities between the two conflicts and the intellectual reaction to them, see Schalk, *War and the Ivory Tower*; as well as Sandy Vogelgesang, *The Long Dark Night of the Soul: The American Intellectual Left and the Vietnam War* (New York: Harper and Row, 1974).

8. Irving Petlin, personal interview, April 2, 2009. See also Handler, "Art of Activism," 78.
9. See Jeffrey Kastner, Mark di Suvero, Irving Petlin, and Rirkrit Tiravanija, "Peace Tower: Irving Petlin, Mark di Suvero, and Rirkrit Tiravanija Revisit *The Artists' Tower of Protest, 1966*," *Artforum*, vol. 44, no. 7 (2006), 252–257.
10. Petlin quoted in Gerald Marzorati, *A Painter of Darkness: Leon Golub and His Times* (New York: Penguin, 1992), 225.
11. Frascina, *Art, Politics, and Dissent*, 23. For more on the issue of American intervention in the Dominican Republic, see Abraham F. Lowenthal, *The Dominican Intervention* (Baltimore: Johns Hopkins University Press, 1994).
12. Petlin quoted in Marzorati, *Painter of Darkness*, 230–231.
13. The ad may have been purposefully timed to appear as it did, between the two AWP ads. Notably, at the bottom of the second ad run by AWP, it explains that APC offered its "West Coast" endorsement for the ad. The text read, "The Artists' Protest Committee of Los Angeles, representing two hundred working artists, expresses its full support for the above statement."
14. See "White Out Blacked Out: Protest by Art Community Gets Silent Treatment," *Los Angeles Free Press*, May 21, 1965, 1–2.
15. Ibid. In subsequent scholarship the one exception is Francis Frascina's *Art, Politics, and Dissent*.
16. Marzorati, *Painter of Darkness*, 230.
17. Ibid.
18. See Frascina, *Art, Politics, and Dissent*, 35. RAND labeled the effects of such strategies "megadeath" or "overkill."
19. "Artists Protest at Rand Corp.," *Los Angeles Free Press*, June 25, 1965, 1.
20. Frascina, *Art, Politics, and Dissent*, 37. See also Marzorati, *Painter of Darkness*, 232.
21. According to Frascina, *Art, Politics, and Dissent*, 54n99, these were Bernard Brodie, Social Science Department, history and strategy; Edward C. De Land, Computer Sciences Department, mathematical models of blood chemistry; Alton Frye, Social Science Department, politics of space; Brownlee Haydon, assistant to the president, Communications Department; Amron Katz, Electronics Department, physicist, reconnaissance specialist; Kolkowicz, Social Science Department, specialist in Soviet politics; Leon Lipson, Social Science Department (consultant), professor of law, Yale University; Guy Pauker, Social Science Department, specialist in Southeast Asia; and Robert Wolfson, Logistics Department, economist.
22. Frascina, *Art, Politics, and Dissent*, 40. He bases this information on interviews with Petlin and Golub as well as their comments included in Albert Mall, "Artist Versus RAND Debate Not a Fruitful Exchange," *Los Angeles Free Press*, August 13, 1965.
23. Marzorati, *Painter of Darkness*, 232–233.
24. Lippard quoted in Martin, *Theatre Is in the Street*, 128.
25. Lippard, "Dreams, Demands, and Desires," 77; Handler, "Art of Activism," 86.
26. Martin, *Theatre Is in the Street*, 128.

27. Zaroulis and Sullivan, *Who Spoke Up?* 44.

28. "Nation: Festival of the Arts," *Time*, June 25, 1965.

29. Dwight MacDonald, "A Day at the White House," *New York Review of Books*, July 15, 1965, 10; Richard Shepherd, "Robert Lowell Rebuffs Johnson as Protest over Foreign Policy," *New York Times*, June 3, 1965, 1–2. In the same article, Shepherd quotes Lewis Mumford's May 19, 1965, statement denouncing the U.S. political and military policy in Vietnam as a "moral outrage" and "abject failure." (Mumford at the time was president of the American Academy of Arts and Letters.)

CHAPTER THREE

1. Fitzgerald, *Fire in the Lake*, 304

2. Shelters for the people were located underground and from above appeared to be manholes in streets. In the country, extensive networks of tunnels ran from villages to fields, to enable the cultivation of food to continue even during attacks.

3. Karnow, *Vietnam*, 474.

4. Bombing halts, which occurred several times over the course of the war, the first on May 13, 1965, were a complicated issue for both sides. The United States feared that if it did stop bombing, the communists would use the time to build their forces up in the interval, while the communists believed that, like the French, the United States would do the same or engage in other means of aggression. See ibid., 437.

5. Zaroulis and Sullivan, *Who Spoke Up?* 76.

6. See Clement Greenberg, "Modernist Painting," which was first published in 1960 as a pamphlet by the Voice of America. It then appeared in *Arts Yearbook*, vol. 4 (1961); with slight revisions in *Art and Literature*, vol. 4 (1965); and then in *The New Art: A Critical Anthology*. Ed. Gregory Battcock (New York: Dutton, 1966).

7. Greenberg, "Modernist Painting," in Battcock, *New Art*, 203.

8. See Irving Sandler, *Art of the Postmodern Era* (Boulder, CO: Westview/Icon Editions, 1996), 293.

9. Clement Greenberg, "Interview Conducted by Lily Leino (United States Information Service, April 1969)," in *Clement Greenberg: The Collected Essays and Criticism, Volume 4*. Ed. John O'Brien (Chicago: University of Chicago Press, 1995), 311–312. Because of the source, however, one wonders if Greenberg might have spoken differently to another (non-government-affiliated) interviewer.

10. Sandler, *Art of the Postmodern Era*, 293.

11. One cannot discount Greenberg's critical appeal during the 1950s and 1960s. Before Greenberg lay what Barbara Rose described as a criticism of jargon or what Rosalind Krauss saw as vagueness and unverifiable opinion championing abstract expressionism. This could be seen in the writings of "everyone," Krauss has explained, though she specifically cites the work of Sidney Janis, Thomas Hess, Harold Rosenberg, and Dore Ashton. Apart from this kind of thinking, there were few aesthetic "positions" in the art world, other than that of John Cage and Susan Sontag, whose "Against Interpretation" is essentially a restatement of Cage's position.

See Amy Newman, *Challenging Art: "Artforum," 1962–1974* (New York: SoHo Press, 2003), 167. Newman's book also features comments by Rose discussing Greenberg as a kind of paternal authority who offered writing grounded by philosophy and aesthetics, in concrete terms, with claims you could check out (59).

12. Ibid., 216.

13. See Michael Fried, "Manet's Sources: Aspects of His Art, 1859–1865," *Artforum*, vol. 7 (March 1969), 28–82.

14. Considered one of the most shocking rejections of Greenbergian formalism was Barbara Rose's series of articles "The Problems of Criticism: The Politics of Art," which ran in *Artforum* from February 1968 through May 1969.

15. See Michael J. Lewis, "Art, Politics, and Clement Greenberg," *Commentary*, June 1998.

16. For the first discussions of minimalism's denial of content, see Barbara Rose, "ABC Art," *Art in America*, vol. 53 (October/November 1965), 57–69; or Lucy Lippard, "The Third Stream: Painted Structures and Structured Paintings," *Art Voices* (New York), vol. 4, no. 4 (1965), 44–49. Also see, for example, the comments of Hilton Kramer in Newman, *Challenging Art*, 299; or Irving Sandler, *American Art of the 1960s* (New York: Harper and Row, 1988), 267. Importantly, the canonization of "minimalism," and particularly its conceived homogeneity, has been progressively reversed by recent scholarship, such as James Meyer's *Minimalism: Art and Polemics in the Sixties* (New Haven: Yale University Press, 2001). Meyer has called minimalism "a field of difference" (8) in this way. See also Tony Godfrey, *Conceptual Art* (London: Phaidon, 1998), 15.

17. Sandler, *American Art of the 1960s*, 61.

18. See Carl Andre, "Preface to Stripe Painting," in *Sixteen Americans*. Ed. Dorothy Miller (New York: Museum of Modern Art, 1959), 76.

19. See Bruce Glaser and Lucy Lippard, "Questions to Stella and Judd," *Art News*, September 1966, 58–59.

20. See Robert Hughes, "The Rise of Andy Warhol," *New York Review of Books*, February 18, 1982, 7.

21. See Alex Potts, "'in . . . cool white' and 'infected with a blank magic,'" in *Dan Flavin: New Light*. Ed. Jeffrey Weiss (New Haven: Yale University Press, 2006), 19.

22. In the late fall of 1965, army units were beginning to suffer heavy casualties due to ambushes, such as at Ia Drang Valley, where one unit lost 151 men. See ibid.

23. See Bryan-Wilson, *Art Workers*, 80. As she explains, the fact that the manufacturer of Andre's works, Dow, was hidden under his pieces allowed him to avoid the criticism Flavin endured (discussed later in this chapter). She also suggests that Andre's high status in AWC also enabled him to be insulated from criticism (74).

24. See Handler, "Art of Activism," 152; and Carl Andre, "Carl Andre Interviewed by Achille Bonito Oliva," *Domus*, vol. 10, no. 515 (1972), 51.

25. David Raskin, "Specific Opposition: Judd's Art and Politics," *Art History*, vol. 24, no. 5 (2001), 683.

26. Ibid.

27. Ibid., 688.

28. Ibid., 683.

29. Tischler quoted in ibid., 694, 702.

30. Ibid., 697

31. Of the thirty-two quotations, twelve appeared, in part or in full, in issues of *Public Life*. See ibid., 692.

32. See Leon Golub, "Letter," *Artforum*, vol. 7, no. 7 (1969), 4.

33. Bryan-Wilson, *Art Workers*, 77.

34. This came up as a result of the *Spaces* exhibition at the Museum of Modern Art, which ran from December 30, 1969, to March 1, 1970.

35. Bryan-Wilson, *Art Workers*, 77.

36. See, for example, Joan Seeman-Robinson's proposal for "They Ruled the Night," in the Irving Sandler files at the Getty Research Institute. According to Seeman-Robinson, Marden "recollected that he commenced his mid-60s gray paintings as the war began." He explained about them, "It was as if your country was making death . . . I wanted the viewer to come away from my paintings feeling twisted" (11).

37. Judith L. Dunham, "Wally Hedrick Vietnam Series," *Artweek*, June 28, 1975.

38. Saul's work, which will be discussed subsequently, was seen as an "errant breed" and a progenitor of pop, and Rosler's works could be easily compared with early pop collages by Richard Hamilton and Eduardo Paolozzi.

39. As Michael Lobel has recently commented, "The sense of *F-111* as a Vietnam painting is part and parcel of latter-day critical accounts of the work." See *James Rosenquist: Pop Art, Politics, History* (Berkeley: University of California Press, 2009), 144. The combination of a young blonde girl in the pilot's seat and presentation of American consumer products has also been read as criticism of the collusion between American society and the American war machine.

40. Previously the painting had only been shown in 1965 at the Castelli Gallery and briefly at the Jewish Museum the following summer. Between 1965 and 1968, the painting went on a "European tour" of sorts, traveling to the Moderna Museet in Stockholm, the Stedelijk Museum in Amsterdam, the Staatliche Kunsthalle in Baden-Baden, and the Galleria Nazionale d'Arte Moderna in Rome. A section of the painting was also shown in Brazil, as part of an exhibition at the Sao Paulo Bienal, curated by William Seitz. Interestingly, Rosenquist didn't even intend for the work to exist as one work after the initial show but had wanted it to be sold off in pieces.

41. Lobel, *James Rosenquist*, 145. The exhibition in which *F-111* was shown is worth noting as it truly foregrounded the painting, probably in the most significant way in its history. Titled *History Painting*, the exhibition installed *F-111* alongside three historically central history paintings from the museum's permanent collection: Nicolas Poussin's *Rape of the Sabine Women* (1634–1635), Jacques-Louis David's *The Death of Socrates* (1787), and Emanuel Leutze's *George Washington Crossing the Delaware* (1851). With the installation, the museum seemed to assert that *F-111*

was equal in stature to these three works. The exhibition was the work of Thomas Hoving, who had taken over as director in 1967 and who sought to make the Met a populist institution. Along with J. Carter Brown (the director of the National Gallery of Art from 1969 to 1992), Hoving originated the blockbuster exhibition. Hoving also oversaw—to both acclaim and condemnation—a huge expansion of the Met into Central Park, the creation of a contemporary art department, and the installation of the now-familiar banners and monumental staircase framing the museum's front doors. For an example of some of the backlash against Hoving, see Matthew Israel, "As Landmark: An Introduction to 'Harlem on My Mind,'" *Art Spaces Archives Project*, December 2004; as well as Steven Dubin, *Displays of Power: Controversy in the American Museum from the "Enola Gay" to "Sensation"* (New York: New York University Press, 1999). In addition to being labeled as antiwar, *F-111* was harshly reviewed as part of *History Painting*. In the *New York Times*, John Canaday and Hilton Kramer both found it overblown and superficial. Yet, as Lobel argues, this hostility was probably more attributable to Hoving's management of the museum and the provocation of his exhibition than to the painting itself and particularly its criticisms of the United States (148).

42. Lucy Lippard, for example, commented in her notes on the manuscript, "Rosenquist certainly went along with and as I recall agreed that *F-111* had something to do with the war."

43. Rose quoted in Martin, *Theatre Is in the Street*, 152.

44. Barbara Rose, "Oldenburg Joins the Revolution," *New York*, June 2, 1969, 54.

45. See Tom Williams, "Lipstick Ascending: Claes Oldenburg in New Haven in 1969," *Grey Room*, vol. 31 (Spring 2008), 117–144.

46. Between September 19 and September 26, 1970, well-known galleries including Andre Emmerich, Leo Castelli, O. K. Harris, Richard Feigen, Terry Dintenfass, Bykert, Poster Originals, and Sidney Janis, regardless of what they were showing, organized themselves in an effort to become peace centers and distributed antiwar literature. This organization was the aforementioned "Art for Peace" and it ended up comprising thirty-two galleries in New York. The precedents for this were the events in Boston, where artists held a benefit show for Eugene McCarthy and raised $17,000. Boston art dealers also had a fund-raising drive called "Fifteen Days in May." See Jane Holtz Kay, "Artists as Social Reformers," *Art in America*, January/February 1969, 44–47. During this week a benefit auction was held at Parke Burnet, and the Oldenburg drawing was on the catalog cover. The drawing also served as an advertisement for the auction postcard, a copy of which is in the Lucy Lippard Papers at the Smithsonian Institution.

47. Williams, "Lipstick Ascending," 125.

48. See Max Kozloff, "A Collage of Indignation," *The Nation*, February 20, 1967.

49. Kozloff quoted in Newman, *Challenging Art*, 269. Formalism's influence was also to blame for the absence of artistic antiwar engagement from television. Yet equally at fault was the American mainstream media's tendency—almost throughout the war—to both reflect the government's view of the antiwar movement as

irrelevant and wrongheaded, and to present only the most eye-catching images for its audiences, which most often were images of graphic, war-front violence. See Zaroulis and Sullivan, *Who Spoke Up?* xiii.

50. Newman, *Challenging Art*, 406.

51. Linda Nochlin recently explained to the author in a personal interview that her work at the IFA was always completely politically engaged during this period. Nochlin earned her PhD at the IFA in 1963 and her research focused on Gustave Courbet, 1848, and the Nürnberg Kleinmeister. However, this would make Nochlin an exception to the rule, and as is well-known, in so doing she paved the way for feminist art history.

52. By challenging scholarship and exhibitions, I mean to refer to the publication of Camilla Gray's seminal study, *The Russian Experiment in Art: 1863–1922* (London: Thames and Hudson, 1962); and Gene Swenson's *The Other Tradition*, which he curated in 1965 at the Philadelphia Institute of Contemporary Art.

53. In addition to examples that will be discussed in later chapters, Rudolph Baranik used Picasso's woman wailing over her child and a soldier being trampled by a horse—both at the bottom left of the painting—in one of two posters he designed for Angry Arts Week in 1967. The November 1, 1965, cover of *Newsweek* also featured a student poster that used a portion of *Guernica* juxtaposed with the text, "Stop the War in Vietnam *Now*." See McCarthy, "Dirty Freaks and High School Punks," 95. For more on *Guernica*, see Gijs van Hensbergen, *Guernica: The Biography of a Twentieth-Century Icon* (London: Bloomsbury, 2005).

54. For the information about the MoMA retrospective I am indebted to David McCarthy. See "Dirty Freaks and High School Punks," 96.

55. Gertje Utley, *Pablo Picasso: The Communist Years* (New Haven: Yale University Press, 2000), 117.

56. This occurred to such an extent that "when United Nations delegates gathered in Panmunjom, Korea, in July 1953 to sign the armistice ending the war, representatives of the pro-American powers refused to enter the building where the documents would be signed because Communist workmen had installed the *Peace Dove* over the entrance." Ibid., 128.

57. Ibid., 106.

58. Ibid.; and Tony Judt, *Past Imperfect: French Intellectuals, 1944–1956* (Berkeley: University of California Press, 1994), 222.

59. For example, the dove was used as the backdrop for the awarding of the 1951 Stalin Peace Prize.

60. Schwartz, "Politicization of the Avant-Garde," 98.

61. See Sandler, *American Art of the 1960s*, 292.

62. By that point Chicago had been included in 1966's seminal exhibition of minimalist work, *Primary Structures* at the Jewish Museum. Clement Greenberg notably called her work *Rainbow Picket* one of the best in the exhibition. See Edward Lucie-Smith, *Judy Chicago: An American Vision* (New York: Watson-Guptill, 2000).

63. This specific description of the tower I owe to Frascina; see *Art, Politics, and Dissent*, 67.

64. For example, see *Artforum*, May and December 1965.
65. The bulletin was sent out in Italian, French, Spanish, and English, and panels were sent or brought in by artists to designated drop points across the United States and in Europe. See Bryan-Wilson, *Art Workers*, 5; Schwartz, "Politicization of the Avant-Garde," 98. Leon Golub's studio was the central New York drop point.
66. This number is one estimate of the amount of panels actually installed on the tower. An accurate count cannot be established for a few reasons. First, no complete count was undertaken or complete photographic record made at the final installation. Second, the panels were sold off individually—this will be discussed subsequently—when the tower was taken down, so no grouping of them still exists to count. Third, there were multiple lists of names: Irving Petlin had a packing list from the European artists who contributed, from Galerie du Dragon, that included 319 names; there was an advertisement published in the *New York Times* announcing the opening of the tower that listed 166 names of American artists; and, finally, a letter written by Arnold Mesches inviting financial support for the project lists twenty-two significant artists who would be involved, and some of Mesches's names are absent from the other two lists. See Frascina, *Art, Politics, and Dissent*, 65. Frascina includes all the names included in the various lists in his footnotes and I reprint them here as a historical reference even though (as Frascina explains) what was most important about the tower was that it was in the end a collective statement and not about the individual artists who participated. (For Frascina's lists see p. 98n22, though they are also reproduced below.) To begin with, Petlin's typed, uncorrected list, according to Frascina, was as follows: Ailland, Gilles; Aitkin, S.; Allen, Tom; Appel, Karl; Arcilisi, Vincent; Armoto, Sam; Arnal, Francois; Aronson, Sardo; Arroyo; Asher, Elsie; Avalon, Helen; Baker, Walter; Baranik, Rudolf; Barnet, Will; Baruchello, Gianfranco; Beberman, Edward; Belzono; Bleek, Margit; Bubalo, Vladamire; Bayer, Walter; Boutin, Allen; Blaire, Camille; Brill, J.; Butts, Freeman; Blackwell, Patrick; Berlant, Anthony; Brown, Ray; Brooks, James; Blaine, Nell, Brach, Paul; Bolles, Bob; Brittin, Charles; Benjamin, Karl; Brown, M.; Bird, Annette; Bromfomel, I.; Botts, Edward; Bowin, Milton; Bleckman; Brooks, James; Berman; Biras; Busse, Jacques; Benoit, Jean; Collins, Jess; Contino, E.; Crampton, Rollin; Cannon, J.; Cajori, Jim; Cruz, Emilo; Clayberger, Sam; Clutie; Colbern, Jan; Camacho; Cardenas, César; Chemay; Cremonini; Cueco; Candell, Victor; Copley, William; Cohen, G.; Coleman, John; Chavez, Roberto; Celmins, Vija; Curtis, Ron; Canin, Martin; Dougherty, Frazer; De Hirsch, Storm; Donley, Robert; d'Archangelo, Allen; Di Meo, Dominich; Dimondstein, Morton; Dovvos, Peter; de Kooning, Elaine; Dash, Robert; Diebenkorn, Richard; Dillon, Dejon; De Feo, Jay; Dimetrakas; Dmitrienko; de Noailles, Marie; Dewasne, Jean; Erythrope, Ilse; Eunese, Mariano; Evans, D.; Evergood, Philip; Elgard, Elliot; Etherton, Tom; Fuller, Mary; Francis, Sally; Feldman, Bella; Flomelbalch, Sidro; Fine, Perle; Finch, Kieth; Ferrer, Joaquin; Freedensohn, Elias; Eilmus, Tully; Finkelstein, Max; Formica, Rachel; Frasconi, Antonio; Golpinopoulas, P.; Gikow, Ruth; Golden, Leon; Girona, Julio; Goodman, Sidney; Golub, Leon; Greene, S; Gordon; Greene, Cynthia; Gershgoren, M.; Gutman, Walter; Garcia, Jose; Gwathmey; Gilchriest,

Loreno; Greene, Balcomb; Grayson, Marvin; Gillson, George; Guston, Philip; Gill, James; Gelber, Anne; Gebhardt, Al; Goswell, Stephen; Greenough, Lowell; Gilbert, Hugo; Gerardo, Chaves; Hunt, Richard; Hanson, Bert; Hui, H.; Hielihia; Hirsh, Joseph; Hopkins, Budd; Halkin, Theodore; Holbrook, Peter; Hubbard, W; Honig, Etheleyn; Hornisher, Anna; Hanson, Hardy; Hesse, Eva; Hatch, David; Hardin, Marvin; Hairer, Carol; Hulpberg, J.; Harris, Kay; Helion, Jean; Ippolito, Angelo; Johnson, Ives; Jakoson, Ward; Junkers, Adja; Joffey, W.; Jaffee, Nora; Juke, Richard; Kramer, Harry; Kahn, W.; Kaufman, Jane; Kippelman, Chaim; Kadish; King, Raymond; Kapsalio, Theodore; Kosta, Angela; Kraicke, Jane; Kantowitz, Howard; Katzman, Herbert; Kaplan, S.; Kishing, William; Koppelman, Dorothy; Kassay; Kline, Jane; Klix, Richard; Kadell, Katherine; Koster, Sue; Krof, N.; Kozloff, Max; Lysowski, J. S.; Little, John; Lyons, Marvin; Liebowitz, Diane; Lawrence, Michael; Lublin, Lee; Leroy, Phillipe; Leap, June; Levin, Kim; Levin, Jack; Lunk, David; Lewen, Si; Lindaberg, Linda; Lubner, Lorraine; Laderman, Gabriel; Lichtenstein, Roy; Lawless, David; Matter, Herbert; Matter, Mercedes; Mattox, Charles; Miller; Maurice, Henry; Melliken, Margaret; McKnight, Eine; Motherwell, Robert; McNee, Joan; Main, D.; Martiner, Joseph; Monoru; McChesney, Robert; Merz, R.; Majdrakoff, Ivan; Maggi, Anthony; Moesle, Robert; Matta; Mercado; Mellon, James; Marcus, Mardin; Mesches, Arnold; Mugnaimie, Joe; Neufeld, Tanya; Nevelson, Louise; Nesbitt, Lowell; Oster; Gerald; Ohlson; Douglas; Petlin, Irving; Pearl, Judith; Presonello, Harold; Pedreguera, R.; Parker, Ray; Padron, Abilio; Picard, Lil; Pittenger, Robert; Passirntino, Peter; Pazzi, L.; Pessillo, Christina; Paris, Freda; Paris, Harold; Pinsler, Jorry; Pollack, Sam; Palestino, Dominick; Pearlstein, Philip; Pfriem, Bernard; Parker, Keith; Piqueras; Pellon, Gina; Parre, Michel; Rosenbein, Sylvia; Rosenquist, Jim; Rosenhouse, Irwin; Reisman; Philip; Rieti, Falio; Robert, Niki; Rockless, Robert; Rooney, Pauline; Rapoport, Sonya; Roff, Richard; Richenheimerk, Alice; Rubens, Richard; Reinhardt, Ad; Raffaele, Joe; Rosofasky, Seymore; Russ, Charlotte; Rich, Marsha; Rivkin, Jay; Rancillac, Bernard; Ramon; Secunda, Arthur; Sterne, Hedda; Saar, Betye; Sherman, C.; Serisawa; Spaventa, George; Stefanelli, Joe; Schapiro, Meyer; Schwartz, Ellen; Schnackenberg, Roy; Sotz, Rick; Szapocznikow, Alina; Stewart, Michelle; Sanders, Joop; Sonberg, A. H.; Stevens, May; Simon, Ellen; Soyer, Moses; Speyer, Nora; Swartz, Shol; Spero; Sonenberg, Josh; Soyer; Rudolf; Sugarman, Seley, Jason; Sugarman, George; Sherman, S.; Talachnik, Acne; Teschout, David; Tytell, Lois; Toney, Anthony; Tauger, Susanna; Todd, Mike; Tavoularis, Constantine; Tunberg, Wm.; Thek; Paul; Telemaque, Nerve; Tabuchi, Yasse; Uraban, Reva; Vicente, Esteban; Vlack, Don; Valentin, Helene; Vincent, Richard; Voss, Jan; Van Veer; Walters, Charles; Wines, James; Weal, Alica; Weber, Ellen; Wesselmann, Tom; Wolf, Sara; Witherspoon; White, Charles; Watlin, Larry; Wiegand, Robert; Yamii, Alice; Yeargans, H.; Zajac, Jack; Zaro, Sid; Zaslove, Allen. The *New York Times* advertisement of February 1966 names the following artists: Susie Aitkin; Elise Asher; Helen Daphnis Avlon; Tony Balzano; Rudolf Baranik; Walter Barker; Will Barnet; Baruchello; Margit Beck; Milton Berwin; Edward Betts; Nell Blaine; R. O. Blechman; Bob Bolles; Paul Brach; L. Bronfman;

James Brooks; Charles Cajori; Victor Candel; Martin Canin; Herman Cherry; George Cohen; CPLY; Emilio Cruz; Robert Corless; Ron Curtis; Allan D'Arcangelo; Robert Dash; Storm De Hirsch; Elaine de Kooning; Fraser Dougherty; Georfe Dworzan; Isle Erythropel; D. Evans; Philip Evergood; Tully Filmus; Perle Fine; Rachel Formica; Elias Friedensohn; Sideo Fromboluti; Ruth Gikow; Lorenzo Gilchrist; George Gillson; Julio Girona; Leon Goldin; Peter Golfinopoul; Leon Golub; Ron Gorchov; Balcomb Greene; Cynthia Greene; Stephen Greene; Philip Guston; Walter Gutman; Robert Gwathmey; Carol Haerer; Kay Harris; Burt Hasen; John Heliker; Eva Hesse; Joseph Hirsch; Budd Hopkins; Helene Hui; John Hultberg; Robert Huot; Angelo Ippolito; Donald Judd; Ward Jackson; Nora Jaffee; William Jeffrey; Reuben Kadish; Wolf Kahn; Howard Kanowitz; Bernard Kassoy; Herbert Katzman; Jane Kaufman; Chaim Koppelman; Dorothy Koppelman; Max Kozloff; Harry Kramer; Gabriel Laderman; Jacob Landau; David Lawless; June Leaf; Kim Levin; Jack Levine; Si Lewen; Roy Lichtenstein; Linda Lindeberg; John Little; David Lund; Manuel Manga; Ernest Marciano; Marcia Marcus; Emily Mason; Herbert Matter; Mercedes Matter; Eline McKnight; James Mellon; Jack Mercado; Margaret Milliken; Robert Motherwell; Bob Natkin; Alice Neel; Lowell Nesbitt; Louise Nevelson; Doug Ohlson; Gerald Oster; Ray Parker; Peter Passantino; Philip Pearlstein; R. Pedreguera; Christina Pesirillo; Harold Pesirillo; Bernard Pfriem; Lil Picard; Bob Pittinger; Lucio Pozzi; Andre Racz; Joe Raffaele; Ad Reinhardt; Philip Reisman; Pauline Roony; Irwin Rosenhouse; James Rosenquist; Richard Rubens; Joop Sanders; Jason Seeley; Meyer Schapiro; Sarai Sherman; Burt Silverman; Ellen Simon; Jack Sonenberg; Phoebe Sonenberg; Moses Soyer; Rafael Soyer; George Spaventa; Nancy Spero; Nora Speyer; Joe Stefanelli; Hedda Sterne; May Stevens; Sahl Swarz; Michelle Stuart; George Sugarman; Susanne Tanger; Paul Thek; Mike Todd; Anthony Toney; Louis Tytell; Reva Urban; Helene Valentin; Stuyvesant Van Veen; Esteban Vicente; Richard Vincent; Don Vlack; Ellen Weber; Tom Wesselman; Robert Wicgand; John Willenbacher; James Wines; Sara Wolf; Alice Yamin; Heartwell Yeargens; Adja Yunkers; Sidney Goodman; Eddie Johnson. Mesches's list is as follows: Elaine de Kooning, Herbert Ferber, Sam Francis, Judy Gerowitz [Judy Chicago], Lloyd Hamrol, Roy Lichtenstein, Robert Motherwell, Lee Mullican, Ad Reinhardt, Larry Rivers, Jim Rosenquist, Mark Rothko, Frank Stella, George Segal, Jack Zajac, Philip Evergood, George Sugarman, Claes Oldenburg, César, Karel Appel, Jean Helion, Leon Golub. The citation from Frascina regarding the Mesches list is Arnold Mesches, "Letter," University of California, Department of Special Collections, Collection 50, "A Collection of Underground, Alternative and Extremist Literature," Box 36, Folder "Artist's Tower Los Angeles."

67. I am indebted here to ideas included in Beth Handler's dissertation. See "Art of Activism," 50.

68. Bryan-Wilson, *Art Workers*, 5.

69. Duncan's article "The Whole Thing Was a Lie: Memoirs of a Special Forces Hero" ran in *Ramparts* in February 1966. Also, at the dedication, children released six white doves to "symbolize peace." See Frascina, *Art, Politics, and Dissent*, 48.

70. Susan Sontag, "Inventing and Sustaining an Appropriate Response," *Los Angeles Free Press*, March 4, 1966, 4.

71. Bryan-Wilson, *Art Workers*, 8.

72. Petlin, personal interview.

73. According to Petlin, the lease was carefully and ambiguously worded because they knew the landlord wouldn't comply. Frascina comments that the owner's anger at the artists stemmed also from attacks on himself by others, who accused him of being "soft on communism." For more information on both of these issues, see Frascina, *Art, Politics, and Dissent*, 60.

74. Schwartz, "Politicization of the Avant-Garde, Part I," 99.

75. Where this was has not been clarified.

76. Petlin, personal interview.

77. See Lucy Lippard, "Flagged Down: The Judson Three and Friends," *Art in America*, vol. 60 (May/June 1972), 48.

78. Radich was sentenced to either sixty days in jail or a fine of five hundred dollars. After the exhibition, Morrel did not stop making his flag works. For example, his contribution to the *Collage of Indignation* in 1967 was a facsimile of a flag that was incorporated into a sculptural construction. Like the other flag works he made, this work was removed from the *Collage* because NYU authorities deemed it "disrespectful." Specifically, the director of the student center at NYU removed the work as he was instructed to do by the university coordinator of protection.

79. Jeanne Siegel, *Artwords: Discourse on the 60s and 70s* (Ann Arbor: UMI Research Press, 1992), 117.

80. According to Carrie Lambert-Beatty, the work stemmed from a 1965 painting by Johns, in which "the viewer's concentrated gaze at the mis-colored flag could produce the official red, white and blue as an optical illusion when the eyes moved down to a gray monochrome version below." See *Being Watched: Yvonne Rainer and the 1960s* (Cambridge: MIT Press, 2008), 340n82. Johns also used the same image in a series of 1966–1967 prints.

81. In later years it should be noted that Donald Judd created a similar image, which he hung outside his studio window and which Yvonne Rainer borrowed for the performance of her 1970 work *War*.

82. Martin, *Theatre Is in the Street*, 151.

83. See Lippard, *A Different War*, 26–27.

84. Grace Glueck, "A Strange Assortment of Flags Is Displayed at People's Flag Show," *New York Times*, November 10, 1970, 53; Clark Whelton, "The Flag as Art: Bars and Stripes Forever," *Village Voice*, November 19, 1970, 1, 20; Grace Glueck, "Art Notes," *New York Times*, November 1, 1970, sec. 2, 22.

85. Martin, *Theatre Is in the Street*, 151. The flag draped over a toilet bowl was by Kate Millet.

86. Ibid., 152.

87. However, the show, against the DA's orders, stayed open on its last day.

88. See Judson 3 Defense Committee, "Historical Background of the People's Flag

Show," 1–6, reprinted in Jon Hendricks, Jean Toche, Guerrilla Art Action Group, et al., *GAAG: The Guerrilla Art Action Group, 1969–1976: A Selection* (New York: Printed Matter, 1978). See also Lippard, *A Different War*, 26–27, 34–62, n. 119.

89. Though in contrast to Spero's series, these works presented American weaponry as automated or robotic, often with the inclusion of robotic-looking soldiers. For example, Lichtenstein's *Preparedness*, combined pop and 1930s-style realism to show soldiers as parts of a grand war machine; and the works of Nancy Grossman, Bernard Aptekar, and Arnold Belkin "invented gruesome automata with anatomies of weapons." For some discussion of this, see Joan Seeman-Robinson's book proposal for "They Ruled the Night," in the Irving Sandler Papers at the Getty Research Institute, 2000.M.43: Sandler, Box 42.

90. Bernstein's work is best known because of its involvement in a controversy in the early 1970s. Specifically, her *Horizontal*, a huge (9½ × 12 foot) charcoal drawing of a screw-like penis, was withheld from "Women's Work: American Art 1974," an exhibition at the Philadelphia Civic Center. This action of censorship provoked protests from various significant artists and writers.

91. *Dispatches* (New York: Vintage, 1977) was culled from Herr's late 1960s reports for *Esquire* magazine.

92. Ibid., 160.

93. Ibid., 9.

94. See, for example, James Aulich, "Vietnam, Fine Art, and the Culture Industry," in *Vietnam Images: War and Representation*. Ed. James Aulich and Jeffrey Walsh (New York: St. Martin's Press, 1989), 76.

CHAPTER THREE

1. Karnow, *Vietnam*, 520.

2. Zaroulis and Sullivan, *Who Spoke Up?* 110. As usual, estimates varied according to the source. There was also a huge demonstration in San Francisco on the same date.

3. Though the article was published in a number of places it is characteristically seen as a *NYRB* contribution.

4. Chomsky, "Responsibility of Intellectuals."

5. George Steiner, "Letter to Noam Chomsky," *New York Review of Books*, March 23, 1967, 28.

6. See Schalk, *War and the Ivory Tower*, 57.

7. See Noam Chomsky, "On Resistance," *New York Review of Books*, December 7, 1967.

8. Many of those involved in Angry Arts Week had actually been involved in the *Peace Tower* as well. See Aulich, "Vietnam, Fine Art, and the Culture Industry," 75.

9. From copy of the announcement in the "Dore Ashton" file, *PAD/D* Archive, Special Collections, Museum of Modern Art Library.

10. Ibid.

11. Schneemann remembers first hearing of the war around 1960 when she and her partner, James Tenney, met a young Vietnamese poet while they were both graduate students at the University of Illinois. See Carolee Schneemann, *More Than Meat Joy: Performance Works and Selected Writings*. Ed. Bruce R. McPherson (Kingston, NY: McPherson, 1997), 146.

12. Carolee Schneemann, personal interview, March 24, 2009.

13. In this respect, Schneemann commented recently that some members of her audience were not particularly happy to submit to her work. They said to her angrily after seeing it, "You're *forcing* us to think about this; you're *forcing* us to look at this!" Ibid.

14. Robert C. Morgan, "Carolee Schneemann's Viet-Flakes (1965)," in *After the Deluge: Essays on Art in the Nineties* (New York: Red Bass, 1993), 36. For a discussion of the effect of flashing lights on the consciousness, see National Research Council Committee to Review and Assess the Health and Productivity Benefits of Green Schools, *Green Schools: Attributes for Health and Learning* (Washington, DC: National Academies Press, 2007).

15. See Berger, *Representing Vietnam*, 5–6. Berger also discusses—through the examples of Roland Barthes—how indirect evidence can be moving.

16. Ibid.

17. The quote is from *Gardner's Photographic Sketchbook of the American Civil War*, which Susan Sontag quotes in her *Regarding the Pain of Others* (New York: Farrar, Straus & Giroux, 2003), 53.

18. See Franklin, *Vietnam and Other American Fantasies*, 71. The national and global campaign to publicize the disastrous effects of napalm began in and around Stanford University in 1966.

19. See Frascina, *Art, Politics, and Dissent*, 116, 118, 125.

20. Thanks to Linda Nochlin for making this connection between Baranik and Goya.

21. For example, WBAI reported live on the 1968 riots at Columbia University and innumerable antiwar protests. The station also was the first station to broadcast Arlo Guthrie's countercultural anthem "Alice's Restaurant," and it hosted audio experimental theater, featuring groundbreaking work by performance artists like Yvonne Rainer, Vito Acconci, John Cage, Robert Wilson, and Richard Foreman. As well, in the 1970s, it featured weekly arts coverage by critics such as John Perreault, Les Levine, Cindy Nemser, and Kenneth Koch.

22. There is some debate about what Petlin wrote. Martin believes the inscription said, "LBJ, infant people burner/Long may you roast in History's Hell!" Also, in the next year, Black Mask would change its name to Up Against the Wall Motherfuckers.

23. For more on specific contributions to the *Collage*, see Handler, "Art of Activism," 51.

24. Regarding attendance figures of the Week, Angry Arts estimated that sixty-two thousand people attended all the events of the Week. Notably, after the conclusion of Angry Arts Week, the organization met with other groups, distributed works to colleges and universities, and contributed to the Spring Mobilization to End the

War in Vietnam, which took place on April 15, 1967. For the Mobilization they decorated performing platforms and created six floats. One of them, by Marc Morrel, was a twenty-foot-high yellow mound, meant to represent Vietnam, which was topped with a coffin and an American flag. See Frascina, *Art, Politics, and Dissent*, 125; as well as my descriptions of Morrel's flag show in chapter 3.

25. See Handler, "Art of Activism," p. 55 and n. 39 for an impressive list of literature on the *Collage*. Notably, Rosenberg contrasted the *Collage* with an exhibition held at the same time at the New School for Social Research, *Protest and Hope*, curated by Paul Moscanyi. *Protest and Hope* featured works by Robert Rauschenberg, Red Grooms, and George Segal, among others. Rosenberg markedly praised the show for successfully braving the issue of aesthetic quality versus politics. See Rosenberg, "Art of Bad Conscience," *New Yorker*, December 16, 1967.

26. Kozloff, "A Collage of Indignation," *The Nation*, February 20, 1967.

27. See Martin, *Theatre Is in the Street*, 295.

28. Hoffman specifically invoked a pantheon of global deities and played cymbals.

29. Norman Mailer, excerpt from *The Armies of the Night*, in *Reporting Vietnam* (New York: Library of America, 1998), 510.

30. Importantly, in his speech, David Dellinger specifically urged people toward such a transition.

31. The petition is quoted from Handler, "Art of Activism," 103. For Meyer Schapiro's involvement in this petition, see Francis Frascina, "Meyer Schapiro's Choice: My Lai, *Guernica*, MoMA, and the Art Left, 1969–1970: Part I," *Journal of Contemporary History*, vol. 30, no. 3 (1995), 495.

32. Via Cecilia Clarac-Serou. From Petlin, personal interview.

33. During the fall of 1967, Golub also organized the benefit exhibition *Art for Peace* at his studio. The dates for the benefit were October 18–22, 1967.

34. See Martha Rosler, "Here and Elsewhere," *Artforum*, vol. 46, no. 3 (2007), 50. Not all the collages include a specific Vietnam reference. Her *First Lady* features Faye Dunaway shot up at the end of *Bonnie and Clyde* in a framed "tondo" above a fireplace in Pat Nixon's White House. Toward the end of the series, the collages are images of soldiers against a completely white background of the card stock to which the collages were affixed (as can be seen in Rosler's last work of the series, *Scatter*). Additional images from the series collage in images from protests, such as *Boys Room*, a work that includes an image of a protestor being subdued.

35. Martha Rosler, personal interview, April 3, 2008.

36. Rosler was also influenced by images she saw on television. However, after a certain point she said she dismissed TV coverage. She explained recently that this was due to her disgust that television images would be shown during dinnertime. She remembers most often these images would feature correspondents speaking into the camera "with huts burning behind them!" She asked herself, "How could I watch this? What do they expect me to do? Get up and cook dinner? Go and see a movie?" Ibid.

37. Rosler, "Here and Elsewhere."

38. See Tim Griffin, "Domesticity at War: Beatriz Colomina and Homi K. Bhabha in Conversation," *Artforum*, vol. 45, no. 10 (2007), 442–447.

39. As Rosler explains, windows and doors separate spaces in only four of the twenty images of the series.

40. Rosler's work was reproduced in *Goodbye to All That!* on October 13, 1970, and on other occasions.

41. In 1968, the *Journal* estimated that readership was a third of million; ten months later it put the figure over two million (an increase of 600 percent). See Franklin, *Vietnam and Other American Fantasies*, 90. He also quotes from Robert J. Glessing, *The Underground Press in America* (Bloomington: Indiana University Press, 1970), 120.

42. Franklin, *Vietnam and Other American Fantasies*, 90, citing Abe Peck, *Uncovering the Sixties: The Life and Times of the Underground Press* (New York: Pantheon Books, 1985). Other useful sources on the subject are Lawrence Lerner, *The Paper Revolutionaries: The Rise of the Underground Press* (New York: Simon and Schuster, 1972); and Roger Lewis, *Outlaws of America: The Underground Press in Its Context: Notes on the Cultural Revolution* (Harmondsworth: Penguin, 1972). See also David Cortright, *Soldiers in Revolt: The American Military Today* (Garden City, NY: Doubleday, 1975), 283. Cortright gives a detailed list of 259 GI newspapers he was personally able to locate.

43. Much of the story of the underground press and its relationship to dissent during the Vietnam War has disappeared into the "black hole of national amnesia." See Franklin, *Vietnam and Other American Fantasies*, 71–91. In the late 1960s, mainstream media continued to dominate the news landscape, and its antipathy toward underground media sources meant the underground was largely overlooked. The short life spans of many of these underground outlets and their lack of accessible archives also have made it hard for their impact to be felt in the wider media culture.

44. Interestingly, a Violet Ray was a machine that administered low-frequency shocks to the body that was used in sexual situations but also covertly by law enforcement. There is no confirmed relationship between the machine and the artist's choice of the name, however.

45. The image was captured by the Japanese photographer Kyoichi Sawada.

46. See unpublished Violet Ray biography, sent directly to the author. The pamphlet then continues, "Don't wait for the news to tell you what's happening. Make your own headlines with prestype. Cut up your favorite magazine and put it together again. Cut big words in half and make little words out of them—like environ mental crisis. All you need is a good pair of scissors and rubber cement. Abuse the enemy's images. Turn the man from Glad into a Frankenstein. Make comic strips out of great art. *Don't let anything interfere with your pleasure.*" See Violet Ray's anonymously published *The Anti-Mass*, printed in 1970, which was sent to author by Ray.

47. Susan Brownmiller, *Against Our Will: Men, Women, and Rape* (New York: Simon and Schuster, 1975), 31, 110.

48. Ibid., 110.
49. Ibid., 99. Information on sentencing was difficult to come by, according to Brown-miller. She explains, "A sentence of two to eight years at hard labor might be typical for rape, even in cases in which the victim had been murdered; sodomy, attempted rape and attempted sodomy were preferred as charges because they carried lesser penalties; and sentences were routinely cut in half by a board of review" (101).
50. See Karen Stuhldreher, "State Rape: Representations of Rape in Viet Nam," in *Nobody Gets Off the Bus: The Viet Nam Generation Big Book* (Tucson, AZ: Burning Cities Press, 1994).
51. Among others, *Esquire* published a special issue on violence in the United States, pointing to mass murders and rape, the ease with which Americans could purchase weapons, and the numerous recent best sellers on deviant behavior, among them *In Cold Blood* and *The Boston Strangler*. The essayist Tom Wolfe characterized the national obsession as a "mass perversion called porno-violence." Meanwhile, *The Dirty Dozen*, a film about misfits, murderers, and rapists sent on a special mission by the United States Army during World War II, was on its way to becoming the top-grossing film of the year. See McCarthy, "Dirty Freaks and High School Punks," 92.
52. Dan Cameron, *Peter Saul* (New York: Distributed Art Publishers, 2008), 14.
53. These words are distorted in such a way to be suggestive of decals found on hot rods, or the painted images found on planes during wartime. See Joseph Mascheck, "Peter Saul," *Artforum* 10 (January 1972), 85. Saul was very influenced by comics, such as *Crime Boy and Squeaks* and *Crime Does Not Pay*. Also in the mix was *Little Orphan Annie*. And then there were the "undergrounders" like *Mr. Toad*, which Saul says he still owns. Saul, personal interview, April 6, 2009. In other places, Saul dubbed soldiers during the war "dirty freaks" and "high school punks." See McCarthy, "Dirty Freaks and High School Punks," 79.
54. See "Letter to Ellen H. Johnson," in Cameron, *Peter Saul*, 149. See also McCarthy, "Dirty Freaks and High School Punks," 94.
55. The use of the green beret in *Saigon* is particularly significant. It identifies members of the U.S. military's Special Forces group, founded in 1952 and promoted by Kennedy to combat "wars of liberation" funded by the Soviet Union and China. On the one hand these men were celebrated, top-tier members of the armed forces. Robin Moore's *The Green Berets* (New York: Crown) was a *New York Times* best seller in 1965 (and would be made into a movie by John Wayne in 1968). Sergeant Barry Sadler's "The Ballad of the Green Berets" was number one on the pop music charts in 1966. On the other hand, I. F. Stone wrote of the Green Berets as "communists in reverse," and "fascists," who operated according to "cloak and dagger methods" and "dirty tricks." See "When Brass Hats Begin to Read Mao Tse-Tung, Beware!" *I. F. Stone's Weekly*, May 15, 1961, reprinted in I. F. Stone, *In a Time of Torment* (New York: Random House, 1967), 170–173. Former member Donald Duncan—who spoke at the dedication of the *Peace Tower*—also ended up exposing the methods of the Green Berets in his writing in *Ramparts* ("It Was All a Lie," February 1966)

and his publication of *The New Legions* (New York: Random House) in 1967, explaining the "hard truths" of training to be in the Special Forces, their violent actions in Vietnam, and how he managed to stay alive.

56. Alfred V. Frankenstein, "Saul's Caricature of Agony," *San Francisco Examiner-Chronicle*, August 11, 1968, 37. See also McCarthy, "Dirty Freaks and High School Punks," 90.

57. In contrast to McCarthy's view of the baby as a product of an American and Vietnamese coupling, it seems to me that the baby is meant more to suggest the infancy of American soldiers. See McCarthy, "Dirty Freaks and High School Punks," 90.

58. McCarthy explains that Saul's parents took him to see *Picasso: Forty Years of His Art* when it traveled to San Francisco. Saul also saw the painting in the summer of 1956 when he was in Amsterdam, while the painting was there on tour. McCarthy additionally discusses the fact that the painting would have been available to Saul through books, such as Alfred H. Barr's *Picasso: Forty Years of His Art* (New York: Museum of Modern Art, 1939) and *Picasso: Fifty Years of His Art* (New York: Museum of Modern Art, 1946); Juan Larrea's *Guernica* (New York: Arno Press, 1947); and Rudolf Arnheim's *Picasso's* Guernica: *The Genesis of a Painting* (Berkeley: University of California Press, 1962). See also McCarthy, "Dirty Freaks and High School Punks," 96.

59. McCarthy, "Dirty Freaks and High School Punks," 96.

60. For Picasso's comments on the symbolism of the mural, see Jerome Seckler, "Picasso Explains," *New Masses*, vol. 54 (March 13, 1945), 5, reprinted in *Theories of Modern Art: A Source Book by Artists and Critics.* Ed. Herschel B. Chipp (Berkeley: University of California Press, 1968), 487.

61. McCarthy, "Dirty Freaks and High School Punks," 96.

62. Ibid., 97.

63. Ibid., 82.

64. Ibid.

65. For example, see John Perreault, "Art: Repeating Absurdity," *Village Voice*, December 14, 1967.

66. See McCarthy, "Dirty Freaks and High School Punks," 100. He cites the Saul questionnaire, File: 69.103, Whitney Museum of American Art. Saul's comments likely were shaped by artist Rockwell Kent's gift of $10,000 to the "suffering women and children" of the Vietcong in the late spring of 1967. Along with the Mexican muralist David Alfaro Siqueiros and the German peace activist Martin Niemöller, Kent had just been awarded the Lenin Peace Prize by the Soviet Union. Kent directed the Soviet Union to transmit the money to North Vietnam's ambassador in Moscow. See Associated Press, "Rockwell Kent Gift Sent to Vietcong," *New York Times*, July 7, 1967, 12. For further proof of Saul's belief that his efforts were serious, see Marjorie Heins, "I Like to See Things Crudely," *San Francisco Express Times*, August 21, 1968, 8. As well, see Beth Fagan, "Saul Intends Provoking Reaction with Vietnam Paintings," *Sunday Oregonian*, September 22, 1968, 18.

67. Cameron, *Peter Saul*, 30–31.

68. Saul, personal interview.

69. See Joyce Carol Oates, "The Miniaturist Art of Grace Paley," originally published in the *London Review of Books*, April 16, 1998, and reprinted in *Where I've Been, and Where I'm Going: Essays, Reviews, and Prose* (New York: Plume, 1999). A copy of Schlanger's poster is in the Charles Brittin file at the Getty Research Institute, 2005.M.11, FF 2: "Artists' Tower Ephemera." Other posters of the time used additional government rhetoric in conjunction with images of napalm victims; phrases such as "Know Your Enemy" or "Winding It Down" were common. The juxtapositions suggested that the government accepted these injuries and deaths as collateral damage. Texts accompanying napalm images could also be used in a more straightforward fashion, the text itself acting as a kind of direct evidence echoing the image. One example is a poster created by the San Francisco–based Angry Arts Against the War (different from Angry Arts in New York), which uses the text "Napalm Bombed" in conjunction with the image of a boy whose chin and lower lip have been almost entirely melted by napalm to the extent that they blend horrifically into his upper chest.

70. Thomas McEvilley has recently written of this technique as a formal breakthrough. He says, "This scraped and scarred surface, on which the original image lay in irregular patches, might have been regarded as a proposal for a new mode of the quality of 'touch' that foremost critics of the Greenbergian era cherished as the essence of painterliness. But if so, it was not a friendly proposal. To anyone formed in the Greenbergian mold, it seemed, rather than a new mode of touch, a rejection of the quality of touch altogether and that the sensibility that had promoted reverence toward it." See "Outside the Comfort Zone," *Art in America*, vol. 90, no. 4 (2002), 102. Max Kozloff has also called these surfaces attractive. He explains that during the 1950s and early 1960s, "[Golub] endowed the surfaces of his burnt men with an exquisite, darkening, enamel-like film, corroded and crusted in such a way as to make them dreamy landscapes of incineration. It was as if fleshy oils had half-carbonized into a mineral splendor, rendering the excruciating cruelty of his theme lookable and even pleasurable. Here then was that special psychic economy of modern art: the discount it makes on its own pessimism through the care lavished on imaginative processing. No doubt these burnt men of Golub's were terrible images, but they censored some portion of their terror by the effective beauty of their textures." See "The Late Roman Empire in the Light of Napalm," *Art News*, vol. 69, no. 7 (1978), 77.

71. Marzorati, *Painter of Darkness*, 166.

72. Frumkin also represented Peter Saul.

73. Quoted in Marzorati, *Painter of Darkness*, 200. See the same page in Marzorati for Golub's humorous reply to Rubin. He wrote, "Dear Billie, / Honey, I want you to know what a big slob you are—After comparing your bully boy critique of my paintings in 'New Images' with your next pretty boy ecstasy—it's a pleasure to call you a sap, you sap—Yum, yum, kid / Leon Golub. / turn over, sap, for original

drawings." The drawings were titled *Hey Bill! heads up! time to write an article!* And below this was an image of a cartoon figure flushing his head in the toilet. Below that was the text "oh, i love to write art criticism, i love it." (This topped a cartoon figure with his arms thrown back, either pissing or ejaculating a large looping stream in front of his body.) It is unclear whether this letter was ever sent.

74. Ibid., 235.

75. David Levi-Strauss, "Where the Camera Cannot Go: Leon Golub on the Relation Between Art and Photography," *Aperture*, vol. 162 (Winter 2001), 55.

76. Golub quoted in Marzorati, *Painter of Darkness*, 64.

77. Ibid., 119.

78. McEvilley, "Outside the Comfort Zone," 105.

79. See Deborah Wye, *Committed to Print: Social and Political Themes in Recent American Printed Art* (New York: Museum of Modern Art, 1988), 73.

80. Michelle Oka Doner, personal interview, March 6, 2009. Subsequently, these works gained national exposure in the major 1968 Smithsonian Institution exhibition of craft objects, *Objects USA*, which was featured on NBC's *Today Show*. The next large exhibition of craft objects did not occur until 1987's *Craft Today: Poetry of the Physical*, at the American Craft Museum. See Robert Barnard, "Crafts in a Muddle," *New Art Examiner*, February 1987.

81. Frank Starkweather, *Traditional Igbo Art, 1966: An Exhibition of Wood Sculpture Carved in 1965–1966* (Ann Arbor: University of Michigan, 1968).

82. Baranik quoted in Wye, *Committed to Print*, 69.

83. The image was also used as the centerpiece for various antiwar posters and flyers he made during the late 1960s. One flyer, for example, prints the image and then below, in capital letters, asks, "for this you've been born?" Another poster, which Baranik made, features the photograph and above it the title of the group for which the poster was made: "Angry Arts Against the War in Vietnam." (The other poster Baranik created for Angry Arts was based on images from *Guernica*, mentioned above.)

84. "Conversation with Rudolf Baranik, Charlene Spurlock and William Spurlock," in Rudolf Baranik, Charlene Spurlock and William Spurlock, *Rudolf Baranik: Napalm Elegy and Other Work* (Dayton: Wright State University Art Galleries, 1977).

CHAPTER FIVE

1. While I stipulate January as a start date, it has been argued that the offensive actually began in September 1967 with various North Vietnamese offensives against specific targets. See Karnow, *Vietnam*, 551.

2. While the Americans and South Vietnamese eventually reclaimed Hue on February 24, it was only after three thousand people had been killed by the DRV (and subsequent research has argued that the death toll was probably even higher).

3. Khe Sanh and the other so-called hinterland battles were later realized to be a means to draw the Americans away from Saigon and the urban areas for the

Vietcong assaults that eventually took place there. At the time, Westmoreland believed the reverse: that urban battles were the diversion from battles such as Khe Sanh. See Fitzgerald, *Fire in the Lake*, 392; and Karnow, *Vietnam*, 355.

4. Karnow, *Vietnam*, 558–559.

5. Fitzgerald, *Fire in the Lake*, 390. Tet is now seen as an intelligence failure comparable to that of Pearl Harbor. See also Karnow, *Vietnam*, 536.

6. Karnow, *Vietnam*, 536.

7. Ibid., 546.

8. The photograph won the Pulitzer Prize in 1969. The captive's name was Nguyen Van Lem. Not well-known is the fact that the image was also captured on film and broadcast on NBC at the time. The story behind the Adams photograph was that beforehand, communist invaders had killed several of Loan's men; one of them was gunned down along with his wife and children in their house. A group of soldiers marched up to Loan with Lem, the communist prisoner, and Loan took out his pistol, waved his men back with it, and then, without hesitation, executed Lem in the street. Vo Suu captured the image on film. The film (slightly edited so as not to show the spurt of blood coming out of the prisoner's head) was shown on NBC the following night.

9. Zaroulis and Sullivan, *Who Spoke Up?* 151–152.

10. Tom Wicker, "Kennedy Asserts U.S. Cannot Win," *New York Times*, February 9, 1968, 1.

11. Ibid. See also excerpts from Kennedy's speech excerpted in the same article.

12. Karnow, *Vietnam*, 580.

13. In the late 1960s, most of the country, and especially New York City, consistently saw itself on the brink of race war. For example, in addition to the assassination of King, the Black Power movement had reached an international audience, black students had immobilized Northwestern and Columbia Universities, and a special committee formed by the mayor of New York reported "an appalling amount of racial prejudice" in the city. The mayor warned that if "lines of communication and understanding were not formed quickly, this city will suffer severe traumas of successive racial and major confrontations." For more on this subject in relation to art history, see Israel, "As Landmark."

14. See Todd Gitlin, *The Sixties: Years of Hope, Days of Rage* (New York: Bantam, 1987), 331.

15. Ibid., 319.

16. This figure is drawn from various sources. See, for example, Patricia Kelly, *1968: Art and Politics in Chicago* (Chicago: DePaul University Art Museum, 2008), 10. See also Gitlin, *Sixties*, 327.

17. Gitlin, *Sixties*, 334.

18. Among the various sources that discuss this matter, see Kelly, *1968*, 14–15. The two-year proposal was authored by the New York artist Hedda Sterne and Jesse Reichek, a professor of painting at the University of California, Berkeley. Fifty artists signed it.

19. See "Artists vs. Mayor Daley," *Newsweek*, November 4, 1968, 117.
20. See Kelly, *1968*, 15. Feigen is quoted from an interview in the archives of the Museum of Contemporary Art, Chicago. See also Aulich, "Vietnam, Fine Art, and the Culture Industry," 73. The exhibition ran from October 23 to November 23.
21. For the full list of participating artists, see Kelly, *1968*, 27.
22. During the exhibition, Motherwell explained, "There is a certain kind of art which I belong to. It can no more make a direct political comment than chamber music can. But by exhibiting with these artists who can, and with the theme of the exhibit, we are showing our support." See "Artists vs. Mayor Daley," 117. The quote is also included in Kelly, *1968*, 28.
23. Kelly, *1968*, 15.
24. Ibid.
25. Ibid. As a final note, as Patricia Kelly has explained, the Daley exhibition was not the first time in recent history a Chicago art gallery dedicated itself to works concerning a major political figure. Predating Feigen's exhibition by more than a year was *Portraits of LBJ* at the Richard Gray Gallery, which opened in February 1967. The show was conceived as a response to President Johnson's 1966 rejection of a commissioned portrait by the New Mexico artist Peter Hurd. When the painting was unveiled, Johnson described it as "the ugliest thing I ever saw." Yet Johnson made the completion of the painting incredibly difficult for Hurd. From the onset of the commission, Hurd was denied access to the president, and he was allowed only two sittings to complete the work, and during one the president was rumored to have fallen asleep.
26. Introduction to *Peace Portfolio*, viewed in the Department of Prints and Illustrated Books at the Museum of Modern Art.
27. Lippard, *A Different War*, 17. She takes the quote from Reinhardt's cartoon in *PM*, "How to Look at More Than Meets the Eye," September 22, 1946.
28. Fitzgerald, *Fire in the Lake*, 403. For example, Nixon proposed that he might be able to persuade the Soviet Union and China to press North Vietnam to acquiesce to an acceptable solution to end the war. It was well-known that the war was draining the Soviet economy, since the Soviets had a massive aid program in effect for North Vietnam. Nixon also wanted to bring China closer to the United States to add leverage to both of their dealings with the Soviet Union. He wrote in *Foreign Affairs* in late 1967 that "we simply cannot afford to leave China forever outside the family of nations . . . to live in angry isolation." Nixon also had his madman approach to end the war, which he did not publicize. This was the idea that if he looked like he could drop an atomic bomb on Vietnam and was unpredictable, the enemy would capitulate. See Karnow, *Vietnam*, 597.
29. For the most extended discussion of this show, see Sébastien Delot, "New York, 1968: Une exposition de groupe manifeste à la galerie Paula Cooper," *Les Cahiers du MNAM*, vol. 82, no. 99 (2007), 82–95.
30. Bryan-Wilson, *Art Workers*, 145.
31. Press release, accessed at Paula Cooper Gallery, New York.

32. Importantly, though Lippard, Huot, and Wolin use "art-for-art's-sake" here to describe these artists, the term refers in actuality to a nineteenth-century movement that emphasized the pleasure of art over its possible morality. Thus it had little to do with these artists.

33. Grace Glueck, "Art Notes," *New York Times*, October 27, 1968.

34. Gregory Battcock, "Art: Reviewing the Above Statement," *New York Free Press*, October 31, 1968.

35. Ibid.

36. See Thomas Crow, *The Rise of the Sixties* (New Haven: Yale University Press, 1996), 151.

37. Rosenthal's image is arguably the most widely reproduced photograph ever taken. Rosenthal has also endured over fifty years of accusations that the image was staged. See, for example, James Bradley and Ron Powers, *Flags of Our Fathers* (New York: Bantam, 2000); as well as the 2006 Clint Eastwood–directed movie based on the book.

38. Ed Kienholz, "The Portable War Memorial (1968)," in *Theories and Documents of Contemporary Art*. Ed. Kristine Stiles and Peter Selz (Berkeley: University of California Press, 1996), 514.

39. Archie Goodwin et al., *Blazing Combat* (Seattle: Fantagraphics Books, 2009), 39.

40. See ibid., 46. Other stories focus on the effect that killing has on soldiers, especially those who came into the war looking for some "action." See, for example, "Face to Face," 65. There is also a profile of a fighter pilot named Billy Bishop. The story ends by explaining, "It's not the tally of kills, nor his medals, that makes Bishop unique. . . . It's not his flying or shooting skills . . . nor his incredible dash and daring. . . . This is what makes Billy Bishop unique . . . he walked away [from the war] . . . alive!!" See "Lone Hawk," 77.

41. See "A Conversation with James Warren," in ibid., 187.

42. See Seeman-Robinson, "They Ruled the Night," 14.

43. Stevens specifically cites a snapshot of her father sitting in front of the television as the root of the series. Lucy Lippard makes the link between the threat of drafting Stevens's son and the *Big Daddy* series. Lippard also explains that Stevens's teaching at a midwestern college "exacerbated her antiwar feelings" due to the ignorance and callousness of the people she encountered there. See Lippard's essay in *May Stevens: Big Daddy, 1967–75: Lerner-Heller Gallery, March 11–29, 1975* (New York: Lerner-Heller Gallery, 1975).

44. *May Stevens: Big Daddy, 1967–75.*

45. In this vein, Stevens also made a *Big Daddy* coloring book.

CHAPTER SIX

1. Vietnamization officially began on April 10, when Defense Secretary Clark Clifford announced a ceiling of 549,000 American troops in Vietnam, and said that the administration had decided to shift the burden of the war to the South Vietnamese.

2. See Zaroulis and Sullivan, *Who Spoke Up?* 269.

3. Richard Nixon, "Address to the Nation on the War in Vietnam," November 3, 1969, available online at http://www.presidency.ucsb.edu/ws/?pid=2303.

4. Haeberle's photographs were then published on November 20 in *Life*. While the number of deaths at My Lai is still debated, with estimates ranging widely between 109 and 567, most reports tend toward 567. The initial coverage of My Lai was quickly followed by national newspaper coverage and then television coverage. Two of the most significant examples of television coverage were Walter Cronkite's December 5, 1969, report on the CBS *Evening News* and a November 24, 1969, *60 Minutes* interview between Mike Wallace and Paul Meadlo. For more explanation of media coverage, see Frascina, "Meyer Schapiro's Choice." For a followup report on My Lai, in which he expanded on the disturbing realities of Charlie Company, see Hersh, "My Lai 4: A Report on the Massacre and Its Aftermath," *Harper's*, May 1970, 53–84.

5. Fitzgerald explains My Lai was comparable to Nazi atrocities at Lidice in 1942. Lidice was once as infamous as Guernica or Auschwitz. Today few outside the Czech Republic recognize the name. At Lidice, a few kilometers west of Prague, on June 10, 1942, the Nazis took revenge on the village, which was suspected of harboring suspects in the murder of the Nazi Staatssekretär of the Protectorate, Reinhard Heydrich. One hundred and seventy-three men were executed; nearly two hundred women were transported to Ravensbruck. Lidice's children were sent to families in Germany and elsewhere to be "Germanized." Of one hundred and four children taken away, only sixteen were ever found after the event. In the days that followed, the town of Lidice was systematically erased from the face of the earth. Even the town's cemetery was desecrated, its four hundred graves dug up. Jewish prisoners from the camp at Terezin were brought in to shift the rubble, new roads were built and sheep set down to graze. No trace of the village remained.

6. The exhibition specifically ran from November 1968 through February 1969.

7. MoMA's explanation for why the original work was not included was because it had to be shipped from Paris.

8. This information is from Takis's handbill, which is discussed in more detail below. See Sandler, *American Art of the 1960s*, 296.

9. See "Takis' Letter to Sindrofoi," in *Art Workers' Coalition: Documents, Open Hearing* (Seville: Editorial Doble J., 2009), 1.

10. See Bryan-Wilson, *Art Workers*, 4, 165. For more on the *Harlem on My Mind* protest see Dubin, *Displays of Power*, 18–63. See also Israel, "As Landmark."

11. Bryan-Wilson, *Art Workers*, 4–5, 14–15.

12. See Jeanne Siegel, "Carl Andre: Artworker," in *Artwords*, 130. Originally published in *Studio International*, vol. 180, no. 927 (1970), 175–179.

13. Sandler, *American Art of the 1960s*, 297.

14. Ibid., 296.

15. MoMA still remained the central focus of the majority of speeches, however, since it was the most important museum of modern and contemporary art in the world

and one of the primary tastemakers for the period's art market. See Martin, *Theatre Is in the Street*, 133–134. The meeting lasted over four hours, exemplifying the epic meeting phenomenon that "typified 1960s oppositional politics." A wide range of issues was discussed, such as alternatives to the art museum, the reform of art institutions, the legal and economic relationship of artists to galleries and museums, the artists' relationship to society, and the situation of black and Puerto Rican artists. One of the most historically significant speeches of the meeting was Lee Lozano's discussion of her *General Strike Piece*, which initiated her departure from the art world.

16. According to Irving Petlin, the poster committee procured a copy of Haeberle's photograph by breaking into the *Life* magazine offices in New York City. They believed they had license to take the image when they found out from Haeberle that the magazine had printed the image but kept it in their possession, even though *Life* had one-time-use permission only.

17. "Transcript of Interview of Vietnam War Veteran on His Role in Alleged Massacre," *New York Times*, November 25, 1969, 16. This was actually the first time that an item from *60 Minutes* would grace the cover of the *Times*. See David Blum, *Tick . . . Tick . . . Tick . . . : The Long Life and Turbulent Times of "60 Minutes"* (New York: HarperCollins, 2004), 48.

18. Petlin manipulated the text. This fact is worth mentioning because Bryan-Wilson (in *Art Workers*) describes the text as being "typed out" by the poster committee, rather than having been appropriated from the actual newspaper in which the interview was featured.

19. Notably, even though the poster committee wanted AWC to be known as the author, Petlin, Jon Hendricks, and Fraser Dougherty created it. See, for example, Handler, "Art of Activism," 257. Also see Art Workers' Coalition, "To the Editor," in "Art Mailbag: Why MoMA Is Their Target," *New York Times*, February 8, 1970, 23–24. Information also drawn from Petlin personal interview with the author.

20. Newman, *Challenging Art*, 267.

21. Lucy Lippard Papers, Archives of American Art, Smithsonian Institution, Box 6, "Art Workers' Coalition."

22. See Lippard, "The Dilemma," in *Get the Message?* 8.

23. Newman, *Challenging Art*, 267. See also Lippard, *A Different War*, 27.

24. Lucy Lippard, personal interview, July 30, 2009. As part of National Peace Action Week, on April 24, 1971, AWC participants wore the Calley masks again and distributed five thousand of them to other demonstrators.

25. Marzorati, *Painter of Darkness*, 235.

26. Notably, the three did continue to be involved with AWC. Martin, *Theatre Is in the Street*, 138.

27. Ibid. For example, at one point, the Rockefeller Foundation and the New York State Council for the Arts gave AWC $17,000 for community cultural centers in Spanish-speaking sectors of New York City. GAAG (and others) did not approve of such support from the established authorities. Importantly, though GAAG formed

out of AWC and apart from it, GAAG was involved with AWC's Action Committee, AWC participants supported GAAG actions, and those involved with both groups worked together often, according to Lippard's notes on the manuscript.

28. Martin, *Theatre Is in the Street*, 145.

29. See Jean Toche, "Letter, Dedicated to Marcel Broodthaers," May 10, 1968, in Hendricks, Toche, Guerrilla Art Action Group, et al., GAAG.

30. Dore Ashton, "Response to Crisis in American Art," *Art in America*, vol. 57 (January/February 1969), 33.

31. Alan Moore, "Collectives: Protest, Counter-Culture, and Political Postmodernism in New York City Artists Organizations 1969–1985" (PhD diss., City University of New York, 2000), 20–21.

32. Hendricks, Toche, Guerrilla Art Action Group, et al., GAAG.

33. David Rockefeller was chairman of the board of trustees of the Museum of Modern Art. Nelson Rockefeller, the pro-war Republican governor of New York, was at that time a high-profile member of the MoMA board of trustees. In a further link to the family, the museum had been founded by Abby Aldrich Rockefeller.

34. GAAG sources much of its material used in the statement. It cites Lundberg's *The Rich and the Super-Rich*, Hersh's *Chemical and Biological Warfare*, and Thayer's *War Business*. See Martin, *Theatre Is in the Street*, 6. For a further understanding of the greater movement to redefine legitimate corporate behavior by the New Left, the women's liberation movement, and the counterculture, Martin recommends Terry H. Anderson, "The New American Revolution: The Movement and Business," in *The Sixties: From Memory to History*. Ed. David Farber (Chapel Hill: University of North Carolina Press, 1994), 175–201. Also, as Martin has noted, though commendable for its confidence and forthrightness, GAAG's letter was compromised both by its inability to link Rockefeller interests directly with the war and by its skewing of evidence. For instance, the Rockefellers' relationship to United Technology Center dated to 1966, and there was no indication as to whether it was still involved. (In fact, by 1967, Dow was the only company producing napalm.) See Martin, *Theatre Is in the Street*, 140.

35. See "Guerrilla Art Action at the Whitney Museum of American Art," in Hendricks, Toche, Guerrilla Art Action Group, et al., GAAG. Also, it should be noted that this action took place during the installation in the lobby of Paul Thek's *Tomb*, one of the lost monuments of 1960s art. Before, during, and after this point, in addition to this action and *Blood Bath*, GAAG organized other extra-artistic actions against the war, two of which will be discussed later on. What will not be covered in detail are the following: their action no. 13 (a protest of the censorship of Abbie Hoffman on CBS); their action no. 16 (a letter to Nixon protesting the escalation of the Vietnam War); their action no. 22 (letters in support of the Pentagon papers); and their action no. 32 (a broadside protesting the carpet bombing of North Vietnam). Additionally, on October 31, 1969, Hendricks and Toche removed Kazimir Malevich's *Supremacist Composition: White on White* of 1918 and hung in its place the group's October 30 manifesto. The manifesto made three

demands. Foreshadowing the Art Strike, the third demand was that MoMA close until the war in Vietnam was over. GAAG explained, "There is no justification for the enjoyment of art while we are involved in the mass murder of people. Today the museum serves not so much as an enlightening educational experience, as it does a diversion from the realities of war and social crisis. It can only be meaning-ful if the pleasures of art are denied instead of reveled in. We believe that art itself is a moral commitment to the development of the human race and a negation of the repressive social reality. This does not mean that art should cease to exist or to be produced—especially in serious times of crisis when art can become a strong witness and a form of protest—only the sanctification of art should cease during these times." See Hendricks, Toche, Guerrilla Art Action Group, et al., *GAAG*.

36. Handler, "Art of Activism," 270–273. For the full text of the AWC participants' statements, see Lucy R. Lippard Papers, Box 6, File "Art Workers' Coalition." Bryan-Wilson has recently pointed out that even though *And Babies* was held up as a parallel to *Guernica*, there were fundamental differences between the two works that made such a comparison problematic. For one, she clarifies that *Guernica* is monochrome and full of activity, and *And Babies* is colorful and features a pile of dead bodies. See Bryan-Wilson, *Art Workers*, 21.

37. A letter from Meyer Schapiro was a notable absence. Schapiro rejected the ideas involved and wrote a significant response to the organizers, which has been cov-ered in-depth in various locations, yet none more than Frascina's two-part series of articles, "Meyer Schapiro's Choice."

38. Petlin also has said that a column written by Lawrence Alloway further compli-cated the distribution of the petition by making it national news. It seemed like those involved wanted to approach artists and especially Picasso in a controlled fashion. See Lawrence Alloway, "Art," *The Nation*, February 23, 1970.

39. Hanson's work is in the collection in the Wilhelm Lehmbruck Museum, Dulsberg, Germany, and has been exhibited in the United States only once, in Fort Worth, where a 1994 retrospective of Hanson's works traveled from its original site in Montreal.

40. I say never *fully* executed because an abbreviated version was exhibited in 2004 at the Whitney Museum. At the same time, it is unclear whether Kienholz ever expected to fully realize the work. He may have just seen the piece as a conceptual statement.

41. Among other endeavors, Kienholz and Hopps established the landmark Ferus Gal-lery in Los Angeles together in 1957.

42. See Walter Hopps, *Kienholz: A Retrospective* (New York: Whitney Museum of American Art, 1996), 144.

43. Martin says that they marched to the "war memorial" at Columbus Circle, and this seems to be the memorial to the battleship *Maine*, whose explosion in Havana harbor was the catalyst for the Spanish–American War. Irving Petlin, who orga-nized this action, recently explained in my interview with him that the body bags were bought from "a little Jewish firm" on 8th Street and Broadway that supplied many of the body bags the government used. Petlin located the firm through an

Orthodox friend of his, and said he was able to procure the bags because he knew a little Yiddish. Upon finding out that its bags were used in the march however, Petlin said, the firm was not particularly happy with him.

44. Martin, *Theatre Is in the Street*, 137. See also Lippard, *A Different War*, 24; and *Get the Message?* 16.

CHAPTER SEVEN

1. Karnow, *Vietnam*, 621

2. An aide to Nixon called this unrest the most severe security threat since the Great Depression. See Bryan-Wilson, *Art Workers*, 112.

3. While some believe that the protest's diversity of aims pushes the Jackson State incident out of the historical discourse, such exclusion probably has more to do with the fact that Jackson State was a black college.

4. *Using Walls* was one of several forays into vanguard art made by the Jewish Museum. The exhibition included fifteen artists, whom the museum asked to make works on the walls of the institution. The works would be destroyed when the exhibition closed. According to a press release, the works were conceptual, ephemeral, and temporal. Without autonomous physicality they were not commodities. As such, the press release claimed, these non-objects rejected the mediation of dealers, critics, and museums. They also offered a new experience for the viewer. The show included two groups of artists who created public murals: Smokehouse Associates and City Walls Inc. According to the Jewish Museum, both groups were interested in a socially committed public art that engaged and benefited urban communities. For more on the Jewish Museum during the 1960s, see Matthew Israel, "A Magnet for the With-It Kids: The Jewish Museum, New York, of the 1960s," *Art in America*, vol. 95, no. 9 (2007), 72–83.

5. See Handler, "Art of Activism," 355.

6. On May 15 Morris announced he would close the exhibition on May 18; the exhibition was scheduled to run through May 31. See, for example, Sandler, *American Art of the 1960s*, 299.

7. Handler, "Art of Activism," 356. A copy of the statement is included in the MoMA Archives; see John Hightower Records, III.i.13.

8. In 1970 the number of strikes by union workers had reached a postwar high, and as labor historians have documented, "large strikes were more important in 1970–72 than at any time during the 1930s, and the proportion of workers involved in them and was surpassed only in 1946–49." See P. K. Edwards, *Strikes in the United States, 1881–1974* (New York: St. Martin's Press, 1981), 180. As part of what has been called "the Vietnam-era labor revolt," a postal wildcat strike in March 1970 halted the U.S. mail in fifteen states, and record numbers of wildcat strikes by autoworkers shut down plants in the Midwest. See Jeremy Brecher, *Strike!* (San Francisco: Straight Arrow Books, 1972), 249. High-profile strikes such as the 1968 Memphis sanitation workers strike, the United Farm workers strike of 1973, the 1972 longshoremen strike, the 1968 New York City teachers strike, and late 1960s

wildcat strikes in the auto industry led some union workers to coin this phrase. In April 1970, the Teamsters, air traffic controllers, steel workers, various teachers' unions, and newspaper workers held significant strikes in New York. See "Scorecard on Labor Trouble," *New York Times*, April 5, 1970, 159.

9. Herbert Marcuse, *An Essay on Liberation* (Boston: Beacon Press, 1969), 25.

10. Ibid., 118. According to Bryan-Wilson (*Art Workers*, 118), Morris took his theory of artistic negation directly from Marcuse, as seen in the following statement made by Morris in 1970: "My first principle for political action, as well as art action, is denial and negation. One says no. It is enough at this point to begin by saying no." She cites Robert Morris, notebook page, ca. 1970s, Robert Morris Archives.

11. See Bryan-Wilson, *Art Workers*, 119.

12. Maurice Berger, *Labyrinths: Robert Morris, Minimalism, and the 1960s* (New York: Harper and Row, 1989), 92. For a further discussion of the New Left in this context, see Stanley Aronowitz, "When the New Left Was New," in *The 60s Without Apology*. Ed. Sohnya Sayres et al. (Minneapolis: University of Minneapolis Press, 1984), 20.

13. See Marcuse, *Essay on Liberation*, 91; and Berger, *Labyrinths*, 121–132.

14. See Bryan-Wilson, *Art Workers*, 103.

15. See Berger, *Labyrinths*, 114.

16. Handler, "Art of Activism," 357.

17. See Lippard, *A Different War*, 53; and Cindy Nemser, "Artists and the System: Far from Cambodia," *Village Voice*, May 28, 1970, 20–21.

18. Berger, *Labyrinths*, 111. Berger notes that this information is from an undated May 1970 press release in the Morris Archives, Gardiner, New York.

19. In her notes on the manuscript, Lippard explained that Johnson was elected as cochair because people "insisted on a woman leader too."

20. Corrine Robins, "The New York Art Strike," *Arts Magazine*, vol. 45, no. 1 (1970), 27.

21. Grace Glueck, "Art Community Here Agrees to Fight War, Racism, and Oppression," *New York Times*, May 19, 1970, 30.

22. Involved in the steering committee, in addition to Morris and Johnson, were Frank Stella, Irving Petlin, and Max Kozloff. See Grace Glueck, "Peace Plus," *Art in America*, vol. 58, no. 5 (1970), 38.

23. See Grace Glueck, "500 in Art Strike Sit on Steps of Metropolitan," *New York Times*, May 23, 1970.

24. Ibid. See also John Hightower Files at MoMA, JBH, I.1.13.

25. See Glueck, "500 in Art Strike Sit on Steps of Metropolitan."

26. See Sean Elwood, "The New York Art Strike of 1970" (master's thesis, Hunter College, 1981).

27. See, for example, John Perreault, "On Strike," *Village Voice*, May 28, 1970, 17.

28. See Gregory Battcock, "Art and Politics at Venice: A Disappointing Biennale," *Arts*, September/October 1970; Barbara Rose, "The Lively Arts: Out of the Studios, on to the Barricades," *New York*, August 10, 1970, 54–57. Rose explains that although many art world luminaries signed in support of the call, no one was willing to pull

NOTES TO PAGES 155–156

their art from the Biennale. She comments, "Government support of the arts was so provisional that artists, loath to give up the little gravy they were getting at the affluence banquet, were not anxious to draw attention to themselves."

29. Statement from ECG press release, from Berger, *Labyrinths*, 125.

30. These artists were Richard Anuskiewicz, Leonard Baskin, Herbert Bayer, Robert Birmelin, John Cage, Raymond Deshais, Jim Dine, Sam Francis, Ron Kitaj, Nick Krushenick, Roy Lichtenstein, Vincent Longo, Sven Lukin, Michael Mazur, Deen Meeker, Robert Morris, Robert Motherwell, Claes Oldenburg, Robert Rauschenberg, Lucas Samaras, Frank Stella, Carol Summers, Ernest Trova, Andy Warhol, Jack Youngerman, and Adja Yunkers. See Berger, *Labyrinths*, 125n16. Other sources list different artists and different counts. Barbara Rose in "Out of the Barricades" (56) says twenty-two artists withdrew.

31. Petlin, personal interview.

32. See Battcock, "Art and Politics at Venice."

33. Handler, "Art of Activism," 386. Rose, in "On the Barricades," explains that the new show was supposed to open on Independence Day for symbolic reasons but was delayed.

34. Women Students and Artists for Black Liberation was cofounded by Faith Ringgold and her daughters Michele and Barbara Wallace. Also included were Tom Lloyd and several students from the School of Visual Arts. According to Ringgold, the catalyst for WSABAL's formation was her hearing of the fact that the "liberated Venice Biennale" exhibition did not intend to include any black or women artists. After this incident, WSABAL continued to agitate for inclusion of minorities in exhibitions. In 1970, for example, the group collaborated with the Ad Hoc Women Artists' Committee to protest the Whitney Annual's lack of women in its exhibition. This protest led to the exhibition of works by Betye Saar and Barbara Chase-Riboud, the first black artists exhibited in the Whitney.

35. See Julie Ault, ed., *Alternative Art New York, 1965–1985* (Minneapolis: University of Minnesota Press, 2002), 21. Ault notes that Museum was subsequently beset by considerable philosophical disagreement among its three hundred or so members. She explains that "some members wanted formal exhibition and administrative structures; others wanted a looser art association with exhibitions, events, forums, and services; and still others wanted a completely unrestricted artists' space. A steering committee was formed to seek state funds for exhibition programs and to organize drawing classes and a print workshop. Museum was also used as a meeting hall for groups such as the Art Workers' Coalition. All exhibitions were group shows with no criteria restricting subject matter or access; the schedule was determined on a first-come, first-serve basis. . . . Museum ceased its activities in 1971." Barbara Rose noted at the time that this was the first open exhibition in New York to be held in fifty years, since the annual exhibition held by the Society of Independent Artists in the first decades of the twentieth century. This show is best-known for its 1917 refusal of Marcel Duchamp's *Fountain*.

36. Handler, "Art of Activism," 386.
37. Berger, *Labyrinths*, 113.
38. From June 9 through July 1.
39. For example, the first proceeds were given to 1970 election candidates "committed to ending the war."
40. From *Print Portfolio 1*, no. 60, viewed at the Daedalus Foundation, New York.
41. For more on conceptual art's political implications, the complexities, successes, and failures therein, and its connections to AWC and the New Left, see Handler, "Art of Activism," 212; Alex Alberro, "Deprivileging Art: Seth Siegelaub and the Politics of Conceptual Art" (PhD diss., Northwestern University, 1996); and Malcolm Blake Stimson, "A Theory of the Neo-Avant-Garde" (PhD diss., Cornell University, 1998). Additionally, see Blake Stimson, "The Promise of Conceptual Art," in *Conceptual Art: A Critical Anthology*. Ed. Alexander Alberro and Blake Stimson (Cambridge: MIT Press, 1999), xxviii–lii.
42. Lippard, "Dreams, Demands, and Desires," 7.
43. Jeanne Siegel, "An Interview: Hans Haacke by Jeanne Siegel," *Arts Magazine*, vol. 45, no. 7 (1971), 18–21.
44. Rockefeller was specifically on the board from 1932 to 1979 (as president from 1939 to 1941; as chairman from 1957 to 1958). See Handler, "Art of Activism," 329. See also Brian Wallis, ed., *Hans Haacke: Unfinished Business* (Cambridge: MIT Press, 1987), 86–87; and Frascina, *Art, Politics, and Dissent*, 111.
45. Hans Haacke, Benjamin Buchloh, Rosalind Deutsche, and Walter Grasskamp, *Hans Haacke: For Real* (Dusseldorf: Richter Verlag, 2007), 254.
46. Emily Genauer quoted in Alberro and Stimson, *Conceptual Art*.
47. Haacke, Buchloh, Deutsche, and Grasskamp, *Hans Haacke*, 255. A reflection of his belief of artists' lack of power was his comment that it would have "been naïve to assume that this poll-taking could affect the outcome of the 1970 gubernatorial elections, in which Nelson Rockefeller enjoyed solid conservative support."
48. Hilton Kramer, "'Miracles,' 'Information,' 'Recommended Reading,'" *New York Times*, July 12, 1970, 87.
49. See Gregory Battcock, "Informative Exhibition at the Museum of Modern Art," *Arts*, Summer 1970, 24–27.
50. Bryan-Wilson explains, "Battcock's notion of accommodating versus adversarial art drew from his engagement at the time with the writings of Marcuse, and he saw the exhibit as a clear example of repressive tolerance. Because the works in *Information* responded to the site of the museum but [did] not interrupt its daily functioning, according to Battcock, they [were] not abusive enough to their context. Instead the potential of a negative confrontation is wasted. . . . In an unmistakable (yet unattributed) reference to Marcuse, he states that art should 'widen the gap and that already exists between that which is and a vision of what can be.' This directly echoes Marcuse's vision for an art that sustains 'a dialectical unity between what is and what can (and ought) to be.' While he maintained

that the *Information* show fell short of the mark, Battcock did in other instances embrace the radical negation of conceptualism, particularly as it instanced its own de-commodification. Haacke's knowledge management in the MOMA-*Poll* suffered under Battcock's loose Marcusian reading, as it concerned itself with unmasking present conditions rather than offering a 'prefigurative' vision of a utopian world, to use Marcuse's phrase." Bryan-Wilson, *Art Workers*, 195. See also R. W. Marx's *The Meaning of Marcuse* (New York: Ballantine Books, 1970).

51. See Lucy Lippard Papers, Archives of American Art, Smithsonian Institution.

CHAPTER EIGHT

1. See Franklin, *Vietnam and Other American Fantasies*, 69.

2. See Fitzgerald, *Fire in the Lake*, 456.

3. Kissinger had begun meeting with Le Duc Tho to discuss a peace agreement on February 21, 1970. See Karnow, *Vietnam*, 646.

4. This is not to imply that bombing operations had not been in place for the duration of the war. Since Flaming Dart they had followed almost without interruption, so that by the end of 1972, the United States had dropped on Vietnam—an area the size of Texas—triple the bomb tonnage dropped on Europe, Asia, and Africa during World War II.

5. Karnow, *Vietnam*, 667

6. *American Posters of Protest* received a rare favorable review from *New York Times* critic John Canaday.

7. The march was organized by the People's Coalition for Peace and Justice and the National Peace Action Coalition.

8. Lippard, *A Different War*, 29.

9. See Levi-Strauss, "Where the Camera Cannot Go," 55.

10. See Marzorati, *Painter of Darkness*, 26.

11. Ibid.

12. Fahlström created sculpture, prints, films and performances, Happenings, lengthy manifestos, scripts for stage, screen, and radio, a five-hour audio-phonic novel, and his invented "variable pictures." During his lifetime, Fahlström enjoyed worldwide recognition—high points were his solo exhibition organized by the Museum of Modern Art (which traveled to various locations in the United States but was never shown at MoMA) and his representation of Sweden at the 1966 Venice Biennale. In the past few years, Fahlström's work has been the subject of critical reappraisal. He was included in Daniel Birnbaum's 2009 Venice Biennale exhibition at the Palazzo delle Esposizioni, *Fare Mondi/Making Worlds*, and his work was the subject of a retrospective exhibition in Barcelona, which traveled to Italy, the United Kingdom, the United States, and France between 2000 and 2002. Among the reasons proposed for his mainstream dismissal until now—and here I refer in part to Mike Kelley's 1995 essay "Myth Science" on Fahlström—has been his complex nationality. He was born in Brazil to Swedish and Norwegian parents, then

sent back to Sweden; then he lived in Italy and France; and then finally New York, where he had his most productive years—though he was still always traveling. According to Kelley, what also worked against Fahlström were his politics, which were very topical compared with other pop artists who did not engage with politics. He was also interested in narrative; his compositions were busy; and finally, his graphic style and use of color were common in the craft (not the art) world. Kelley additionally mentions that Fahlström's practice was more conceptual than pop. See Mike Kelly, "Myth Science: On Öyvind Fahlström," in *Foul Perfection: Essays and Criticism*. Ed. John C. Welchman (Cambridge: MIT Press, 2003), 158–177.

13. Öyvind Fahlström, "Historical Painting," *Flash Art*, vol. 43 (December 1973–January 1974), 14

14. In later works, such as *Seven Elements from S.O.M.B.A.* (1974), Fahlström's blobs broke "free to drift independently, or congeal in little clumps of cartoonish matter floating on a white ground." See Susan Tallman, "Pop Politics: Öyvind Fahlström's Variables," *Arts*, vol. 65, no. 4 (1990), 16.

15. Fahlström, "Historical Painting."

16. Tallman, "Pop Politics," 15. See also Fahlström, "Description of Five Paintings," in Manuel BorjaVillel, JeanFrancois Chevrier, Immanuel Wallerstein, Octavi Rofes, Suely Rolnik, and Öyvind Fahlström, *Öyvind Fahlström: Another Space for Painting* (Barcelona: Museu D'Art Contemporani De Barcelona and Actar, 1990), 258; and Raphael Rubenstein, "Fahlström Afresh," *Art in America*, vol. 89, no. 7 (2001), 69.

17. Quoted from Rubenstein, "Fahlström Afresh," 69.

18. See Fahlström, "Description of Five Paintings," in BorjaVillel et al., *Öyvind Fahlström*, 258.

19. Quoted directly from *World Map*.

20. See Fahlström, "Historical Painting."

21. See BorjaVillel et al., *Öyvind Fahlström*, 269.

22. Donald Kuspit, "Oyvind Fahlström's Political Puzzles," *Art in America*, vol. 70, no. 4 (1982), 107.

CONCLUSION

1. In her notes on the manuscript, Lippard commented that she was out of town when they came up with the idea.

2. The registry has been housed at 55 Mercer Street, A.I.R. Gallery, and Artists Space during its history. Since 1994 it has been housed at the Mabel Smith Douglass Library at Rutgers University.

3. See Bryan-Wilson, *Art Workers*, 153, 160, 161, for a discussion of Lippard's perspective on feminism's place in AWC. Michael Aulich specifically sees feminism's "deliberate circumvention of conventional forms of representation in art and the media" to be indebted to the actions of those involved in AWC. See "Vietnam, Fine Art, and the Culture Industry," 76.

4. Yet on the whole, members have argued that the group was ineffective. Leon Golub explained at the time that AMCC functioned more as meetings for cultural change, rather than doing anything further.

5. It must be said here that Ault's 1996 exhibition *Cultural Economies: Histories from the Alternative Arts Movement, NYC*, in the Drawing Center, and the vast catalog/book of the exhibition, *Alternative Art, New York, 1965–1985: A Cultural Politics Book for the Social Text Collective* (Minneapolis: University of Minnesota Press, 2002), introduced the subject of New York alternative art spaces, places, and voices to a significant audience (including myself). Ault explained in the catalog that such an exhibition was extremely necessary, for in her experience, she found "existing documentation of New York City's highly influential alternative art culture of the 1970s and 1980s [to be] ephemeral, and its circulation . . . restricted." She explained further that any significant writing about alternative art spaces and groups was limited to local newspapers, reviews for art journals, or self-published books that usually focus on individual institutions rather than contextualizing them within a larger field. As such, she said that the goal of her book was to ensure that alternative activities are not written out of the cultural histories of the recent past.

6. See Steven F. Hayward, *The Age of Reagan: The Conservative Counterrevolution, 1980–1989* (New York: Random House, 1989), 385.

7. See "Editorial," *Art and Artists*, January 1984, 2.

8. Ibid., 4.

9. Ibid.

10. Lucy Lippard, "Trojan Horses: Activist Art and Power," in *Art After Modernism: Rethinking Representation*. Ed. Brian Wallis (New York: New Museum of Contemporary Art, 1984), 341–358.

11. Martin, *Theatre Is in the Street*, 162.

12. Ara Merjian, "Diminishing Returns: Wartime Art Practices," *Modern Painters*, April 2008, 54–61.

13. See press release for the Peter Blum exhibition, accessed at http://www.peterblum gallery.com/exhibitions/2008/fransisco-de-goya-los-desastres-de-la-guerra/press-release.

14. Since 2003, the group has held seven exhibitions of its work. The book documenting this work is simply titled *Yo! What Happened to Peace?* (Los Angeles: Yo! What Happened to Peace? 2007).

15. See Rakowitz's website, http://michaelrakowitz.com/projects/return/.

Selected Bibliography

BOOKS AND DISSERTATIONS

Adams, Laurie. *The Methodologies of Art: An Introduction*. New York: Icon Editions, 1996.

Adler, Edward J. "American Painting and the Vietnam War." PhD diss. New York University, 1985.

Alberro, Alex. "Deprivileging Art: Seth Siegelaub and the Politics of Conceptual Art." PhD diss. Northwestern University, 1996.

Alberro, Alexander, and Patricia Norvell, eds. *Recording Conceptual Art: Early Interviews with Barry, Huebler, Kaltenbach, LeWitt, Morris, Oppenheim, Siegelaub, Smithson, Weiner, by Patricia Norvell*. Berkeley: University of California Press, 2001.

Alberro, Alex, and Blake Stimson, eds. *Conceptual Art: A Critical Anthology*. Cambridge: MIT Press, 1999.

Albright, Thomas. *Art in the San Francisco Bay Area, 1945–1980: An Illustrated History*. Berkeley: University of California Press, 1985.

Archer, Michael. *Art Since 1960*. New York: Thames and Hudson, 2002.

Aristotle, and Theodore Alois Buckley. *Treatise on Rhetoric*. Amherst, NY: Prometheus Books, 1995.

Arlen, Michael J. *Living-Room War*. New York: Penguin, 1982.

Arrighi, Giovanni, Terence K. Hopkins, and Immanuel Maurice Wallerstein. *Antisystemic Movements*. New York: Verso, 1989.

Art Workers' Coalition: "Documents," "Open Hearing." Seville: Editorial Doble J., 2009.

Aulich, James, and Jeffrey Walsh, eds. *Vietnam Images: War and Representation*. New York: St. Martin's Press, 1989.

Ault, Julie, ed. *Alternative Art New York, 1965–1985*. Minneapolis: University of Minnesota Press, 2002.

Azoulay, Ariella. *Death's Showcase: The Power of Image in Contemporary Democracy.* Cambridge: MIT Press, 2001.

Baker, Stephen. *Visual Persuasion.* New York: McGraw-Hill, 1961.

Baranik, Rudolf, Charlene Spurlock, and William Spurlock. *Rudolf Baranik: Napalm Elegy and Other Work.* Dayton: Wright State University Art Galleries, 1977.

Barthes, Roland, and Stephen Heath. *Image, Music, Text.* London: Fontana Press, 1987.

Basilio, Miriam. "Re-inventing Spain: Images of the Nation in Painting and Propaganda, 1936–1943." PhD diss. New York University, 2002.

Battcock, Gregory. *Idea Art: A Critical Anthology.* New York: Dutton, 1973.

Baynes, Ken, et al. *Art in Society.* Woodstock, NY: Overlook Press, 1975.

Bercht, Fatima, ed. *Voces y Visiones: Highlights from El Museo Del Barrio's Permanent Collection: El Museo Del Barrio, 1969–2003.* New York: Museo del Barrio, 2003.

Berger, Maurice. *How Art Becomes History: Essays on Art, Society, and Culture in Post–New Deal America.* New York: Icon Editions, 1992.

———. *Labyrinths: Robert Morris, Minimalism, and the 1960s.* New York: Harper and Row, 1989.

———. *Representing Vietnam: The Antiwar Movement in America, 1965–1973.* New York: Bertha and Karl Leubsdorf Art Gallery, Hunter College, 1988.

Bernays, Edward L. *Propaganda.* New York: H. Liveright, 1928.

Bishop, Claire, ed. *Participation.* Cambridge: MIT Press, 2006.

Blum, David. *Tick . . . Tick . . . Tick . . . : The Long Life and Turbulent Times of "60 Minutes."* New York: HarperCollins, 2004.

Bradley, Will, and Charles Esche, eds. *Art and Social Change: A Critical Reader.* London: Tate Publishing, 2007.

Browne, Malcolm. *The New Face of War.* Indianapolis: Bobbs-Merrill, 1965.

Brownmiller, Susan. *Against Our Will: Men, Women, and Rape.* New York: Simon and Schuster, 1975.

Bruckner, D. J. R., Seymour Chwast, and Steven Heller. *Art Against War: 400 Years of Protest in Art.* New York: Abbeville Press, 1984.

Bryan-Wilson, Julia. *Art Workers: Radical Practice in the Vietnam War Era.* Berkeley: University of California Press, 2009.

Cameron, Dan. *Peter Saul.* New York: Distributed Art Publishers, 2008.

Chipp, Herschel B., ed. *Theories of Modern Art: A Source Book by Artists and Critics.* Berkeley: University of California Press, 1968.

Churcher, Betty, and Australian War Memorial. *The Art of War.* Carleton: Miegunyah Press, 2004.

Compton, Michael, David Sylvester, and Robert Morris. *Robert Morris: The Tate Gallery, 28 April–6 June 1971.* London: Tate Gallery, 1971.

Craven, David. *Abstract Expressionism as Cultural Critique: Dissent During the McCarthy Period.* Cambridge: Cambridge University Press, 1999.

Crow, Thomas. *The Rise of the Sixties.* New Haven: Yale University Press, 1996.

Debray, Regis. *Revolution in the Revolution? Armed Struggle and Political Struggle in Latin America.* Westport, CT: Greenwood Press, 1967.

de Zegher, Catherine M., ed. *Persistent Vestiges: Drawing from the American–Vietnam War*. New York: Drawing Center, 2005.

Dijkstra, Bram. *American Expressionism: Art and Social Change, 1920–1950*. New York: Harry N. Abrams, 2003.

Dubin, Steven C. *Arresting Images: Impolitic Art and Uncivil Actions*. New York: Routledge, 1992.

Duncan, David Douglas. *I Protest!* New York: New American Library, 1968.

Edelman, Murray J. *From Art to Politics: How Artistic Creations Shape Political Conceptions*. Chicago: University of Chicago Press, 1995.

Ewen, Stuart. *All Consuming Images: The Politics of Style in Contemporary Culture*. New York: Basic Books, 1988.

Fall, Bernard. *Hell in a Very Small Place*. New York: Lippincott, 1966.

Farber, David. *The Sixties: From Memory to History*. Chapel Hill: University of North Carolina Press, 1994.

Fitzgerald, Frances. *Fire in the Lake: The Vietnamese and the Americans in Vietnam*. Boston: Back Bay Books, 2002.

Fogle, Douglas, Walker Art Center, and UCLA Hammer Museum of Art and Cultural Center. *The Last Picture Show: Artists Using Photography, 1960–1982*. Minneapolis: Walker Art Center, 2003.

Foley, Michael S. *Confronting the War Machine: Draft Resistance During the Vietnam War*. Chapel Hill: University of North Carolina Press, 2003.

Foot, M. R. D., and Imperial War Museum (Great Britain). *Art and War: Twentieth-Century Warfare as Depicted by War Artists*. London: Headline, 1990.

Franklin, H. Bruce. *Vietnam and Other American Fantasies*. Amherst: University of Massachusetts Press, 2000.

Frascina, Francis. *Art, Politics, and Dissent: Aspects of the Art Left in Sixties America*. New York: St. Martin's Press, 1999.

Frasconi, Antonio. *Antonio Frasconi: Exposición Retrospectiva*. Ed. Museo Nacional de Artes Visuales de Montevideo. Montevideo, Uruguay: Ministerio de Educacion y Cultura, Museo Nacional de Artes Visuales, 1986.

———. *Woodcuts*. New York: Typophiles, 1957.

Frieling, Rudolf, and San Francisco Museum of Modern Art. *The Art of Participation: 1950 to Now*. New York: Thames and Hudson, 2008.

Fry, Edward F., et al. *Robert Morris: Works of the Eighties*. Chicago: Museum of Contemporary Art, 1985.

Gitlin, Todd. *The Sixties: Years of Hope, Days of Rage*. New York: Bantam Books, 1987.

Glenn, Constance W., and James A. Rosenquist. *Time Dust, James Rosenquist: Complete Graphics, 1962–1992*. New York: Rizzoli, 1993.

Godfrey, Tony. *Conceptual Art*. London: Phaidon, 1998.

Goldstein, Ann, Diedrich Diederichsen, and Museum of Contemporary Art. *A Minimal Future? Art as Object, 1958–1968*. Cambridge: MIT Press, 2004.

Goldstein, Ann, Anne Rorimer, and Museum of Contemporary Art. *Reconsidering the Object of Art: 1965–1975*. Cambridge: MIT Press, 1995.

Gombrich, Ernst H., and Richard Woodfield. *The Essential Gombrich: Selected Writings on Art and Culture*. London: Phaidon, 1996.

Goodwin, Archie, et al. *Blazing Combat*. Seattle: Fantagraphics Books, 2009.

Greenberg, Clement, and John O'Brian. *Clement Greenberg: The Collected Essays and Criticism*. Chicago: University of Chicago Press, 1986.

Greene, Felix. *Vietnam! Vietnam!* Palo Alto, CA: Fulton, 1966.

Griffiths, Philip Jones. *Vietnam Inc.* London: Phaidon, 2001.

Gumpert, Lynn, Leon Golub, Ned Rifkin, and New Museum of Contemporary Art. *Golub*. New York: New Museum of Contemporary Art, 1984.

Haacke, Hans, with Benjamin Buchloh, Rosalind Deutsche, and Walter Grasskamp. *Hans Haacke: For Real*. Dusseldorf: Richter Verlag, 2007.

Hahne, Ron, Ben Morea, and Black Mask. *Black Mask and Up Against the Wall Motherfucker: The Incomplete Works*. London: Unpopular Books and Sabotage Editions, 1993.

Halberstam, David. *The Best and the Brightest*. New York: Ballantine, 1993.

———. *The Making of a Quagmire*. New York: Alfred A. Knopf, 1965.

Handler, Beth. "The Art of Activism: Artists and Writers Protest, the Art Workers' Coalition, and the New York Art Strike Protest the Vietnam War." PhD diss. Yale University, 2001.

Hemingway, Andrew. *Artists on the Left: American Artists and the Communist Movement, 1926–1956*. New Haven: Yale University Press, 2002.

Hendricks, Jon, Jean Toche, Guerrilla Art Action Group, et al. GAAG, *The Guerrilla Art Action Group, 1969–1976: A Selection*. New York: Printed Matter, 1978.

Herr, Michael. *Dispatches*. New York: Vintage, 1977.

Herring, George C. *America's Longest War: The United States and Vietnam, 1950–1975*. New York: Wiley, 1979.

Hopps, Walter. *Kienholz: A Retrospective*. Ed. Rosetta Brooks and Whitney Museum of American Art. New York: Whitney Museum of American Art, 1996.

Hudson, Anna, and Gertrude Kearns. *Conflict, Conscience, and the Artist–Healer*. Toronto: Mount Sinai Hospital, 2005.

Iles, Chrissie. *Into the Light: The Projected Image in American Art, 1964–1977*. Ed. Whitney Museum of American Art. New York: Harry N. Abrams, 2001.

Jagusch, Sybille A., ed. *Antonio Frasconi at the Library of Congress: A Lecture Presented on May 18, 1989, for International Children's Book Day by Antonio Frasconi*. Washington, DC: Library of Congress, 1993.

Jones, Betsy B., and the Museum of Modern Art. *The Artist as Adversary: Works from the Museum Collections (Including Promised Gifts and Extended Loans)*. New York: Museum of Modern Art, 1971.

Jones, Caroline A., et al. *Bay Area Figurative Art, 1950–1965*. Berkeley: University of California Press, 1990.

Judt, Tony. *Past Imperfect: French Intellectuals, 1944–1956*. Berkeley: University of California Press, 1994.

Kardon, Janet, and University of Pennsylvania, Institute of Contemporary Art. *1967: At the Crossroads: March 13–April 26, 1987, Institute of Contemporary Art, University of Pennsylvania*. Philadelphia: Institute of Contemporary Art, University of Pennsylvania, 1987.

Karnow, Stanley. *Vietnam: A History*. New York: Penguin, 1984.

Kelly, Patricia. *1968: Art and Politics in Chicago*. Chicago: DePaul University Art Museum, 2008.

Kultermann, Udo. *Art and Life*. New York: Praeger, 1971.

Kunzle, David. *American Posters of Protest, 1966–70*. Ed. New School Art Center. New York: New School Art Center, 1971.

Lambert-Beatty, Carrie. *Being Watched: Yvonne Rainer and the 1960s*. Cambridge: MIT Press, 2008.

Lippard, Lucy R. *A Different War: Vietnam in Art*. Ed. Independent Curators Incorporated and Whatcom Museum of History and Art. Bellingham, WA: Whatcom Museum of History and Art, 1990.

———. *Get the Message? A Decade of Art for Social Change*. New York: Dutton, 1984.

———. *May Stevens: Big Daddy, 1967–75: Lerner-Heller Gallery, March 11–29, 1975*. New York: Lerner-Heller Gallery, 1975.

Lowenthal, Abraham F. *The Dominican Intervention*. Baltimore: Johns Hopkins University Press, 1994.

Lucie-Smith, Edward. *Judy Chicago: An American Vision*. New York: Watson-Guptill, 2000.

Mailer, Norman. *The Armies of the Night*. New York: New American Library, 1968.

Maranis, David. *They Marched into Sunlight: War and Peace, Vietnam and America, October 1967*. New York: Simon and Schuster, 2003.

Marcuse, Herbert. *An Essay on Liberation*. Boston: Beacon Press, 1969.

Martin, Bradford D. *The Theater Is in the Street: Politics and Performance in Sixties America*. Amherst: University of Massachusetts Press, 2004.

Marzorati, Gerald. *A Painter of Darkness: Leon Golub and His Times*. New York: Penguin, 1992.

McQuiston, Liz. *Graphic Agitation*. London: Phaidon, 1995.

Meyer, James. *Minimalism: Art and Polemics of the Sixties*. New Haven: Yale University Press, 2001.

Meyer, Ursula. *Conceptual Art*. New York: Dutton, 1972.

Miles, Barry, and Maggs Bros, ed. *4973: Berkeley Protest Posters, 1970*. London: Francis Boutle Publishers, 2000.

Millon, Henry A., and Linda Nochlin. *Art and Architecture in the Service of Politics*. Cambridge: MIT Press, 1978.

Mitchell, W. J. Thomas. *Iconology: Image, Text, Ideology*. Chicago: University of Chicago Press, 1986.

Monte, James K., Marcia Tucker, and Whitney Museum of American Art. *Anti-illusion: Procedures/Materials*. New York: Whitney Museum of American Art, 1969.

Moore, Alan. "Collectives: Protest, Counter-Culture, and Political Postmodernism in New York City Artists Organizations, 1969–1985." PhD diss. City University of New York, 2000.

Morris, Robert. *Continuous Project Altered Daily: 1969*. New York: Multiples, 1970.

———. *Continuous Project Altered Daily: The Writings of Robert Morris*. Cambridge: MIT Press, 1993.

Morris, Robert, Corcoran Gallery of Art, and Detroit Institute of Arts. *Robert Morris*. Washington, DC: Corcoran Gallery of Art, 1969.

Morris, Robert, and France Association LAC. *Robert Morris: Recent Felt Pieces and Drawings, 1996–1997: Association LAC (Lieu d'Art Contemporain) Sigean*. Hannover: Kunstverein Hannover, 1997.

Morris, Robert, and Grey Art Gallery and Study Center. *Robert Morris: The Felt Works*. New York: Grey Art Gallery and Study Center, New York University, 1989.

Morris, Robert, Marti Mayo, and Contemporary Arts Museum. *Robert Morris: Selected Works, 1970–1980: December 12, 1981–February 14, 1982, Contemporary Arts Museum, Houston, Texas*. Houston: The Museum, 1981.

Morris, Robert, and Nuova Icona. *Robert Morris: Tar Babies of the New World Order*. Venice: Nuova Icona, 1997.

Morris, Robert, and Nena Tsouti-Schillinger. *Have I Reasons: Work and Writings, 1993–2007*. Durham: Duke University Press, 2008.

Morris, Robert, and University of Pennsylvania, Institute of Contemporary Art. *Robert Morris/Projects: Institute of Contemporary Art, University of Pennsylvania, Philadelphia, March 23 to April 27, 1974*. Philadelphia: Institute of Contemporary Art, University of Pennsylvania, 1974.

———, et al. *Robert Morris: Less Than: Invito a Luciano Fabro, Sol LeWitt, Eliseo Mattiacci, Robert Morris, Richard Serra*. Prato: Gliori, 2005.

———, et al. *Robert Morris: Rétrospective, 1961–1994*. Paris: Centre Georges Pompidou, 1995.

Museo del Barrio. *Arte [no Es] Vida: Actions by Artists of the Americas, 1960–2000*. Ed. Deborah Cullen. New York: El Museo del Barrio, 2008.

Newman, Amy. *Challenging Art: "Artforum," 1962–1974*. New York: SoHo Press, 2003.

New School Art Center, ed. *Protest and Hope: An Exhibition of Contemporary American Art*. New York: New School Art Center, 1967.

Oates, Joyce Carol. *Where I've Been, and Where I'm Going*. New York: Plume, 1999.

Obler, Geraldine. "Aspects of Social Protest in American Art, 1963–1973." PhD diss. Columbia University, 1974.

O'Brien, Mark, and Craig Little. *Reimaging America: The Arts of Social Change*. Philadelphia: New Society Publishers, 1990.

O'Brien, Tim. *Going After Cacciato*. New York: Broadway Books, 1999.

Owens, Craig, and Scott Stewart Bryson. *Beyond Recognition: Representation, Power, and Culture*. Berkeley: University of California Press, 1992.

Perlmutter, David D. *Visions of War: Picturing Warfare from the Stone Age to the Cyber Age*. New York: St. Martin's Press, 2001.

Pincus-Witten, Robert. *Postminimalism*. New York: Out of London Press, 1977.

Plagens, Peter. *Sunshine Muse: Art on the West Coast, 1945–1970*. Berkeley: University of California Press, 1999.

Ranciere, Jacques. *The Politics of Aesthetics: The Distribution of the Sensible*. London: Continuum, 2004.

Reporting Vietnam. New York: Library of America, 1998.

Richardson, Peter. *A Bomb in Every Issue: How the Short, Unruly Life of "Ramparts" Magazine Changed America*. New York: New Press, 2009.

Rickards, Maurice. *Posters of Protest and Revolution*. New York: Walker, 1970.

Robins, Corinne. *The Pluralist Era: American Art, 1968–1981*. New York: Harper and Row, 1984.

Rorimer, Anne. *New Art in the 60s and 70s: Redefining Reality*. New York: Thames and Hudson, 2001.

Rosenthal, T. G., Francis Hoyland, and British Broadcasting Corporation. *The Artist and War in the 20th Century*. London: BBC Publications, 1967.

Rosler, Martha. *Martha Rosler: Positions in the Life World*. Ed. M. Catherine de Zegher and Ikon Gallery. Cambridge: MIT Press, 1998.

Roy, Jules. *The Battle of Dienbienphu*. New York: Harper and Row, 1965.

Rubin, David S., et al. *Wally Hedrick: Selected Works*. San Francisco: San Francisco Art Institute, 1985.

Rutberg, Jack. *Hans Burkhardt: Paintings of the 1960s*. Los Angeles: Jack Rutberg Fine Arts, 2008.

———. *Hans Burkhardt: The War Paintings: A Catalogue Raisonné*. Northridge: Santa Susana Press and California State University, Northridge, 1984.

Sandler, Irving. *American Art of the 1960s*. New York: Harper and Row, 1988.

———. *Art of the Postmodern Era*. Boulder: Icon Editions, 1996.

Saul, Peter, et al. *Peter Saul*. Newport Beach, CA: Orange County Museum of Art, 2008.

Sayres, Sohnya, et al., eds. *The 60s Without Apology*. Minneapolis: University of Minneapolis, 1984.

Schalk, David L. *The Spectrum of Political Engagement: Mounier, Benda, Nizan, Brasillach, Sartre*. Princeton: Princeton University Press, 1979.

———. *War and the Ivory Tower: Algeria and Vietnam*. New York: Oxford University Press, 1991.

Schmidt, Hans-Werner, and Edward Kienholz. *Edward Kienholz, the Portable War Memorial: Moralischer Appell Und Politische Kritik*. Frankfurt: Fischer Taschenbuch Verlag, 1988.

Schmidt Campbell, Mary, and Studio Museum in Harlem, eds. *Tradition and Conflict: Images of a Turbulent Decade, 1963–1973*. New York: Studio Museum in Harlem, 1985.

Schneemann, Carolee, and Bruce R. McPherson. *Carolee Schneemann: Imaging Her Erotics: Essays, Interviews, Projects*. Cambridge: MIT Press, 2002.

———. *More Than Meat Joy: Complete Performance Works and Selected Writings*. New Paltz, NY: Documentext, 1979.

Schudson, Michael. *Advertising, the Uneasy Persuasion: Its Dubious Impact on American Society*. New York: Basic Books, 1984.

Selz, Peter. *Art of Engagement: Visual Politics in California and Beyond*. Ed. Susan Landauer and San Jose Museum of Art. Berkeley: University of California Press, 2006.

Shikes, Ralph E. *The Indignant Eye: The Artist as Social Critic in Prints and Drawings from the Fifteenth Century to Picasso*. Boston: Beacon Press, 1969.

Siegel, Jeanne. *Artwords: Discourse on the 60s and 70s*. Ann Arbor: UMI Research Press, 1992.

Siegel, Katy, et al. *High Times, Hard Times: New York Painting, 1967–1975*. New York: Independent Curators International, 2006.

Silver, Kenneth E. "Esprit de Corps: The Great War and French Art, 1914–1925." PhD diss. Yale University, 1981.

Small, Melvin. *Johnson, Nixon, and the Doves*. New Brunswick: Rutgers University Press, 1989.

Sontag, Susan. *Regarding the Pain of Others*. New York: Farrar, Straus & Giroux, 2003.

Spurlock, William H., et al. *Napalm Elegy and Other Works: Conversation with Rudolf Baranik, Charlene Spurlock, and William Spurlock*. Dayton: Wright State University Art Galleries, 1977.

Starkweather, Frank, University of Michigan Department of Anthropology, and University of Michigan Museum of Art. *Traditional Igbo Art, 1966: An Exhibition of Wood Sculpture Carved in 1965–66*. Ann Arbor: University of Michigan, 1968.

Stermer, Dugald, and Susan Sontag. *The Art of Revolution*. New York: McGraw-Hill, 1970.

Stiles, Kristine, and Peter Howard Selz. *Theories and Documents of Contemporary Art: A Sourcebook of Artists' Writings*. Berkeley: University of California Press, 1996.

Stimson, Blake, and Gregory Sholette. *Collectivism After Modernism: The Art of Social Imagination After 1945*. Minneapolis: University of Minnesota Press, 2007.

Stimson, Malcolm Blake. "A Theory of the Neo-Avant-Garde." PhD diss. Cornell University, 1998.

Stone, I. F. *In a Time of Torment*. New York: Random House, 1967.

Storr, Robert, ed. *Nancy Spero: The War Series, 1966–1970*. Milan: Charta, 2003.

Studio Museum in Harlem. *Symbols and Other Works by Benny Andrews: April 25 to June 6*. New York: Studio Museum in Harlem, 1971.

Talbott, John. *The War Without a Name: France in Algeria, 1954–1962*. London: Faber and Faber, 1981.

Taylor, Brandon. *Contemporary Art: Art Since 1970*. Upper Saddle River, NJ: Pearson/Prentice Hall, 2005.

Toynbee, Arnold Joseph, and Solomon R. Guggenheim Museum. *On the Future of Art*. New York: Viking Press, 1970.

Utley, Gertje. *Pablo Picasso: The Communist Years*. New Haven: Yale University Press, 2000.

Vogelgesang, Sandy. *The Long Dark Night of the Soul: The American Intellectual Left and the Vietnam War*. New York: Harper and Row, 1974.

Von Blum, Paul. *Other Visions, Other Voices: Women Political Artists in Greater Los Angeles*. Lanham, MD: University Press of America, 1994.

Wallace, Michele. *Invisibility Blues*. London: Verso, 1990.

Wallis, Brian, ed. *Hans Haacke: Unfinished Business*. Cambridge: MIT Press, 1987.

Weiss, Jeffrey, ed. *Dan Flavin: New Light*. New Haven: Yale University Press, 2006.

Westheider, James E. *The African American Experience in Vietnam: Brothers in Arms*. Lanham, MD: Rowman and Littlefield, 2007.

Wye, Deborah. *Committed to Print: Social and Political Themes in Recent American Printed Art*. New York: Museum of Modern Art, 1988.

Zaroulis, Nancy, and Gerald Sullivan. *Who Spoke Up? American Protest Against the War in Vietnam, 1963–1975*. Garden City, NY: Doubleday, 1984.

ARTICLES AND ESSAYS

Adorno, Theodor. "Commitment." In *The Essential Frankfurt School Reader*. Ed. A. Arato and E. Gebhardt, 300–318. New York: Continuum, 1985.

Alloway, Lawrence. "Art." *The Nation*, February 23, 1970.

Andre, Carl. "Carl Andre Interviewed by Achille Bonito Oliva." *Domus*, vol. 10, no. 515 (1972), 51.

"Artists Protest at Rand Corp." *Los Angeles Free Press*, June 25, 1965.

"Artists vs. Mayor Daley." *Newsweek*, November 4, 1968, 117.

Art Workers' Coalition. "To the Editor." In "Art Mailbag: Why MoMA Is Their Target." *New York Times*, February 8, 1970.

Ashton, Dore. "Response to Crisis in American Art." *Art in America*, vol. 57, no. 1 (1969), 24–35.

Associated Press. "Rockwell Kent Gift Sent to Vietcong." *New York Times*, July 7, 1967.

Battcock, Gregory. "Art and Politics at Venice: A Disappointing Biennale." *Arts*, September/October 1970, 22–26.

———. "Art: Reviewing the Above Statement." *New York Free Press*, October 31, 1968.

———. "The Art Critic as Social Reformer, with a Question Mark." *Art in America*, vol. 59, no. 5 (1971), 26–27.

———. "Informative Exhibition at the Museum of Modern Art." *Arts*, Summer 1970, 24–27.

Chomsky, Noam. "On Resistance." *New York Review of Books*, December 7, 1967.

———. "The Responsibility of Intellectuals." *New York Review of Books*, February 23, 1967.

Delot, Sébastien. "New York, 1968: Une exposition de groupe manifeste à la galerie Paula Cooper." *Les Cahiers du Mnam*, vol. 82, no. 99 (2007), 82–95.

Dunham, Judith L. "Wally Hedrick Vietnam Series." *Artweek*, June 28, 1975.

Fagan, Beth. "Saul Intends Provoking Reaction with Vietnam Paintings." *Sunday Oregonian*, September 22, 1968, 18.

Foster, Hal. "The Crux of Minimalism." In *The Return of the Real: Art and Theory at the End of the Century*, 35–70. Cambridge: MIT Press, 1996.

Frankenstein, Alfred V. "Saul's Caricature of Agony." *San Francisco Examiner-Chronicle*, August 11, 1968, 37.

Frascina, Francis. "Meyer Schapiro's Choice: My Lai, *Guernica*, MoMA, and the Art Left, 1969–70: Part I." *Journal of Contemporary History*, vol. 30, no. 3 (1995), 481–511.

———. "Meyer Schapiro's Choice: My Lai, *Guernica*, MoMA, and the Art Left, 1969–70: Part II." *Journal of Contemporary History*, vol. 30, no. 4 (1995), 705–728.

Glueck, Grace. "500 in Art Strike Sit on Steps of Metropolitan." *New York Times*, May 23, 1970.

———. "Art Notes." *New York Times*, October 27, 1968.

———. "Art Notes." *New York Times*, November 1, 1970.

———. "Peace Plus." *Art in America*, vol. 58, no. 5 (1970), 38.

———. "A Strange Assortment of Flags Is Displayed at People's Flag Show." *New York Times*, November 10, 1970.

Golub, Leon. "Art and Politics." *Artforum*, vol. 13, no. 2 (1974), 66–71.

———. "Letter." *Artforum*, vol. 7, no. 7 (1969), 4.

Greenberg, Clement. "Avant-Garde and Kitsch." *Partisan Review*, vol. 6 (Fall 1939), 34–49.

———. "Interview Conducted by Lily Leino." In *Clement Greenberg: The Collected Essays and Criticism, Volume 4*. Ed. John O'Brien, 311–312. Chicago: University of Chicago Press, 1995.

———. "Towards a Newer Laocoon." *Partisan Review*, vol. 7 (Fall 1940), 296–310.

Griffin, Tim. "Domesticity at War: Beatriz Colomina and Homi K. Bhabha in Conversation." *Artforum*, vol. 45, no. 10 (2007), 442–447.

Harper, Paula Hays. "California Art for Peace." *Art Journal*, vol. 30, no. 2 (1970–1971), 163–164.

Heins, Marjorie. "I Like to See Things Crudely." *San Francisco Express Times*, August 21, 1968.

Hersh, Seymour. "My Lai 4: A Report on the Massacre and Its Aftermath." *Harper's*, May 1970, 53–84.

Holt, Michael Ned. "Wally Hedrick: The Box." *Artforum*, vol. 46, no. 10 (2008), 448.

Israel, Matthew. "A Magnet for the With-It Kids: The Jewish Museum, New York, of the 1960s." *Art in America*, vol. 95, no. 9 (2007), 72–83.

———. "As Landmark: An Introduction to 'Harlem on My Mind.'" *Art Spaces Archives Project*, December 2004.

Israel, Nico. "On Kawara, David Zwirner." *Artforum*, vol. 43, no. 5 (2005), 180.

Jones, D. A. N. "The Monstrous Thing." *New York Review of Books*, December 17, 1964, 8–9.

Kastner, Jeffrey, Mark di Suvero, Irving Petlin, and Rirkrit Tiravanija. "Peace Tower: Irving Petlin, Mark di Suvero, and Rirkrit Tiravanija Revisit *The Artists' Tower of Protest*, 1966." *Artforum*, vol. 44, no. 7 (2006), 252–257.

Kay, Jane Holtz. "Artists as Social Reformers." *Art in America*, vol. 57, no. 1 (1969), 44–47.

Kelly, Mike. "Myth Science: On Öyvind Fahlström." In *Foul Perfection: Essays and Criticism*. Ed. John C. Welchman, 158–177. Cambridge: MIT Press, 2003.

Kozloff, Max. "A Collage of Indignation." *The Nation*, February 20, 1967.

———. "The Late Roman Empire in the Light of Napalm." *Artnews*, vol. 69, no. 7 (1978), 58–60, 76–78.

Kramer, Hilton. "'Miracles,' 'Information,' 'Recommended Reading.'" *New York Times*, July 12, 1970.

Levi-Strauss, David. "Where the Camera Cannot Go: Leon Golub on the Relation Between Art and Photography." *Aperture*, vol. 162 (Winter 2001), 52–64.

Lewis, Michael J. "Art, Politics, and Clement Greenberg." *Commentary*, June 1998.

Lippard, Lucy. "The Dilemma." *Arts*, November 1970, 27–29.

———. "Flagged Down: The Judson Three and Friends." *Art in America*, vol. 60, no. 3 (1972), 48.

MacDonald, Dwight. "A Day at the White House." *New York Review of Books*, July 15, 1965, 10–15.

Mascheck, Joseph. "Peter Saul." *Artforum*, vol. 10 (January 1972), 85.

McCarthy, David. "Dirty Freaks and High School Punks: Peter Saul's Critique of the Vietnam War." *American Art*, vol. 23 (Spring 2009), 78–103.

———. "Fantasy and Force: A Brief Consideration of Artists and War in the American Century." *Art Journal*, vol. 62, no. 4 (2003), 93–100.

McEvilley, Thomas. "Outside the Comfort Zone." *Art in America*, vol. 90, no. 4 (2002), 102.

Morgan, Robert C. "Carolee Schneemann's Viet-Flakes (1965)." In *After the Deluge: Essays on Art in the Nineties*, 36–40. New York: Red Bass, 1993.

"Nation: Festival of the Arts." *Time*, June 25, 1965.

Nemser, Cindy. "Artists and the System: Far from Cambodia." *Village Voice*, May 28, 1970.

Pepper, William F. "The Children of Vietnam." *Ramparts*, vol. 5 (January 1967), 44–68.

Perreault, John. "Art: Repeating Absurdity." *Village Voice*, December 14, 1967.

———. "Art on Strike." *Village Voice*, May 28, 1970.

———. "Faith and Fire." *Village Voice*, October 31, 1968.

Raskin, David. "Specific Opposition: Judd's Art and Politics." *Art History*, vol. 24, no. 5 (2001), 682–706.

Robins, Corinne. "The NY Art Strike." *Arts Magazine*, vol. 45, no. 1 (1970), 27–28.

Rose, Barbara. "The Lively Arts: Out of the Studios, on the Barricades." *New York*, August 10, 1970, 54–57.

Rosenberg, Harold. "Art of Bad Conscience." *New Yorker*, December 16, 1967.

Rosler, Martha. "Here and Elsewhere." *Artforum*, vol. 46, no. 3 (2007), 50.

Schwartz, Therese. "The Politicization of the Avant-Garde: Part I." *Art in America* vol. 59, no. 6 (1971), 97–105.

Shepherd, Richard. "Robert Lowell Rebuffs Johnson as Protest over Foreign Policy." *New York Times*, June 3, 1965.

Siegel, Jeanne. "Carl Andre: Art Worker, in an Interview with Jeanne Siegel." *Studio International*, vol. 180, no. 927 (1970), 175–176.

———. "An Interview: Hans Haacke by Jeanne Siegel." *Arts Magazine*, vol. 45, no. 7 (1971), 18–21.

Sontag, Susan. "Inventing and Sustaining an Appropriate Response." *Los Angeles Free Press*, vol. 3, no. 9 (1966), 4.

———. "A Lament for Bosnia." *The Nation*, December 25, 1995.

Steiner, George. "Letter to Noam Chomsky." *New York Review of Books*, March 23, 1967, 28.

Stimson, Blake. "The Promise of Conceptual Art." In *Conceptual Art: A Critical Anthology*. Ed. Alex Alberro and Blake Stimson, xxviii–lii. Cambridge: MIT Press, 1999.

"Transcript of Interview of Vietnam War Veteran on His Role in Alleged Massacre." *New York Times*, November 25, 1969.

Walker, H. "Peter Saul." *Artforum*, vol. 47, no. 10 (2009), 300–303.

Whelton, Clark. "The Flag as Art: Bars and Stripes Forever." *Village Voice*, November 19, 1970.

"White Out Blacked Out: Protest by Art Community Gets Silent Treatment." *Los Angeles Free Press*, May 21, 1965.

Wicker, Tom. "Kennedy Asserts U.S. Cannot Win." *New York Times*, February 9, 1968.

Williams, Tom. "Lipstick Ascending: Claes Oldenburg in New Haven in 1969." *Grey Room*, vol. 31 (Spring 2008), 116–144.

SPECIAL COLLECTIONS

Carolee Schneemann Papers, Special Collections, Getty Research Institute, Los Angeles.

Center for the Study of Political Graphics, Los Angeles.

Charles Brittin Papers, Special Collections, Getty Research Institute, Los Angeles.

Daedalus Foundation, New York.

David Zwirner Gallery Library, New York.

Department of Prints and Illustrated Books, Museum of Modern Art, New York.

Downtown Collection, Fales Library and Special Collections, Elmer Holmes Bobst Library, New York University.

Harold Rosenberg Papers, Special Collections, Getty Research Institute, Los Angeles.

Irving Sandler Papers, Special Collections, Getty Research Institute, Los Angeles.

Lucy Lippard Papers, Archives of American Art, Smithsonian Institution, Washington, DC.

Michael Rossman Political Poster Collection (in the possession of Lincoln Cushing), Berkeley, CA.

Museum of Television and Radio, New York.

New Left Collection, Hoover Institution, Stanford University.

PAD/D Archive, Special Collections, Museum of Modern Art Library, New York.

Paula Cooper Gallery Library and Archives, New York.
Ronald Feldman Gallery Library, New York.

PERSONAL INTERVIEWS

Abeles, Sigmund. February 24, 2009.
Acconci, Vito. April 3, 2009.
Andre, Carl. April 15, 2009.
Aptekar, Bernard. February 27, 2008.
Berger, Maurice. July 10, 2008.
Bochner, Mel. February 6, 2009.
Brown, Kay, February 24, 2009.
Cajori, Charles. February 3, 2009.
Chwast, Seymour. February 12, 2009.
Dean, Peter. March 6, 2009.
Duncan, David Douglas. February 24, 2009.
Garcia, Rupert. February 12, 2009.
Glaubman, Evelyn. March 27, 2009.
Grooms, Red. March 10, 2009.
Haacke, Hans, March 10, 2009.
Heller, Steven. February 6, 2009.
Iles, Chrissie. January 27, 2009.
Indiana, Robert. February 24, 2009.
Lippard, Lucy. July 30, 2009.
Oka Doner, Michele. March 12, 2009.
Petlin, Irving. April 2, 2009.
Pitman Weber, John. March 7, 2009.
Ray, Violet. April 14, 2009.
Rosler, Martha. April 3, 2008.
Saul, Peter. April 6, 2009.
Schneemann, Carolee. March 24, 2009.
Smith, Joel. April 7, 2009.
Spero, Nancy. May 6, 2008.
Stevens, May. February 12, 2009.
Weege, William. March 3, 2009.

Index

Page numbers in *italics* indicate figures.